DUTCH SEVENTEENTH AND EIGHTEENTH CENTURY PAINTINGS IN THE NATIONAL GALLERY OF IRELAND

A complete catalogue

DUTCH SEVENTEENTH AND EIGHTEENTH CENTURY PAINTINGS IN THE NATIONAL GALLERY OF IRELAND

A complete catalogue

HOMAN POTTERTON

THE NATIONAL GALLERY OF IRELAND 1986

For A.H. in gratitude

British Library Cataloguing in Publication Data
National Gallery of Ireland.
 Dutch seventeenth and eighteenth century
 paintings in the National Gallery of Ireland:
 a complete catalogue.
 1. Painting, Dutch — Catalogs 2. Painting,
 Modern — 17th-18th centuries — Netherlands —
 Catalogs
 I. Title II. Potterton, Homan
 759.9492'074 ND646

 ISBN 0-903162-30-X
 ISBN 0-903162-31-8 Pbk

First published, 1986, by the National Gallery of Ireland, Dublin 2.

© Homan Potterton and the National Gallery of Ireland, 1986.

Edited by Elizabeth Mayes
Photography by Michael Olohon
Design, origination and print production by Printset & Design Ltd., Dublin.
Printed in Ireland by Criterion Press Ltd.

COVER: detail of *The village school* by Jan Steen (cat. no. 226).

Contents

PREFACE

THIS CATALOGUE describes all the Dutch seventeenth and eighteenth century paintings in the National Gallery of Ireland, a total of almost two hundred works. It is the first of a planned series of catalogues by different authors which will describe in critical detail the Gallery's entire collection of Old Masters, and other titles in the series are shortly to be published. As the note preceeding the bibliography (p. 214) states, catalogues of the Gallery's pictures were published frequently in the nineteenth century and in the early years of this century; but these gave only the briefest of information, rarely referred to bibliography or comparative pictures and, as often as not in the case of provenances, simply stated the year of purchase. Since 1914 only four descriptive catalogues of the collection have been published: all of these were selective and nor did they set out to document fully the pictures they described. The task of compiling this and other catalogues in the series has, therefore, often been daunting, although in my own case it has always been exhilarating and sometimes thrilling: not least on the day when I discovered that our Schalcken, listed in Gallery records as 'purchased in 1898' had, in fact, once been in the Orléans Collection.

When I started work on the catalogue six years ago I had no specialist knowledge of Dutch seventeenth and eighteenth century painting and I foolishly imagined that one Dutch cow in a landscape was the same as the next, and that the task of cataloguing such pictures would be a simple one. Over the years, as I proved to myself the silliness of my misconception, I have acquired some knowledge of Dutch painting in its Golden Age; but only sufficient for me to appreciate how much more there is to know. In publishing the catalogue, therefore, I am all too well aware that scholars will have criticisms to make and information to add to the results of my researches, and I can only say that I would welcome any such observations. Many of the pictures described in the Catalogue are the work of *petits maîtres*: as such they were never famous paintings and nor were they expensive. Because of this it has often been extremely difficult to trace their history in sale records of the eighteenth and nineteenth centuries. While I believe I have compiled many useful references in relation to the paintings themselves, I would make the point that the biographies of the artists lay no claim to being the products of original research; and I willingly acknowledge my indebtedness, where relevant, to Neil MacLaren's biographies in his catalogue of The Dutch School in the National Gallery published as long ago as 1960; but in most cases never superseded.

In compiling the catalogue I have benefitted from information given by numerous people and I have recorded this assistance in the appropriate places throughout the catalogue. I would, however, above all like to thank the following: Christopher Brown, who, by reading the final text of the catalogue, gave generously of his time and expertise and made many useful suggestions; Michael Robinson for the care he took

in advising me on the entries relating to paintings associated with Willem van de Velde the Younger; F.G.L.O. van Kretschmar, the former Director of the Stichting Iconographisch Bureau in The Hague, and P. J. J. van Thiel of the Rijksmuseum in Amsterdam for their ready responses to my frequent enquiries; Margaret Christian of Christie's for constant help in relation to sale records; Margaret Cook in London and Christiaan Vogelaer in Holland for checking various references (and to the latter for also providing me with translations from Dutch).

I owe a particular debt of gratitude, as indeed does everyone engaged in research on Dutch painting, to the staff and facilities of the Rijksbureau voor Kunsthistorische Documentatie in The Hague, the photographic archive and library of which I have consulted freely and frequently. I am also grateful to the staffs of the Witt Library of the Courtauld Institute in London and the Frick Art Reference Library in New York for their assistance during the periods when I researched in those institutions. For library facilities, however, I would express a special obligation to the Director of the National Gallery, Sir Michael Levey and the Librarian, Christopher Brown for according me the singular privilege of access to the Library in the Gallery on a regular basis; and my thanks are due to Elspeth Hector and the staff there for their friendly, efficient and always co-operative assistance.

At the National Gallery of Ireland it is a pleasure to record my appreciation of Raymond Keaveney, Mary McCarthy and Janet Drew all of whom have always undertaken more than their share of administration to allow me the luxury of time for research and writing. A number of the pictures in the Catalogue have been cleaned over the past six years in the Gallery's Conservation Department by Andrew O'Connor and Sergio Benedetti and then photographed by Michael Olohon. For her careful editing and correcting of proofs I am very thankful to Elizabeth Mayes and also to Adrian Le Harivel who spotted a number of inconsistencies in my text.

Throughout the years of research I have always been conscious of what the Gallery owed to two particular people: I refer to two of my most distinguished predecessors as Director of the National Gallery of Ireland, Henry Doyle and Walter Armstrong. Between them, a century ago, they purchased the greater part of the Dutch collection: a collection which has given pleasure to countless people over the decades since their time. If the information given in my catalogue enhances in any way the enjoyment to be derived from the pictures described, then it will be a small tribute to the memory of those two men.

HOMAN POTTERTON
Director, The National Gallery of Ireland
July 1986

INTRODUCTION

THE COLLECTION of Dutch seventeenth and eighteenth century paintings in the National Gallery of Ireland is numerically the largest representation of any school among the Old Master pictures in the Gallery. There are in fact a greater number of Italian works in the Collection but they date from over five hundred years spanning the fifteenth to the nineteenth centuries, whereas from Holland in the seventeenth and eighteenth centuries there are almost two hundred paintings. Among this collection there are some few very important pictures by very important names: Rembrandt's *Landscape with the rest on the flight into Egypt* and Steen's *Village school* for example; but the strength of the Collection and its character derive from the large number of pictures of high quality by minor masters. The Collection was formed largely in the forty years, 1870-1910 and was for the most part purchased on the open market in London, mainly at Christie's. The tone of the Collection is, therefore, specifically of the late nineteenth century and is quite different in content from the traditional collection of Dutch pictures that would have been formed in these islands in the eighteenth or early nineteenth centuries. Such a collection would have consisted of a fairly large representation of some few painters such as Rembrandt, Aelbert Cuyp, Wouwerman and, perhaps, Hobbema. There would have been genre paintings by van Mieris, Gerard Dou and Adriaen van der Werff and probably some seascapes by van de Velde and van de Capelle. Apart from Rembrandt (shown by a single masterpiece) none of these painters are represented in Dublin, at least not by any picture of quality. Instead there are fine landscapes by Both, Berchem, van Goyen, Salomon van Ruysdael, Jacob van Ruisdael, and by the lesser painters, van Bergen, Soolmaker, Wijnants, Ludolf de Jongh, van der Croos and Weenix. There are genre paintings by Molenaer, Sorgh, de Pape, Duck, Codde, Duyster, Ochtervelt and de Hooch. Portraiture is shown with Mytens, Moreelse, Maes and, on a small scale, Slingeland, Kamper and Pot. The style of Rembrandt is demonstrated by a group of paintings by his close followers including de Wet, de Poorter, Bol, Flinck, van den Eeckhout and Victors, as well as by two quite exceptional rarities: Drost's *Bust of a man* and the only signed work by Rembrandt's documented pupil, Isaac de Jouderville. Rembrandt's own teacher, Lastman, is included with a picture which the master himself copied in a drawing.

The first Dutch picture acquired for the Gallery, *David's dying charge to Solomon* by Bol remains among the most important in the Collection. It had, from the early nineteenth century, been at the Vice-Regal Lodge in Dublin and when the proposal to establish a National Gallery in Dublin was mooted, the then Lord Lieutenant bestowed his patronage on the project by presenting the painting to the Irish Institution in 1854 for the purpose of the future gallery. Apart from this work, the Dutch School at the time of the inauguration of the Gallery in 1864 was very poor. In anticipation of the opening some few purchases were made in 1863 by the new Director, George

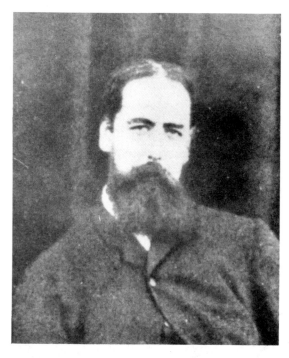

HENRY DOYLE, DIRECTOR OF THE
NATIONAL GALLERY OF IRELAND, 1869-92
Doyle was a passionate collector
with an exceptional eye for quality.
He purchased, mainly at
Christie's, almost sixty Dutch
pictures for the Collection during
the twenty-two years of his
Directorship.

Mulvany; but the policy of the Governors and Guardians at the time was based
on the premise that 'as it might be impossible to obtain an example of the greatest
names in the history of art, the great painters may for years be only known to the
Irish public through the imperfect means of copies'; and that is largely what Mulvany
bought. Two notable exceptions were the highly unusual Pieter de Molijn (purchased
in 1864) and de Heem's *Fruit-piece*: a painting which had been described by Descamps
in the eighteenth century.

With Mulvany's death in 1869 the Governors and Guardians appointed Henry
Doyle, Director. Doyle was an artist and indeed was one of a famous family of Irish
artists in the nineteenth century. His father was 'HB' the political cartoonist and his
brother was Dickie Doyle the illustrator of *Punch*. Doyle was living in London at the
time of his appointment (he was Commissioner for the International Exhibition in
London in 1862) and he seems to have retained a residence in London during the
twenty-two years of his Directorship. He was not a scholar and in fact seems never
to have contributed in any way to the literature of art history; but he was exceptionally
talented as a connoisseur and was a passionate collector with enormous skill in making
purchases from very meagre resources. With an annual budget of £1,000 Doyle
purchased pictures of all schools, but he laid a particular emphasis on the Dutch
School. Most of his acquisitions were made at Christie's in London and in an
illustration published in *The Graphic* in 1887 he is identified, standing behind the
rostrum, 'a rather favourite place for the *cognoscenti* to compare notes', with one of
the Governors and Guardians, Lord Powerscourt. As *The Graphic* remarked, Doyle
'never missed a chance of adding a good picture to his Gallery', and while he often
paid top prices, for example £790 for Both's *Italianate landscape* (no. 179) in 1880 and

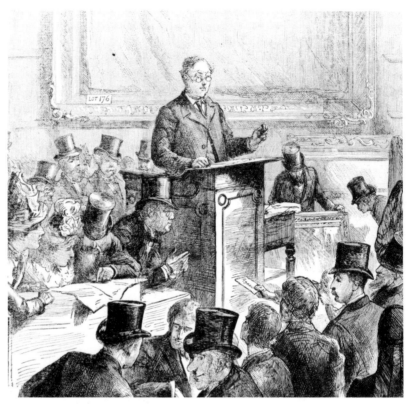

HENRY DOYLE AT CHRISTIE'S IN 1887
Illustration from 'The Graphic' 10th September 1887
Doyle, bearded and wearing a top-hat, is standing behind the rostrum
to the left. He is accompanied by Lord Powerscourt who was one of the
Governors and Guardians.

420 guineas for the small Jacob van Ruisdael (no. 37) in 1873, he frequently collected
a bargain: 5 guineas for Moreelse's *Portrait of a child* (no. 263) in 1885 and 15 guineas
for Bleker's rare *Raid on a village* (no. 246) in the same year. Many of the pictures
which Doyle acquired had, in the past, been in distinguished collections: van
Ruisdael's *Landscape* had been owned by William Beckford; Sorgh's *The breakfast* by
J. B. P. Le Brun; Steen's *Village school* by the Greffiers Fagel; and Rembrandt's *Landscape*
came from Stourhead. By the time of Doyle's death in February 1892 the National
Gallery of Ireland, then only twenty-eight years in existence, was well established
and had a collection that was sufficiently large for the Gallery to be hung according
to Schools, of which the Dutch School was among the most notable. The Governors
and Guardians rightly minuted that Doyle's zeal and remarkable ability had left their
mark for ever on the Gallery.

Doyle's successor as Director, Walter Armstrong was recommended for the post
by among others, Abraham Bredius who referred to him as 'one of the best among
the *very few* real connoisseurs of the old Dutch School in England'. Unlike Doyle,
Armstrong was an academic and had published widely at the time of his appointment

SIR WALTER ARMSTRONG,
DIRECTOR OF THE NATIONAL
GALLERY OF IRELAND, 1892-1914
*Detail of a portrait by Walter
Osborne (coll. The National
Gallery of Ireland).*
Armstrong was a
distinguished scholar and a
connoisseur of the Dutch
School. During his time as
Director he purchased a
number of important Dutch
pictures for the Gallery and, in
1914, wrote the last complete
catalogue of the Collection.

and continued to do so throughout his tenure of office. Catalogues of the collection in Dublin had been published regularly under Doyle but on his appointment Armstrong set about a complete revision and the resulting work, published six years later, contained a number of new attributions particularly in relation to the Dutch School. In making purchases Armstrong added a number of rare and beautiful pictures to the collection: de Gyselaer's *Interior; The riding school* by Dujardin and Schalken's *Pretiose recognised*: a painting which had been in the Orléans Collection, although this fact was unknown to Armstrong. In 1909 he purchased Troost's masterpiece *The Dilettanti* and it was he who acquired the *tronie* by de Jouderville, and the enigmatic *Interior* of superb quality which is here catalogued as School of Rembrandt. In 1901, under the terms of the will of Sir Henry Page Turner Barron (an Irish diplomat who had spent his life abroad), Armstrong was allowed to make his choice of pictures from Barron's collection; and in this way he added major paintings to the collection by Berchem, Heda, de Hondecoeter, de Lorme, Salomon van Ruysdael, Weenix and Wijnants. Most of these had been purchased by Barron from well-known collections: the de Hondecoeter had been owned by the Viscomte du Bus de Gisignies; Lagoor's *Landscape* by Wynn Ellis; de Lorme's *Church interior* by Corneille de Badts; van Ruysdael's *The halt* by Prince Demidoff; the *Landscape* by Wijnants came from the C. J. Nieuwenhuys sale; and *The sleeping shepherdess* by Weenix had once been in the collection of Etienne Le Roy. The Barron Bequest was in fact the most important bequest or gift of Dutch pictures ever made to the Gallery. The following year, in 1902, Armstrong was offered a similar opportunity in relation to the Milltown Gift. The strength of the Milltown Collection lay, however, in the Italian School and it

is quite likely that Armstrong would have selected only the early painting by Both from among the Dutch School. The donor Lady Milltown had, however, other ideas and although she initially offered the Gallery its choice of pictures, in the event the Board were obliged to accept the entire collection some of which Armstrong found 'generally undesirable . . . and all the more so because they had been rendered more fully unacceptable by some process of cleaning, renovation of frames, etc.'. The group of paintings in the style of Wouwerman included in this catalogue which came with the Milltown Gift are all painted yellow on the reverse, and it is probably this to which Armstrong referred. Through his scholarship, Armstrong brought international distinction to the Gallery and during his time the Dublin pictures became well-known to scholars everywhere and they were also frequently published. Bode, Bredius, Hofstede de Groot and many others all came to Dublin; and at the time of Armstrong's retirement in 1914 the Gallery and its collection enjoyed the international reputation which it deserved.

Sir Hugh Lane, who was the National Gallery of Ireland's single most munificent benefactor ever, presented during his lifetime and bequeathed after his death a number of Dutch pictures to the Gallery. Before his untimely death in May 1915 he had been Director of the Gallery, as successor to Armstrong, for thirteen months. His Dutch pictures were in fact not the best among his collection although they included the fine van Goyen, *View of Rhenen-on-the-Rhine*, Bol's *Portrait of a lady* and, most notably, the beautiful *Portrait of a lady with a glove* which is now catalogued as Studio of Rembrandt. The controversy which surrounded this picture, and which is here recounted in full, was a source of bitter disappointment to Lane during his lifetime and the status of the picture has never been satisfactorily resolved since his time.

Since Lane the Dutch School has been augmented mainly through isolated gifts and bequests. The large *Gamepiece* by Jan Weenix, which had been in the collection of Gerret Braamkamp in Amsterdam in the eighteenth century was presented by Sir W. Hutcheson Poë in 1931; Both's *Italianate landscape* formerly in the Hope Collection, was presented by Sir Alfred Chester Beatty in 1950 (although only received in the Gallery in 1978); and Robert Langton Douglas, who unexpectedly resigned the Directorship in 1923, presented at the same time Post's *Brazilian landscape*. In the period 1921-1930 some few pictures were purchased. These were mainly recommended by Thomas Bodkin who was one of the Governors and Guardians and then Director from 1927-35. Chief among his purchases was *Joseph selling corn in Egypt* by Rembrandt's teacher, Pieter Lastman, the composition of which was known, before the picture was discovered, through Rembrandt's drawing after the painting. Bodkin also acquired ter Borch's *Four Franciscan monks*, which, although much damaged, is of great interest on account of its subject matter; and a rare seascape by the little-known Gerrit Pompe was uncovered by Bodkin at a sale in Dublin in 1923 and acquired for as little as £50.

This brief account of how the Collection came to be acquired may be augmented by reference to the chronological list of acquisitions at the back of the Catalogue (pp. 199-200) and the index of former owners (pp. 201-07) conveys the variety of sources from which the Dutch seventeenth and eighteenth century paintings in the National Gallery of Ireland derive.

Map of
HOLLAND

indicating the location of the principal
places mentioned in the text

30 km

THE TEXEL

LEEUWARDEN

ASSEN

EMDEN

MEDEMBLIK

HOORN ENKHUIZEN

EGMOND AAN ZEE

ALKMAAR KAMPEN

BEVERWIJK ZWOLLE

ZAANDAM

ZANDVOORT HAARLEM

HEEMSTEDE AMSTERDAM

NAARDEN DEVENTER

SOEST APELDOORN

SCHEVENINGEN LEIDEN AMERSFOORT

THE HAGUE

RIJSWIJK UTRECHT BURGSTEINFURT

DELFT VIANEN RHENEN ARNHEM

ROTTERDAM MÜNSTER

DORDRECHT

GORINCHEM NIJMEGAN

ZIERIKZEE HEUSDEN KLEVE

BREDA 's-HERTOGENBOSCH WESEL

MIDDELBURG GERMANY

BERGEN-OP-ZOOM

ANTWERP

BELGIUM DUSSELDORF

BRUSSELS

RIVER MAAS

RIVER RHINE

WILLEM VAN AELST Delft 1627-c.1683 ? Amsterdam

He was the pupil of his uncle Evert van Aelst in Delft and became a member of the Guild of St. Luke there in 1643. About 1645 he went to France and then to Italy where he entered the service of the Grand Duke of Tuscany. From 1657 he worked in Amsterdam. He painted exclusively flower-pieces in a very minute technique: unlike many painters of similar subject matter he never repeated his compositions and was the first to deploy asymmetrical arrangements.

1015 A fruit-piece (Fig. 1).

Oil on canvas, 71.5 × 55.3 cms. (28¼ × 21¾ ins.).

SIGNED: bottom right, *W. VA* (the *VA* in monogram).

CONDITION: very good, underneath a heavy varnish.

PROVENANCE: Miss H. M. Reid of Dublin, by whom bequeathed, 1939.

Peaches and black grapes are arranged with vine leaves on a ledge against a dark background. The light falls from the left and highlights the leaves and the fruit. A vine branch leading upwards to the left lends asymmetry to the composition and is typical of the painter.

Although van Aelst was capable of painting very elaborate and showy fruit and flower-pieces, no. 1015 is one of his simpler compositions and may be compared with, for example, a similar painting by him previously in a British private collection.[1] Haex[2] has compared no. 1039 with a dated picture of 1661 by van Aelst in Schwerin[3] which shows a much more elaborate composition; and a date of about the same time may be suggested for no. 1015.

1. Sold Sotheby's, 8 April 1981, lot 93. The picture is signed indistinctly.
2. Odette Haex in a letter dated 4 March 1983 now in the archive of the Gallery.

3. Staatlisches Museum, inv. no. 424. Repr. *Schwerin, Staatliches Museum, cat. 1982*, fig. 102, p. 71.

ARNOLDUS (or AERNOUT) VAN ANTHONISSEN
Leiden c.1630-1703 Zierikzee

He was the son of Hendrik van Anthonissen and uncle of Aert Anthonisz, called Antum — both marine painters. He worked first in Leiden where he was a hoofdman of the Guild of St. Luke in 1662; but from 1664 was a Burger of Zierikzee where he mainly lived until his death in 1703. He is referred to in the records of the Guild of St. Luke in Middelburg in 1665 and from 1667-69 was a member of that Guild. He painted sea and river landscapes first in the grey-green tones of his father and later in tones of brown and grey similar

1

to the work of Jan van Goyen (q.v.). In Zierikzee he painted wall paintings for churches, had a hat and glove shop and was most probably also a dealer in pictures.

152 A river scene with shipping (Fig. 2).

Oil on canvas, 65.4 × 96 cms. (25¾ × 37¾ ins.).

SIGNED: on the side of the sail-boat second from left: *A.A.*

CONDITION: paint surface in fair condition. Some damages in the sky, left; and above the sails of the vessel, right; also damage in the water, right of centre. Cleaned in 1985.

PROVENANCE: Major Corbett-Winder sale, Christie's, 6 April 1889, lot 81, where purchased for 30 guineas.

LITERATURE: Bol 1973, p. 135 and fig. 139, p. 136; Preston 1974, p. 1.

The scene depicts fishing and other coastal craft in inland waters. The sprit-rigged vessel second from right, which is shown before the wind, was probably used for passengers. To the extreme right a sprit-rigged vessel with a squaresail before the wind.

No. 152 was sold in 1889 as Simon de Vlieger and accessioned as such at the Gallery. The signature was discovered by Hofstede de Groot in 1898, since when the picture has been correctly catalogued as van Anthonissen. Bol[1] compares no. 152 with a signed seascape by van Anthonissen in Zierikzee[2] which he refers to as one of the best works of van Anthonissen, and he treats no. 152 as 'of the same quality'. A comparison might also be made with a monogrammed painting by van Anthonissen, smaller in size to no. 152, in Leiden[3] which shows a choppy sea and a somewhat similar disposition of boats.

1. Bol 1973, p. 135.
2. In the Burgerweeshuis.
3. In the Lakenhal. *Leiden, de Lakenhal, cat. 1983*, cat. no. 8, p. 48.

PIETER JANSZ. VAN ASCH Delft 1603-1678 Delft

It is not known by whom he was trained but he became a member of the Guild of St. Luke in Delft in 1623. According to Houbraken he was one of the most admired landscape painters of his day. He painted wooded and river landscapes in the manner of Jacob van Ruisdael (q.v.) and worked in Delft throughout his career.

343 Landscape with figures (Fig. 3).

Oil on octagonal panel, 43 × 50.5 cms. (16⅞ × 21½ ins.).

SIGNED: bottom centre, *PVA* (in monogram).

CONDITION: the support consists of two members joined on a horizontal 15.3 cms. from the top. Some wearing; overpaint in the clouds. The trees may also be strengthened. Otherwise in fair condition.

PROVENANCE: Mrs. Algie of Dublin, from whom purchased, 1894, for £5.

They are falconing.

The octagonal format of no. 343 is by no means usual in van Asch's oeuvre, although at least one pair of paintings similar in size and format is known.[1] van Asch favoured subject matter similar to that shown in no. 343 with falconers or other huntsmen on horseback in a landscape.[2] The Italianate landscape is also unusual in his oeuvre although by no means unique.[3]

Few of his works are dated, so that no reasonably secure date may be suggested for no. 343.

1. Sold at Sotheby's, 22 February 1956, lot 114.
2. For example, a painting in Glasgow Art Gallery and Museum, Glasgow, cat. 1961, vol. 2, no. 91, p. 31.

3. There is an example in the Rijksmuseum, Amsterdam, inv. no. C88, Repr. *Amsterdam, Rijksmuseum, cat. 1976*, p. 88.

HENDRICK AVERCAMP Amsterdam 1585/86-1634 Kampen

He was baptised in Amsterdam on 27 January 1585 but his family moved to Kampen the following year. He returned to Amsterdam where he may have trained in the studio of Pieter Isaacksz, a Danish history and portrait painter. He is recorded back in Kampen in 1613 where he remained for the rest of his life. As he was a mute, he was known in his lifetime as 'de stomme van Campen'. His paintings are in the tradition of the Flemish followers of Pieter Brueghel the Elder and it is possible that he was a pupil of one of those, who settled in Amsterdam, such as David Vinckboons. He painted mainly snow and ice scenes and was a talented draughtsman executing a number of watercolours and chalk drawings.

496 Scene on the ice (Fig. 4).

Oil on panel, 20.5 × 43.8 cms. (8^{1}/$_{16}$ × 17¼ ins.).

SIGNED: bottom, left of centre, *HA* (in monogram).

CONDITION: good. Cleaned in 1979.

PROVENANCE: T. Humphry Ward, by whom presented, 1900.

LITERATURE: Welcker 1933, no. S45, p. 207; Welcker 1979, no. S45, p. 210; *The Hague, Mauritshuis, cat. 1980*, p. 4; Paris 1986, p. 128.

DRAWING: related to the composition, Museum Boymans–van Beuningen, Rotterdam, inv. no. H.95 (Fig. 5).

No. 496 is somewhat similar in format and composition to a larger painting by Avercamp in The Hague.[1] A drawing by Avercamp in Rotterdam[2] of a draw-bridge similar to that shown in both no. 496 and The Hague picture has been described[3] as preparatory for The Hague picture; but it would have a more justifiable claim to being preparatory for no. 496. The bridge in the drawing is almost identical with that shown in no. 496, whereas there are several differences between it and that in The Hague picture. The sail-boat

moored on the right of no. 496, although not in The Hague picture, appears, seen from a different angle in the drawing.

The Hague painting is thought to have been painted about 1610[4] but it has been pointed out that it was Avercamp's practice to re-use elements from his compositions in later paintings; and a date after 1620 has been suggested for no. 496.[5]

1. Mauritshuis inv. no. 785. Oil on panel, 36 × 71 cms. Repr. *The Hague, Mauritshuis, cat. 1977*, p. 33.
2. Museum Boymans–van Beuningen inv. no. H.95. It is Welcker 1979, cat. no. T.62.2 and repr. *ibid.* pl. 13.

3. By Hensbroek van der Poel in Welcker 1979, no. T.62.2, p. 263.
4. *The Hague, Mauritshuis, cat. 1977*, p. 33.
5. Paris 1986, p. 128.

LUDOLF BAKHUIZEN Emden 1631-1708 Amsterdam

He was born in Emden, East Friesland on 28 December 1631. He moved to Amsterdam in 1650 where, according to Houbraken, he became a merchant's clerk and also taught calligraphy. As an artist he developed by first of all making pen drawings of shipping and later learned painting from Allaert van Everdingen (q.v.) and Hendrick Dubbels. His later shipping pictures show the influence of Willem van de Velde the Younger (q.v.). After the van de Veldes went to England in 1672 he became the leading marine painter in Holland and was very successful and widely patronised. He married four times, in 1657, 1660, 1664 and 1680, and he died in Amsterdam on 7 November 1708. He painted some portraits but was principally a marine painter and was a talented draughtsman. There are also a number of etchings by him.

173 The arrival of the *Kattendijk* at The Texel, 22 July 1702 (Fig. 6).

Oil on canvas, 133 × 111 cms. (53⅜ × 43¾ ins.).

SIGNED: on the spur, bottom left, *L. Bak*

INSCRIBED AND DATED: on the stern of the *Kattendijk*, *A° Katten Dyck 1702*; and on the flag flying from the ship's boat, foreground right, *1702*.

CONDITION: good.

PROVENANCE: F. W. Reynolds sale, Christie's, 10 April 1883, lot 78, where purchased for 92 guineas.

LITERATURE: Armstrong 1890, p. 287; Hofstede de Groot 1908-27, vol. 7, no. 198, p. 262; Preston 1974, p. 4.

No. 173 was called by Armstrong[1] *The Dutch East India fleet leaving port* and has always been so referred to at the Gallery. In fact it shows the arrival of the *Kattendijk* at The Texel on 22 July 1702 and is so identified by the inscription on the ship itself. The *Kattendijk*,[2] which was a Dutch East Indiaman of 759 tonnes, was one of a fleet of nineteen East Indiamen which returned to The Texel from the East on 22 July 1702 with Harman Voet

in command on the *Generale Vrede*. On board the *Kattendijk*, which was built in Zeeland in 1694, were ninety seafarers and twenty-five soldiers: it is not recorded who was in command. The *Kattendijk* left Batavia on 28 November 1701 and rounded the Cape between 13 and 15 February 1702. In no. 173 she is shown arriving on the Marsdiep between the mainland of Holland and the island of Texel. She flies a Dutch flag from her mainmast. The large East Indiaman to the left of the *Kattendijk* is the *Sion*, Rear-Admiral Gerrit Kollaart in command. In the foreground right is a ship's boat crowded with people; and there are numerous other small vessels shown under sail.

1. Armstrong 1890, p. 287.
2. See Bruijn, Gaastra, Schöffer 1979, p. 166.
The compiler is indebted to R. M. Vorstman of

the Rijksmuseum 'Nederlands Scheepvaart Museum' for this reference and also for identifying the ship.

1673 A shipwreck (Fig. 7).

Oil on canvas, 49 × 74 cms. (19¼ × 29⅛ ins.).

CONDITION: fair. Cleaned, lined and restored in 1970.

PROVENANCE: by descent in the family of the Earls of Milltown, Russborough, county Wicklow to Geraldine, Countess of Milltown, by whom presented in memory of her husband, the 6th Earl of Milltown, (Milltown Gift), 1902.

Bakhuizen painted a number of pictures of shipwrecks and often showed some figures reaching land, setting up a cross and praying. Hofstede de Groot[1] described these paintings variously as *Jonah, Christ in the storm on the lake of Tiberias,* the *Calling of St. Peter* and *The shipwreck of St. Paul.* In the case of no. 1673 Vorstman[2] has suggested that the scene depicted may relate to an actual storm in the Mediterranean on 1st March 1694.[3] On that occasion a combined Anglo-Dutch fleet of warships was escorting trading vessels from Portsmouth to the Mediterranean. Having left Portsmouth on 6th January the fleet arrived in Cadiz on 29 January and again raised anchor on 23 February to continue via the Straits of Gibralter to Sicily. The fleet was surprised by a heavy storm from 1st to 3rd March which sank several English warships and seven trade vessels. In a painting in an Amsterdam private collection,[4] Bakhuizen shows the shipwreck of the *Ridderschap* and the *Hollandia* during the storm.

In style and composition no. 1673 is somewhat similar to a *Shipwreck of St Paul* by Bakhuizen in Emden[5] which shows figures reaching land, and a fortress with a round tower on a rock. That painting has been dated to the 1690's[6] and the *Shipwreck of the Ridderschap and Hollandia* to about 1694.[7] A date in the same decade may be suggested for no. 1673.

1. Hofstede de Groot 1908-27, vol. 7.
2. In a letter dated 26th November 1985 now in the archive of the Gallery.
3. See Amsterdam 1985, no. S33, p. 59.
4. Repr. Amsterdam 1985, p. 59.

5. Verzameling Stiftung Henri Nannen. Repr. Amsterdam 1985, p. 54.
6. *Ibid.*
7. *Ibid.*

JAN ABRAHAMSZ. BEERSTRAATEN Amsterdam 1622-1666 Amsterdam

He was born in Amsterdam the son of Abraham Jansz. Beerstraaten and baptised there on 31 May 1622. He married in Amsterdam in 1642 and lived there until his death. He was buried in Amsterdam on 1 July 1666. He painted topographical views of Dutch towns and castles and some imaginary sea ports. Although always based in Amsterdam the accuracy of his views of other places indicates that he travelled in other parts of Holland. There are a number of other painters with the name Beerstraaten.

679 The Heiligewegs Gate, Amsterdam (Fig. 8).

Oil on panel, 75.3 × 105 cms. (39⅝ × 41⅜ ins.).

SIGNED AND DATED: bottom right, *JA* (in monogram) *Beerstraten. 1665.* (Fig. 221).

CONDITION: the support consists of three members joined on horizontals 33.5 and 54.5 cms. from the top. The support had once been cradled but is now planed down and the joins strengthened by balsa wood inserts. Paint surface in fair condition. Worn throughout and the sky is strengthened. The joins in the support are visible on the surface. Figures in good condition. Cleaned and restored in 1968.

PROVENANCE: Sir Hugh Lane, by whom presented, 1914.

EXHIBITED: 1918, *Pictures by Old Masters given and bequeathed to the National Gallery of Ireland by the Late Sir Hugh Lane*, National Gallery of Ireland, Dublin, no. 60.

LITERATURE: Blankert 1975-79, p. 34.

The Heiligewegs Gate (Heiligewegspoort) was designed by Jacob van Campen (1595-1657) and built in 1637-8. It was at the end of the Heiligewegsburgwal on what is now the Koningsplein. On the extension of the canals in 1663 it was demolished.[1]

Beerstraaten painted the subject on at least three other occasions[2] although none of these show a view that is exactly similar to that shown in no. 679. No. 679 is the only signed and dated example.

1. See Kruizinga, Banning 1966, p. 209.
2. In pictures now at Dyrham Park, Oxfordshire, 73 × 105 cms. and with Houthakker, Amsterdam before 1940 referred to by Blankert 1975-79, p. 34; and in the Amsterdams Historisch Museum, Amsterdam, 91 × 130 cms., Blankert 1975-79, cat. no. 38, pp. 34-35.

CORNELIS BEGA Haarlem 1631/32-1664 Haarlem

He was the son of the gold and silversmith Pieter Jansz. Begeijn and Maria Cornelisdr. daughter of the painter Cornelis van Haarlem. Houbraken says he was the first and best pupil of Adriaen van Ostade (q.v.). He may have visited Italy and in 1653 travelled in Germany and Switzerland. He became a member of the Guild of St. Luke in Haarlem on 1 September 1654 and died in Haarlem on 27 August 1664. As in the case of his teacher van Ostade, most of Bega's paintings, drawings and etchings depict peasants in village taverns and kitchens.

28 Two men singing (Fig. 9).

Oil on canvas, laid on panel, 35.9 × 31.9 cms. (14⅛ × 12⁹⁄₁₆ ins.).

SIGNED AND DATED: on the box, bottom right: *c bega A° 1662* (Fig. 222).

CONDITION: good. Cleaned in 1985.

PROVENANCE: William Hope sale, Christie's, 14-16 June 1849, lot 92, bt. Smith; George Blamire sale, Christie's, 7-9 November 1863, lot 70, where purchased for 39 guineas.

LITERATURE: Armstrong 1890, p. 284; Moes 1909a, p. 1974; Philadelphia/Berlin/London 1984, pp. 133, 136 and fig 1, p. 136; Boydell 1985, pp. 11-12.

No. 28 is one of several paintings by Bega which show peasants singing or making music. In no. 28 the instrument in the foreground is a large four-stringed violoncello known as a *basse de violon*.[1] The setting in no. 28 is deliberately disordered with fine clothes, books and even the musical instrument, shown in disarray. Surrounded by such luxury items, the peasants seem incongruous and there is a note of ridicule in their attempt to read the music. In another painting by Bega dated 1663[2] such disorder has been interpreted as an appropriate accompaniment to transitory indulgences and that painting seen as a *memento mori*.[3] In this way our painting could be interpreted as pointing the moral that music, learning and fine apparel are temporary enhancements and subject to mortality; and ignorance of them as demonstrated by the peasants in the picture is just as worthy.

The composition of no. 28 has been compared[4] to *The Duet* by Bega of 1663 in Stockholm[5] where a man and woman perform a duet. The most obvious parallel is the *basse de violon* which is similarly shown in both paintings. The compiler finds tenuous the resemblance which has been remarked upon[6] between the figures in no. 28 and a group of two men singing in a *Merry-company in a tavern* by Bega in Brussels.[7] In the view of Armstrong,[8] Bega 'seldom painted better' than in no. 28.

1. Boydell 1985, pp. 11-12.
2. *Two women in a bedroom*, Städelesches Kunstinstitut, Frankfurt-am-Main, inv. no. 1233.
3. Stone-Ferrier 1985, p. 193.
4. By P. C. Sutton in Philadelphia/Berlin/London 1984, p. 136.
5. Nationalmuseum, inv. no. NM310. Repr. Philadelphia/Berlin/London 1984, pl. 35 and cat. no. 4, p. 135.

6. By P. C. Sutton in Philadelphia/Berlin/London 1984, p. 133.
7. Musées Royaux des Beaux-Arts de Belgique, inv. no. 3369. Repr. Philadelphia/Berlin/London 1984, pl. 33 and cat. no. 2, p. 132.
8. Armstrong 1890, p. 284.

NICOLAES (OR CLAES PIETERSZ.) BERCHEM
Haarlem 1620-1683 Amsterdam

He was the son of the still-life painter, Pieter Claesz. (q.v.) and he adopted the surname Berchem. He was baptised in Haarlem on 1 October 1620. According to Houbraken he studied with his father and then with Jan van Goyen (q.v.), Nicolaes Moeyaert, Pieter

de Grebber, Johannes Wils and with his cousin, Jan Baptist Weenix (q.v.); although this is unlikely as the latter was younger than Berchem. He entered the Guild of St. Luke in Haarlem in June 1642 and already later that year is recorded as having three pupils. He possibly went to Italy with Jan Baptist Weenix and is said to be recorded in Rome from the winter of 1642-43 until 1645. He drew up his will in Haarlem in 1649. He probably revisited Italy sometime between 1651 and 1653. From 1656 he is documented in Haarlem where he probably lived until 1677 when he settled in Amsterdam. He died there on 18 February 1683. In Italy he made landscape studies which served him for his compositions throughout his life. He is the main Dutch painter of Italianate pastoral landscapes. As an artist he was very prolific. Apart from Italianate landscapes, he also painted imaginary southern harbour scenes, winter landscapes, hunts and battle scenes and some religious and mythological subjects. He had many pupils including Pieter de Hooch (q.v.), Jacob Ochtervelt (q.v.), Karel Dujardin (q.v.), Dirk Maes (q.v.) and Willem Romeyn (q.v.). Among his closest imitators are Willem Romeyn (q.v.) and Dirck van Bergen (q.v.).

176 An Italian farmhouse (Fig. 10).

Oil on panel, 40 × 53 cms. (15⅝ × 20⅞ ins.).

SIGNED: bottom right of centre, *Berchem* (Fig. 223).

REVERSE: label on frame in handwriting, *Berghem 1-7-by 1-2/2 touched with infinite spirit and in his very best manner.*

CONDITION: good. Some craquelure in the sky. The support is planed down and cradled.

PROVENANCE: Mrs. Edgar Disney sale (as 'Property of a Lady'), Christie's, 3 May 1884, lot 101, bt. Colnaghi for the Gallery for 52 guineas.

LITERATURE: Hofstede de Groot 1907-28, vol. 9, no. 611, p. 220.

VERSION: sold Christie's, 17 December 1985, lot 134, as Romeyn.

245 A stag hunt (Fig. 11).

Oil on canvas, 49.4 × 77.5 cms. (19⁹⁄₁₆ × 30½ ins.).

SIGNED: indistinctly, bottom right, *Berchem.* (Fig. 223).

CONDITION: fair. Some wearing in parts throughout. Cleaned, lined and restored in 1968.

EXHIBITED: 1877, *Old Masters*, Royal Academy, London, no. 70.

PROVENANCE: Marquis of Breadalbane sale, Christie's 5 June 1886, lot 45, where purchased for 64 guineas.

LITERATURE: Armstrong 1890, p. 284; Hofstede de Groot 1907-28, vol. 9, no. 134A, p. 276; Schaar 1958, p. 38.

In subject matter no. 245 is unusual within Berchem's oeuvre and it might perhaps be mentioned that the style is not entirely characteristic. As a comparison for subject matter the painting of *A boar hunt* in the Mauritshuis may be instanced.[1] That painting by Berchem, of the same size as no. 245 and on panel, is dated 1659. The Hague picture shows an elegant couple on horseback watching the hunt which is taking place in a

beautiful landscape and in that respect it differs from the more brutal atmosphere of no. 245. There are, however, some similarities in the figures.

Schaar,[2] refers to the fine drawing of the figures in no. 245 and compares the picture with one in a private collection which is dated 1653[3] and he implies a similar date for no. 245. von Sick[4] places Berchem's hunting pictures from the mid- to late 1650's. No. 245 may be dated 1655-60.

1. Inv. no. 12. Repr. *The Hague, Mauritshuis, cat. 1977*, p. 38.
2. Schaar 1958, p. 38.

3. Coll. Neuerberg, Cologne, 1930. Repr. von Sick 1930, fig. 31.
4. von Sick 1930, p. 35.

510 An Italianate landscape (Fig. 12).

Oil on canvas, 61.4 × 65.3 cms. (24⅛ × 29⅝ ins.).

REVERSE: descriptive label in the handwriting of Sir Henry Barron.

CONDITION: very good. Paint losses in the area of the legs of the black horse. Pronounced craquelure on the surface. Cleaned in 1984.

PROVENANCE: Christopher Beckett Denison sale, Christie's, 6-13 June 1885, lot 5, bt. Sir Henry Page Turner Barron, by whom bequeathed, 1901.

LITERATURE: Hofstede de Groot 1907-28, vol. 9, no. 369, p. 156 and p. 277.

DRAWING: related to the composition in the Hermitage, Leningrad.[1] (Fig. 13).

VERSIONS & COPIES: 1. Sold Spik, Berlin, 10 June 1942, lot 34;[2] 2. With P. de Boer, Amsterdam 1945;[3] 3. Elchengreen sale, Spik, Berlin, 20 April 1959, lot 211;[4] 4. Countess of Roseberry sale, Sotheby's London, 11 December 1974, lot 104.

No. 510 was identified by Hofstede de Groot first[5] as being identical with Smith's no. 184.[6] Smith's description fits exactly with no. 510 although the measurements he gives are of a considerably smaller picture. Hofstede de Groot's revised opinion[7] was that Smith was describing another picture and he correctly identifies no. 510 as a separate picture in his Appendix.

The drawing in Leningrad has not hitherto been linked with no. 510 for which it is probably preliminary. There are a number of differences between drawing and painting and it is more likely that the drawing is a first idea for the painting. In the drawing there is only the round tower on the rock, the two-arched bridge is closer to the foreground and, of the cows and figures, only the man on horseback is similar in both.

1. Inv. no. 15029. Manchester 1974, no. 9 and repr. pl. 13.
2. Panel, 48 × 46 cms. The painting showed the buildings from a greater distance. The staffage on the right of no. 510 is included exactly, except for the goat which is excluded. The man carrying sticks in the centre is also missing; but the group of cows and sheep on the left is included exactly.
3. Panel, no measurements given, but the proportions are similar to no. 510. The buildings are seen from a greater distance than in no. 510. The figures, with the exception of the goat are included exactly.
4. Panel, 56 × 61 cms. The buildings are seen from a greater distance than in no. 510 and the sense of their being in water is greatly enhanced. The figures are entirely different.
5. Hofstede de Groot 1907-28, vol. 9, no. 369, p. 156.
6. Smith 1829-42, Part 5, p. 61.
7. Hofstede de Groot 1907-28, vol. 9, p. 277.

After NICOLAES BERCHEM

1939 A Landscape with a ford (Fig. 191).

Oil on canvas, 86 × 112 cms. (33¹³/₁₆ × 44½ ins.).

CONDITION: fair. Two extensive damages in the centre, bottom.

PROVENANCE: Miss Cranfield of Dublin, from whom purchased, 1879, for £100.

No. 1939 is a copy of a painting by Berchem in The Louvre.[1]

1. Inv. no. 1041. The painting is on deposit at the French Embassy to the United Nations in New York. (Information from Pierre Rosenberg in a letter dated 29 October 1985 now in the archive of the Gallery.) It is not included in *Paris, Louvre, cat. 1979.*

Style of NICOLAES BERCHEM

1657 A market scene (Fig. 192).

Oil on canvas, 99 × 132 cms. (39 × 52 ins.).

CONDITION: fair. There a number of small paint losses throughout, and the support was once folded on a vertical about 4 ins. from the left. Very discoloured varnish.

PROVENANCE: by descent in the family of the Earls of Milltown, Russborough, county Wicklow to Geraldine, Countess of Milltown, by whom presented in memory of her husband, the 6th Earl of Milltown, (Milltown Gift), 1902.

As far as one may judge in its present condition, no. 1657 is of reasonably good quality and is probably seventeenth century in date. It does not appear to be a copy after any known painting by Berchem, although the composition is very much in his style. The mounted lady is found in many of his pictures and is depicted, for example, in an identical pose in a painting in the Mauritshuis,[1] the background of which shows ruins that are also similar to those shown in no. 1657.

1. *Fording a brook,* inv. no. 13. Repr. *The Hague, Mauritshuis, cat. 1977,* p. 38.

DIRCK VAN BERGEN Haarlem c.1640-c.1690 Haarlem

According to Houbraken he was a pupil of Adriaen van de Velde in Amsterdam. Before establishing himself in Haarlem he was in England where he worked at Ham House for the Duke and Duchess of Lauderdale in the 1670's. His style is similar to that of his teacher and also influenced by Nicolaes Berchem (q.v.).

59 The old white horse (Fig. 14).

Oil on canvas, 58.6 × 52.2 cms. (23¼ × 20½ ins.).

REVERSE: inscribed *899* in manuscript on back of lining canvas.

CONDITION: good. Cleaned in 1985.

PROVENANCE: M. Zachary;[1] Edmund Higginson of Saltmarsh by 1841; his sale, Christie's, 4-6 June 1846, lot 171 (bought in, 135 gns.); Edmund Higginson sale, Christie's, 16 June 1860, lot 16, bt. van Cuyck (85 gns.); Edward Wright Anderson sale, Christie's, 7 May 1864, lot 58, where purchased for 66 guineas.

LITERATURE: Artaria 1841, p. 9.

No. 59 was described in Artaria's catalogue of the Higginson collection as follows: 'In a woody landscape of much beauty is observed a white horse, and on the right two cows and three sheep reposing. Behind, a shepherd and shepherdess are seated beside a pedestal under a tree — near them is a dog. Other animals are on the left. From the collection of M. M. Zachary, Esq.'

The horse is repeated exactly in a signed painting by van Bergen in the Louvre,[2] which shows a different composition. The prices which no. 59 fetched at auction over a twenty-year period in the nineteenth century, 135 guineas in 1846, 84 guineas in 1860 and 66 guineas in 1864, may possibly be interpreted as indicating a decline in taste for such compositions at the time.

1. According to Artaria 1841, p. 9. No. 59 was, however, not included in the M. M. Zachary sale at Phillips, London, 31 May 1828.

2. Inv. no. 1035. Repr. *Paris, Louvre, cat. 1979*, p. 24.

274 Cattle in a rocky landscape (Fig. 15).

Oil on canvas, 58.8 × 63.2 cms. (23⅛ × 24⅞ ins.).

CONDITION: paint surface in good condition. Cleaned in 1985.

PROVENANCE: Executors of Mrs. Malcolm Orme sale, Christie's, 7 May 1887, lot 4, where purchased for 40 guineas.

No. 274 is somewhat similar to a signed and dated painting of 1681 by van Bergen sold at Christie's in 1951.[1] In that picture there is a gnarled tree in the centre with a black cow reaching upward towards it as in no. 274. Other similarities are the spotted cow facing the spectator and the girl conversing in the background.

In view of the similarity to the painting cited above, a date of about 1680-81 may be proposed for no. 274.

1. Bedford sale, 19 January 1951, lot 6.

GERRIT CLAESZ. BLEKER Haarlem c.1600-1656 ? Haarlem

His date of birth is uncertain. He was a hoofdman *of the Guild of St. Luke in Haarlem in 1643. His earliest dated work is of 1625. He was a landscape and animal painter, but often painted pictures with religious and mythological themes, and in these was influenced by Elsheimer, Lastman (q.v.) and Moeyaert. He was also an etcher and print maker.*

246 A raid on a village (Fig. 16).

Oil on panel, 75.5 × 136 cms. (29¾ × 53½ ins.).

SIGNED AND DATED: bottom, right of centre, *C G Bleker* (the GB in monogram) *f. 1628* (Fig. 224).

CONDITION: the support consists of three members joined on horizontals at 24.5 and 48.5 cms. from the top. Paint surface in good condition. Cleaned in 1970.

PROVENANCE: Executors of the late Rev. W. J. Langdale, decd., sale, Christie's, 27 June 1885, lot 121, where purchased for 15 guineas.

LITERATURE: Brown 1984, p. 108.

The general subject matter of no. 246, referred to by the term, *boerenverdriet* (peasant sorrow) was traditional in Netherlandish painting from at least the time of Pieter Brueghel.[1] The theme of the sufferings of the peasantry at the hands of the military is open to different interpretations but no. 246 shows the fairly ordinary occurence of soldiers stealing peasants' cattle and setting fire to their property. Although the size of the army, in the Netherlands was increased enormously during the late sixteenth and early seventeenth centuries, there was no formalised system for provisioning such an army and troops were lodged with civilians. As they received low wages they lived off the peasantry, extorting money from them and taking away their livestock. In addition there existed a large number of *vrijbuiters* (freebooters), who were armed soldiers not under the control of any government, but who roamed the countryside burning and looting.[2]

In the early years of the seventeenth century the Flemish painter David Vinckboons painted rather violent *boerenverdriet* scenes[3] showing peasants in their homes being attacked by soldiers; but later in the century the Haarlem painters Esaias van de Velde and his pupils Jan van Goyen (q.v.) and Pieter de Molijn (q.v.) produced scenes of *boerenverdriet*[4] set in a landscape, and it is to this tradition that no. 246, which was also painted in Haarlem, belongs. A somewhat similar composition by Bleker is a *Stag hunt* in Haarlem dated 1627.[5] In the case of that picture the figures are said to be by Willem Duyster[6] so there may be some case for considering the figures in no. 246 as also by Duyster.

1. For the subject see Fishman 1982, *passim.*
2. See also Brown 1984, pp. 108, 110.
3. For example the paintings in the Rijksmuseum, Amsterdam, inv. nos. A1351 and A1352. Repr. *Amsterdam, Rijksmuseum, cat. 1976,* p. 580.
4. See Fishman 1982, p. 67.
5. Frans Halsmuseum, inv. no. 550. Repr. Bol 1969, fig. 239, p. 246.
6. In *Haarlem, Halsmuseum, cat. 1969,* p. 17.

FERDINAND BOL Dordrecht 1616-1680 Amsterdam

He may have been a pupil in Dordrecht of Jacob Gerritsz. Cuyp (q.v.). He is recorded still in Dordrecht in 1635. He moved to Amsterdam in the late 1630's where he became a pupil of Rembrandt (q.v.). About 1642 he established himself as an independent artist and remained in Amsterdam until the end of his life. He was one of Rembrandt's ablest pupils and also a great favourite with the master. His earliest works are close in style to Rembrandt's but from about 1650 he turned more to the example of Bartholomeus van der Helst (q.v.) in portraiture although his subject pictures remain indebted to Rembrandt. He was successful in Amsterdam as a portraitist throughout his life.

47 David's dying charge to Solomon (Fig. 18).

Oil on canvas, 171 × 230 cms. (67½ × 89¾ ins.).

SIGNED AND DATED: bottom, right of centre, *f. bol. fecit 1643*. (Fig. 225).

CONDITION: good. There is a horizontal join in the canvas across the centre. The jug on the right is painted on an inserted piece of canvas. Damages at the top of the pillow and in the top right hand corner. Cleaned, lined and restored in 1970.

PROVENANCE: at the Vice-Regal Lodge, Dublin by 1814;[1] and thereafter until 1854 when deposited with the Irish Institution for the National Gallery of Ireland by the then Lord Lieutenant, the Earl of St. Germans.

EXHIBITED: 1814, Royal Irish Institution, Dublin; 1831, Royal Irish Institution, Dublin; 1854, The Irish Institution, Dublin, no. 102.

LITERATURE: Armstrong 1890, p. 286; Armstrong 1912, pp. 258-63; Valentiner 1933, p. 241; Sumowski 1968, p. 271 and n.5, p. 274; Richardson 1978, pp. 212-33; Sumowski 1979-, vol. 5, p. 2832; Blankert 1982, no. R16, p. 163; Bruyn 1983, pp. 211-13 and n.16-17, p. 216.

COPIES: 1. Hunterian Museum, Glasgow; 2. Wahlis sale, Vienna, 18 April 1921, lot 76 (as Bramer); 3. Galerie Kalmer, Paris; 4. Several copies dating from the Dublin nineteenth century exhibitions; 5. Formerly coll. P. F. Lynch, Dublin; 6. Berkeley Court Hotel, Dublin.

DRAWING: Musée des Beaux-Arts, Besançon.[2] (Fig. 19).

The subject is from *I Kings*, ch. 2, vs. 1-9. King David on his death bed charges his son and heir Solomon. On the right, Bathsheba, mother of Solomon.

No. 47 was known as Bol since at least 1814, and was so catalogued at the Gallery until 1904 when Armstrong called it Horst[3] and referred to the Bol signature as a forgery. In 1912 he published it as Horst,[4] and substantiated his claim by comparing the picture with a double portrait[5] that he attributed to Horst, and by reference to signed paintings by Horst in Berlin.[6] In the 1971 catalogue of the Gallery the picture was reattributed to Bol, and later published as Bol by Richardson, who interpreted the Bol signature as authentic.[7] Sumowski, referring to the 'spurious signature of Bol over the signature'[8] (of Horst), accepted no. 47 as Horst, and on this basis attributed a drawing at Besançon also to Horst.[9] Blankert[10] also refers to the Bol signature as a forgery and that of Horst 'still seeming to be visible'. He accepts the attribution to Horst and offers as comparison a *Blessing of Jacob* by Horst formerly in the Bode-Museum, Berlin.[11]

In his review of Blankert, Bruyn[12] rejects the attribution to Horst, illustrates the signature and describes no. 47 as a 'capital early work by Bol'. He also gives the Besançon drawing to Bol. There is no doubt that the signature on no. 47 is authentic and there is no reason to suggest an attribution to Horst: the painting, as Bruyn has stated, is a very fine early masterpiece by Bol.

Sumowski[13] draws attention to the fact that the interior as shown in no. 47 is based on Rembrandt's *Danae* in The Hermitage, Leningrad, from which the carved bedstead and table have been copied exactly, while the vessel on the table has been copied from a lost painting by Rembrandt of *Zacharias in the Temple*.[14]

In the drawing in Besançon, the view shown is wider, and the bed longer so that the figures of David and Solomon do not overlap as in no. 47. In the drawing the figures appear smaller and the costume and face of Bathsheba are different.

1. When it was lent to the Royal Irish Institution Exhibition, see 'Exhibited' above.
2. Inv. no. D27561. Repr. Sumowski 1979-, vol. 5, no. 1277, p. 2832.
3. In the 1904 Catalogue of the Gallery. In the 1898 Catalogue Armstrong called the picture Bol but suggested a claim for Horst.
4. Armstrong 1912, *passim*.
5. Now in the Walker Art Gallery, Liverpool, inv. no. 1019 as School of Rembrandt, *The Betrothal*. Repr. *Liverpool, Walker, cat. 1977*, plates vol. p. 232.
6. *The Chastity of Scipio* and a *Still-life*. Repr. Armstrong 1912, pls. A and B, p. 259.
7. Richardson 1978, *passim*.
8. Sumowski 1968, n.5, p. 274.
9. *Ibid.*, p. 271.
10. Blankert 1982, p. 163.
11. Repr. Bernt 1948-62, vol. 2, no. 404.
12. Bruyn 1983, pp. 211-13.
13. Sumowski 1979-, vol. 5, p. 2832.
14. The composition is extant in two versions: formerly with P. de Boer, Amsterdam and in the Staatlisches Museum, Schwerin. Repr. *Schwerin, Staatlisches Museum, cat. 1982*, fig. 59, p. 48.

810 Portrait of a lady (Fig. 17).

Oil on canvas, 97.5 × 74.5 cms. (38½ × 29¼ ins.).

SIGNED AND DATED: left, *F. Bol fecit 1644*. (Fig. 226).

REVERSE: label on stretcher, *Mrs. (?) Hollond no. 2 with frame*.

CONDITION: some damages in the background left and above the sitter's left shoulder. Other minor paint losses. The painting of the ruff is strengthened. Cleaned, lined and restored in 1985.

PROVENANCE: John R. Hollond sale, Christie's, 11 April 1913, lot 63, bt. Agnew; Arthur Grenfell sale, Christie's, 26 June 1914, lot 5, bt. Sir Hugh Lane,[1] by whom bequeathed, 1915, and received in the Gallery, 1918.[2]

EXHIBITED: 1918, *Pictures by Old Masters given and bequeathed to the National Gallery of Ireland by the Late Sir Hugh Lane*, National Gallery of Ireland, Dublin, no. 59.

LITERATURE: Isarlov 1936, p. 34; Blankert 1982, no. 118, p. 131.

The millstone collar, fashionable in the first quarter of the century, was well out of fashion by the time the picture was painted. No. 810 is, as Blankert[3] has pointed out, among the first of Bol's signed and dated portraits, and marks a time when the artist, having left Rembrandt's studio began his career as an independent portraitist. His earliest portraits are a series of female portraits the earliest of which are dated 1642, for example those

in East Berlin[4] and Baltimore.[5] Blankert notes that 'on first sight no. 810 seems to bear a close resemblance to the portrait in East Berlin . . . however, closer scrutiny reveals that Bol's aim had changed slightly in the two intervening years';[6] and he points to a greater effect of three dimension in no. 810.

1. Arthur Grenfell had purchased his collection mainly from Hugh Lane and, being in financial difficulties at the beginning of the War, he sold the collection at Christie's. Lane having sold him the paintings, felt he ought to support the sale and purchased back several of the lots. Letter from Alec Martin to James White, 1965, quoted in Gregory 1973, p. 14.
2. Blankert 1982, p. 131 gives no. 810 as once in the Perière collection, Paris, by referring to

Bredius 1927b, p. 156. In doing so he has confused no. 810 with Studio of Rembrandt no. 808 in this catalogue which is the painting referred to by Bredius.
3. Blankert, *op. cit.*, p. 56.
4. Blankert, *op. cit.*, cat. no. 117.
5. Blankert, *op. cit.*, cat. no. 121.
6. *Ibid.*, p. 56.

GERARD TER BORCH Zwolle 1617-1681 Deventer

His father, also an artist, was of the same name. He was born in Zwolle and was first taught by his father. In 1632 he was in Amsterdam and the following year in Haarlem where he was a pupil of Pieter de Molijn (q.v.). In 1635 he was in England. Houbraken says that he travelled in Germany, Italy, Spain and France. From 1646-48 he was in Münster (see further under no. 849 below) and then until 1654 in Amsterdam, Zwolle, The Hague and possibly Kampen. He married in 1654 in Deventer where he lived for the rest of his life. His most important pupil was Casper Netscher. He excelled at genre; and in portraiture evolved a new type of small full-length portrait.

849 Four Franciscan monks (Fig. 20).

Oil on canvas, 71.7 × 95.5 cms. (28³/₁₆ × 37½ ins.).

CONDITION: very poor. Most of the background is badly worn and also badly worn in the costumes. The hand of the standing monk, right, is completely repainted. An obvious pentimento in the head of the seated monk, right. Cleaned in 1973.

PROVENANCE: probably painted for Don Caspar de Bracamonte y Guzman, Conde de Peñaranda, c.1647; Earl of Essex, Cassiobury Park, sale, 12 June 1922, lot 814, bt. anon; purchased from that purchaser by C. Hofstede de Groot, The Hague, from whom purchased, 1923, for £1,571 7s 4d.

EXHIBITED: 1974, *Gerard Ter Borch*, Landesmuseum, Münster, no. 12A.

LITERATURE: Bodkin 1924, p. 138; Plietzsch 1944, p. 34 and no. 26, p. 43; Gudlaugsson 1959-60, text vol., pp. 61-62, cat. vol., p. 18 and no. 54, pp. 79-80; Münster 1974, no. 12A, p. 78.

No. 849 was described in the Cassiobury House sale catalogue as 'An interior with figures of four ecclesiastics' and no artist was given. It was purchased by the Gallery as 'Four Spanish monks' and described as such by Hofstede de Groot[1] who also attributed it to ter Borch and referred to it as 'certainly painted in Spain'. Bodkin[2] referred to it also as Spanish in origin and identified the figures as 'members of the Order of Capucins who

wore in those days a grey habit'. Plietzsch[3] also identified the subject as 'four monks in Spain'. Gudlaugsson[4] identified the monks more precisely as being Franciscans by their habits and also tonsures. The book held by the oldest monk is inscribed on the spine with the Spanish word *Enfermeros* and the paper held by the seated monk on the right is some form of inventory inscribed with the numbers 1-14.

The contention of Hofstede de Groot and Bodkin that the picture was painted in Spain was based on the assumption, which is now known almost certainly to be false,[5] that ter Borch worked at some period in Spain. The inscription *Enfermeros* on the book may have encouraged Hofstede de Groot and Bodkin in their belief, although Bodkin gives as reason for the possible Spanish origin of the painting 'the countenances of the four monks'. Gudlaugsson[6] has drawn attention to Houbraken's record that when ter Borch painted a portrait of the Spanish nobleman, the Conde de Peñaranda[7] in Münster 'it gave him the opportunity to paint still further pictures for him' (i.e. Peñaranda). Gudlaugsson shows that Peñaranda, who was in Münster as Spanish Ambassador for the Ratification of the Treaty of Münster in 1648,[8] lived in a Franciscan monastery in the Bergstrasse quarter where ter Borch also lived.[9] Gudlaugsson[10] concludes that no. 849 was one of those pictures, referred to by Houbraken, that ter Borch painted at this time for Peñaranda.

The word *Enfermeros* means approximately 'sick-nurse'. Gudlaugsson has shown that, when in Münster, Peñaranda suffered an illness or more precisely was a victim of gout, bladder trouble and furuncles. He concludes, therefore, that the real subject of no. 849 is the nursing brothers from the monastery who looked after him in his illness.

Gudlaugsson[11] compared the composition with other Dutch group portraits of the 1640's in particular those of Hendrick Pot, Pieter Codde and Hendrick Martensz. Sorgh; and also pointed to a distant relationship with Zurbarán's *Pope Urban II with St. Bruno* in Seville.[12]

ter Borch was in Münster certainly from the end of 1645 until, at the latest, Spring 1648;[13] Peñeranda was in Münster from 5 July 1645 until 29 June 1648.[14] No. 849 was painted sometime between those dates and Gudlaugsson places it about 1647-48.

1. In a letter dated December 1923 now in the archive of the Gallery.
2. Bodkin 1924, p. 138.
3. Plietzsch 1944, p. 34.
4. Gudlaugsson 1959-60, cat. vol. no. 54, pp. 79-80.
5. *Ibid.*, p. 80.
6. *Ibid.*, p. 18.
7. The portrait is now in the Museum Boymans-van Beuningen, Rotterdam, inv. no. 2529. Repr. Gudlaugsson 1959-60, text vol. fig. 56, p. 222.

8. See the picture by ter Borch now in the National Gallery, London, cat. no. 896. Repr. Gudlaugsson 1959-60, text vol. fig. 57, p. 223.
9. Gudlaugsson 1959-60, cat. vol., p. 80.
10. *Ibid.*, p. 18.
11. *Ibid.*, p. 80.
12. Museo Provincial. Repr. Gudlaugsson 1959-60, cat. vol. pl. 6, fig. 2.
13. Gudlaugsson 1959-60, cat. vol. pp. 18-19.
14. *Ibid.*, p. 81.

After TER BORCH

1087 Interior with a lady washing her hands (Fig. 193).

Oil on oak, 49 × 37 cms. (19½ × 14½ ins.).

CONDITION: the support is warped. Paint surface in good condition. Discoloured varnish.

PROVENANCE: Patrick Sherlock, by whom bequeathed, (Sherlock Bequest) 1940.

No. 1087, which has always been catalogued as 'Dutch School 17th Century', is a copy after a painting by ter Borch in Dresden.[1] It is of reasonably good quality and is probably seventeenth century in date.

1. Gemäldegalerie inv. no. 1830. Repr. Gudlaugsson 1959-60 text vol., fig. 113, p. 272.

JAN BOTH Utrecht c.1615-1652 Utrecht

He was born in Utrecht between 1610 and 1618 — probably about 1615. He was first apprenticed to his father, the glass painter Dirck Both and afterwards, together with his brother Andries, to Abraham Bloemaert in Utrecht. He went with his brother, via France, to Rome and was there probably from 1635. He was in Rome certainly in 1638, 1639 and 1641 and in that year returned to Utrecht where he is recorded in 1644, 1648, 1649 and 1650. He died there in 1652. His landscapes, of which very few are dated, are almost exclusively in an Italianate style. He had many followers, pupils and imitators and was enormously influential in the development of landscape painting in Holland.

179 An Italianate landscape (Fig. 21).

Oil on canvas, 74.1 × 101 cms. (29⅛ × 39⅝ ins.).

SIGNED: on the rock, foreground right, *J. Both* (*J B* in monogram).(Fig. 227).

CONDITION: good. There is a two inch horizontal tear three inches from the top, left. Cleaned in 1972.

PROVENANCE: Palazzo Rasponi, Ravenna; Comte Ferdinand Rasponi sale, Brussels, 25 October 1880, lot 5, where purchased for £790.

LITERATURE: Armstrong 1890, p. 283; Hofstede de Groot 1907-28, vol. 9, no. 55, p. 438; Burke 1976, no. 24, pp. 196-97.

No. 179 may be one of those pictures seen by Otto Mündler in the Palazzo Rasponi on 7 June 1858:[1] 'Palazzo Ferdinando Rasponi has a collection of mostly Flemish and Dutch pictures some of really first rate excellence. A van de Velde, Berghem *(sic)* Both etc. are well represented. . . .' It was described by Hofstede de Groot as 'a very good picture'.[2]

Burke[3] refers to the composition as being frequent in Both's *oeuvre* and cites it shown in reverse in two paintings in the Rijksmuseum[4] as well as in a painting in an English

private collection.[5] He points out that a road is used similarly in the *Landscape with St. Philip baptising the eunuch* in the British Royal Collection.[6] The composition, as Burke states, is paralleled in Both's etching, *A View of the Tiber in the Campagna*.[7] Burke dates no. 179 to the mid-1640's. Armstrong[8] recognised no. 179 as being early Roman work and indeed described the picture as a collaborative work between Andries and Jan Both.

1. His manuscript diaries are in the National Gallery, London.
2. Hofstede de Groot 1907-28, vol. 9, no. 55, p. 438.
3. Burke 1976, no. 24, pp. 196, 197.
4. Cat. nos. A52 and A51. Repr. *Amsterdam,*

Rijksmuseum, cat. 1976, p. 137.
5. Hofstede de Groot 1907-28, no. 80, pp. 444-45.
6. White 1982, no. 30, p. 27 and pl. 25.
7. Hollstein 1949-, vol. 3, no. 7, pp. 160-61.
8. Armstrong 1890, p. 283.

706 A horse drinking (Fig. 22).

Oil on panel, 28.6 × 22.7 cms. (14¼ × 8⁵/₁₆ ins.).

CONDITION: fair.

PROVENANCE: possibly purchased in Italy in the eighteenth century by the 1st or 2nd Earl of Milltown; thence by descent to Geraldine, Countess of Milltown by whom presented in memory of her husband, the 6th Earl of Milltown (Milltown Gift) 1902.[1]

LITERATURE: Hofstede de Groot 1907-28, vol. 9, no. 40, p. 464; Burke 1976, no. 25, pp. 196-97.

Burke[2] has drawn attention to the fact that the subject was strongly influenced by Pieter van Laer and it is one of the few purely *bambocciante* scenes by Both. He refers to another scene with a white horse and boy in the Rijksmuseum,[3] Amsterdam which is later in date. He dates the picture to Both's earliest days in Rome, referring to the crude manner of painting and limited colour scene; and showing the influence of the artist's brother. A date, therefore, of about 1635-38 is likely.

1. The painting is not identifiable in the inventory of the Milltown Gift prepared by Walter Armstrong. It was first catalogued in 1928 and the provenance given as 'Milltown Gift'.

2. Burke 1976, no. 25, pp. 196-97.
3. Cat. no. A50. Repr. *Amsterdam, Rijksmuseum, cat. 1976*, p. 138.

4292 CB An Italianate landscape (Fig. 23).

Oil on canvas laid on board, 80 × 97 cms.[1] (31½ × 38¼ ins.).

SIGNED: on the rock, bottom left, *J Both* (Fig. 228).

REVERSE: manuscript label *Hope Collection*.

CONDITION: good.

PROVENANCE: van der Land sale, Amsterdam, 22 May 1776, lot 12, bt. Fouquet; Nicolas Nieuhoff sale, Amsterdam, 14 April 1777, lot 21, bt. Wubbens (as canvas laid on panel); Phillip Henry Hope, London, 1835;[2] Henry Thomas Hope, London, 1854;[3] Lord Francis Pelham Clinton-Hope, London, from whom purchased in 1898 by Colnaghi; Leggatt Brothers, London, 1927, from whom purchased by Sir Alfred Chester Beatty, by whom presented to the Irish Nation in 1950 and received in the Gallery, 1978.

EXHIBITED: 1876, *Art Treasures Exhibition*, Wrexham, no. 187; 1881, Royal Academy, London, no. 103; 1891, *The Hope Collection of Pictures of the Dutch and Flemish Schools*, South Kensington Museum, London, no. 65.

LITERATURE: Smith 1829-42, Part 6, no. 8, pp. 174-75 and no. 65, pp. 194-95; Waagen 1854, vol. 2, p. 122; Hope 1898, no. 65; Hofstede de Groot 1907-28, vol. 9, no. 49, p. 435 and no. 159, pp. 468-69; Burke 1976, no. 125, p. 253.

VERSIONS: 1. Residenz Gallery, Salzburg, inv. no. 1844; 2. Hermitage, Leningrad, inv. no. 1896.

No. 4292 CB was described by Burke as whereabouts unknown and identified by him as Hofstede de Groot no. 49. The painting is, however, also identical with Hofstede de Groot no. 159. The standing figure on the extreme right leaning on a staff appears also in Both's etching *Landscape with ox cart*.[4] Burke refers to the version in Salzburg as falsely signed and not by Both. He dates the composition 1645-50.

1. The canvas was already laid on board by 1777 as it was described as such in the Nieuhoff sale catalogue (see 'Provenance' below).
2. When seen by Smith; see 'Literature' below.

3. When seen by Waagen; see 'Literature' below.
4. Bartsch no. 2.

JAN SALOMONSZ. DE BRAIJ Haarlem c.1627-1697 Haarlem

He was the son of the painter, architect and poet Salomon de Braij. His earliest known works are of 1648 and 1650. Between 1667 and 1684 he was on several occasions an officer of the Guild of St. Luke in Haarlem. He married three times, in 1668, in 1672 and in 1678. Apart from living in Amsterdam for two years prior to 1688, he lived throughout his life in Haarlem. He painted mainly portraits although some genre scenes, religious and mythological pictures are known as well as some etchings. He was also an architect.

180 The artist's brothers (Fig. 24).

Oil on panel, 27.7 × 36.4 cms. ($10^{15}/_{16}$ × $14^{3}/_{8}$ ins.)

SIGNED AND DATED: right, *J d. Bray. 1651*. (J d. in monogram). (Fig. 229).

REVERSE: collector's seal (Fig. 282) and the letters F.H.

CONDITION: good. The support has been extended by 2.5 cms. all round. Measurements above are of the original panel. Radiographs (Fig. 25) reveal that the head of the prominent boy was originally painted facing to the spectator's left. In good condition. Cleaned in 1982.

PROVENANCE: J. G. Robinson, from whom purchased, 1875, for £10.

LITERATURE: von Moltke 1938-39, no. F17, p. 392.

By comparing no. 180 with a *Banquet of Cleopatra* by Jan de Braij in the British Royal Collection,[1] which is dated 1652 and in which de Braij shows his own family, it is possible to identify the children in our picture as the younger brothers of the artist. The painter's father was married in 1625 and had at least ten children, four of whom died in infancy. Of the surviving children only Jan and Dirck (d. 1694) survived the plague in Haarlem in 1663/64 which killed two brothers and two sisters as well as the parents.

The boys in no. 180 are most probably the two youngest children shown in *The banquet of Cleopatra* which White[2] has tentatively identified as Jacob, the youngest surviving son and the child buried in 1640. It would not be unusual to depict deceased children in a painting as the *Banquet of Cleopatra* demonstrates; and Jan de Braij included portraits of himself and the members of his family in several pictures.

No. 180 was purchased as Jacob de Braij and so catalogued until 1898 when Armstrong gave it to Salomon de Braij. This attribution was rejected by von Moltke[3] who referred to the signature as 'far from that of any known signature' of de Braij. von Moltke neither considers no. 180 likely to be by Salomon de Braij nor Joseph de Braij. He suggested the possibility of the so far unidentified Jacob de Braij. Cleaning of the picture in 1982 has revealed the signature to be convincingly that of Jan de Braij.

1. White 1982, no. 31, p. 28.
2. *Ibid.*

3. von Moltke 1938-39, p. 392.

RICHARD BRAKENBURGH Haarlem 1650-1702 Haarlem

He was born in Haarlem and according to Houbraken was a pupil of Adriaen van Ostade (q.v.) and Hendrik Mommers. About 1670 he was in Leeuwarden and from 1687 was a member of the Guild of St. Luke in Haarlem. He died in Haarlem in 1702. He was an imitator of Jan Steen (q.v.) both in his style of painting, his character types and in the composition of his pictures of barn interiors, merry-companies and peasant weddings. He repeated figures in many of his pictures. He was also a poet.

1949 Interior with figures (Fig. 26).

Oil on canvas, 40 × 49.2 cms. (15¾ × 19⅜ ins.).

SIGNED AND DATED: bottom left, *R. Brak* (indistinct) *1689*.

CONDITION: canvas lined. Paint surface in poor condition. Speckled paint losses throughout.

PROVENANCE: unknown.

No. 1949 is of a type of merry-making scene in a peasant interior painted by Jan Steen, for example in two paintings in the Rijksmuseum, Amsterdam.[1] A similar composition by Brakenburgh is a picture in Braunschweig[2] which is signed and dated 1689, the same year as no. 1949. The prominent seated woman on the right of no. 1949 is repeated almost exactly in the Braunschweig picture. No. 1949 is of poor quality.

1. Inv. nos. A384 and A388. Repr. *Amsterdam, Rijksmuseum, cat. 1976*, pp. 522-23.
2. Herzog Anton-Ulrich Museum, inv. no. 329.

Repr. *Braunschweig, Anton-Ulrich Museum, cat. 1983*, p. 33.

BARTHOLOMEUS BREENBERGH Deventer 1598-1657 Amsterdam

He was baptised in Deventer on 13 November 1598. He is first mentioned as a painter in Amsterdam in 1619. Immediately thereafter he went to Rome where he associated with Paul Bril whose paintings he copied. In 1623 he enrolled in the company De Bentvueghels. He left Italy in 1629. He married in Amsterdam in 1633 and remained there for the rest of his life. Mainly a landscape painter, he was influenced by Jacob Pynas, Paul Bril and Cornelis van Poelenburgh.

700 A landscape with the ruins of the Baths of Diocletian, Rome (Fig. 27).

Oil on canvas, 50 × 62 cms. (19⅝ × 24⅜ ins.).

CONDITION: fair.

PROVENANCE: possibly purchased in Italy in the eighteenth century by the 1st or 2nd Earl of Milltown; thence by descent to Geraldine, Countess of Milltown by whom presented in memory of her husband, the 6th Earl of Milltown (Milltown Gift) 1902.

LITERATURE: Roethlisberger 1981, no. 96, p. 50.

Hitherto always referred to as *A landscape with ruins*, Roethlisberger[1] identified the subject as a fairly exact rendering of the south-east facade of the Baths of Diocletian in Rome. They are placed in an imaginary setting. Breenbergh included the ruin in at least two other paintings,[2] although in both of those the setting is different. In the foreground of no. 700 is a herdsman with two buffaloes.

No. 700 was presented to the Gallery as Breenbergh and has always been so catalogued. It is accepted as such by Roethlisberger who nevertheless, justifiably, refers to the quality as 'mediocre'. Oehler suggested that 'it must be Poelenburgh'.[3] Roethlisberger[4] also sees links with van Poelenburgh in the distant view and points out that his no. 95 (also of the Baths of Diocletian) was listed as van Poelenburgh as early as 1719. He also sees a similarity in the area on the right with the work of Filippo Napoletano.

Breenbergh was in Rome from 1619-1629/30. No. 700 was painted sometime in that decade and Roethlisberger implies a date of about 1625.

1. Roethlisberger 1981, no. 96, p. 50.
2. Roethlisberger, *op. cit.*, nos. 95 and 134; both in private collections.

3. Undated manuscript note in the archive of the Gallery.
4. *Op. cit.*, p. 50.

QUIRIJN VAN BREKELENKAM ? Zwammerdam c.1620-1668 Leiden

In 1648 he was one of the founder members of the Guild of St. Luke in Leiden but otherwise records of his life are scant. He painted genre scenes of work in domestic or peasant interiors.

Style of *QUIRIJN VAN BREKELENKAM*

1225 The pancake maker (Fig. 194).

Oil on panel, 33.1 × 27.6 cms. (13 × 10⅞ ins.).

REVERSE: collector's seal (Fig. 283); paper label printed, *Metzu, (Gabriel)*.

CONDITION: fair.

PROVENANCE: Mrs. E. Finnegan of Dublin, from whom purchased, 1951, for £25.

The subject is found fairly frequently in seventeenth-century Dutch painting. Pancakes were consumed in large quantities by the Dutch who purchased them in taverns or from street vendors.[1]

No. 1225 was purchased as the work of van Brekelenkam and has always been so called at the Gallery.[2] It is however very inferior in quality although possibly seventeenth century in origin. The facial types of the children are somewhat akin to those found in the work of van Brekelenkam.[3]

1. See Philadelphia/Berlin/London 1984, p. 163.
2. For a painting of a pancake maker by van Brekelenkam see the picture in the Frans Halsmuseum, Haarlem, inv. no. 484.
3. See for example *Domestic care* in the Stedelijke Museum 'de Lakenhal', Leiden, inv. no. 47; and *Grace before a meal* in the Museum Boymans-van Beuningen, Rotterdam, inv. no. 1095.

JAN VAN DE CAPPELLE Amsterdam 1626-1679 Amsterdam

The son of François van de Cappelle, who owned a dye works, Jan was baptised in Amsterdam on 25 January 1626. He was married in 1653 in Amsterdam and buried there, where he passed all his life, on 22 December 1679. He inherited his father's business and also owned a large collection of paintings and drawings by contemporary artists. Although there is a record of him being self-taught, he may have had instruction from Simon de Vlieger. His early style is similar to that of de Vlieger and the inventory of his possessions in 1680 shows that he owned nine paintings by de Vlieger and no fewer than 1,300 drawings. His extant oeuvre is not large. Apart from views of estuaries and rivers, there are some forty winter landscapes somewhat in the manner of Aert van der Neer (q.v.). He also made some etchings.

74 A river scene in winter (Fig. 28).

Oil on canvas, 45 × 54.7 cms. (17¾ × 21⅝ ins.).

SIGNED: bottom right, *J.V. C*

CONDITION: good. Original edges trimmed. Some small paint losses on left edge. Thin in the sky behind the cottage on right. Cleaned in 1982.

PROVENANCE: Mrs. Sloane Stanley sale, Christie's, 21 April 1888, lot 25, where purchased for £55 5s.[1]

LITERATURE: Hofstede de Groot 1908-27, vol. 7, no. 146, p. 199; Russell 1975, no. 146, p. 83.

The view has not been identified. Hofstede de Groot refers to the skaters as playing golf,[2] Armstrong as 'apparently playing a game like curling'.[3] They are playing kolf, a seventeenth-century ancestor of the present day game, golf, which was played on ice. No. 74 was sold in 1888[4] as the work of Jan van der Meer but accessioned at the Gallery as van de Cappelle by Doyle — who presumably noticed the signature. The attribution has been doubted by van Thiel.[5]

No. 74 is of a type, a winter landscape with some houses, trees, a bridge and figures playing kolf that van de Cappelle painted on several occasions. Examples are in the Thyssen-Bornemiza Collection, Lugano,[6] Institut Néerlandais, Paris[7] and the Mauritshuis.[8] The coarse weave of the canvas and the somewhat rough technique of no. 74 is apparent also in the Mauritshuis painting and it would seem unnecessary to doubt the authenticity of no. 74.

The three pictures cited in comparison above are all signed and dated 1653 and it would be reasonable to suggest that no. 74 also dates from that time.

1. An annotated copy of the sale catalogue in the National Gallery, London gives the purchaser of lot 25 as Doyle and the price as £55 5s.; the price in the Gallery register is £56 14s. The same sale catalogue lists Doyle as the purchaser of lot 16, Rottenhammer and Breughel, *A dance of cupids and allegorical figures* — for which he paid £56 14s. No such picture is entered in the Gallery Register.
2. Hofstede de Groot 1908-27, vol. 7, no. 146, p. 199.

3. In the 1898 Catalogue of the Gallery.
4. See 'Provenance' above.
5. On a visit to the Gallery in 1968.
6. Repr. Borghero 1981, no. 54A, p. 61.
7. Inv. no. 528. Repr. *Paris, Institut Néerlandais, cat. 1983*, pl. 28.
8. Inv. no. 567. Repr. *The Hague, Mauritshuis, cat. 1977*, p. 58.

HENDRIK CARREE Amsterdam 1656-1721 The Hague

He was born in Amsterdam on 2 October 1656. After the death of his father in 1669 he entered the studio of Jurriaen Jacobsz. and later that of Jacob Jordaens in Antwerp. He married in 1683 and thereafter lived at The Hague. He painted room interiors in the Orange castle at Rijswijk and also painted portraits, genre scenes and animal pieces. Several of his sons were also painters. He died at The Hague on 17 August 1721.

1944 Portrait of a lady (Fig. 29).

Oil on canvas, 72 × 60 cms. (28⅜ × 23⅝ ins.).

SIGNED AND DATED: left, on the balustrade, *H. Carre 1704*

CONDITION: good.

PROVENANCE: Miss M. O. Crowe of Hastings, by whom bequeathed, 1969.

The oval format of no. 1944, with a view of a landscape in the background, is usual within the artist's oeuvre.[1]

1. See for example the *Portrait of a young officer* in the Rijksmuseum, Amsterdam, inv. no. A1493. Repr. *Amsterdam, Rijksmuseum, cat. 1976,* p. 164.

PIETER CLAESZ. Burgsteinfurt 1597/98-1660 Haarlem

Little is known of his origins. By May 1617 he was living in Haarlem where he married at that time; and his son Nicolaes Berchem (q.v.) was born there in 1620. His earliest known dated work is of 1621, the latest 1660. He was buried in Haarlem on 1 January 1661. Houbraken says he painted small still-life pictures and he signs always in monogram with the initials PC. Until the end of the 1620's his pictures are in the style of the older Haarlem still-life painters such as Floris van Dijck. From then he painted monochrome breakfast-pieces characteristic of the later school of Haarlem still-life painting of which he and Willem Claesz. Heda (q.v.) were the founders.

326 A breakfast-piece (Fig. 30).

Oil on panel, 40.3 × 58 cms. (17⅞ × 22¾ ins.).

SIGNED AND DATED: right, *PC* (in monogram) *1637.* (Fig. 230).

REVERSE: label inscribed '*9393 Peter Claesz. de 2*'.

CONDITION: good. The background is thin. There is a horizontal split or join in the support 13 cms. from the top. Support cradled.

PROVENANCE: Sedelmeyer, Paris, where purchased, 1893, for £40.

Hitherto referred to as a *Still-life,* the picture is of a type known by the generic term *breakfast-piece,* and more specifically, as in the case of no. 326, a monochrome breakfast-piece.[1] The development of the genre in seventeenth-century Holland is most associated with the schools of Amsterdam and, more specifically, Haarlem. While some symbolism is generally associated with still-life pictures, Vroom warns that such symbolism was unlikely to be intended by a painter such as Claesz.[2] Verbeek[3] has observed that the beaker is probably made of silver and certainly Dutch: it cannot be dated precisely as similar beakers were made in Holland from about 1580 until 1680. The glass is a Berkemeyer. The lemon, with its coil of peel, was depicted by most still-life painters in seventeenth-century Holland. It was regarded in painting circles as a touchstone of talent by which a painter could generally demonstrate his virtuosity and specifically establish his pictorial handwriting.[4]

1. See also no. 514 by Heda in this catalogue. For the subject see Bergström 1983, pp. 112 *et seq.*; also Vroom 1980, *passim.*
2. Vroom 1980, text vol., p. 31.

3. Of the Rijksmuseum, Amsterdam in a letter dated 2 October 1981, now in the archive of the Gallery.
4. See Auckland 1982, p. 95.

1285 A breakfast-piece (Fig. 31).

Oil on panel, 49.6 × 68.8 cms. (19⁹/₁₆ × 27¹/₁₆ ins.).

SIGNED AND DATED: to the right of the roemer, *P C* (in monogram) *1651.* (Fig. 231).

CONDITION: the support has been repaired and now consists of three horizontal members joined by buttons. The joins are about 3.7 and 19.5 cms. from the top. There is further cracking in the panel at the bottom from the left. The paint surface, apart from the areas along the joins, is in good condition.

PROVENANCE: Sir Alfred Chester Beatty, by whom presented, 1953.

The picture, hitherto referred to as a *Still-life* is more specifically a *breakfast-piece* (see no. 326 by Claesz. in this catalogue). Verbeek[1] has identified the objects as, from left to right, a Dutch beer glass dating from the first half of the seventeenth century; a Dutch pewter can, now, but not then, known as a 'Rembrandt-kan'; a mustard pot which is probably Chinese; and a Berkemeyer. On the pewter plate a twist of tobacco and oysters. In the seventeenth century as now, the latter were considered a delicacy. Meals of oysters were a favourite subject for painters. The celebrated Dutch doctor, Johan van Beverwyck, wrote in his *Schat der Gesontheydt* (Treasury of Good Health) published in 1636 that oysters 'whet the appetite both for eating and having intercourse, two activities which lusty and delicate persons alike find pleasing'.[2] The doctor did not consider oysters particularly healthy.

No. 1285 may be compared with a painting of identical size dated 1652 in the Hoogsteder collection, The Hague,[3] that includes the same components.

1. Of the Rijksmuseum, Amsterdam in a letter dated 2 October 1981, now in the archive of the Gallery.

2. Quoted in Auckland 1982, p. 129.
3. Repr. Vroom 1980, inv. vol., no. 155, p. 36.

PIETER CODDE Amsterdam 1599-1678 Amsterdam

He was baptised in Amsterdam on 11 December 1599. Nothing is known of his early training but he is recorded as a practising painter at the time of his marriage in 1623. By 1630, at the time of the death of his father, he seems to have been successful as he bought his own house in Amsterdam in that year. About this time he was apparently active in literary circles in Amsterdam and in 1633 published some poetry. In 1637 he completed a large militia group, The company of Captain Reynier Reael and Lieutenant Cornelis Michielsz. Blaeuw (Rijksmuseum, Amsterdam) which had been left unfinished by Frans Hals (q.v.). He died in October 1678. He is known mainly as a genre painter but he also painted portraits and history subjects.

321 Interior with figures (Fig. 32).

Oil on panel, 32 × 41.2 cms. (12⅛ × 16¼ ins.).

SIGNED: indistinctly, on the footboard of the bed, *PC* (in monogram).

CONDITION: good. Some damages to the top of the support. The area of the bed is very thinly painted.

PROVENANCE: G. Smith of London, from whom purchased, 1892, for 70 guineas.

EXHIBITED: 1894, *Old Masters*, Royal Academy, London, no. 97.

LITERATURE: Duncan 1906-07, p. 17; Moes 1912, p. 156.

No. 321 is probably a brothel scene *(bordeeltje)*. The dog, which is placed with some prominence, was often included in paintings of brothel scenes, and was intended to convey licentiousness. It was not until after the mid-seventeenth century that Dutch domestic architecture allowed separate chambers for sleeping, and thus beds were placed in public rooms until then. A dated painting of 1635 by Codde in the Rijksmuseum, Amsterdam,[1] showing *Cavaliers and ladies*, has a bed similar to that shown in no. 321. The inclusion of the bed in no. 321, with the draped curtain pulled suggestively aside would indicate that the principal intent of the man in the picture was neither music nor conversation. Similar beds in other pictures by Codde have been linked to carnal intent.[2]

No. 321 was purchased in 1892 as the work of Cornelis Palamedesz. by whom was presumably intended Anthonie Palamedesz. (q.v.), who indeed painted similar scenes.[3] The signature was deciphered by Armstrong and the painting has always been catalogued as Codde at the Gallery. It was described by Duncan as 'a characteristic example of this painter at his very best'.[4] No. 321 may be compared to a picture of similar size by Codde, *The Lute player*, formerly in the Johnson Collection, Philadelphia.[5] The principal figure in that painting is a man standing with his back to the spectator in a pose similar to that of the man in no. 321.

No. 321 is of a type and format painted by Codde early in his career, i.e. between 1627 and 1630, which showed such a group of figures silhouetted against a plain wall in a sparsely-furnished and somewhat ill-defined interior.[6] The costumes in no. 321 would indicate a date of about 1630-31 and may be compared with those shown in a dated *Merry-company* of 1631.[7]

1. Inv. no. C1578. Repr. *Amsterdam, Rijksmuseum, cat. 1976*, p. 170.
2. See Philadelphia/Berlin/London 1984, pp. 176-77.
3. See *ibid.*, cat. no. 95.
4. Duncan 1906-07, p. 17.
5. Repr. Valentiner 1913, vol. 2, p. 306.
6. See Philadelphia/Berlin/London 1984, p. xxxii.
7. Private Collection, Montreal. Repr. Philadelphia/Berlin/London 1984, cat. no. 29, p. 178.

JAN TEN COMPE Amsterdam 1713-1761 Amsterdam

He was born in Amsterdam on 14 February 1713 and was a pupil of Dirk Dalens III. He lived and worked mainly in The Hague but died in Amsterdam on 11 November 1761. He painted townscapes and topographical landscapes the majority of which have an identifiable town in the background.

1681 Village with a windmill (Fig. 33).

Oil on panel, 33 × 45.4 cms. (13 × 17⅞ ins.).

SIGNED: bottom left, *ten Compe.* (Fig. 232).

CONDITION: very good. A line damage in the clouds, right. Cleaned in 1968.

PROVENANCE: by family descent to Geraldine, Countess of Milltown, by whom presented in memory of her husband, the 6th Earl of Milltown (Milltown Gift) 1902.

The view, which has not been identified, is, however, possibly real.

ANTHONY JANSZ. VAN DER CROOS 1606/07- after 1661 The Hague

He was born between 13 July 1606 and 1 March 1607 but his place of birth is unknown. He lived at The Hague from 1634 where he married for the second time in 1646. He entered the Guild of St. Luke at The Hague in 1647. Between November 1649 and November 1651 he lived at Alkmaar and became a member of the Guild of St. Luke there in 1649. Thereafter he returned to The Hague where he is documented at various dates until 1661. His date of death is not known. He was one of the numerous followers of Jan van Goyen (q.v.) and painted for the most part landscapes with views of towns executed in the vicinity of The Hague, Alkmaar, Haarlem and Amsterdam. He owned a spiegeljacht *(pleasure boat) in which he travelled the canals noting points of interest which he later used in his landscapes.*

328 The castle of Montfoort near Utrecht (Fig. 34).

Oil on canvas, 63.8 × 80.1 cms. (25⅛ × 31½ ins.).

SIGNED AND DATED: on the post, bottom right, *A Croos. F. 1660.* (Fig. 233).

CONDITION: very good. Some wearing in the water, bottom left. Cleaned in 1985.

PROVENANCE: Mrs. S. Morton sale, Christie's, 29 June 1892, lot 46, where purchased, for 45 guineas.

LITERATURE: Belonje 1967, pp. 63-65 and p. 80.

No. 328 has hitherto been catalogued as showing the castle of Egmont, near Alkmaar but Belonje[1] has shown that the castle, more precisely called Egmont-aan-de-Hoef, was a ruin by the seventeenth century and that van der Croos's painting actually shows the castle of Montfoort which is 15 km. south-west of Utrecht; a fact which had been pointed out as early as 1938.[2] Belonje refers to an engraving after a drawing by Roelant Roghman (d. 1692) of Montfoort[3] which confirms the identification of the view.

van der Croos painted the castle on at least one other occasion[4] taking his viewpoint from the opposite side of the castle to that used here.

1. Belonje 1967, p. 63.
2. By the Director of the Rijksbureau voor de Monumentenzorg in a letter dated 4 March 1938 now in the archive of the Gallery.
3. It is Plate 5 in L. Smids, *Schatkamer der Nederlandsche Oudheden* and reproduced by

Belonje, *op. cit.*, fig. 2, p. 80; a photograph of the drawing (location unknown) is in the archive of the Gallery.
4. The painting was with the London dealer E. Burg-Berger in 1935. Photo neg. RKD 13/18 26848.

AELBERT CUYP Dordrecht 1620-1691 Dordrecht

He was the son of the painter Jacob Gerritsz. Cuyp (q.v.) and was baptised in Dordrecht in October 1620. He had his first training under his father. Before 1652 he travelled to Arnhem, to Nijmegen and Kleve. On this trip he made topographical drawings which he later used in his landscapes. Up to 1658 he was very productive as an artist; but after that year when he married a rich widow, less so, as he had a number of other commitments. He was a deacon in 1660 and churchwarden from 1672-74 of the Reformed Church in Dordrecht, a Regent of the Hospice of the Grote Kerk in Dordrecht from 1673 and from 1679-83 a member of the High Court of Justice of South Holland. He was buried on 15th November 1691 in the church of the Augustins in Dordrecht. Except for some few portraits, religious, animal and genre scenes, Cuyp painted principally landscapes with views of rivers bathed in a warm light. Initially he was influenced by Jan van Goyen (q.v.) but during the 1630's he came under the influence of the Utrecht painter, Jan Both (q.v.).

Studio of AELBERT CUYP

49 Milking cows (Fig. 36).

Oil on panel, 50.5 × 66.9 cms. (20 × 26 ins.).

SIGNED: bottom right, *A: cüyp.* (Fig. 234).

CONDITION: paint surface in very good condition. Cleaned in 1982.

PROVENANCE: Joseph Gillot of Birmingham sale, Christie's, 3 May 1872, lot 315, bt. John Heugh of Tunbridge Wells, by whom presented, 1872.

LITERATURE: Armstrong 1890, p. 287; Hofstede de Groot 1908-27, vol. 2, no. 364, p. 110; Reiss 1975, no. 55, p. 90.

DRAWING: formerly at The Hague.[1] (Fig. 37).

The overall composition of the picture relates in a general way to a much larger painting in the collection of the Duke of Sutherland.[2] The group of the milkmaid and the cow is repeated exactly in that painting and again, almost exactly, in a painting by Cuyp in Leningrad[3] and in another painting in the Weber collection, Hamburg in 1907[4] and one in Rotterdam.[5] A drawing for the milkmaid and cow, said to have been in The Hague, is reproduced by Reiss,[6] but the drawing of a milkmaid and cow in Vienna[7] which is referred to by Hofstede de Groot[8] as preparatory, in fact shows quite a different composition.

No. 49 which is signed, was described by Hofstede de Groot as 'of the early period'.[9] Reiss,[10] on the basis of the drawing, which is to him 'unquestionably of the mid-1640's', places no. 49 about 1645-50, although at the same time recognising the style of the picture as more apparently that of the late 1630's. He refers to no. 49 as studio work. Armstrong,[11] writing in 1890 also had doubts about the attribution. In referring to the Gallery's collection, he remarked 'Cuyp is represented by nothing one can trust. A rather large picture of cows being milked has much beauty, but does not recommend itself as characteristic. In many ways it suggests rather Govaert Camphuysen'. In a communication in 1968 van Thiel[12] considered the signature a forgery and the painting more probably the work of Aelbert Cuyp's father, Jacob Gerritsz. Cuyp. The latter was known principally as a portrait painter, but Reiss points out that Aelbert was first employed by his father in providing the landscape backgrounds of his pictures.[13] The recent cleaning of no. 49 has revealed it to be of high quality and in very good condition; but in view of the reservations always expressed over the attribution, it is here catalogued as Studio of Cuyp.

1. It is reproduced by Reiss 1975, p. 90; but no collection is given.
2. Repr. Reiss 1975, no. 56, p. 91.
3. Hermitage inv. no. 1107. Repr. Reiss 1975, no. 57, p. 92.
4. Hofstede de Groot 1908-27, vol. 2, no. 367, pp. 110-11.
5. Museum Boymans-van Beuningen, Foundation Willem van der Vorm, inv. no. v de v 11b.
6. See 'Drawing' above.
7. Albertina inv. no. 8753.
8. *Op. cit.,* p. 110.
9. *Ibid.*
10. *Op. cit.,* p. 90.
11. Armstrong 1890, p. 287.
12. On a visit to the Gallery. Note now in the archive of the Gallery.
13. Reiss 1975, p. 8.

After AELBERT CUYP

344 Landscape with three cows and a herdsman (Fig. 35).

Oil on panel, 74.4 × 59.6 cms. (29¼ × 23½ ins.).

CONDITION: the support consists of three members joined vertically at 18 cms. and 43 cms. from the right. The joins in the support are visible on the surface. Paint surface in good condition.

PROVENANCE: Mrs. Algie of Dublin, from whom purchased, 1894, for £2. 10s.

No. 344 was purchased and has always been catalogued as the work of Jacob van Strij. It is, however, a copy of a signed painting by Aelbert Cuyp in Enschede.[1] Jacob van Strij was perhaps the best known and most frequent of Aelbert Cuyp's copyists, but there is no certain means of identifying no. 344 as from his hand. Other copies of Cuyp's painting attributed to Jacob or Abraham van Strij are known.[2]

1. Inv. no. BR I G 20. Repr. *Enschede, Rijksmuseum Twenthe, cat. 1967,* no. 20.
2. For example the painting sold at Graupe, Berlin, 23 March 1936, lot 119 as Abraham van Strij; and the painting in the Museum Pescatore, Luxembourg (1872 Catalogue, no. 63).

JACOB GERRITSZ. CUYP Dordrecht 1594-1651/52 Dordrecht

He was born in Dordrecht in 1594 the fifth child by his first marriage of Gerrit Gerritsz. Cuyp, a glass maker-painter and painter in Dordrecht. He married in November 1618 and had one son the painter Aelbert Cuyp (q.v.). According to Houbraken he was a pupil in Utrecht of Abraham Bloemaert. He joined the Guild of St. Luke in Dordrecht in 1617 and was treasurer of the Guild in 1629, 1633, 1637 and 1641. He was connected with the Waalse Kerk in Dordrecht from 1618, was a deacon in 1629 and 1634, and in 1641-43 and from 1649 until his death was an elder. His precise date of death is uncertain. He is documented in church records in October 1651.

He is principally known as a portrait painter but he also painted history scenes and animals. His portraits of Dordrecht burghers are mainly head and shoulder studies in tones of grey-brown; but he also painted a number of children's portraits generally shown with animals, and the landscape in the background of these is in the style of Aelbert Cuyp.

1047 Portrait of a man aged 40 (Fig. 38).

Oil on panel, 73.8 × 59 cms. (29 × 23¼ ins.).

SIGNED, DATED AND INSCRIBED: right, *AE tatis 40. J.G.* (in monogram) *cuÿp. fecit A°. 1651.* (Fig. 235).

CONDITION: there is a collector's seal (Fig. 284) on the front of the support, bottom left. The support consists of three members joined on verticals 19 cms. and 45 cms. from the right. The joins have been strengthened by balsa wood inserts. The support is planed down. Paint surface in poor condition, worn and considerable overpaint throughout. Cleaned in 1970.

PROVENANCE: Mrs. White of Naneton, Rathkeale, county Limerick; J. M. Cogan of Dublin, from whom purchased, 1940, together with no. 1048, for £150.

1048 Portrait of a lady aged 55 (Fig. 39).

Oil on panel, 73.8 × 58.6 cms. (29 × 23 ins.).

SIGNED, DATED AND INSCRIBED: left, *AE tatis. 55 / J G.* (in monogram) *cuÿp. fecit / .1651* (Fig. 236).

CONDITION: poor. Much over-painting throughout. The support is very badly damaged. It has been planed down and repaired and now consists of five vertical members joined. The joins are visible on the surface. Cleaned in 1970.

PROVENANCE: Mrs. White of Naneton, Rathkeale, county Limerick; J. M. Cogan of Dublin, from whom purchased, 1940, together with no. 1047, for £150.

The design, handling and signature, in spite of present condition, are all characteristic of the painter at this time, i.e. 1651. The portrait may be compared to a *Portrait of an old lady aged 73* in Dordrecht[1] which is signed in an identical fashion and dated the same year. Martin[2] characterised this type of portrait as 'simple format' and it is one of a series of similar portraits of quality which the artist painted in the late 1640's and early 1650's.

1. Dordrechts Museum inv. no. DM904/124. Repr. Dordrecht 1977-78, no. 9.

2. Martin 1935-36, vol. 1, p. 322.

Ascribed to J. G. CUYP

151 Portrait of a child with a dog (Fig. 40).

Oil on panel, 61 × 52.5 cms. (24 × 20¾ ins.).

CONDITION: the support consists of three members joined on verticals 8 cms. and 38.5 cms. from the right. The paint surface is in poor condition with much retouching throughout.

PROVENANCE: acquired by Joseph Strutt of Derby by 1827;[1] thence by descent to Howard Galton of Hadzor; by descent to Hubert Galton; his sale (Hadzor sale) Christie's, 22 June 1889, lot 20, where purchased for 35 guineas.

LITERATURE: Strutt 1827, no. 429, p. 24.

No. 151 was described in 1827[2] as 'Weenix . . . a Girl with a dog'. It seems not to have been seen by Waagen[3] at Hadzor and was sold in 1889 as J. G. Cuyp, *A girl with a greyhound* and has always been so referred to at the Gallery, although Armstrong had perhaps doubts about the attribution as he catalogued it in 1898 as 'ascribed to J. G. Cuyp'.

It is not certain whether the child is a boy or a girl. It would be more usual for a boy to be shown with a dog; although the bracelets and necklace would indicate that the sitter was a girl. The costume is similar to that worn by a girl in a *Portrait of two children* ascribed to J. G. Cuyp formerly in Milwaukee.[4]

No. 151 is reasonably characteristic of J. G. Cuyp although not in very good condition and is here 'ascribed' to J. G. Cuyp. The costume would indicate a date of the early to mid-1640's.[5]

1. Strutt 1827, no. 429, p. 24.
2. *Ibid.*
3. Waagen 1854, vol. 3, pp. 222ff., describes the Hadzor collection.
4. Formerly collection Alfred Bader. Repr. de Jongh 1986, fig. 50a, p. 225.
5. Information from Marÿke de Kinkelder of the RKD.

DIRCK VAN DELEN Heusden 1605-1671 Arnemuiden

He may have been a pupil of Hendrick Arts, the painter of architectural fantasies. By 1626 he had settled in Arnemuiden near Middelburg and he is recorded in the Guild of St. Luke in Middelburg from 1639-65. He continued to live at Arnemuiden where he became a burgomaster but was apparently in Antwerp in 1666 and 1668-69. He died in Arnemuiden on 16 May 1671.

He painted pictures of imaginary architecture, chiefly church and palace interiors in the Northern Renaissance style. The figures in his compositions were generally painted by other artists including Dirck Hals (see no. 119 below), Anthonie Palamedesz. (q.v.), Pieter Codde (q.v.) and Jan Olis.

DIRCK VAN DELEN and DIRCK HALS
(For biography of Hals see p. 53).

119 An interior with ladies and cavaliers (Fig. 42).

Oil on panel, 73 × 96.5 cms (28¾ × 38 ins.).

SIGNED AND DATED: bottom centre, *Dirck van Delen 1629* (Fig. 237).

CONDITION: very good. Cleaned in 1982.

PROVENANCE: Leopold Double sale, Paris, 30 May 1881, lot 12; Secretan sale, Paris, 1 July 1889, lot 127, where purchased for £243 11s. 8d.

LITERATURE: Bode 1883, p. 124; Jantzen 1910, no. 105, p. 160; Jantzen 1913, p. 12; Schatborn 1973, pp. 115, 116; Blade 1976, pp. 130, 132-34, 190 and no. 21, p. 217; Jantzen 1979, no. 105, p. 221; Sutton 1980, fig. 14.

DRAWINGS: of the standing woman on the extreme right, coll. Victor de Stuers;[1] of the man smoking a pipe, Rijksprentenkabinet, Amsterdam.[2] (Figs. 44 and 43).

No. 119 is signed by Dirck van Delen but the figures were recognised as the work of Dirck Hals by Bode[3] as early as 1883 and the painting was sold in 1889 as the joint work of both artists. The attribution of the figures to Hals is substantiated by that artist's preparatory drawings for them which have been published by Schatborn.[4]

The room in no. 109 is almost certainly imaginary and of a type, according to Blade,[5] which is very probably much more sumptuous than any either existing or ever built in seventeenth-century Holland. In the painting of architecture, Dirck van Delen was influenced and inspired by the architectural pattern books of Hans and Paul Vredeman de Vries.[6] Blade has also drawn attention to the influences of similar books by Sebastiano Serlio and Abraham Bosse.[7] A chimney-piece in Serlio's *D'Architettura et Prospetiva* published in 1619 is similar to the chimneypiece shown in no. 119;[8] and the general appearance of the room has been compared by Sutton[9] to a plate in Hans Vredeman de Vries's *Scenographiae, sive Perspectivae* of 1560. In painting such compositions van Delen was also influenced by the work of other Dutch architectural painters such as Hendrick Arts, Hendrick van Steenwyck the Younger and Bartholomeus van Bassen. A very similar room to that shown in no. 119 is that depicted in a painting by van Delen in the Rijksmuseum, Amsterdam:[10] in that painting there is a similar disposition of windows, an arched entrance door, a pilastered overmantle and above all, a set of engraved portraits decorate the room as in no. 119. The people shown in the Amsterdam painting are recognisable as portraits of members of the House of Orange and the engravings are also of identifiable persons.[11] In no. 119 the only figure who is possibly a portrait is the man fifth from left who may be intended as Frederik Hendrik of Orange;[12] and he may also be the subject of the engraving to the immediate left of the chimneypiece.[13] The other engravings are most probably fanciful.

Blade has suggested that the scene depicted in no. 119 could well be intended as representing the Five Senses.[14] If that is the case, and taking into account the more usual method of depicting the senses in seventeenth-century Dutch painting, the lady offering the wine glass and the platter of fruits would be intended as Taste; the pipe-smoker,

Smell; the lady who touches the shoulder of the man in the centre, Touch — which could also be suggested by the couple on the right if it is assumed that the man has his arm round the waist of the lady; Hearing would be suggested by the statue in the niche above the chimneypiece who holds a traditional symbol of Hearing — a bowed instrument, as well as a horn. Sight is less obviously demonstrated, although the mirror on the wall, left, could be relevant.

The seated figure smoking a pipe, for which a preparatory drawing exists, was repeated by Hals in paintings now in Berlin[15] and San Francisco;[16] and the standing woman on the extreme right, for which there is also a preparatory drawing, was repeated by Hals in a painting now in Haarlem.[17] Blade compares no. 119 in general terms of both setting and subject to four other paintings by van Delen with figures by Dirck Hals.[18] Of these pictures the comparison of no. 119 with Blade's no. 27 (coll. Sir Cecil Newman) and his no. 29 (sold at Sotheby's 12 April 1978, lot 8) seems most apt to the compiler; although as Blade has pointed out the standing man with his back to the spectator in the very centre of the composition is of a type used by Hals in paintings of 1627 in Berlin[19] and of 1628 in Haarlem.[20] The couple on the extreme right are also represented in other compositions.

1. Repr. Schatborn 1973, fig. 13 p. 113.
2. Inv. no. 1965: 180. Repr. Schatborn 1973, fig. 9, p. 111.
3. Bode 1883, p. 124. Bode saw the painting in the Leopold Double sale in 1881, see 'Provenance' above.
4. Schatborn 1973, no. 1, pp. 114-15 and no. 11, p. 116.
5. Blade 1976, p. 63.
6. See Balleger 1967, p. 55 and Liedtke 1970, pp. 15ff.
7. Blade 1976, pp. 21-70.
8. As pointed out by Blade 1976, p. 30. it is p. 69 of Serlio.
9. Sutton 1980, p. 20 and figs. 13 and 14.
10. Inv. no. 3938. Repr. *Amsterdam, Rijksmuseum, cat. 1976*, p. 190.
11. See Staring 1965, pp. 3-13.
12. This observation has been made by van Kretschmar in a letter dated 24 June 1983 now in the archive of the Gallery.
13. *Ibid.*
14. Blade 1976, p. 190.
15. Dahlem Gemäldegalerie cat. no. 816A, dated 1627. Repr. Schatborn 1973, fig. 8, p. 111.
16. Palace of the Legion of Honor, inv. no. 1957:160. Repr. Schatborn 1973, fig. 3, p. 109.
17. Frans Halsmuseum inv. no. 674. Repr. Schatborn 1973, fig. 5, p. 110. The repetition is with some variation as the woman is facing to her right.
18. His cat. no. 15, fig. 8: *Interior of a palace with merry company*, signed and dated 1628 by van Delen now in the Frans Halsmuseum, Haarlem; his cat. no. 16, fig. 127, *Interior of a palace with merry company*, signed and dated 1628 by Hals and now in the Akademie der Bildenden Künste, Vienna, inv. no. 684; his cat. no. 27, fig. 19, *Interior of a palace with company at a table*, signed and dated 1629 by van Delen which in 1953 was in the collection of Sir Cecil Newman, Burloes Royston; his cat. no. 29, fig. 20, *Interior of a palace with musical company*, sold Sotheby's, 12 April 1978, lot 8.
19. See n. 15 above.
20. See n. 17 above.

JOOST CORNELISZ. DROOCHSLOOT ? Utrecht 1586-1666 Utrecht

He became a member of the Guild of St. Luke in Utrecht in 1616. He married in Utrecht in 1618. He was Dean of the Guild of St. Luke in Utrecht 1623, 1641 and 1642. He became a Regent of the St. Job's Hospital in Utrecht in 1638. He worked in Utrecht all his life

and was buried there on 14 May 1666. He was the teacher of Jacob Duck (q.v.). In his earliest works he was influenced by Esaias van de Velde and he frequently incorporated biblical themes into his landscapes. He painted views, generally of his native Utrecht, and some few portraits, and village scenes with kermesses. He repeated details from his pictures frequently.

252 The ferry (Fig. 45).

Oil on panel, 62.2 × 107.9 cms. (24½ × 42⅜ ins.).

SIGNED AND DATED: on the fence, left, *JC* (in monogram) *DS* (in monogram) *1642*. (Fig. 238).

CONDITION: the support consists of two members joined on a horizontal 31 cms. from the top. The back of the support has at some time been planed down and repaired. Paint surface in good condition. Some abrasions in the sky. Cleaned in 1970.

PROVENANCE: 'Property of a Lady decd'. (Miss E. Elliotson) sale, Christie's, 27 June 1885, lot 57, where purchased for 43 guineas.

LITERATURE: Armstrong 1890, p. 283.

Although the artist repeated all his compositions on a frequent basis, the type of scene portrayed in no. 252 is found less often than other compositions. The detail of the ferry carrying a horse is repeated almost exactly in a painting by Droochsloot dated 1652 in The Hague,[1] although it could be that the ferry in that picture is travelling in the opposite direction. A further painting of the same type, dated 1650 is in the Rijksmuseum, Amsterdam.[2] It should be said that no. 252 is of particularly high quality; and indeed was described as such by Armstrong.[3]

1. Mauritshuis inv. no. 35. Repr. *The Hague, Mauritshuis, cat. 1977*, p. 74.
2. Inv. no. A3227. Repr. *Amsterdam,*

Rijksmuseum, cat. 1976, p. 200.
3. Armstrong 1890, p. 283.

1529 A village festival (Fig. 46).

Oil on panel, 59 × 92.8 cms. (23³⁄₁₆ × 36½ ins.).

CONDITION: the support, which is cradled, consists of three members joined on horizontals at 26.5 and 31 cms. from the top. The figures and landscape are in good condition. Some wearing in the sky and retouchings along the joins in the panel.

PROVENANCE: Sir Alfred Chester Beatty, by whom presented, 1954.

No. 1529 is the type of scene usually portrayed to depict a kermis. A kermis was a village festival generally held on the feast day of the patron saint of a rural town or village. On such occasions the traditional flag of the town's patron saint was hung from the church spire or some other building. In no. 1529 similar activities to those which took place at a kermis, eating, drinking, dancing and love-making, are taking place; but as there is no flag, the occasion is simply a village festival. Paintings of such scenes were popular from at least the time of Pieter Brueghel the Elder and they are particularly associated with a Flemish painter who worked in Amsterdam in the early seventeenth century, David Vinckboons.

No. 1529 was presented in 1954 as the work of Jan Molenaer and has always been so catalogued at the Gallery. It is, however, fairly typical of the work of Droochsloot to whom it is here given. Droochsloot painted such scenes throughout his career but particularly during the 1640's. A date in that decade might be suggested for no. 1529.

WILLEM DROST Active 1652-1680

Neither the place and date of his birth nor death is known. His earliest dated work is an engraved self-portrait of 1652. His dated paintings are from the years 1653-63. Houbraken says that he studied with Rembrandt; this may have been in the late 1640's. His paintings reflect the style of Rembrandt in the years 1650-55. He painted history scenes, biblical compositions and allegorical or emblematic studies of single figures and portraits. Also according to Houbraken he went to Rome where he associated with Johann Carl Loth and Jan van der Meer of Utrecht. It is substantiated that he followed Loth to Venice but this can have been in 1657 at the earliest. It is not known how long he stayed in Italy but he was back in Holland by 1663 when he signed a portrait of a Rotterdam sitter. The last reference to him is in 1680 when he was witness to an inventory of the possessions of Jan van Spijckvoort in Rotterdam.

107 Bust of a man wearing a large-brimmed hat (Fig. 41).

Oil on canvas, 73.1 × 62 cms. (28¾ × 24½ ins.) stretcher size; 64 × 55.7 cms. (24¼ × 22 ins.) original canvas.

SIGNED: on the right, centre, *W. Dro(st)* (Fig. 239).

CONDITION: the original canvas size has been extended all round (seen dimensions above). Paint surface in good condition. The background had been overpainted to conceal the join in the canvas and the signature: this was removed in 1982. Cleaned in 1982.

PROVENANCE: purchased by Joseph Strutt of Derby between 1820 and 1821;[1] thence by descent to Howard Galton of Hadzor by 1854; by descent to Hubert Galton, his sale (Hadzor Sale) Christie's, 22 June 1889, lot 26, where purchased for 96 guineas.

EXHIBITED: 1857, *Manchester Art Treasures*, definitive catalogue no. 676; 1882, *Worcestershire Exhibition*, Worcester, no. 72; 1883, *Old Masters*, Royal Academy, London, no. 64; 1983, *Rembrandt: the Impact of a Genius*, Waterman Gallery, Amsterdam and Groninger Museum, Groningen, no. 20.

LITERATURE: Strutt 1827; Waagen 1854, vol. 3, p. 221; Armstrong 1890, p. 286; Duncan 1906-07, p. 16; Potterton 1982, p. 104 and n.6-10, p. 107; Sumowski 1983-, vol. 1, no. 328, p. 615; Amsterdam/Groningen 1983, no. 20, p. 130.

No. 107 may be the picture described in 1827 as 'No. 163 Rembrandt, *Head of a Jewish rabbi*' in the collection of Joseph Strutt of Derby.[2] It was called van den Eeckhout, *A male portrait* by Waagen in 1854[3] and lent as such to the Manchester Exhibition of 1857. It was sold in 1889 as van den Eeckhout *A gentleman* and has subsequently been referred to as a *Jewish rabbi* at the Gallery and attributed to van den Eeckhout; Armstrong[4] referred to

it as a 'first rate example' of van den Eeckhout's work. Duncan[5] noted that no. 107 was evidently by the same hand as the *Christ blessing little children* in the National Gallery, London which was then attributed to van den Eeckhout[6] and pointed out that 'in the sheer dexterity of handling, concentration of purpose and brilliant rendering of values, it approaches the work of the painter's master (i.e. Rembrandt) and if by van den Eeckhout is probably his finest work'. The attribution to van den Eeckhout was accepted by von Wurzbach.[7] Cleaning in 1982 revealed the signature of Drost and it was then published.[8] There is no reason to support the suggestion that the sitter is a rabbi. The man wears costume very similar to that worn by Rembrandt in his *Self-portrait aged 34* dated 1640 in the National Gallery, London[9] and also worn by the man in the *Male portrait* by Ferdinand Bol in Munich.[10] This type of costume was not necessarily of the period but used by Rembrandt and his followers as a studio prop in which to dress the sitters and models which they painted.

Sumowski[11] dates no. 107 to about 1654. He points out that the artist used the same model in the painting of a *Man in armour (Mars)* in Cassel[12] and in the *Man in a red cap* in Dresden[13] and in the *Seated man with a feather beret* formerly in the Rothschild Collection[14] which is dated 1654. Sumowski describes as related work the *Young woman with a feather cap* by Bol in Cincinnati which Nieuwstraten has given to Drost.[15] That picture is of similar size to no. 107 and shows the head and shoulders of a woman wearing a large-brimmed hat facing to the right.

1. Information from C.E.W. Deacon in a letter dated 6 April 1973 now in the archive of the Gallery.
2. Strutt 1827.
3. Waagen 1854, vol. 3, p. 221.
4. Armstrong 1890, p. 286.
5. Duncan 1906-07, p. 16.
6. Cat. no. 757. Now attributed to Nicolaes Maes, it was called Rembrandt in the eighteenth and nineteenth centuries, but given to van den Eeckhout by Bode and Hofstede de Groot in 1902. See MacLaren 1960, pp. 229 ff. Repr. *London, National Gallery, cat. 1973*, p. 398.
7. von Wurzbach 1906-11, vol. 3, p. 81.
8. Potterton 1982, p. 104. An attribution to Drost had earlier been proposed by Schneider, see Sumowski 1983-, vol. 1, p. 615.

9. Cat. no. 672. Repr. *London, National Gallery, cat. 1973*, p. 599.
10. Alte Pinakothek inv. no. 609. Repr. Blankert 1982, pl. 154.
11. Sumowski 1983-, vol. 1, no. 328, p. 615.
12. Gemäldegalerie, inv. no. 245. Repr. Sumowski 1983-, vol. 1, p. 630.
13. Gemäldegalerie, inv. no. 1568. Repr. Sumowski 1983-, vol. 1, p. 638.
14. Repr. Sumowski 1983-, vol. 1, p. 640.
15. Art Museum, inv. no. 1954:21. Repr. Holmes 1915-16, p. 28. The attribution to Bol is not accepted by Blankert, *op. cit.* 1982, no. R252, p. 189, who refers to the opinion in Nieuwstraten. The painting is not included as Drost by Sumowski, 1983-, vol. 1.

JACOB DUCK Utrecht c.1600-1667 Utrecht

He was born in Utrecht about 1600 and is assumed to have been a pupil of the Utrecht painter Joost Cornelisz. Droochsloot (q.v.). He is mentioned as an apprentice portraitist in the records of the Guild of St. Luke in Utrecht in 1621, and was enrolled as a Master in the Guild by 1630-32. Some of his paintings were included in a raffle sponsored by

the Haarlem Guild of St. Luke in 1636, so he may have become a resident of Haarlem by this time, and probably entered the Guild there in that year. He is recorded in Utrecht in 1643 and 1646, and from 1656-1660 was at The Hague. He painted guardroom and merry-company scenes in the tradition of Willem Duyster (q.v.), Pieter Codde (q.v.) and Anthonie Palamedesz. (q.v.). He was also an etcher.

335 Interior with a woman sleeping (Fig. 47).

Oil on panel, 27.1 × 23.8 cms. (10¾ × 9⅜ ins.).

SIGNED: bottom right, *J Duck* (the JD in monogram).

CONDITION: the support consists of two members joined on a horizontal 9 cms. from the top. Paint surface in very good condition. Cleaned in 1983.

PROVENANCE: Sir Walter Armstrong, from whom purchased, 1891, for £30.

EXHIBITED: 1985, *Masterpieces from the National Gallery of Ireland*, National Gallery, London, no. 31.

LITERATURE: London 1985, no. 31, p. 78.

The subject of the painting is not clear, but in the context of other paintings by Duck, it is most likely that it is intended to convey some moral rather than represent some specific subject from, for example, literature. Duck painted any number of pictures of sleeping figures, both male and female, and, in general he incorporated in these paintings some other action which had specific sexual implications. In a painting in Munich[1] an older woman, overcome by drink and tobacco smoking, is shown asleep in the foreground, while in the background a younger woman enjoys the attentions of a young soldier. In another painting by the artist[2] a sleeping woman is about to be awakened by a soldier who is making a very lewd gesture. The woman in no. 335 keeps company with soldiers: she is leaning on a drum, an instrument that may be associated with the military. On the drums are coins, a gold chain, pearls and an open jewel casket. The soldier in the centre background appears to be about to add to the jewels and coins that are on the drum. Duck, like other painters of his time such as W. C. Duyster (q.v.), painted several pictures of soldiers plundering jewels. In paintings by him in the Louvre[3] and elsewhere, the soldiers offer their plunder to women of easy virtue. In the context of these pictures the subject of no. 335 might simply be explained as a prostitute whose procuress is the woman in the background doorway.

The panel on which the picture is painted has been extended at the top and the extension is clearly visible on the surface. It would not be unusual for Duck to paint a picture horizontal in format as no. 335 would be, without the addition. A pair of paintings in Groningen[4] are so shaped. It would also be usual for him to have painted a picture in the format of no. 335 as it now appears. The very thin painting of the addition, with the grain of the wood showing through, is a similar technique to that found in the Groningen paintings; and it is probable that the addition to the panel is original.

Duck's style of the 1650's and 1660's has been summed up[5] as 'use of strong local colour, the choice of an upright format, and the depiction of an interior limited to only a few figures'. A date in the late 1650's may be proposed for no. 335. The woman in

the picture is repeated almost exactly in a different composition in the Landesmuseum Ferdinandeum, Innsbruck.[6] (Fig. 209).

1. Alte Pinakothek, Repr. Naumann 1981, vol. 1, fig. 114.
2. Coll. The Earl of Lichfield, Shugborough. Repr. Philadelphia/Berlin/London 1984, fig. 3, p. 193.
3. Inv. no. 1228. Repr. *Paris, Louvre, cat. 1979*, p. 49.

4. Museum voor Stad en Lande, inv. nos. 2026 and 2027.
5. Philadelphia/Berlin/London 1984, p. 193.
6. Inv. no. 1976.

KAREL DUJARDIN ? Amsterdam c.1622-1678 Venice

He was possibly the son of a painter Guilliam Dugardin (b.1597). Houbraken says he studied with Nicolaes Berchem (q.v.). In the late 1640's he was probably in Rome where he remained for several years; but was back in Amsterdam by 1650, preparing to leave for Paris. He was again in Amsterdam in September 1652 and was still there in 1655. He was a member of Pictura in The Hague between 1656 and 1658; but was back in Amsterdam by 1659 where he is last mentioned in November 1674. By 1675 he was again in Rome and died in Venice on 20 November 1678. From about 1650 Dujardin worked in a style inspired by Paulus Potter (q.v.) and Jan Asselijn and painted landscapes with animals and shepherds, generally on a small scale. After 1675 his style changed and he painted in a much broader technique. Apart from landscapes he also painted portraits, religious subjects and bamboicciante scenes. There are a number of drawings known by him as well as about fifty engravings.

544 The riding school (Fig. 48).

Oil on canvas, 60.2 × 73.5 cms. (23¾ × 28⅞ ins.).

SIGNED AND DATED: bottom left, *.DV. Jardin .f. Roma. 1678.*

CONDITION: worn throughout in the background but the figures and the horse are in good condition. There is a damage in the area of the left leg of the principal figure. Cleaned and restored in 1972.

PROVENANCE: Sale, Bicker and Wykersloot, Amsterdam, 19 July 1809, lot 24, bt. Coclers; L. B. Coclers sale, Amsterdam, 7 August 1811, lot 34, bt. Roos (bought in); L. B. Coclers sale, Amsterdam, 8 April 1816, lot 54, bt. J. de Vries; Lapeyriere sale, Paris, 14 April 1817, lot 24; Henry Doetsch sale, London, 22 June 1895, lot 414, bt. McLean; Forbes & Patterson, London, from whom purchased, 1903, for £100.

EXHIBITED: 1965, *Nederlandse 17ᵉ Eeuwse Italianiserende Landschapschilders*, Centraal Museum, Utrecht, no. 132.

LITERATURE: Smith 1829-42, Part 5, no. 74, p. 257; Hofstede de Groot 1907-28, vol. 9, no. 274, p. 371; Gerson 1953, n. 21, p. 51; Brochhagen 1957, p. 253; Brochhagen 1958, p. 134; Utrecht 1965, no. 132, pp. 211-12.

No. 544 was called by Smith[1] *Cavaliers trying their horses* and by Hofstede de Groot[2] *A grey horse with black legs*. It was catalogued as *A white Arabian horse* in the Doetsch sale[3]

but the description pointed out that the scene seems to represent a riding school in Rome. It was referred to as *The manège* in the Register of the Gallery and in the 1914 and subsequent catalogues as *The riding school*, which is one and the same thing. Hofstede de Groot refers to no. 544 as being one of a pair of pictures, its pendant[4] being sold at the same sale (see 'Provenance' above) in Amsterdam, 19 July 1809. That picture showed *A pretty woman with two children* and was similar in size to no. 544. No. 544 is the last known painting by Dujardin;[5] and a reflection of the work of Poussin has been noted in the composition,[6] also some similarity to the work of Michiel Sweerts.[7]

1. Smith 1829-42, Part 5, no. 74, p. 257.
2. Hofstede de Groot 1907-28, vol. 9, no. 274, p. 37.
3. See 'Provenance' above.

4. Hofstede de Groot 1907-28, vol. 9, p. 371.
5. According to Brochhagen 1958, p. 134.
6. Utrecht 1965, p. 132.
7. *Ibid.*

CHRISTIAEN JANSZ. DUSART Antwerp 1618-1682/83 Amsterdam

He was born in Antwerp on 25 February 1618 and married in Amsterdam in 1642. He visited London in 1656 but had returned to Amsterdam by 1658 where he is documented in 1661, 1666 and 1668-71. In 1664 he became a member of the Guild of St. Luke at The Hague. He was a friend of Rembrandt. He painted portraits, history-pieces and still-life, but works by him are rare.

961 Dead game (Fig. 49).

Oil on canvas, 84 × 102 cms. (33⅞ × 40⅛ ins.).

SIGNED AND DATED: on the ledge, left, *C Dusart fe 1650* (the CD in monogram) (Fig. 241).

CONDITION: very good. There is a tear about 2 ins. long in the top left-hand corner. Cleaned, lined and restored in 1970.

PROVENANCE: Dr. Travers Smith of London, by whom bequeathed, 1933.

The game has been identified[1] as follows: from left to right, a mallard *(Anas platyrhynchos)* or domestic drake of the wild colour pattern, a domestic goose *(Anser anser)*, two domestic rabbits *(Oryctolagus cuniculus)*, two young pigeons *(Colomba livia)*. The object on the ledge, to which a ribbon is attached, is not identifiable: it may be some sort of gavel.

Works by Dusart are exceptionally rare and the compiler has been unable to trace any still-life by him which approaches no. 961 in style. It should also be said that no. 961 is of exceptionally fine quality. Scott A. Sullivan[2] has remarked that no. 961 appears to be a Dutch game-piece in the tradition of Elias Vonck and Matthias Bloem who worked in Amsterdam in the mid-century. A painting by Dusart in the Rijksmuseum, Amsterdam shows a *Young boy reading by candlelight* and it is signed and dated 1645.[3] van Thiel[4] has remarked that the signature on that painting and that on no. 961 differ considerably, with the handwriting on the Amsterdam painting not nearly so elegant as on no. 961. He

concludes that 'I can imagine that Dusart developed his abilities in five years time from the promising level of our work to the accomplished one' of no. 961.

1. By D. Goodwin of the British Museum, Natural History in a letter dated 3 April 1981 now in the archive of the Gallery.
2. In a letter dated 13 January 1986 now in the archive of the Gallery.

3. Inv. no. A1684. Repr. *Amsterdam, Rijksmuseum, cat. 1976,* p. 206.
4. In a letter dated 8 November 1985 now in the archive of the Gallery.

CORNELIS DUSART Haarlem 1660-1704 Haarlem

He was born in Haarlem on 24 April 1660. He was apprenticed to Adriaen van Ostade (q.v.) and is reputed to have been one of the master's most promising pupils. He joined the Guild of St. Luke in Haarlem in 1679 and in 1682 is recorded as an unmarried member of the Reformed Church in Haarlem. In 1692 he became a hoofdman of the Guild and he died in Haarlem on 1 October 1704. His art collection, which included several works by Adriaen van Ostade, was auctioned in The Hague in 1708. He is known mainly as a painter of peasant scenes which invariably contain some element of caricature; he was also a draughtsman and etcher.

324 A merry-making (Fig. 50).

Oil on canvas, 33.5 × 38.5 cms. (13⅛ × 15⅛ ins.).

SIGNED AND DATED: bottom right, *C ? Dusart. fe 1692*

REVERSE: fragments of a Dutch newspaper are pasted to the stretcher.

CONDITION: good.

PROVENANCE: S. S. Joseph, by whom presented, 1892.

LITERATURE: Boydell 1985, p. 11.

The boy, second from right, plays a hurdy-gurdy. Hurdy-gurdy players feature in any number of Dutch seventeenth-century paintings.[1] The instrument consisted of a sound-box whose shape suggested that of a violin with a series of strings stretched across it. By rotating a small wheel which was set into the sound-box the strings were made to vibrate. The instrument is associated with beggars in Dutch seventeenth-century painting who are shown playing it as a means of soliciting money, and, as playing a hurdy-gurdy was entirely a mechanical process, requiring no skill, it is most often shown played by blind beggars. By the time no. 324 was painted, however, late in the century, the hurdy-gurdy had no specific implication.

The composition of no. 324 is of a type developed by Dusart's master, Adriaen van Ostade[2] and repeated by Dusart on many occasions.[3]

1. See Reinold 1981, pp. 94-128.
2. See for example *The violinist* in the Mauritshuis, The Hague, inv. no. 129. Repr. *The Hague, Mauritshuis, cat. 1977*, p. 173.

3. See for example *The country kermis* in the Rijksmuseum, Amsterdam, inv. no. A99. Repr. *Amsterdam, Rijksmuseum, cat. 1976*, p. 206.

DUTCH SCHOOL, 1641

36 Portrait of a man aged 28 (Fig. 51).

Oil on panel, 68.6 × 56 cms. (27⅛ × 22 ins.).

INSCRIBED AND DATED: top left, *Anno 1641 Ætatis 28 (?)*

REVERSE: indecipherable collector's seal.

CONDITION: the support consists of two members joined on a vertical 14 cms. from the right. Paint surface in fair condition although quite worn throughout. Cleaned in 1986.

PROVENANCE: purchased in Dublin in 1872 for £20.

No. 36 was purchased as the work of Cornelius Jonson and so catalogued until 1898 when Armstrong described it as 'Dutch School'. Since 1971 it has been given to Anthonie Palamedesz. (q.v.). The style of the portrait is somewhat too polished for Palamedesz. Although no. 36 is of fine quality, the compiler has been unable to identify any painter to whom a reasonably secure attribution might be made.

WILLEM DUYSTER Amsterdam 1599-1635 Amsterdam

He was baptised in the Oude Kerk in Amsterdam on 30 August 1599 the son of Cornelis Dircksz. by his second wife. In 1620 the family moved to a house in the Koningsstraat in Amsterdam and Willem took his adopted surname from the name of this house 'De Duystere Werelt' (the dark world). He married on 5 September 1631 in a double wedding ceremony: his bride was Margrieta Kick, the sister of Simon Kick (q.v.) who married at the same time Willem's younger sister Styntge. After the marriage both couples moved into 'De Duystere Werelt'. Willem's marriage was, however, shortlived as he died of the plague in 1635 and was buried in the Zuiderkerk on 31 January 1635. Nothing is known of his training. His works, which are comparatively rare, are mainly genre scenes with soldiers, similar in style to those of Pieter Codde (q.v.) and Simon Kick. He also painted portraits.

436 Interior with soldiers (Fig. 53).

Oil on circular panel, 48.2 cms (19 ins.) diameter.

SIGNED AND DATED: on the step, bottom right, *W D* (in monogram) *1632*.

REVERSE: collector's seal. (Fig. 285). Old inventory number 3.

CONDITION: very good. There is a small damage in the area of the horizontal beam, top left. Cleaned in 1985.

PROVENANCE: Dermot Bourke, 7th Earl of Mayo, from whom purchased, 1895, for £50.

LITERATURE: Duncan 1906-07, p. 17.

A powder bag hangs on the wall right. The man is clearly an officer. No. 436 was described by Duncan[1] as 'a full-length portrait of a Dutch officer. A very early work of the type formerly attributed to Le Duc'. The painting is somewhat similar in composition to a rectangular painting in the Mauritshuis[2] with a single soldier standing sideways facing the spectator and other soldiers in the background. The motif of the bannister and steps is repeated exactly in the Mauritshuis painting.

1. Duncan 1906-07, p. 17.
2. Inv. no. 408. Repr. *The Hague, Mauritshuis, cat. 1977*, p. 80.

556 Portrait of a married couple (Fig. 52).

Oil on panel, 64.2 × 51.5 cms. (25¼ × 20¼ ins.).

SIGNED: on the stretcher of the chair, W (as part of a monogram) the remainder indistinct.

CONDITION: fair. The background is considerably worn and strengthened throughout. The faces are in good condition. Cleaned and restored in 1968.

PROVENANCE: Miss A. Clarke, by whom bequeathed, 1903.

Portraits by Duyster are exceptionally rare. In scale and in the simplicity of the composition no. 556 may be compared to the contemporary portraits painted in Amsterdam by Pieter Codde, for example the *Portrait of a married couple* dated 1634 in the Mauritshuis.[1] Within Duyster's own oeuvre a comparison might be made with *The group portrait at a wedding feast* in the Rijksmuseum, Amsterdam[2] which has a floor similar to that shown in no. 556.

They are wearing Vlieger costume, but as they are elderly it is probable that they are unfashionably dressed and a date of about 1625 may be suggested.

1. Inv. no. 857. Repr. *The Hague, Mauritshuis, cat. 1977*, p. 63.

2. Inv. no. C514. Repr. *Amsterdam, Rijksmuseum, cat. 1976*, p. 207.

GERBRANDT VAN DEN EECKHOUT Amsterdam 1621-1674 Amsterdam

van den Eeckhout was born in Amsterdam on 16 August 1621, the son of a goldsmith, Jan Pietersz. van den Eeckhout. According to Houbraken he was Rembrandt's favourite pupil and also a great friend of Rembrandt. It is not known when exactly he was apprenticed to Rembrandt but it is thought to have been from about 1635. His earliest dated work

is of 1641, a Moses and Aaron, *the present whereabouts of which is unknown. He was primarily a history-painter but also painted portraits and genre scenes. His style was greatly influenced by that of his master and also by that of Rembrandt's own teacher, Pieter Lastman.*

253 Christ in the synagogue at Nazareth (Fig. 54).

Oil on canvas, 61 × 79 cms. (24⅛ × 31 ins.).

SIGNED AND DATED: on the pavement, bottom right, *G.V Eeckhout. Fe. A° 1658.* (Fig. 240).

CONDITION: very good. Cleaned in 1981.

PROVENANCE: possibly Hoare Collection, Stourhead;[1] S. Herman de Zoete, 1884; his sale, Christie's, 9 May 1885, lot 223, where purchased for 150 guineas.[2]

EXHIBITED: 1884, *Old Masters*, Royal Academy, London, no. 65; 1985, *Masterpieces from the National Gallery of Ireland*, National Gallery, London, no. 26.[3]

LITERATURE: Armstrong 1890, p. 286; Roy 1972, no. 58, p. 219; Nystad 1975, p. 147; Potterton 1982, pp. 104-05 and n. 11-14, p. 107; Sumowski 1983-, vol. 2, no. 428, p. 733; London 1985, no. 26, p. 68.

The picture has always been catalogued in Dublin as *Christ in the temple* or *Christ preaching in the temple* and was called by Roy,[4] *Christ and the scribes*. Its true subject was identified by Nystad[5] as *Christ preaching in the synagogue at Nazareth* (St. Luke, ch. 4, vs. 16-21). In referring to drawings and etchings by Rembrandt, Nystad has explained the composition of the picture as representing the *sjoel* or study-room which was at the entrance to a synagogue, but built at a lower level to the entrance. The bench to the right of Christ is typical furnishing for a *sjoel* and was used to separate the room from the entrance to the synagogue.

The composition of the painting, particularly with regard to the placing of Christ is related in a general way to Rembrandt's etching of *Christ preaching 'La Petite Tombe'* of about 1652,[6] and also to Rembrandt's *'Hundred guilder print'*[7] of about 1639-49. A closer comparison for the left-hand side of the painting is with Rembrandt's etched *Tribute money*[8] of about 1635 which includes in the background a loggia with figures and other figures poring over a book. Within van den Eeckhout's own oeuvre the composition comes closest to *Christ among the doctors* of 1662 in Munich,[9] and an undated *Presentation in the temple* in Dresden.[10]

Although always given to van den Eeckhout, the attribution was only fully confirmed in 1981 when overpainting of the signature and date was removed.

1. Armstrong 1890, p. 286 says that no. 253 had been at Stourhead; but the compiler has been unable to trace any record of the picture having been there.
2. Redford 1888, and the annotated sale catalogue in the National Gallery, London give the purchase price of no. 253 as 150 guineas; but the *ms.* catalogue and the Register of the Gallery both give £122 5s.
3. A *Christ in the temple disputing with the doctors* by van den Eeckhout was no. 87 in the Dublin

Exhibition of 1872, lent by John R. Smith, Esq.; but it cannot have been no. 253.
4. Roy 1972, no. 58, p. 219.
5. Nystad 1975, p. 147.
6. Bartsch no. 72.
7. Bartsch no. 74.
8. Bartsch no. 68.
9. Alte Pinakothek, inv. no. 184. Repr. Sumowski 1983-, vol. 2, no. 436, p. 799.
10. Gemäldegalerie, inv. no. 1638. Repr. Sumowski 1983-, vol. 2, no. 456, p. 819.

ISACK ELYAS active c.1620-30, probably in Haarlem

He is known only through one signed painting, A merry-company *in the Rijksmuseum, Amsterdam. This demonstrates that he was a follower of Willem Buytewech.*

Ascribed to ISACK ELYAS

333 The five senses (Fig. 55).

Oil on panel, 104 × 75 cms. (41 × 29½ ins.).

CONDITION: the support consists of three members joined on verticals at 27.5 cms. and 53.4 cms. from the right. The support had at some time been cradled: this has been removed and the joins are now strengthened by buttons. There are vertical repairs to the top of the support at 8 cms. (23 cms. high) and 40 cms. (32.5 cms. high) from the right. The paint surface is in poor condition and there is extensive retouching throughout. Cleaned in 1970.

PROVENANCE: Christie's, where purchased, 1892 through W. McKay, for 28 guineas.[1]

Previously always referred to as *An interior with figures,* no. 333 is clearly an illustration of the Five Senses. They are, from left, Touch, Sight, ? Smell, Taste and Hearing. The lady on the right plays a lute; on the table a lute and a violin. On the background wall, right, there hangs a painting of a landscape, and in the background left, probably a bed.

No. 333 has always been attributed at the Gallery to Willem Duyster (q.v.) but on a stylistic basis the attribution is untenable. The artist of the work should be sought among the followers of Willem Buytewech. The few interior genre scenes by Buytewech executed between 1616 and 1622[2] show a small number of figures seated around a table in a confined space. On the background wall is a map or a painting; the foreground figures project out of the picture plane towards the spectator; the figures are self-conscious and almost seem to be acting a role rather than interacting with each other; costumes are elegant and music plays a part. The type of chair, which is three-legged with stretchers at two levels joining the legs, and a short back, on which the foreground figure in no. 333 is seated, is also found in the work of Buytewech.[3] Buytewech, who worked in Haarlem in these years, was a pioneer of the development of merry-company scenes in seventeenth-century Dutch painting; and such paintings by him, showing carefree and careless youth were, although painted in a spirit of amusement, also intended to be censorious.[4] In a secondary way several of his paintings contain allegorical references to the Five Senses.[5] No. 333 is clearly in this tradition. Among the artists most influenced by the work of Buytewech were Dirck Hals (q.v.), Hendrick Gerritsz. Pot (q.v.) and the little-known painter, Isack Elyas.[6] The foreground youth in no. 333 bears some physical resemblance to a similar figure playing a lute in a signed *Merry-company* by Elyas in Amsterdam:[7] the somewhat awkward positioning of the legs, the costume, both in style and by the manner in which the folds above the knees are painted; and the angular treatment of the hands are all stylistically comparable in both pictures. Other figures in the Amsterdam painting stare at the spectator with a vacant expression, as do the ladies in no. 333. No. 333 is here ascribed to Elyas.

The Amsterdam painting is said to be dated 1620[8] but this may be a misreading for 1626.[9] On the basis of costume no. 333 may be dated 1625-30.

1. No. 333 was probably purchased sometime between March and August 1892 but the compiler has been unable to trace the painting in Christie's sale catalogues.

2. For example the paintings in the Museum Boymans-van Beuningen, Rotterdam, inv. no. 1103, repr. Haverkamp Begmann 1959, pl. 69; in the Museum Bredius, The Hague, inv. no. 150: 1946, repr. Haverkamp Begemann 1959, pl. 108; in the Szépmüvészeti Múzeum, Budapest, inv. no. 383, repr. Haverkamp Begemann 1959 pl. 117; and in the Bode Museum, East Berlin, inv. no. 1983, repr. Haverkamp Begemann 1959, pl. 148.

3. For example in the painting in Berlin, see n. 2 above.
4. See Haverkamp Begemann 1959, pp. 26-29.
5. For example the painting in Budapest, see n.2 above; and Haverkamp Begemann 1959, pp. 70-71.
6. See Haverkamp Begemann 1959, pp. 49-51.
7. Rijksmuseum inv. no. A1754. Repr. *Amsterdam, Rijksmuseum, cat. 1976*, p. 220.
8. *Ibid.*
9. See Haverkamp Begemann 1959, no. 278, p. 220.

ALLAERT VAN EVERDINGEN Alkmaar 1621-1675 Amsterdam

He was baptised in Alkmaar on 18 June 1621. According to Houbraken he was a pupil of Roelant Savery in Utrecht and of Pieter de Molijn (q.v.) in Haarlem. In 1644 he visited Norway and Sweden. He became a member of the Guild of St. Luke in Haarlem in 1645. He is particularly known for his mountain landscapes with rocks and waterfalls which were inspired by the scenery of Scandinavia.

Style of *ALLAERT VAN EVERDINGEN*

1890 **Landscape with a mountain torrent** (Fig. 195).

Oil on canvas, 64 × 81 cms. (25¼ × 32 ins.).

INSCRIBED: bottom right with an indecipherable monogram surmounted by a coronet.

REVERSE: indecipherable collector's seal.

CONDITION: fair.

PROVENANCE: Robert Clouston, Esq., by whom presented, 1855.

No. 1890 was presented to the Gallery as van Everdingen and so described in the early catalogues of the Gallery. It was soon, however, dropped from the catalogue. The composition is somewhat in the style of van Everdingen and the painting could reasonably be seventeenth-century in date. It is, however, of inferior quality.

GOVERT FLINCK Kleve 1615-1660 Amsterdam

According to Houbraken he was, as a fourteen year old, a pupil of Lambert Jacobsz. in Friesland and later went with Jacob Backer to Amsterdam where he studied with Rembrandt (q.v.) about 1633. He remained in Amsterdam for the rest of his life where he was successful as a portraitist and received many public commissions for portraits as well as historical subjects. His earliest dated work is of 1636. His earliest works are very much in the style of Rembrandt. Later he took up the example of Bartholomeus van der Helst (q.v.) and from the early 1640's devoted most of his work to portraiture and became one of the leading painters in Amsterdam.

64 Bathsheba's appeal (Fig. 56).

Oil on canvas, 105.5 × 152.6 cms. (41½ × 60 ins.).

SIGNED AND DATED: bottom right, *G. Flinck F 1651.* (Fig. 242).

CONDITION: numerous areas of paint loss in the centre and along the lower and right hand edges. Cleaned, lined and restored in 1968.

PROVENANCE: M. Anthony, London, from whom purchased, 1867, (price unknown).

LITERATURE: Armstrong 1890, p. 286; Hofstede de Groot 1916, p. 99; Isarlov 1936, p. 34; von Moltke 1965, no. 29, p. 70; Sumowski 1979-, vol. 4, p. 2081; Sumowski 1983-, vol. 2, no. 633, p. 1025.

The subject is from *I Kings,* ch. 1, vs. 15-17 and vs. 28-30. Bathsheba appeals to the old King David that her son Solomon shall reign after him. Abishag the Shunammite holds the crown and sceptre; in the background, Nathan the prophet. The subject is relatively rare in painting.[1] Among the Rembrandt circle it was treated by de Poorter[2] and Aert de Gelder.[3] The composition of no. 64 relates in a general way to any number of pictures and drawings by Rembrandt and his school, for example, no. 47 by Bol in this catalogue. The basic type of blessing scene is most frequently associated with the subject of *Isaac blessing Jacob,* and the type of composition depends on three figures generally shown at a bedside.[4]

No. 64 was purchased as Flinck and so catalogued by Doyle. Although excluded from the Gallery catalogues from 1904 until 1971 it was at some stage during that time attributed to Bol.[5] It is accepted as Flinck by von Moltke[6] and Sumowski[7] who has attributed a drawing of the same subject to Flinck.[8] He draws attention to the fact that the figure and headdress of Bathsheba are 'generally reminiscent' in both painting and drawing.

1. See Pigler 1974, vol. 1 p. 161.
2. The painting by de Poorter was formerly in the Staatliche Gemäldegalerie, Dresden where it was called *Esther before Ahasuerus* (1930 catalogue, no. 1389); it is not included in *Dresden, Gemäldegalerie, cat. 1982,* and is presumably, therefore, destroyed.
3. Coll. E. Haat-Escher, Zurich, 1983. Repr. Sumowski 1983-, vol. 2, p. 1210.

4. For the subject in general see Paris 1970-71, under no. 225, p. 233.
5. Note in the manuscript catalogue of the Gallery.
6. von Moltke 1965, no. 29 p. 70.
7. Sumowski 1983-, no. 633 p. 1025.
8. The drawing is in Munich, Graphische Sammlung inv. no. 1394 and is repr. Sumowski 1979-, vol. 4, p. 2081.

254 **Head of an old man** (Fig. 57).

Oil on panel, 64 × 47.4 cms. (25³⁄₁₆ × 18⅝ ins.).

SIGNED: top left, indistinctly: *G F.*

INSCRIBED: bottom right, with inventory no. ?350.

REVERSE: collector's seal. (Fig. 286).

CONDITION: good. Cleaned in 1972.

PROVENANCE: Joseph Sandars sale, Christie's, 5 June 1886, lot 73, where purchased for 30 guineas.

EXHIBITED: 1965, *Govert Flinck, der Kleefsche Apelles, 1616-1660*, Städtisches Museum Haus Koekkoek, Kleve, no. 22.

LITERATURE: Armstrong 1890, p. 286; von Moltke 1965, p. 25 and no. 177, p. 102; Sumowski 1979-, vol. 3, p. 1600; Amsterdam/Groningen 1983, p. 160; Sumowski 1983-, vol. 2, no. 676, p. 1034.

ETCHING: by G. F. Smidt, 1772;[1] copy of that by Fr. Brauer, 1800.[2]

No. 254 was etched in 1772 as *'Bust of a man with beret, cloak and necklace'* and sold in 1886 as *'Head of a man in black cap and gold chain'*. It was accessioned at the Gallery as *Head of a rabbi* and first catalogued in 1890 by Doyle as *Head of a Jewish rabbi*. It was so called by Armstrong,[3] who also identified the model as one and the same as that of David in Flinck's *Bathsheba's appeal*, no. 64 in this Catalogue. There is little that is unusual in the costume portrayed. The inclusion of chains in portrait studies at the time was fairly commonplace and did not reflect the social status of the subject. No such chain was ever awarded to Rembrandt as an honour but that did not preclude his including chains in several of his self-portraits. Rather it was used by him, as it was by Flinck, as a dress accessory for the purpose of the painting.[4] The beret is also usual; the cloak may be a tallith; but there is no certain means of identifying the subject as either a Jew or a rabbi.

Flinck had been a pupil of Rembrandt from 1632-36 and von Moltke[5] points out that no. 254 was influenced in colour, the type portrayed and in details by the work of Rembrandt. In this context one might draw a comparison with Rembrandt's *Man in oriental costume* of 1633[6] or *Uzziah struck by leprosy* of 1635.[7] Rembrandt continued the type long after Flinck left his studio and his *Old man in rich costume*[8] is about contemporary with no. 254 with which it compares.

A somewhat similar composition to no. 254 is a *Bust of a man wearing a beret* in a private collection which was for long attributed to Rembrandt but is now accepted as Flinck and dated about contemporary with no. 254.[9] On the basis of a comparison with no. 254 von Moltke has attributed a drawing in Warsaw[10] of a *Scholar in his study* to Flinck and dates the drawing about 1642/45. Sumowski[11] however does not accept the similarity of the painting to the drawing and attributes the latter to van den Eeckhout.

The etching of no. 254 dated 1772 is inscribed *G. Flinck p. 1642* and von Moltke accepts 1642 as a correct approximate date for no. 254.[12]

1. Hollstein 1949-, vol. 6, no. 44 p. 248.
2. Repr. von Moltke 1965, p. 103.
3. Armstrong 1890, p. 286.
4. See Held 1969, pp. 35-37.

5. von Moltke 1965, p. 25.
6. Alte Pinakothek, Munich, inv. no. 421. Repr. Gerson 1969, p. 152.
7. Coll. Duke of Devonshire, Chatsworth. Repr.

Gerson 1969, p. 512.
8. Coll. Duke of Bedford, Woburn Abbey. Repr. Gerson 1969, p. 181.
9. Repr. von Moltke 1965, p. 103. The comparison with no. 254 is referred to in Amsterdam/Groningen 1983, p. 160 where the painting is referred to as bearing a striking

resemblance to no. 254.
10. University Library, Warsaw (Potocki Collection) inv. no. T1115.N.13. Repr. von Moltke 1965, p. 185.
11. Sumowski 1979-, vol. 3, p. 1600.
12. von Moltke 1965, no. 177, p. 102.

319 Portrait of a young man (Fig. 58).

Oil on oval panel, 68 × 52.6 cms. (26¾ × 20¾ ins.).

REVERSE: the label of the R.A. Winter Exhibition 1899 (see 'Exhibited' below).

CONDITION: the support consists of two members joined on a vertical 33 cms. from the left edge. The join is strengthened by a baton. The paint surface is in good condition. Discoloured varnish.

PROVENANCE: Antony Dansaert of Brussels, from whom purchased, 1890, for £880.[1]

EXHIBITED: 1882, *Exposition néerlandaise de Beaux-Arts*, Brussels, no. 303; 1899, *Old Masters*, Royal Academy, London, no. 88.

LITERATURE: Dutuit 1883-85, no. 359, p. 50; Bode 1883, no. 25, p. 560; von Wurzbach 1886, no. 5; Michel 1893, p. 555; Michel 1894, vol. 2, pp. 233-34; Bode, Hofstede de Groot 1897-1906, no. 102, pp. 84-85; Duncan 1906-07, pp. 15-16; Rosenberg 1906, p. 80; Valentiner 1909, p. 195; Hofstede de Groot 1908-27, vol. 6, no. 737, pp. 346-47; Bredius 1935, no. 198, p. 9; von Moltke 1965, no. 254, p. 118; Bauch 1966, p. 47; Gerson 1969, p. 159, and no. 198, p. 564; Sumowski 1983-, vol. 2, no. 689, p. 1037.

The recent history of no. 319 originates from the time when, in 1882, it was exhibited as Rembrandt, *Portrait of a man* at Brussels.[2] Bode[3] referred to it as a portrait of J.-A. (Jean Antonides) van der Linden. It was later identified as Louis van der Linden.[4]

No. 319 was universally accepted as a Rembrandt until von Moltke published it as Flinck in 1965. This attribution has gained general acceptance, for example, by Bauch[5] and by Gerson,[6] who accepts it as Flinck but refers to it as not one of Flinck's most inspired works. Sumowski[7] also accepts the attribution to Flinck and dates the painting to the end of the 1630's.

The support may have been cut down. Doyle's opinion was that 'from signs on the back of the panel there can be little doubt but that it had originally been square, and had been cut to suit the frame (which was an oval at the time the picture was purchased), in which case the signature had probably been cut away'.[8]

1. G. Dansaert, *Courte Notice au sujet de deux portraits peints par Rembrandt* (Brussels, n.d.), who identified the sitter as Louis van der Linden, gives the information that the painting passed from Louis van der Linden to his son, Pierre van der Linden (1667-1733). Thence to the latter's daughter, Catherine Gheude (1699-1766); thence to her son, Jean-Dominique Gheude (1743-1801); thence to his cousin Anne-Louise Snagels (1799-1883) who married secondly Charles Dansaert (1795-1849) father of the vendor.
2. See 'Exhibited' above.
3. Bode 1883, p. 560.

4. By Dansaert (see n.1 above) whose provenance and identification of the sitter is most probably apocryphal. Louis van der Linden was a member of a Pays Bas meridionaux family which had nothing to do with the Dutch milieu of Rembrandt. Information from Dr. Henry Pauwels of the Musée Royaux des Beaux Arts, Brussels in a letter dated 21 June 1983 now in the archive of the Gallery.
5. Bauch 1966, p. 47.
6. In his revised edition of Bredius 1935, Gerson 1969, p. 564.
7. Sumowski 1983-, vol. 2, no. 689, p. 1037.
8. Quoted by Duncan 1906-07, pp. 15-16.

BAREND GAEL Haarlem c.1630-after 1681 ? Amsterdam

He was born in Haarlem, the son of the painter Cornelis Gael I, who was also his first teacher. He was also a pupil of Philips Wouwerman (q.v.) and he painted the figures in the landscapes of Jan Wijnants (q.v.). He worked in Haarlem but moved to Amsterdam possibly about 1660. His date of death is unknown. He painted many village views with such subjects as figures before an inn or market scenes and these show the influence of Wouwerman. In his landscapes the influence of Klaes Molenaer (q.v.) and Roelof van Vries (q.v.) is also evident. In his painting of figures he was influenced by Isack and Adriaen van Ostade (q.v.).

325 Landscape with figures (Fig. 59).

Oil on panel, 25.7 × 34.5 cms. (10 × 13⅜ ins.).

SIGNED: bottom right *.B. Gael*

REVERSE: *ms.* label 14260.

CONDITION: good. Thin in the area of the clouds and worn in the trees. Cleaned in 1968.

PROVENANCE: H. J. Pfungst of London, by whom presented, 1893.

The composition of no. 325 is fairly typical of Gael and the attribution need not be doubted. It compares with similar pictures formerly in the collection of Dr. van Aalst, Hoevelaken and in the Dr. Walcher sale, Cologne, 16 November 1909, lot 42.[1]

1. Photographs of both pictures are in the RKD.

JAN VAN GOYEN Leiden 1596-1656 The Hague

He was born on 13 January 1596 in Leiden. From the age of ten he was a pupil of Coenraet Adriaensz. van Schilperoort, Isaac Nicolas van Swanenburgh, Jan Arentsz. de Man and of the glass-painter, Hendrick Clock, all in Leiden; and then of Willem Gerritsz. in Hoorn. After a visit to France in 1615-16, he went to Haarlem where he studied under the pioneering landscape painter, Esaias van de Velde. On 5 August 1618 van Goyen married in Leiden. In 1632 he settled in The Hague where he obtained citizenship in March 1634. He was a hoofdman *in the Guild of St. Luke in The Hague in 1638 and 1640. His daughter married the painter Jan Steen (q.v.) in 1649. Throughout his life he had financial difficulties and apart from being a painter was also a dealer in pictures. He died on 27 April 1656. With Salomon van Ruysdael (q.v.) he may be considered the most important landscape painter in Holland in the first half of the seventeenth century.*

236 A view of a town in Holland (Fig. 60).

Oil on panel, 36.6 × 33.6 cms. (14⅛ × 13½ ins.).

SIGNED AND DATED: bottom right *VG 1650* (VG in monogram).

CONDITION: good. Discoloured varnish.

PROVENANCE: 'Property of a Foreign Nobleman' sale, Robinson and Fisher, London, 29 April 1875, lot 101, where purchased for £29.

EXHIBITED: 1960, *Jan van Goyen*, Stedelijk Museum 'De Lakenhal', Leiden and Gemeentemuseum, Arnhem, no. 39.

LITERATURE: Hofstede de Groot 1908-27, vol. 8, no. 817, p. 207; Dobrzycka 1966, no. 209, p. 119; Beck 1972-73, vol. 2, no. 185, p. 91.

ENGRAVING: said in the 1875 sale catalogue to have been engraved.

The town has not been identified and may indeed be imaginary. It seems not to be similar to any other views by van Goyen. Beck[1] suggests that the support may have been cut down.

1. Beck 1972-73, vol. 2, p. 91.

807 A view of Rhenen-on-the-Rhine (Fig. 61).

Oil on panel, 64 × 94 cms. (25⅛ × 37 ins.).

SIGNED AND DATED: on the ferry in the foreground, *VG* (in monogram) *1644*.

CONDITION: good. There are cracks in the support from left to right about 20 cms. from the top and along the horizon from the left edge of the tower. Cleaned in 1981.

PROVENANCE: Arthur Maitland Wilson of Stowlangtoft Hall; Stowlangtoft Hall sale, Christie's, 3 April 1914, lot 44, bt. Martin (probably on behalf of Sir Hugh Lane); Sir Hugh Lane, by whom bequeathed, 1915, and received in the Gallery, 1918.

EXHIBITED: 1918, *Pictures by Old Masters given and bequeathed to the National Gallery of Ireland by the Late Sir Hugh Lane*, National Gallery of Ireland, Dublin, no. 56.

LITERATURE: Hofstede de Groot 1908-27, vol. 8, no. 228, p. 65; Dobrzycka 1966, no. 143, p. 108; Beck 1972-73, vol. 2, no. 382, p. 186; Potterton 1982, p. 106.

On accession no. 807 was registered in the Gallery as a view of Rhenen-on-the-Ems, a title it retained until the 1981 catalogue. The view in fact is of Rhenen-on-the-Rhine and Hofstede de Groot[1] had in fact identified it as such. In the centre is the St. Cunera tower and, in front of it, the Winter Palace of the King of Bohemia: the former still stands, the latter was destroyed in 1812. Rhenen-on-the-Rhine is situated about twenty miles south east of Utrecht in the Province of Utrecht. van Goyen painted views of Rhenen-on-the-Rhine over a period from at least 1636 until 1655:[2] pictures in the Louvre[3] and Hamburg[4] are close in composition to no. 807.

1. Hofstede de Groot 1908-27, vol. 8, p. 65.
2. See Beck 1972-73, vol. 1, p. 71 and vol. 2, pp. 182-94.
3. Inv. no. RF 1961-86. Repr. *Paris, Louvre,*
cat. 1979, p. 65.
4. Kunsthalle inv. no. 547. Repr. Beck 1972-73, vol. 2, p. 193.

JAN GRIFFIER Amsterdam c.1645-1718 London

His date of birth is uncertain. He was a pupil of Roelant Roghman in Amsterdam. About 1667 he went to England where he married and also studied with Jan Looten. He painted views of London. About 1695 he returned to Holland for a period of about ten years. He is recorded in Rotterdam but he also travelled throughout Holland on a barge. On his return to London he lived at Millbank and after his death in 1718 his pictures were auctioned. Apart from topographical paintings he also painted Italianate landscapes with ruins; but he is best known for his paintings of landscapes on the Rhine and Moselle in the manner of Herman Saftleven whom he knew in Rotterdam.

336 A river landscape (Fig. 62).

Oil on panel, 50.1 × 64.5 cms. (19¾ × 25⅛ ins.).

SIGNED: bottom left, *J. Griffier* (Fig. 243).

REVERSE: two collector's seals (one indecipherable) (Fig. 287).

CONDITION: basically in good condition although worn badly in places throughout. There are three small paint losses along the bottom, left, right and centre. Cleaned in 1984.

PROVENANCE: Redcliffe of Pall Mall, London, from whom purchased, 1864, for £28 10s.

The landscape is imaginary although intended to convey the scenery of the Moselle with vines growing on the hill on the left; and on the right a barge laden with wine casks. Small towns are shown in the hills in the middle distance.

No. 336 is a very typical work by the artist.

NICOLAES DE GYSELAER Dordrecht 1583-before 1659 ? Amsterdam

He is generally cited as having been born in Leiden about 1592 although the Rijksmuseum, Amsterdam gives Dordrecht in 1583. He became a member of the Guild of St. Luke in Utrecht in 1616 or 1617 and was married in Amsterdam in 1616. He is recorded in Utrecht in 1644 and 1654 and died sometime before 1659, probably in Amsterdam. He painted, exclusively, architectural interiors somewhat in the style of Bartholomeus van Bassen and his work is sometimes confused with Pieter Neeffs. There are very few signed works.

327 Interior with figures (Fig. 63).

Oil on panel, 36 × 56 cms. (13⅝ × 22⅛ ins.).

SIGNED: on the buffet-gast, right, *N D Giselaer F.* (Fig. 244).

CONDITION: very good. Cleaned in 1984.

PROVENANCE: S. T. Smith, Duke Street, London, from whom purchased, 1893, for £20.

EXHIBITED: 1985, *Masterpieces from the National Gallery of Ireland*, National Gallery, London, no. 30.
LITERATURE: Jantzen 1910, no. 160d, p. 162; Jantzen 1979, no. 160d, p. 224; London 1985, no. 30, p. 76.

The subject of the painting is not easily identifiable. Pictures by the artist, which are rare, depict exclusively such architectural interiors; and these are often peopled with Old Testament subjects such as *Joseph and Potiphar's Wife, Haman and Mordecai* and *David and Bathsheba.* In no. 327, whatever the exact subject matter may be, it seems likely that some contrast is intended between the principal pair of figures and the pair of figures in the background. The latter are seated at a table on which is placed bread and wine on a white napkin. It would be difficult not to find some religious significance in this detail and the couple themselves are notably sober in their appearance. Equally it is made clear that the other couple are advancing towards each other with amorous intent. de Gyselaer's style is not sufficiently well known for one to draw definite conclusions as to whether the meanings that may be attached to several of the details in the painting are intended. For example a dog is a well-known symbol of marital fidelity. The standing woman holds her left hand in a position that can also be interpreted as signifying fidelity in marriage: it is for example identical with the gesture of Giovanna Cenami in van Eyck's *Arnolfini marriage.*[1] On the right hand side of the composition, that is, on the same side as the bed, hangs a seascape; and seascapes can be shown in Dutch seventeenth-century paintings in order to suggest that love is as hazardous as a journey by sea; and in this context de Jongh[2] has drawn attention to verses by Jan Harmensz. Krul published in Amsterdam in 1640:[3] 'Love may rightly be compared with the sea, from the viewpoint of her changes, which one hour cause hope, the next fear: so too goes it with a lover, who like the skipper, who journeys to sea, one day encounters good weather, the next storms and roaring wind. . . .' The winged figures on the chimneypiece are cupids. The item of furniture on the extreme right is a *buffet-gast* which was usually placed in a dining room and used for storing and displaying silver and china.

The room shown in no. 327 is imaginary and there were no such interiors in seventeenth-century Holland. Somewhat similar rooms are found in other paintings by the artist, for example the painting signed and dated 1621 in the Fitzwilliam Museum, Cambridge;[4] and an *Interior with Joseph and Potiphar's wife*[5] shows a very similar room indeed. In painting his pictures, de Gyselaer like other architectural painters such as Pieter Neeffs, Sebastian Vrancx, Anton Gheringh and van Bassen, probably looked at the architectural pattern books of Hans Vredeman de Vries and others.[6] In no. 327 the room could be inspired in a general way by some of the plates in Hans Vredeman de Vries's *Scenographiae, sive Perspectivae* of 1560; while the detail of the chimneypiece could have an Italian source in Serlio's *Architettura*, Book IV. There may be some case for considering that the figures in no. 327 were painted by Cornelis van Poelenburgh.[7]

No. 327 compares stylistically with a signed and dated *Joseph and Potiphar's wife* of 1625,[8] and may be dated to about that time.

1. National Gallery, London, cat. no. 186. Repr. *London, National Gallery, cat. 1973*, p. 219.
2. de Jongh 1967, p. 52.
3. J. M. Krul, *Minnebeelden: Tot-gepast de*

lievende jonckheyt (Amsterdam 1640) quoted by de Jongh 1967, p. 52 and quoted in the following English translation by Sutton in Philadelphia/Berlin/London 1984, p. 207.

4. Cat. no. 422. Repr. *Cambridge, Fitzwilliam, cat. 1960*, pl. 29.
5. Sold Sotheby's, 12 April 1978, lot 19.
6. Hans Vredeman de Vries's *D'Architectura et Perspectiva* was published in 1581, a Dutch edition was published in 1604. The same author's *Variae Architcturae Formae* was published in 1601; and his *Scenographiae, sive Prospetivae* in 1560. Another widely known

architectural pattern book in the north of Europe was Sebastiano Serlio's *Architettura* the fourth book of which was published by Pieter Coecke van Aelst in Antwerp as early as 1539.
7. The mount of the photograph of no. 327 in the RKD is inscribed 'figures by Poelenburgh'.
8. Sold at Sotheby's, New York, 12 June 1975, lot 96.

DIRCK HALS Haarlem 1591-1656 Haarlem

He was baptised in Haarlem on 19 March 1591 and was the younger brother of Frans Hals (q.v.): his parents had emigrated from Antwerp sometime between 1585 and the year of Dirck's birth. According to Houbraken he studied with his brother who was about nine or ten years his senior. Between 1621 and 1635 he and his wife had seven children. He is recorded in Leiden in 1641-42 and again in 1648-49 and may have lived there during the entire decade of the 1640's. He died in Haarlem and was buried on 17 May 1656. He was a painter of genre scenes and figures, particularly merry-companies.

DIRCK HALS and DIRCK VAN DELEN

119 An interior with ladies and cavaliers (Fig. 42).
(See under Dirck van Delen and Dirck Hals, pp. 32-33).

FRANS HALS Probably Antwerp c.1580/83-1666 Haarlem

His date and place of birth are unknown but his parents are recorded in Antwerp until 1585, when, like other residents of the city they probably emigrated after the Spanish occupation. They were in Haarlem by 1591 when his brother, Dirck (q.v.) was born. He was a pupil of Carel van Mander. He joined the Guild of St. Luke in Haarlem in 1610. The date of his first marriage is not known, but he had a son born in 1611 and was married a second time in 1617. When his first wife died in 1615 she was buried in a pauper's grave, indicating that the artist was not successful by this time. Only from about 1620 did Hals begin to become well known in Haarlem. His pupils, according to Houbraken, included his brother Dirck, Adriaen van Ostade (q.v.), Philips Wouwerman (q.v.) and Adriaen Brouwer (q.v.). Although he received a number of important commissions throughout his life, Hals was frequently, if not always, in financial difficulties. He died on 29 August 1666.

Ascribed to FRANS HALS

193 A fisherboy (Fig. 64).

Oil on canvas, 74.1 × 60 cms. (29¼ × 23⅜ ins.).

SIGNED: bottom left, *F H* (in monogram).

REVERSE: three seals, one inscribed *Peintre Export ?-roy*; the other two indecipherable.

CONDITION: good, although the background is strengthened. The paint surface gives the impression that the process of lining was too severe.

PROVENANCE: John W. Wilson, Brussels by 1873; his sale, Paris, 14-16 March 1881, lot 60, where purchased for £400.

EXHIBITED: 1873, *Collection de M. John W. Wilson*, Galerie du Cercle Artistique et Litteraire, Brussels; 1937, *Frans Hals: Tentoonstelling ter gelegenheid van het 75-jarig bestaan van het Gemeente-lijk Museum te Haarlem op 30 Juni 1937*, Frans Halsmuseum, Haarlem, no. 49; 1952-53, *Dutch Pictures 1450-1750*, Royal Academy, London, no. 86.

LITERATURE: Tardieu 1873, pp. 218-19; Bode 1883, no. 68, p. 85; Armstrong 1890, p. 283; Duncan 1906-07, pp. 16-17; Hofstede de Groot 1908-27, vol. 3, no. 51, p. 16; Moes 1909, no. 255, p. 111; Bode, Binder 1914, vol. 1, no. 77, p. 32; Valentiner 1921, pp. 111 and 313; Hofstede de Groot 1922, p. 533; Dülberg 1930, p. 126; van Dantzig 1937, no. 91, p. 101; Antwerp, cat. 1958, p. 102; Slive 1970-74, vol. 1, p. 143 and vol. 3, no. 73, p. 44; Grimm, Montagni 1974, no. 321, p. 118; Koslow 1975, n.87, p. 432; Gerson 1976, pp. 423-24.

ENGRAVING: by Paul le Rat, 1881.[1]

No. 193 is sometimes referred to as *A young fisherboy of Scheveningen:* Scheveningen being a coastal resort on the North Sea some two to three miles from The Hague. The motif of fisherchildren in paintings, as Slive[2] has pointed out can be related to earlier Dutch prints showing various occupations. Fisherchildren were also used in allegorical paintings depicting the Four Elements: a fisherboy personifying Water. Slive[3] has also quoted Held's view that some contemporary Dutchmen also probably found a didactic meaning in such paintings. For example, Jacob Cats may have looked upon Hals's pictures of fisherchildren as reminders of the virtues of natural life over town life: Cats's poem, published in 1655, *Op de Gelegentheyt van een Scheveninghs vroutje dat een venne met visch op haer hooft draeght* (On the situation of a young woman of Scheveningen who carries a basket of fish on her head), proclaims that life and work at the seashore, where one can live happy and free, is preferable to the pomp of town life, and the poem is illustrated by an engraving of a fishergirl of Scheveningen. Koslow,[4] by referring to the Antwerp *Fisherboy*, sees the fisherfolk pictures as exemplars of idleness.

No. 119, which was first published in 1873,[5] is one of a group of pictures showing fisherboys or girls in half-length against a background of sand dunes and sea that are attributed to Hals, and of a type believed to have been invented by him.[6] Slive[7] has drawn attention to the fact that paintings of fisherfolk were also made by Hals's close followers and that as a result of this some pictures of the type, at one time ascribed to Hals, need not necessarily be by him. Trivas[8] rejects all of these pictures from the *oeuvre* of Hals. Grimm[9] also rejects them and indicates that they were painted by a single painter whom he calls the Master of the Fisherchildren. Slive[10] rejects a number of fisherfolk pictures from Hals's oeuvre but points out that, in his view, all of these paintings

cannot be assigned to a single artist who could be called the Master of the Fisherfolk. In this context it is perhaps worth mentioning the fact that there seems to be no mention of Fisherfolk pictures in any of the early documents[11] or biographies[12] concerning Hals. Gerson,[13] while accepting some of the fisherfolk pictures, rejects no. 193. No. 193 is here catalogued as 'Ascribed to Frans Hals'. The compiler, while deferring to the authority of Slive in the matter, has reservations about the autograph status of the picture which seems, in places, crudely painted and lacking in the brio which one associates with the master.

Slive[14] has drawn attention to a painting by Jan Molenaer (q.v.) of a *Beach scene with fisherfolk*[15] which includes a fisherboy (shown in full-length) who is clearly derived from the figure in no. 193.

No. 193 was dated by Bode to c.1620[16] and by Valentiner to 1633-35.[17] The group of fisherfolk pictures is now generally held to have been painted about 1630 or at least in the early 1630's. Slive[18] gives 1630 and compares no. 193 stylistically with a *Fruit and vegetable seller*[19] that is dated 1630 and places it in a group with two other pictures.[20]

1. Published in the John W. Wilson sale catalogue, (Paris 1881) p. 57.
2. Slive 1970-74, vol. 1, p. 105.
3. *Ibid.* vol. 1, p. 144.
4. Koslow 1975, *passim*. She refers specifically to the *Fisherboy* in the Musée Royale des Beaux-Arts, Antwerp, inv. no. 188 which has, incorrectly, been referred to (*Antwerp, cat. 1958*, p. 102) as a version of no. 193.
5. Tardieu 1873, pp. 218-19.
6. Slive 1970-74, vol. 1, p. 105. Koslow 1975, p. 432, points out that before Hals, Jan Porcellis depicted the life of fisherfolk in drawings and prints; and that these popularised the theme of fisherfolk among artists.
7. Slive 1970-74, vol. 1, p. 106.
8. Trivas 1941. Trivas's method of selection for inclusion in his book, as explained in his introduction, was, to say the least, idiosyncratic. He excluded 'genuine but badly damaged and restored works by Frans Hals; works executed by Hals in collaboration with other artists . . . a few works which probably are genuine but which I had not the opportunity to re-examine'. He does not explain

his reasons for excluding specific works but by referring to a projected publication of a catalogue of posthumous 'Fisherboys', implies that he believed that no. 193 and similar works were posthumous.
9. Grimm 1971, pp. 175ff., and Grimm 1972, p. 214.
10. Slive 1970-74, vol. 3, pp. 132-33.
11. Given in full in Grimm, Montagni 1974, pp. 83-84.
12. *Ibid.*, pp. 11-12.
13. Gerson 1976, pp. 423-24.
14. Slive 1970-74, vol. 1, p. 143.
15. Location unknown. Repr. Slive 1970-74, vol. 1, fig. 144, p. 142.
16. Bode 1883, no. 68, p. 85.
17. Valentiner 1921, p. 111.
18. Slive 1970-74, vol. 1, p. 143.
19. Coll. Viscount Boyne, Bridgnorth, Shropshire, repr. Slive 1970-74, vol. 2, pls. 112 and 113.
20. The *Fisherboy* in Antwerp, see n.4 above and a *Fishergirl* formerly in the Brooklyn Museum, repr. Slive 1970-74, vol. 2, pls. 115, 116.

JACOB GERRITSZ. VAN HASSELT Utrecht 1597-c.1674 Utrecht

He was born about 1597 or 1598 in Utrecht, the son of a decorative painter, Gerrit Jacobsz. van Hasselt. He is mentioned as a Master in the Guild of St. Luke in Utrecht in the years 1616-17. He married Anna Dareth of Utrecht and by her had three children between 1641

and 1643. He died about 1674. A painting of A marriage feast *showing the members of his own family, signed and dated 1636, is in the Centraal Museum, Utrecht. In 1638 he presented a painting* The unbelieving centurion who came to Christ *to the St. John's Hospital at Utrecht. Wurzbach (1906-11) refers to a landscape painter of this name mentioned at Utrecht about 1638 and 1643 who is said to have worked in Rome; although there is no reference to a painter of this name in the published lists of Dutch painters in Rome (Hoogewerff 1952).*

897 View from the bishop's throne, west from the nave, towards the staircase tower in Utrecht Cathedral (Fig. 65).

Oil on panel, 54.6 × 38.4 cms. (21½ × 15⅛ ins.).

SIGNED AND DATED: on the cartouche, left, *J (?G) V Hasse(lt) A° 1659* (Fig. 245).

INSCRIBED: above the doorway, *Si quid cum. . . . qu*
 Tecum qu (the remainder indecipherable).

REVERSE: the catalogue entry from the Foucart sale (see 'Provenance' below) is attached to the back of the support.

CONDITION: the support consists of two members joined on a vertical leading from points 14 cms. from the left (top) to 16.6 cms. from the left (bottom). The paint surface is in good condition. There are some paint losses along the join. Abraded in the area of the left leg of the man. Cleaned in 1984.

PROVENANCE: Alexandre Dumont sale, Cambrai, 30 September 1878, lot 74; Malherbe sale, Valenciennes, 17-18 October 1883, lot 78; Foucart sale, Valenciennes, 12 October 1898, lot 116; H. Pfungst, London, 1912; Durlacher, London, 1921; L(ippmann) de Londres sale, Muller, Amsterdam, 27 October 1927, lot 5, where purchased by Durlacher on behalf of the Gallery for £202 8s. 6d.

EXHIBITED: 1912, Rijksmuseum, Amsterdam (on loan from H. Pfungst); 1985, *Masterpieces from the National Gallery of Ireland,* National Gallery, London, no. 32.

LITERATURE: Borenius 1921, p. 143; Swillens 1946, p. 133; London 1985, no. 32, p. 80.

The subject of the picture was incorrectly identified in the Dumont and Foucart sales catalogues as a beggar seated at the door of the Hospice of the Cloister St. Agatha at Delft. Borenius[1] referred to it as a Roman beggar seated outside the vaulted gate of a building. Its true subject was identified by Swillens[2] as a *View from the Bishop's throne, west from the nave, towards the staircase tower in Utrecht Cathedral.* While this is indeed the view represented it seems likely that the picture has some further meaning and the positioning of the lady on the staircase may be relevant. A somewhat similar composition is the painting attributed to Egbert van der Poel in the Rijksmuseum, Amsterdam[3] which shows a man descending the stairway tower of the Prinsenhof in Delft; and that picture represents the moment before the assassination of William the Silent. The inscription over the doorway is largely indecipherable. If understood it is probable that it would explain the meaning of the picture.

The picture was attributed to Vermeer in the Dumont Sale catalogue of 1878; to J. C. van Desselt *(sic)* in the Malherbe sale of 1883; and in the Foucart Sale of 1898 it was said to be signed on the cartouche *V. de M., Delft fecit a° 1659.* (i.e. Vermeer). van Hasselt's signature was uncovered by the time the painting was lent to the Rijksmuseum,

Amsterdam in 1912. It was there shown as van Hasselt, and so attributed ever since, although erroneously catalogued at the Gallery as Izaak van Hasselt.

1. Borenius 1921, fig. B, p. 143.
2. Swillens 1946, p. 136.

3. Inv. no. A117. Repr. *Amsterdam, Rijksmuseum, cat. 1976*, p. 448.

CLAES (NICOLAAS) JACOBSZ. VAN DER HECK
? Alkmaar 1575/81-1652 Alkmaar

His date and place of birth are unknown. He is referred to in Alkmaar in 1617 and 1641 and became a member of the Guild of St. Luke there in 1635. According to van Mander he was a pupil of Jan Nagel (d.1616).

904 A winter landscape (Fig. 66).

Oil on panel, 20.5 × 96.7 cms. (52 × 34⅛ ins.).

SIGNED: bottom left, *C. Heck fecit*

CONDITION: the support consists of two members joined on a horizontal 26.7 cms. from the top. The join has been repaired by a balsa wood insert of fairly recent date. A split in the support about 20 cms. long in the centre 3.5 cms from the top has been similarly repaired. The paint surface is in good condition. Retouching along the join. Small damage in the sky, top right. Cleaned in 1970.

PROVENANCE: C. Parker Cussen of Dublin, from whom purchased, 1928, for £100.

The view is possibly real and there could be some case for suggesting that the castle on the right may be Egmond-aan-den-Hof. van der Heck painted Egmond in a picture now in the Rijksmuseum, Amsterdam;[1] and that castle, as depicted by him, is not dissimilar to castles in two other paintings by the artist.[2]

One of those pictures, formerly in Paris, (Fig. 210) is almost a version of no. 904 although the castles as shown in both pictures are only vaguely similar one to another; but the composition of both pictures is related and there are many similarities in staffage. The castle on the right, similarly positioned in both pictures, is similar in mass although different in detail; the town in the middle distance and the windmill are substantially the same in both pictures; but on the hill to the left of the Paris painting there is a church. Of the figures, the man cutting wood on the left, the woman feeding children in the centre and the group of four people with a dog to the right of centre are repeated in both pictures. Some other minor figures are also repeated in both pictures.

In view of the picture's similarity to the Paris painting discussed above, which is dated 1632, a date of about that time may also be suggested for no. 904.

1. Inv. no. A990. Repr. *Amsterdam, Rijksmuseum, cat. 1976*, p. 262.
2. One with the dealer C. Benedict in Paris in 1938, signed and dated *C Heck fecit 1632*, a

photograph of the painting is in the archive of the Gallery; the other picture was in the H. Petri of Anvers sale, Amsterdam, 30 November 1926, lot 65.

WILLEM CLAESZ. HEDA 1593/94-1680/82 Haarlem

His place of birth is not known. In 1631 he was active in the reorganisation of the Guild of St. Luke in Haarlem. He was a hoofdman in the Guild in 1637, 1643 and 1651 and Dean in 1644 and 1652. His son Gerrit Willemsz. was a close imitator. With the exception of a few portraits and figure paintings, his production consisted entirely of still-life of which he was the leading painter in Haarlem of his time.

514 A banquet-piece (Fig. 67).

Oil on panel, 55.3 × 73.8 cms. (21¾ × 29¹⁄₁₆ ins.).

CONDITION: good. Worn in the areas of the flagon and the vessels on the right.

PROVENANCE: Sir Henry Page Turner Barron, by whom bequeathed, 1901.

The painting is of a type known by the generic term banquet-piece *(banketje)* or, more specifically, a monochrome banquet-piece in which food and serving vessels are shown on a table. They are from left to right: pewter plates, a flute glass, a (?) pewter flagon, a Berkemeyer, a (?) pewter mustard pot and spoon. Verbeek[1] has made the following observations: 'the pewter plates are impossible to date and neither may their origin be stated precisely. The flute glass is made *à la façon de Venise* and similar glasses were either made in Holland or imported from Venice in the first half of the seventeenth century. The flagon, used for wine, is relatively commonplace and may have been imported from England although some were made in Holland. It too is pewter and is referred to as a Jan Steen, although known in the seventeenth century as a pijpkan because it had a long thin spout emerging from its base. The Berkemeyer and mustard pot are again commonplace'. While some eucharistic significance could have been seen by Heda's contemporaries on account of the inclusion of the broken bread and wine, Heda himself would not have specifically intended such an allusion.

No. 514 was bequeathed as Heda and always so catalogued at the Gallery. It has not otherwise been published. It would seem unreasonable to doubt the attribution and the painting may be compared with a signed and dated picture of 1635 by Heda in the Galerie Harrach, Vienna.[2] The overall composition of both paintings is similar as also are the components of ham, a white cloth and a knife on a plate that protrudes over the edge of the table. No. 514 may probably be dated to about the same time, i.e. 1635.

1. Of the Rijksmuseum, Amsterdam in a letter dated 2 October 1981 now in the archive of the Gallery.

2. Repr. Bergström 1983, fig. 111, p. 126.

JAN DAVIDSZ. DE HEEM Utrecht 1606-1683/84 Antwerp

He was the son and pupil of David de Heem the Elder and was born in Utrecht in 1606. In his early years he was apprenticed in Utrecht to Balthasar van der Ast. From 1625 he lived in Leiden where he married on 12 December 1626. In 1636 he removed to Antwerp where he was a member of the Guild of St. Luke and became a citizen in 1637. His wife died in 1643 and he then remarried. From 1658 he often travelled and he was a member of the Guild of St. Luke in Utrecht from 1669-72. With the invasion of Holland by the French in 1672, he returned to Antwerp where he remained until his death which was sometime between November 1683 and April 1684. His son by his first marriage, Cornelis de Heem, was a still-life painter; and his son by his second wife, Jan Jansz. de Heem II, was also a painter. Jan Davidsz. de Heem was one of the most important still-life painters in the seventeenth century and combined in his art the traditions of both Dutch and Flemish still-life.

11 A vanitas fruit-piece (Fig. 68).

Oil on canvas, 85.5 × 65 cms. (33½ × 25 ins.).

SIGNED AND DATED: on the ledge, *J de Heem f.a. 1653*. (Fig. 246).

CONDITION: the edges of the original canvas have been slightly trimmed. An old damage in the centre of the picture, otherwise in good condition. Cleaned in 1981.

PROVENANCE: Luke Descamps, Ghent, 1754[1] and thence by descent; Schamp d'Aveschoot sale, Regemorter, Ghent, 14 September 1840, lot 133; George Blamire sale, Christie's, 7-9 November 1863, lot 49, where purchased for 65 guineas.

LITERATURE: Descamps 1753-64, vol. 2, p. 40; Armstrong 1890, p. 283; Schneider 1923, p. 244; de Mirimonde 1970, p. 271.

No. 11 was described in the Schamp d'Aveschoot sale catalogue as follows: 'Rien de plus parfait, de plus vrai, de plus harmonieux en ce genre, n'est sorti du pinceau d'un artiste. On y admire surtout une belle intelligence de clair obscur, un coloris frais et suave, un arrangement plein de gout, une grande delicateuse dans les divers degrés de vegetation, et des reflets savemment combinés. Cette belle toile est citée dans *La Vie des Peintres* de Descamps, comme le Chef d'oeuvre du Mâitre'.

No. 11 is of a type, a garland or hanging bouquet of flowers and fruit, that de Heem painted throughout his time in Antwerp.[2] Examples in the Mauritshuis[3] and the Rijksmuseum, Amsterdam[4] show the bouquets suspended as in no. 11 by a blue ribbon; and Bergstrom[5] has pointed out that similar garlands were painted by Adriaen van Utrecht, and that de Heem was probably to some extent influenced by the latter. Bergström also takes the view that, while the hanging bouquets may seem at first sight to be de Heem's personal creation, their origin can be traced to the decorative style of Frans Floris. Bergström has pointed out that a flower-piece in the form of a hanging bouquet as in no. 11 generally means transience.[6] That this is certainly the intention in no. 11 is indicated by the presence of the skull, the most obvious of all *memento mori* symbols. de

Mirimonde[7] has described the symbolism of no. 11 as follows: 'fig — the Fall, the grape — Redemption, the pomegranate — the Church, which gathers the faithful as this fruit encloses its seeds, the plum — Fidelity. One butterfly is on the ill-omened fig, another on the raisin — image of the choice offered to the Spirit. On the left a glass of wine (sacred liquid of the Eucharist) and beside it a shell — Resurrection. On the right beside the skull on which a fly is always placed, is the cross of which a serpent (the devil) encircles, in vain, the base.' To this one might add that the theme of the painting is that man's salvation is through the Passion of Christ. The cycle of man's life is traced from his fall in Eden (the snake) through the exuberance of youth (the classical relief of cherubs) to his death (the skull). The cycle is echoed by the caterpillars, which become butterflies, symbolising the release of the soul from the body, and the corn which must be buried in the ground before it can spring to life again. The Passion of Christ is illustrated by the crucifix and recalled by the pomegranates which bleed from ripeness, and the single red flower. Man's salvation is through the bread and wine.

The date, incorrectly given in the 1981 Catalogue, reads 1653.

1. According to Descamps 1753-64, vol. 2, p. 40.
2. See Bergström 1956, p. 206.
3. Inv. no. 49. Repr. *The Hague, Mauritshuis, cat. 1977*, p. 108.
4. Inv. nos. A138 and A139. Repr. *Amsterdam, Rijksmuseum, cat. 1976*, p. 208.
5. *Op. cit.*, p. 208.
6. Bergström 1955, pp. 342 *et seq.*; and Bergström 1983, p. 214.
7. de Mirimonde 1970, p. 271.

Bartholomeus van der Helst Haarlem ?1613-1670 Amsterdam

He was the son of an innkeeper and was a native of Haarlem. His precise date of birth is unknown. He married in Amsterdam in 1636 where he is recorded continuously thereafter until his death in December 1670. He was, from about the middle of the 1640's, the most fashionable Dutch portrait painter of his day. Among the portraits which bear his signature, there is great variation in quality, indicating that he probably employed a large studio.

65 Portrait of a lady aged 54 (Fig. 69).

Oil on oval panel, 71.2 × 59.1 cms. (28$^{1}/_{16}$ × 23¼ ins.).

SIGNED, DATED AND INSCRIBED: left, *B. vander. helst 1647 A. tes.54* (Fig. 247).

CONDITION: the support consists of three members joined on verticals at 14 cms. and 45 cms. from the right. Paint surface in good condition.

PROVENANCE: William Brocas R.H.A., from whom purchased, 1866, for £80.

LITERATURE: Armstrong 1890, p. 286; Duncan 1906-07, p. 17; de Gelder 1921, p. 63 and no. 544, p. 209.

No. 65 was described in 1906 as 'remarkable for its careful finish and one of the best-known pictures in the collection'.[1] The date has always been misread as 1641, but it is

clearly 1647. de Gelder[2] in fact thought that 1641 was probably false and on the basis of style he placed the picture 1647.

1. Duncan 1906-07, p. 17. 2. de Gelder 1921, p. 63.

Studio of BARTHOLOMEUS VAN DER HELST

55 Portrait of a man (Fig. 70).

Oil on canvas, 101 × 81.8 cms. (39⅞ × 32⅛ ins.).

CONDITION: paint surface in fair condition. Discoloured varnish.

PROVENANCE: purchased in Paris in 1864 for £170.[1]

LITERATURE: Armstrong 1890, p. 286; de Gelder 1921, no. 193, p. 180.

No. 55 is said in previous catalogues to be signed and dated 1645 and the signature is reproduced in facsimile in the 1898 Catalogue. In its present condition no trace of a signature is visible. de Gelder[2] rejects the attribution to van der Helst. According to Hofstede de Groot, the painting was at one time attributed to Nicolaes Eliasz. or Jacob Backer.[3]

No. 55 is of poor quality although probably contemporary with van der Helst: it may be studio work.

1. The Minutes of the Gallery record that the then Director, Mulvany, travelled in London and Paris in the months of April, May and June 1864 and that no. 55 was purchased in Paris.

2. de Gelder 1921, p. 180.
3. His notes are quoted by de Gelder 1921, p. 180.

NICOLAES VAN HELT-STOCKADE Nijmegen 1614-1669 Amsterdam

He may have been a pupil of David Ryckaert. Sometime after 1635 he was in Rome where he became a member of De Bentvueghels and there took the name Stokade. From Italy he went to France. In 1645 he was in Lyons where he married Johanna Houwaart whose sister married the painter Jan Asselijn in the same year. In 1646/47 he became a member of the Guild of St. Luke in Antwerp. According to Houbraken he worked at the Court of Queen Christina in Sweden, but this is not substantiated. By 1652 he was in Amsterdam. At Amsterdam, through Artus Quellinus (whom he had met at Lyons) he took part in the decoration of the new Town Hall. In 1665 he painted canvasses for the Town Hall in Nijmegen, but continued to live in Amsterdam where he died.

1046 Jupiter and Ganymede (Fig. 71).

Oil on canvas, 119.5 × 113.8 cms. (47⅛ × 44⅞ ins.).

SIGNED: bottom left, *Stocade. F.*

CONDITION: the background is worn throughout and strengthened. Apart from a horizontal tear through the thigh of Jupiter, the figures are in good condition. Cleaned, lined and restored in 1970.

PROVENANCE: Pierce Higgins, by whom presented, 1940.

Ganymede, a shepherd boy and son of Tros, the legendary King of Troy, was of such beauty that Jupiter fell in love with him, and, in the guise of an eagle carried him off to Olympus where he made him his cup-bearer.[1] In no. 1046 Jupiter carries his attribute of a thunderbolt. While the subject enjoyed a certain popularity with Italian painters from the time of the Renaissance and with French painters in the seventeenth and eighteenth centuries, it was less well-known in seventeenth-century Holland, although Rembrandt's famous picture of 1635 in Dresden may be cited. While Samuel van Hoogstraten,[2] Rembrandt's pupil, considered the subject indecorous because of its homo-erotic overtones, the theme did have an alternative interpretation which was widely understood in Holland in the seventeenth century. Derived from an interpretation of Ovid as followed by van Mander,[3] it dwelled on the fact that it was the beauty and purity of Ganymede which pleased Jupiter and which made him eligible to serve the Gods; and as Ganymede was the only one of Jupiter's love objects to be taken up to Olympus, the theme did in fact represent the pure human soul being lifted up to God. As purity of soul is traditionally associated with young children, and as the Ganymede myth involves a young child being taken from its parents to attain a place with the gods, paintings of Ganymede assumed a meaning that was appropriate to the death of a young child.

It is Rembrandt's pupil Nicolaes Maes who is particularly associated with this type of painting, and there are at least six paintings[4] by him of the theme dating from the 1660's and 1670's; it had been specifically demonstrated that Maes's paintings are portraits of dead children.[5] While no. 1046 has a more pronounced homo-erotic sentiment than any of the pictures by Maes, it is still probably fairly certain that Ganymede in no. 1046 is a portrait of a child recently deceased; although Jupiter does not appear to be a portrait.

van Helt-Stockade's work is so varied that it is difficult to suggest a comparison with no. 1046. Mention might be made of a *Venus and Adonis* in Nijmegen[6] which shows Venus and Adonis entwined in a pose not dissimilar to the poses of Jupiter and Ganymede in no. 1046. The *Venus and Adonis* in style seems much less accomplished than no. 1046.

1. Ovid, *Metamorphoses* 10 : 155 ff.
2. Quoted from van Hoogstraten 1678, p. 94 in Amsterdam 1976, p. 132.
3. A Dutch translation of Ovid's *Metamorphoses* with moralising explanations formed the fifth part of van Mander's *Het Schilder-boeck* published in Haarlem, 1603-04. The theme of Ganymede in Dutch painting is treated by Russell 1977, *passim,* and it is from that source

that information given here is derived.
4. Five of these are listed by Russell 1977, p. 9; and a further painting was no. 53 in the exhibition, *Rembrandt: the Impact of a Genius,* the catalogue of which is here abbreviated as Amsterdam/Groningen 1983.
5. By Russell 1977, n.18, p. 9.
6. Stedelijk Museum, inv. no. 1973.02.2.

MEINDERT HOBBEMA Amsterdam 1638-1709 Amsterdam

He was baptised Meindert Lubbertsz. the son of Lubbert Meynertsz. in Amsterdam on 31 October 1638. He adopted the surname Hobbema for unknown reasons when he was a young man. According to a testimony of Jacob van Ruisdael (q.v.) in 1660, Hobbema had been his apprentice for some years; and as van Ruisdael only settled in Amsterdam in June 1657, the apprenticeship presumably took place between that date and 1668. In 1668 Hobbema was made one of the wine gaugers of the Amsterdam octroi and held this post until the end of his life. Although he trained with van Ruisdael, the latter's influence is not apparent until about 1662; before that his paintings, which are primarily river landscapes, suggest the influence of Cornelis Vroom. In his later works he developed as a master of the wooded landscape.

832 The ferry boat (Fig. 72).

Oil on panel, 27.1 × 31.4 cms. (10⅝ × 12⅜ ins.).

SIGNED: bottom right, *M hobbema*. (Fig. 248).

CONDITION: very good. There are additions of about 1 cm. wide attached to the top and bottom of the support. Cleaned in 1985.

PROVENANCE: Clos, Paris, 1792;[1] Villiers sale, Paris, 30 March 1812, bt. Le Brun;[2] J. B. P. Le Brun sale, Paris, 15 April 1812, lot 55; Duc d'Alberg sale, Christie's, London 13-14 June 1817, lot 32, bought in; Samuel Woodburn, 1835;[3] purchased from him by Mr. Labouchere (later Lord Taunton);[4] thence by descent to Capt. E. A. V. Stanley of Quantock, from whom purchased by Langton Douglas. Purchased from Langton Douglas, 1921, for £1,000.

LITERATURE: Le Brun 1792, vol. 1, p. 58; Smith 1829-42, Part 6, no. 835, p. 124; Blanc 1858, vol. 2, p. 289; Hofstede de Groot 1908-27, vol. 4, no. 275, p. 441; Broulhiet 1938, no. 459, p. 438.

ENGRAVING: by Weisbrod, 1792.[5]

Described by Smith[6] as a 'sparkling little picture of excellent quality', no. 832 was probably known to Hofstede de Groot only through the engraving: his description of it alternates left for right and *vice versa* throughout.[7] The painting was also known to Broulhiet[8] only through the engraving, but he refers to it as close to his no. 175 of which he reproduces an engraving. Any similarity between the two compositions is neither obvious nor apparent to the present writer. No. 832 is one of several similar compositions by Hobbema.[9] Of these, a slightly larger painting with Douwes, Amsterdam in 1938[10] is almost a replica. Broulhiet refers to that picture as a replica of his no. 456 (which it clearly is not).

No. 832 is probably an early work and may date from the late 1650's or early 1660's.

1. When engraved by Weisbrod for Le Brun. See Le Brun 1792, vol. 1, p. 58; 'Celle que j'ai fait graver à été vendue mille livres et se trouve dans le cabinet de M. Clos'.
2. Blanc 1858, vol. 2, p. 289.

3. When seen by Smith. Smith 1829-42, Part 6, no. 835, p. 124.
4. The provenance from the time of Woodburn is derived from Langton Douglas's annotations to Hofstede de Groot 1908-27 in the National

Gallery of Ireland. No. 832 is not included in the Woodburn sales 24-25 June 1853, 15-19 and 24 May 1854, 9-11 June 1860; nor is it included in the Stanley of Quantock sale, 13 September 1920.

5. Published in Le Brun 1792, vol. 1, p. 58.

6. *Op. cit.*
7. Hofstede de Groot 1908-27, vol. 4, no. 275, p. 441.
8. Broulhiet 1938, p. 438.
9. *Ibid.* nos. 456, 457, 458 and 463.
10. *Ibid.* no. 458.

MELCHIOR DE HONDECOETER Utrecht 1636-1695 Amsterdam

He was the grandson of the landscape painter Gillis de Hondecoeter and son and pupil of the landscape and bird painter Gysbert de Hondecoeter. He also studied with his uncle, Jan Baptist Weenix (q.v.). By 1659 he was working in The Hague; and in 1662 he was a hoofdman of the Guild of St. Luke there. By 1663 he had settled in Amsterdam where he remained for the rest of his life and died there on 3 April 1695. He painted almost exclusively bird pictures and had many imitators. His works were also much copied.

509 Poultry (Fig. 73).

Oil on canvas, 101.5 × 130 cms. (40 × 51⅛ ins.).

SIGNED: on the stone fragment, *M.D. Hondecoeter*.

CONDITION: paint surface in good condition. Some slight wearing in parts throughout. Cleaned and restored in 1970.

PROVENANCE: Comte de C. . . . (Cahen or Cornelissen) sale,[1] Hotel des Ventes, Paris, 18-19 April 1842, lot 23, bt. Viscomte Bernard du Bus de Gisignies; his sale, Brussels, 9-10 May 1882, lot 36, where purchased by Sir Henry Page Turner Barron, by whom bequeathed, 1901.

COPIES: 1. Walker Art Gallery, Liverpool;[2] 2. With Newhouse Galleries, New York, 1952;[3] 3. van Gelder sale, Moos, Geneva, 7 April 1933, lot 23; 4. Sold Sotheby's, 8 May 1947, lot 50; 5. Sold Sotheby's, 19 December 1985, lot 80.

LITERATURE: Fétis 1878, pp. 74-76.

The birds have been identified as follows:[4] from left to right in the foreground, a domestic drake *(Anas platyrhynchos)*, a drake teal *(Anas crecca)*, a drake wigeon *(Anas penelope)*, domestic ducklings *(Anas platyrhynchos)*. On the far side of the water, a domestic cock, crested variety *(Gallus gallus)*, a domestic hen and chicks and one domestic duckling. As often in paintings of about this date, both domesticated and wild birds are shown together, the teal and wigeon not being domesticated although probably often then, as now, kept captive or pinioned as ornamental birds.

No. 509 was in Parisian collections in the nineteenth century and was probably also in Paris in the eighteenth century as François Boucher made drawings of both the cock[5] (Fig. 74) and the hen[6] (Fig. 75) in the painting. Boucher later used these drawings as preparatory studies for birds in at least two of his pictures. Both the cock and the hen are included by him in a picture *Women at a fountain* in Louisville;[7] and the hen alone is included in a lost picture by him, *Shepherds at a fountain*[8] which was engraved by Fessard in 1756.

1. The sale catalogue announced that the collection was formed for the Comte de C. . . . by Etienne Le Roy. The sale is sometimes referred to as the Etienne Le Roy sale. Lugt identifies the Comte de C. . . . as possibly Cahen or Cornelissen.

2. Inv. no. 870. Repr. *Liverpool, Walker, cat. 1977*, plates vol., p. 113.

3. Possibly the same picture was in the Benjamin sale, Parke Bernet, New York, 8 May 1947, lot 50.

4. By D. Goodwin of the British Museum

Natural History in a letter dated 3 April 1981 now in the archive of the Gallery.

5. Nationalmuseum Stockholm, inv. no. 2953/1863. Repr. Ananoff 1976, vol. 1, fig. 253, p. 184.

6. Nationalmuseum Stockholm, inv. no. 2952/1863. Repr. Ananoff 1976, vol. 1, fig. 251, p. 184.

7. J. B. Speed Art Museum. Repr. Ananoff 1976, vol. 1, fig. 250, p. 183. The painting is datable about 1730.

8. Repr. Ananoff 1976, vol. 1, fig. 252, p. 184.

GERRIT VAN HONTHORST Utrecht 1590-1656 Utrecht

He was the son of a wealthy Catholic family: both his father (Herman Gerritsz. van Honthorst) and his grandfather (Gerrit Huyghen) were artists. The young van Honthorst studied with the leading history painter in Utrecht, Abraham Bloemaert. He went to Rome possibly as early as 1610 where he was influenced by the work of Caravaggio and his Roman followers, in particular Bartolomeo Manfredi. In Rome he was very successful and was patronised by the noted collectors Marchese Vincenzo Giustiniani (in whose house he lived), Cardinal Scipione Borghese and the Grand Duke of Tuscany. He painted a number of works for churches in Rome. By late 1620 van Honthorst was back in Utrecht where he became a member of the Guild of St. Luke in 1622: he was Dean of the Guild on several occasions later in the decade. In 1627 he was visited by Rubens in Utrecht and in 1628 he went to England for six months at the invitation of Charles I. He became a member of the Guild of St. Luke in The Hague in 1637 and remained in that city until 1652 as Court Painter to the Stadhouder. In 1652 he returned to Utrecht where he died in 1656. During his lifetime he enjoyed an international reputation and was well established in Holland by as early as 1625. He is said to have had twenty-five pupils. In his Roman years he painted religious subjects, but later in Holland was best known for his portraits, genre scenes, mythological and historical compositions.

1379 A feasting scene (The interior of a brothel) (Fig. 76).

Oil on canvas, 146 × 205 cms. (57½ × 80¾ ins.).

DATED: on the chair, left, *1628*.

CONDITION: good. The canvas consists of two members joined on a vertical from top to bottom on a line through the left breast of the young woman: retouched along this join. The paint surface is in good condition. The blue of the old woman's skirt (and its reflection in the water jug) has oxidised. Cleaned in 1969.

PROVENANCE: Major Domville Barry, Santry Court, Dublin; P. R. Bald of Surrey, by whom sold, through Bennetts, Dublin, 1929; Kevin Maugham of Dublin, from whom purchased, 1958, for £1,200.

EXHIBITED: 1969, *L'Art et la Musique*, Galerie des Beaux-Arts, Bordeaux, no. 40.

LITERATURE: Nicolson 1968, p. 595; Nicolson 1979, p. 60.

Previously referred to at the Gallery as *A wedding feast* and by Nicolson[1] as a *Feasting scene with luteplayer and betrothed couple,* it is more likely that the scene depicted is intended as the interior of a brothel.[2] The old woman on the right who holds a coin is of a type shown as a procuress in many Caravaggesque paintings and the subject is a traditional one with the *Caravaggisti.* The subject is associated in Netherlandish painting with the story of the Prodigal Son in a tavern (*St. Luke* ch. 15, vs. 13).[3] van Honthorst painted similar merry-company scenes on several occasions,[4] one of the earliest of which is the painting in the Uffizi[5] which was executed in Rome shortly before the artist returned to his native Utrecht in 1620. As Judson[6] has pointed out, the Uffizi painting 'set a precedent' for the artist's conversation pieces. The composition of such pictures is derived from Caravaggio, in particular that artist's two versions of the *Supper at Emmaus.*[7] The figures are presented half-length seated around a table against a plain background wall. The light falls sharply from the left over the group. Key to such compositions is the manner in which the spectator is involved in the action of the picture, and such devices as the plate placed over the edge of the table, and the right elbow of the lutenist in no. 1379, projecting out of the picture plane, are specifically derived from Caravaggio. In no. 1379 the basket of still-life on the table may be compared directly with a similar arrangement in Caravaggio's *Supper at Emmaus* in London.

No. 1379 was not known to either Judson nor Braun.[8] It was published by Nicolson in 1968 with some reservations: 'whether it is by Honthorst or a close follower is hard to say. It is possibly by an imitator with an uncanny knack of deceiving.'[9] The attribution to van Honthorst was not accepted by van de Wetering[10] of the RKD who in a letter in 1969 described the date on the picture as authentic and the picture as authentic for that date but he remarked that 'the types of the figures as well as the composition are entirely in Honthorst's style (but) the execution is entirely different from his way of painting'. In 1979 Nicolson[11] listed no. 1379 as van Honthorst, gave the date and described it as possibly signed. In doing so he referred to the marking on the pewter plate in the centre foreground; this, however, is not a signature but more likely an intended design on the plate.

No. 1379 is here catalogued as van Honthorst and the date of 1628 is accepted. Within van Honthorst's *oeuvre* it may be compared to a signed and dated painting of 1625, *A procuress* in Utrecht[12] and *A concert* in the Borghese Gallery, Rome.[13] The costume of the young girl in no. 1379 is similar to that worn by the girl in the Utrecht painting; the lutenist in pose, costume and physiognomy is almost identical to a man playing a cello in the Rome picture which has been dated c.1625.[14]

1. Nicolson 1979, p. 60.
2. The similar picture of a concert in the Borghese Gallery, Rome, inv. no. 31 (repr. Philadelphia/Berlin/London, pl. 8) has been so interpreted, see Philadelphia/Berlin/London 1984, no. 49, p. 213.

3. *Ibid.*
4. For example the paintings of the Alte Pinakothek, Munich inv. no. 1312, repr. Judson 1959, fig. 17; in Kronberg Castle, Elsinore, repr. Judson 1959, fig. 25; and see further under n.5, 12 and 13.

5. Inv. no. 730. Repr. Judson 1959, fig. 9.

6. Judson 1959, p. 41.

7. In the Brera, Milan, repr. Moir 1967, vol. 2, fig. 19; and in the National Gallery, London, cat. no. 172, repr. Moir 1967, vol. 2, fig. 17.

8. Braun 1966.

9. Nicolson 1968, p. 595.

10. In a letter dated 13 August 1969, now in the archive of the Gallery.

11. Nicolson 1979, p. 60.

12. Centraal Museum, inv. no. 152. Repr. Judson 1959, fig 37.

13. Inv. no. 31. Repr. Philadelphia/Berlin/London 1984, no. 49, p. 213.

14. *Ibid*.

PIETER DE HOOCH Rotterdam 1629-1684 Amsterdam

He was the son of a master bricklayer and a midwife and was baptised in Rotterdam on 20 December 1629. He was, at the same time as Jacob Ochtervelt (q.v.), apprenticed to Nicolaes Berchem (q.v.). In 1652 he is recorded in Delft and a record of the following year lists him as a painter briefly in Leiden in 1653 and the following year he was married in Rotterdam. He had seven children. He joined the Guild of St. Luke in Delft in 1655. By April 1661, and perhaps earlier, he had settled in Amsterdam. Apart from a visit to Delft in 1663 he remained for the rest of his life in Amsterdam where he died in the Dolhuis (lunatic asylum) and was buried on 24 March 1684. He is best known for his Delft period paintings which depict middle class figures in orderly interiors and sunlit courtyards. His earlier guardroom scenes (see no. 322 below) are less well-known as indeed are his later Amsterdam paintings of elegant life.

322 Players at tric-trac (Fig. 78).

Oil on panel, 45 × 33.5 cms. (17^{11}/$_{16}$ × 13¼ ins.).

SIGNED: centre right, *P de hooch* (Fig. 249).

REVERSE: inscribed 1293 (in manuscript); old label in Dutch.

CONDITION: very good. Radiographs (Fig. 79) reveal that the woman was originally painted facing to the left. Cleaned in 1982.

PROVENANCE: H. Twent sale, Leyden, 11 August 1789, lot 27, bt. Delfos; Baron van Coehoorn sale, Amsterdam, 19 October 1801, lot 28, bt. Coclers; England by 1879;[1] A. J. Cliffe sale, Christie's, 25 June 1887, lot 87, bought in; Haines Brothers, London, from whom purchased, 1892, for £75.

LITERATURE: Bode 1906, p. 57; Duncan 1906-07, p. 18; Hofstede de Groot 1908-27, vol. 1, no. 253, p. 545; de Rudder 1914, pp. 18, 100; Bode 1919, pp. 305-08; Lilienfeld 1924, pp. 453-54; Lilienfeld 1924-25, no. I, p. 188; Collins Baker 1925, p. 3; Brière-Misme 1927, pp. 363, 372; Collins Baker 1930, p. 198; Valentiner 1930, pp. xvi, 17; MacLaren 1960, p. 190; Rosenberg, Slive, ter Kuile 1966, p. 124; Fleischer 1976, p. 108; Sutton 1980, no. 12, p. 77.

They are playing tric-trac or backgammon, a subject treated by several Dutch painters of the period and most particularly by the guardroom-scene painters in Amsterdam in the early part of the century such as Willem Duyster.[2] Pictures of the subject may be interpreted as emblematic of human mortality or of idleness; and idleness was seen as leading to licentiousness and sin.[3] That gambling is the theme of the picture is further

demonstrated by the two playing cards which have fallen on the floor. Gambling[4] between the sexes was likewise depicted frequently in paintings of the period and it was widely understood that it was a preliminary to seduction of women by men. An emblem from Johan de Brune's *Emblemata of zinne-werck*[5] published in 1624 shows a man and a woman playing cards and the verse underneath explains that the man, who has greater ambitions in the longer term, allows the woman to win at cards. Drinking and smoking were also associated with licentiousness; and in no. 322 the soldier on the left holds a tankard of wine while the other is shown smoking tobacco from a clay pipe (a used pipe lies on the floor). Although smoking became very popular in seventeenth-century Holland it was, certainly in the early part of the century, much condemned as a harmful intoxicant. It can be shown in paintings to depict the sense of smell, but in scenes such as that depicted by de Hooch it is intended to convey the immoderate pursuit of sensual gratification.[6] Dutch paintings in the early part of the century which depicted such themes as that shown in no. 322 had a strong moralising intent. By the time of de Hooch, however, in the 1650's moral censure was less intended although the motifs were repeated in paintings again and again; Sutton[7] has pointed out that it is improbable that de Hooch painted such pictures solely for the purpose of moral condemnation.

No. 322 was identified by Hofstede de Groot[8] as that sold, together with its pendant in Leiden in 1789 and again in Amsterdam in 1801. Hofstede de Groot identified its pendant incorrectly as *The empty jug*;[9] but its true pendant, as has been pointed out by Sutton, is *A soldier seated with a standing serving woman* in a private collection.[10] The two pictures, as Sutton justifiably claims, 'bear a strong stylistic resemblance, are close in size, and could well have been designed as pendants'.[11]

As early as 1906[12] Armstrong identified no. 322 stylistically with the *Man with dead birds and other figures in a stable* by de Hooch in London,[13] and pointed out that the same models were used in both pictures. MacLaren[14] sees the London painting and no. 322 as related in style and all authorities are agreed that no. 322 is an early work. de Rudder gives 1653-57;[15] Valentiner[16] c.1653; Bode[17] 'among a group of early works'; Fleischer[18] gives the mid-1650's and 'not many years before the signed and dated paintings of 1658'; and Sutton[19] gives c.1652-55.

1. According to Bode 1919, p. 306.
2. For example, the painting in the National Gallery, London, cat. no. 1387, repr. *London, National Gallery, cat. 1973*, p. 206. de Rudder 1914, p. 18 refers to no. 322 specifically as inspired by the guardroom scenes of Duyster.
3. See Brown 1978, p. 26 and Amsterdam 1976 under cat. no. 22.
4. Philadelphia/Berlin/London 1984, pp. 191-93.
5. Repr. *ibid.* p. 192.
6. *Ibid.* p. 164.
7. Sutton 1980, p. 43.
8. Hofstede de Groot 1908-27, vol. 1, no. 253, p. 545.

9. The Saltram Collection, National Trust, Plymouth. Repr. Sutton 1980, pl. 129.
10. Private collection, England. Repr. Sutton 1980, pl. 12.
11. Sutton 1980, p. 177.
12. Quoted by Duncan 1906-07, p. 18.
13. National Gallery, cat. no. 3881. Repr. *London, National Gallery, cat. 1973*, p. 327.
14. MacLaren 1960, p. 190.
15. de Rudder 1914, p. 18.
16. Valentiner 1930, p. 17.
17. Bode 1906, p. 57.
18. Fleischer 1976, p. 108.
19. Sutton 1980, p. 77.

JOHANNES PETRUS HORSTOK Overveen 1745-1825 Haarlem

He was born on 1 April 1745 in Overveen. He was a pupil of the marine painter Tako Hajo Jelgersma (d.1795) and also studied in the Amsterdam Academy. From 1773-1801 he was in Alkmaar, and thereafter he returned to Haarlem. He painted portraits and barn-interiors with peasants. He died in Haarlem on 25 March 1825.

650 Portrait of Jean-Jacques Dessont (1760-1809) (Fig. 77).

Oil on canvas, 49.8 × 39.3 cms. (19⅛ × 15½ ins.).

SIGNED AND DATED: bottom left, *J P Horstok fecit 1801 / ? August (in or u).* (Fig. 250).

INSCRIBED: on the letter on the table, *J. J. Desso - / C*

CONDITION: the darks in the area of the bureau are thin. Some small damages. Cleaned in 1985.

PROVENANCE: Sir Hugh Lane, by whom presented, 1913.

EXHIBITED: 1918, *Pictures by Old Masters given and bequeathed to the National Gallery of Ireland by the Late Sir Hugh Lane,* National Gallery of Ireland, Dublin, no. 55.

LITERATURE: Staring 1924, p. 537.

On the basis of the fact that the portrait was by Horstok, Jonkheer van Kretschmar[1] identified the sitter as being most likely a member of intellectual circles in Haarlem and most probably connected with the Hollandsche Maatschappij van Wetenschappen (the Society for the Sciences in Holland) which always had its seat in Haarlem. From the records of the Society and assuming that the inscription would identify the sitter, Jonkheer van Valkenburg has identified the sitter as Jean-Jacques Dessont who was Secretary of the Economics branch of the Society from 1794 until his death. The Economics Branch was constituted an independent body by the Dutch National Convention in 1797 as The National Netherlands Society of Economics, and Dessont became its Secretary. He was the fourth child of Jacques Dessont, a member of the Walloon Protestant community in Amsterdam and of Elisabeth Portefait. Jean Jacques was born in Amsterdam and died in Haarlem where he lived on the Nieuwe Gracht.[2]

1. In a letter dated 15 August 1983 now in the archive of the Gallery.

2. All information from Jonkheer van Kretschmar.

GERARD HOUCKGEEST The Hague c.1600-1661 Bergen op Zoom

He became a member of the Guild of St. Luke in The Hague in 1625. He was in Delft by March 1635 and married there on 1 November 1636. He became a member of the Guild of St. Luke in Delft in 1639.

After GERARD HOUCKGEEST

530 Interior of the new church in Delft with the tomb of William the Silent (Fig. 80).

Oil on panel, 60.8 × 50.2 cms. (23¹⁵⁄₁₆ × 19¾ ins.).

CONDITION: poor. The support was at some time split in several places from top to bottom. It has been planed down and repaired. The paint surface is thin and probably strengthened in large areas throughout. The area of the tomb itself is in relatively sound condition. The spandrels of the present frame conceal the dark painted arch of the church. Cleaned in 1969.

PROVENANCE: H. P. Cunliffe, from whom purchased, 1901, for £18.

LITERATURE: Liedtke 1982, no. 6B, p. 100 and no. 221, p. 114.

For the subject see no. 450, after de Witte in this catalogue. The statue visible in no. 530 is *Justice* by Hendrick de Keyser.

Similar views of the tomb were painted in, or shortly after, 1650 by Gerard Houckgeest, Emanuel de Witte and Hendrick van Vliet. It is not clear which of these artists invented the composition which manifests such interest in, and competence with, perspective; but of the three painters only Houckgeest had trained as an architectural painter while van Vliet's compositions are probably derived from paintings by de Witte and Houckgeest. In the case of no. 530, which was purchased as, and has always been catalogued as, van Vliet, Liedtke[1] has justifiably described it as 'a weak copy by an unidentified hand of a painting by Houckgeest in The Hague'.[2] He rejects the attribution to van Vliet.[3]

1. Liedtke 1982, no. 6B, p. 100.
2. Mauritshuis inv. no. 58. Repr. Liedtke 1982, fig. 3.
3. Liedtke 1982, no. 221, p. 114.

LUDOLF DE JONGH ? Rotterdam 1616-1679 Hillegersberg

According to Houbraken he was born in Overschie in 1616 but records suggest that his birthplace was actually near Rotterdam. Also according to Houbraken he was successively a pupil of Cornelis Saftleven (q.v.) in Rotterdam, of Anthonie Palamedesz. (q.v.) in Delft and of Jan van Bijlert in Utrecht. From 1635-42 he was in France. He married on 6 February 1646: his wife's sister was married to the painter Dirck Wijntrack (q.v.). From the time of his marriage he lived between Rotterdam and Hillegersberg where he died between May and September 1679. He painted portraits, genre scenes and landscapes with figures often showing hunting scenes. In these he was influenced from about 1650 by the work of Aelbert Cuyp (q.v.).

44 Landscape with a shooting party (Fig. 81).

Oil on panel, 58.8 × 84 cms. (23⅛ × 33 ins.).

CONDITION: the support consists of three members joined on horizontals 20 cms. and 42 cms. from the top. There is evidence of repairs to the back of the panel. The paint surface is in fair condition with some wearing in the landscape and possibly some overpainting in the sky. Cleaned in 1969.

PROVENANCE: 'Property of a Gentleman, Removed from the West of England', sale, Foster's, London, 19 March 1873, lot 78, where purchased for the Gallery by Waters, for 66 guineas.

LITERATURE: Armstrong 1890, p. 287.

The shepherdess on the right in the middle distance is winding yarn, a fairly common sight in seventeenth-century Dutch landscape paintings.

No. 44 was sold in 1873 and purchased by the Gallery as Aelbert Cuyp. Writing in 1890 Armstrong[1] observed, 'in a landscape with a shooting party I feel inclined to recognise a particularly fine example of Benjamin Gerritsz. Cuyp, in which he may have been helped by Aelbert'. In 1898 he catalogued the painting as Ludolf de Jongh. Fleischer[2] has suggested a date of 1648-50; that is the same period as no. 148 below.

1. Armstrong 1890, p. 287.
2. Prof. Roland E. Fleischer in a letter dated

4 December 1985 now in the archive of the Gallery.

148 A canal boat station (Fig. 82).

Oil on panel, 53.4 × 64.8 cms. (21 × 25½ ins.).

SIGNED: on the shed, right: *L.D Jong* (? indecipherable). (Fig. 251).

REVERSE: the bookplate of John Howard Galton dated in manuscript 25 September 1877.

CONDITION: the support is joined on a horizontal about 18 cms. from the top. The paint surface is in good condition with some retouching in the area of the join. There is a damage above the roof, right; and another in the sky, top right. Some overpaint in the area of the figure and the horse, right. Radiographs show that a sheep, left of centre in the foreground, has been painted out. Cleaned and restored in 1973.

PROVENANCE: Joseph Strutt of Derby; thence by descent to John Howard Galton of Hadzor by 1877;[1] thence by descent to Hubert Galton; his sale, Hadzor sale, Christie's, 22 June 1889, lot 35, where purchased for 145 guineas.

LITERATURE: Armstrong 1890, p. 287; Hofstede de Groot 1926a, p. 133; Schatborn 1975, p. 80; Amsterdam/Washington 1981-82, p. 77.

DRAWING: Berlin Dahlem Prentenkabinett no. 2891.[2] (Fig. 83).

COPY: of the right-hand side of the composition only, 53 × 54 cms., said to be signed Th(eodor) Helmont and dated Haarlem 1656, sold at Sotheby's, 5 December 1956, lot 86; the same picture, now 51 × 51 cms. and said to be signed and dated *Theodorus (Helm ?....) g... Haarlem 16(8)0* sold Sotheby's, 23 July 1965, lot 10, bt. Cohen.

No. 148 was sold in 1889 as de Jongh. In spite of this, Armstrong[3] gives the information that 'it was on exhibition at South Kensington some ten years ago when it was called, if my memory may be trusted, Dirck Stoop. It was bought last year at the Hadzor Sale, and on the removal of a dirty varnish the signature L de Jongh or Jonge, set its origin at rest'. The picture seems not to have been described by Waagen[4] or in the 1827 catalogue of Joseph Strutt's collection.[5] It was sold in 1889 as *'A manège'* by L de Jongh. Schatborn[6] has published a drawing for the group of figures on the extreme left. It is in Berlin[7] where it is attributed erroneously to Cornelis Saftleven.[8]

Fleischer suggests a date for no. 148 of 1648-50.[9]

1. See 'Reverse' above.
2. See Bock, Rosenberg 1930, vol. 2, no. 2891, p. 190.
3. Armstrong 1890, p. 287.
4. Waagen 1854, vol. 3, pp. 221 ff. describes the collection of Joseph Strutt of Derby.
5. Strutt 1827.
6. Schatborn 1975, fig. 3, p. 80; and

Amsterdam/Washington 1981-82, p. 77.
7. See n. 1 above.
8. Cornelis Saftleven is said by Houbraken to have been the teacher of Ludolf de Jongh.
9. Prof. Roland E. Fleischer in a letter dated 4 December 1985 now in the archive of the Gallery.

ISAAC DE JOUDERVILLE Leiden c.1612/13-c.1645/48 Amsterdam

He was born in Leiden about 1612-13, the son of an innkeeper from Metz. His apprenticeship to Rembrandt in Leiden is documented by his guardian's accounts as well as by Rembrandt's receipts for the annual fee of 100 guilders which was paid to him for 1630 and 1631. He was orphaned in 1629 when both his parents died within weeks of each other. In 1631 when Rembrandt moved to Amsterdam from Leiden, de Jouderville appears to have followed him as expenses for two journeys to Amsterdam are recorded. He enrolled as a student at the University in Leiden in 1632 and married in that city in 1636. In 1641 he moved to Deventer and in 1643 to Amsterdam where he died between 1645 and 1648. On the basis of a stylistic comparison with no. 433 below, a corpus of work has been ascribed to him. This consists, in general, of head or figure studies painted in a relatively naive style very much after the manner of Rembrandt. He was the father-in-law of the painter Frederik de Moucheron (q.v.).

433 Bust of a young man (Fig. 84).

Oil on oval panel, 48 × 37 cms. (19⅛ × 14½ ins.).

SIGNED: centre right, *Jouderville*, and, falsely, left, *G Dou* (the G D in monogram).

CONDITION: good. Cleaned in 1986.

PROVENANCE: Lawrie and Company, London, from whom purchased, 1895, for £150.

LITERATURE: Hofstede de Groot 1899, pp. 228 ff. and p. 234; Schmidt-Degener 1906, p. 280; von Wurzbach 1906-11, vol. 1, p. 774; Hofstede de Groot 1908-27, vol. 6, p. 13; Bredius 1915-22, vol. 6, p. 1940; Hofstede de Groot 1926b, p. 190; Raleigh 1956, p. 120; Bauch 1960, p. 224; Bernt 1948-62, vol. 4, no. 147; Leiden 1968, p. 15; Haak 1969, p. 48; *The Hague, Museum Bredius, cat. 1980*, p. 70 under no. 80; RRP 1982-, vol. 1, pp. 505-07; Amsterdam/Groningen 1983, under no. 44, p. 178; Sumowski 1983-, vol. 2, no. 940, p. 1436; van de Wetering 1983, pp. 59, 62, 66.

No. 433 is a type of composition painted by Rembrandt and other painters in seventeenth-century Holland and known as a *tronie* (literally, a face). It has been suggested that it is a self-portrait.[1]

The painting was first published in 1899 by Hofstede de Groot.[2] He gave the information that in 1895 when the picture was being cleaned, and prior to its acquisition by the Gallery, the false signature of Gerard Dou was removed and underneath, the signature of *Jouderville* appeared. The then owner of the painting immediately ordered the original signature

to be painted over again and replaced by a new false signature of Dou. In addition Hofstede de Groot published newly-discovered records of the painter Isaac de Jouderville's family and suggested that the artist may have been a pupil of Rembrandt. No. 433 was, however, the only painting supposedly by the artist known to Hofstede de Groot, although he suggested some attributions. Subsequently Bredius discovered important documents which established de Jouderville as one of Rembrandt's apprentices, and in publishing them he referred to no. 433 as fully signed and possibly a self-portrait.[3] The validity of Hofstede de Groot's original account has never been questioned and no. 433 has been accepted by all authorities[4] as the work of de Jouderville and by many as a fully signed work. In addition, a corpus of paintings has been ascribed to de Jouderville on the basis of a stylistic comparison with no. 433.

Recent cleaning of no. 433 has revealed the signature of de Jouderville to be on the right-hand side of the composition, and not, as Hofstede de Groot implied, underneath the false signature of Dou on the left. A drawing of a *Young man laughing*[6] which is stylistically similar to no. 433, is also possibly signed by de Jouderville; but the attribution of that drawing to de Jouderville is disputed.[7] Sumowski has published two further signed paintings by de Jouderville;[8] but both of these works are genre paintings in the manner of Gerard Dou and neither are comparable stylistically to either no. 433 or any of the attributed works.

No. 433, although much cruder in technique than any painting by Rembrandt, is stylistically related to works by the master painted in his later Leiden years. No. 433 is early work probably dating from about 1631-35.

1. By Bredius 1915-22, vol. 6, p. 1940; and also by Sumowski 1983-, vol. 2, p. 1436.
2. Hofstede de Groot 1899, pp. 228 ff. and p. 234.
3. See n. 1 above. Schmidt-Degener 1906, p. 280 had also referred to no. 433 as possibly a self-portrait.
4. See 'Literature' above.
5. Sumowski 1983-, pp. 1434-52; and van de

Wetering 1983, pp. 59-69, 77, 178-81.
6. Sumowski 1979-, vol. 6, no. 1285, p. 2872, where it is given to de Jouderville. The drawing is in the Berlin Dahlem Kupferstichkabinett, inv. no. 13933.
7. See van de Wetering 1983, p. 62 and n. 26, p. 69.
8. Sumowski 1983-, vol. 2, nos. 951 and 953, p. 1438.

GODAERT KAMPER Düsseldorf c.1614-1679 Leiden

From 1633 he was in Leiden where he married in 1644 and became a member of the Guild of St. Luke in 1648. From 1659 he was in Amsterdam where, as a widower, he married the widow of the landscape painter Balthasar van der Veen. From 1663-72 he was in Naarden, and was buried in Naarden on 18 November 1679.
He painted elegant company genre scenes, some landscapes and, in the main, portraits.

806 A man aged 20 tuning a violin (Fig. 85).

Oil on panel, 52.2 × 42 cms. (20½ × 16½ ins.).

SIGNED: on the bottom of the map, *G (?) f.*

DATED AND INSCRIBED: on the top of the map, *An (o) .1645. AE . 20.*

REVERSE: label with *No. 7* written in ink; in manuscript *Le Duc.*

CONDITION: the area of the signature is damaged resulting possibly from a deliberate cancelling out of the signature. Paint in good condition; some wearing in the dark clothes of the sitter. Cleaned in 1982.

PROVENANCE: Sir Charles Coote, Ballyfin, county Laois, 1865;[1] Sir Algernon Coote; Sir Hugh Lane, by whom bequeathed, 1915, and received in the Gallery, 1918.

EXHIBITED: 1865, *Dublin International Exhibition of Arts and Manufactures,* no. 16; 1918, *Pictures by Old Masters given and bequeathed to the National Gallery of Ireland by the Late Sir Hugh Lane,* National Gallery of Ireland, Dublin, no. 54.

No. 806 was bequeathed as the work of J. G. Cuyp but catalogued in 1928 as Kamper. It had earlier been called Le Duc whose name is inscribed in manuscript on the back, and as whom it was exhibited in 1865. There seems no reason to doubt the attribution to Kamper: a similar composition by Kamper in Düsseldorf[2] shows a cellist with a table and map on the background wall: it is dated 1646, that is, one year later than no. 806.

1. When lent to the Dublin Exhibition of 1865, see 'Exhibited', below.

2. Kunstmuseum, repr. Bernt 1948-62, vol. 4, no. 148.

JAN VAN KESSEL Amsterdam 1641 or 1642-1680 Amsterdam

He was the son of a frame-maker Thomas Jacobsz. van Kessel. He married in 1668 when he gave his age as twenty-six. He was a friend of Meindert Hobbema (q.v.) who was godfather to his second son who was baptised in 1675. He was buried in Amsterdam on 24 December 1680. It is possible that he was a pupil of Jacob van Ruisdael (q.v.) in Amsterdam. He painted panoramic and other landscapes and townscapes.

933 The Dam at Amsterdam (Fig. 86).

Oil on canvas, 68 × 83.1 cms. (26¾ × 32¾ ins.).

SIGNED AND DATED: bottom right, *J v Kessel 1669* (Fig. 252).

CONDITION: fair. The area showing the facade of the palace has been strengthened and this was not removed in the 1985 cleaning. The signature is also possibly strengthened. Cleaned in 1985.

PROVENANCE: Rt. Hon. Lord North, Wroxton Abbey, Banbury sale, Christie's, 11 July 1930, lot 72, bt. Buttery, from whom purchased, 1930, for 300 guineas.

The square shown in no. 933 is the Dam and is the site where the first dam was thrown across the Amstel in the thirteenth century. It will be noticed that, although there is no snow or ice, sledges are being used. Transport by carts and wagons was, in Amsterdam

in the seventeenth century, subject to certain restrictions, both to ensure safety and to prevent unnecessary damage to road surfaces.[1]

On the right is the Nieuwe Kerk which dates mainly from the sixteenth century; on the left, the weigh-house. The Town Hall was designed by Jacob van Campen (1595-1657) and building begun in 1648.[2] It was completed about 1665 and was therefore a new building at the time when van Kessel painted it. The east facade fronts the Dam. In the pediment, sculptures by Artus Quellinus the Elder (1609-68) represent an Allegory of Amsterdam being paid tribute to by the sea (not decipherable in the painting). Above the pediment are statues from left to right of *Prudence, Peace* and *Justice*. Constructed as the Town Hall, the building was, in 1808, converted to a royal residence by Louis Bonaparte but later handed back to the city by King William I on his return from exile in 1813. The building was sold by the city to the State in 1935 and is now the Royal Palace.

The new town hall became a popular subject with painters. Johannes Lingelbach (q.v.) painted it while it was still under construction in 1656;[3] and Jan van der Heyden made views of it in 1667[4] and 1668[5] and also in another picture now in the Rijksmuseum, Amsterdam.[6] Berckheyde[7] and Abraham Storck[8] (q.v.) also painted the scene. van Kessel himself painted a larger version of no. 933 a year earlier, in 1668.[9]

Davies[10] attributes the figures in no. 933 to Abraham Storck and she has drawn attention to the fact that a now lost painting of the scene by van Kessel of 1668 was listed in a sale catalogue of 1696[11] as having figures by Storck.

1. See Amsterdam/Toronto 1977 under cat. no. 104.
2. See Freemantle 1959, *passim*.
3. Amsterdams Historisch Museum, inv. no. A.3044, repr. Amsterdam/Toronto 1977, no. 118.
4. Uffizi, Florence, inv. no. 1211.
5. Louvre, Paris, inv. no. 1337. Repr. *Paris, Louvre, cat. 1979*, p. 69.
6. Inv. no. C571. Repr. *Amsterdam, Rijksmuseum, cat. 1976*, p. 273.
7. On several occasions, see for example Rijksmuseum, Amsterdam, inv. nos. A34, A1733 and C101. Repr. *Amsterdam, Rijksmuseum, cat. 1976*, p. 111.
8. Amsterdams Historisch Museum, inv. no. A1755.

9. A. Dykman sale, Amsterdam, 17 July 1794, lot 15, described as 'van Kessel of 1668, 39 × 50 ins.' This picture was included in sales in Amsterdam in 1808 and 1820 but is now lost. The compiler is indebted to Dr Alice I. Davies for this reference and also for generously making available her draft relating to no. 933 from her forthcoming book on van Kessel.
10. Information with a letter dated 21 January 1986 now in the archive of the Gallery, see n.9 above.
11. Anon sale, Amsterdam, 16 May 1696, lot 115, 'A large work showing the Dam and the Town Hall, etc. by van Kessel, staffage by Abraham Storck. 104-0 ins.'

THOMAS DE KEYSER Amsterdam 1596/97-1667 Amsterdam

He was the son of the architect and sculptor Hendrick de Keyser and was a native of Amsterdam. His date of birth is uncertain but he was said to have been twenty-nine in June 1626. From January 1616 he was a pupil of his father for two years. He married in 1626. He entered the Stonemasons' Guild in Amsterdam in 1640, and from that time

was active as a stone merchant: in 1662 he was appointed Stonemason to the city of Amsterdam. He was buried in Amsterdam on 7 June 1667. He is principally known as a portrait painter and indeed was one of the most favoured portrait painters in Amsterdam. Although he painted some life-size portraits, he is mainly associated with small whole-length portraits and in his later years developed a new type, that of small equestrian portraits (see no. 287 below).

469 Interior with figures (Fig. 87).

Oil on panel, 32.5 × 37.4 cms. (12⅝ × 14⅝ ins.).

SIGNED: on the foot-warmer, *D Kij* (Fig. 253).

CONDITION: good. Possibly some overpaint in the area around the head of the man. Some small retouchings in the background.

PROVENANCE: Horace Buttery of London, from whom purchased, 1897, for £175.

LITERATURE: Duncan 1906-07, p. 18; Oldenbourg 1911, no. 55, p. 77; Boydell 1985, pp. 65, 67-68.

VERSION: Huldschinsky sale, Berlin, 5 May 1928, lot 5, as Pieter Codde, later exhibited, 1932, Schaffer, Berlin, no. 59 as Thomas de Keyser.

Hanging on the wall in the background, left, are a dancing master's kit and a cittern.[1] The kit, a relative of the violin, but with a very narrow body which enabled it to be carried about in a dancing master's coat pocket, was widely used for dance music in the seventeenth century. The cittern, which was also popular, was, however, more associated with the lower levels of society: it was, for example, described at the time as 'almost an ignoble instrument, used by cobblers and barbers'.[2] Traditionally it was hung up in barbers' shops for the use of waiting customers. Lying on the table in front of these two instruments is a violin. The chimneypiece is supported by statues of Juno and Jupiter. These sculptures are very much in the style of Hendrick de Keyser, the painter's father: they may be compared, for example, with a pair of statues by Hendrick in Frederiksborg[3] which show Juno and Jupiter: Jupiter, in particular, as depicted in no. 469, is almost identical to the Frederiksborg statue.

Boydell[4] has interpreted no. 469 as an allegory of love and marriage and rightly points to the allusions contained in the painting to profane pleasures (the musical instruments), and the heat of passion (the foot-warmer and the fire). The statues are also symbolic: Jupiter, a god associated with seduction by deception, and Juno, worshipped as the protectress of women. What is actually taking place in no. 469, however, is a scene of prostitution. The woman holds her left hand in a pose which indicates that she is holding a coin which she has received from the man: a traditional pictorial reference to prostitution. The composition of no. 469 may be compared to a similar scene shown in an engraving by Cornelis van Kittensteyn after a design by Dirck Hals,[5] in which a man approaches a woman who is seated at a fire; the print has been interpreted as showing a scene of prostitution.[6]

No. 469 was purchased as the work of Thomas de Keyser and has always been so catalogued at the Gallery. The attribution was accepted by Oldenbourg[7] who described

the painting as 'credible on account of the signature and style'. Adams, who has read the signature as *K?ay*, rejects it as that of Thomas de Keyser.[8] Oldenbourg dated the picture to the beginning of the 1630's.

1. Boydell 1985, p. 68, who also illustrates a French kit of the seventeenth century, fig. 56b, p. 68.
2. By the German musician and writer Michael Praetorius, *Syntagma Musicum* published in 1619, quoted by Boydell 1985, p. 68.
3. Repr. Neurdenburg 1930, pl. 38. The compiler is indebted to Patricia Wengraf for this comparison and reference.

4. *op. cit.*
5. Repr. Lawrence/New Haven/Austin 1983-84, no. 36.
6. *Ibid.*
7. Oldenbourg 1911, no. 55, p. 77.
8. Ann Adams, who is currently preparing a study of de Keyser, in a letter dated July 1981 now in the archive of the Gallery.

THOMAS DE KEYSER AND JACOB VAN RUISDAEL

287 Cornelis de Graeff with his wife and two sons arriving at Soestdijk (Fig. 144). (See under Jacob van Ruisdael and Thomas de Keyser, pp. 135-36).

SIMON KICK Delft 1603-1652 Amsterdam

He was the son of an Amsterdam japanner. He moved from Delft where he was born, to Amsterdam before 1624 and became a permanent resident there where he is frequently documented until his death. He was one of a group of artists including Jacob Duck (q.v.), Pieter Codde (q.v.) and Willem Duyster (q.v.) who painted guardroom scenes. He married the sister of Willem Duyster on 5 September 1631 in a double marriage ceremony when his sister married Duyster himself.

834 An artist painting a portrait (Fig. 88).

Oil on panel, 92 × 69.5 cms. (36¼ × 27⁵⁄₁₆).

CONDITION: the support consists of three members joined on verticals at 20 cms. and 44 cms. from the right. There is a split in the support from top to bottom about 41 cms. from the right. Paint surface in fair condition. There is evidence of overcleaning in the past throughout, particularly in the area of the right shoulder of the sitter and in the background. Cleaned in 1984.

PROVENANCE: W.L. Elkins of Philadelphia, 1900;[1] Executors' sale, American Art Association, New York, 10-11 February 1919, lot 37, bt. F. Muller; Robert Langton Douglas, from whom purchased, 1921, for £420.

LITERATURE: de Jongh 1986, p. 21.

While there would obviously be some case for considering the artist in no. 834 as a self-portrait of Kick, it seems unlikely that this is so. There would appear to be no known

portraits of Kick with which to compare it. The artist in the picture appears identical with the figure in a *Portrait of a young man standing by an open stove* by Kick (Fig. 211), that was sold in 1942.[2] That figure is shown in identical costume, in a similar languid pose and bears a distinct facial resemblance to the artist in no. 834. The sitter in no. 834 appears in other paintings by Kick and he is almost certainly a portrait. He is the principal person in a group portrait by Kick in Copenhagen[3] (Fig. 212) and appears in the background of a *Portrait of an officer with other soldiers*, formerly in the Koti Collection, Paris, but the present whereabouts of which is unknown.[4] The officer in that picture holds a roemer aloft in a gesture similar to that in no. 834 and the same mannerism is employed in *A guardroom with eleven figures* formerly in the Robinson collection.[5]

No. 834 was called Kick in 1900 but Langton Douglas may have believed it to be Ochtervelt,[6] and the attribution to Kick seems to have been suggested by Mellaert.[7] In view of the similarity between the sitter and the figure in the ex-Koti painting which is signed and dated 1648, it may be that no. 834 also dates from about that time.

1. Elkins 1887-1900, no. 105.
2. von Polnitz sale, Munich. A photograph of the painting is now in the archive of the Gallery.
3. Royal Museum of Fine Arts, inv. no. 3886. Repr. *Copenhagen, Royal Museum, cat. 1951*, no. 363, p. 154.
4. Repr. Haex 1981-82, p. 296.
5. Now in a private collection. Repr.

Philadelphia/Berlin/London 1984, no. 58, pl. 41.
6. The mount of the photograph of no. 834 in the RKD is inscribed 'a copy was in September 1919 as Ochtervelt with Langton Douglas'. It is fairly certain that the picture with Langton Douglas was no. 834, see 'Provenance' above.
7. The mount of an old photograph of no. 834 in the Witt Library is inscribed 'Mellaert's attribution'.

WOUTER KNIJFF Wesel c.1607-after 1693 ? Bergen op Zoom

Very little is known about him. He worked in Haarlem where he became a member of the Guild of St. Luke in 1640. In 1675 he sat for his portrait to Jacob de Braij (q.v.). van der Vinne speaks of his works as 'entirely in the manner of van Goyen'.

53 The windmill (Fig. 89).

Oil on canvas, 99 × 144.2 cms. (39 × 56¾ ins.).

SIGNED: traces of a false signature, bottom, right of centre: J V R .

CONDITION: paint surface in fair condition. Discoloured retouching along a vertical fold down the centre. Thin in all the darks. Some overpaint in the sky.

PROVENANCE: Thomas Turton, Bishop of Ely sale, Christie's, 14-16 April 1864, lot 212, where purchased for 27 guineas.

EXHIBITED: 1952-53, *Dutch Pictures 1450-1750*, Royal Academy, London, no. 288.

LITERATURE: Armstrong 1890, p. 287; Duncan 1906-07, p. 18; Hofstede de Groot 1927b, p. 46; van Gelder 1953, n. 23, p. 52.

No. 53 was sold in 1864 as Jacob van Ruisdael and said in the sale catalogue to be signed and dated 1663. It was so described in the early catalogues of the Gallery, but Armstrong

doubted the attribution in 1890[1] and in 1898[2] gave it to van Kessel. In 1904[3] he gave it to Wouter Knijff, an attribution it has retained ever since.

In the early catalogues of the Gallery no. 53 was said to be signed *J R 1663*; Armstrong in 1898 read this as *J K 1663* but in 1904 interpreted the signature as falsely *J R*. There are faint traces of a signature without a date visible, but it is indecipherable and possibly false. No. 53 is not obviously comparable with any known work by the artist although it should be said that there are relatively few paintings by him. The attribution was accepted by van Gelder.[4]

1. Armstrong 1890, p. 287.
2. In the catalogue of the Gallery.
3. In the catalogue of the Gallery.
4. van Gelder 1953, n. 23, p. 52.

SALOMON KONINCK Amsterdam 1609-1656 Amsterdam

He was the son of a goldsmith from Antwerp, Pieter de Koninck, and was born in Amsterdam. At the age of twelve he was apprenticed to David Colijns to learn drawing and later was a pupil of Nicolaes Moeyaert. From about 1633 until the end of his life he painted in the style of Rembrandt following the master's style of the mid-1630's. He painted biblical and mythological scenes, portraits and genre scenes with philosophers, rabbis and gold-weighers. He was also an etcher.

Style of SALOMON KONINCK

329 Portrait of a man (Fig. 90).

Oil on canvas, 129.7 × 104 cms. (51 × 41 ins.).

REVERSE: label inscribed, *Ph. de Koning*, and a description of the picture in Dutch.

CONDITION: fair. Cleaned and restored in 1970.

PROVENANCE: B. Watkins, Esq., of Dublin, from whom purchased by the Irish Institution for the National Gallery of Ireland, 1855, for £42.

No. 329 was purchased as the work of Philips Koninck and so catalogued at the Gallery until 1867 when it was given to Salomon Koninck. Armstrong in 1898 catalogued it as 'after Salomon Koninck'. It is of a type of composition, a man reading or studying, which was painted by Salomon Koninck,[1] although no. 329 is certainly a portrait and the man wears some form of official robe. On the basis of costume it would date from the late 1630's. No. 329 is, however, not of very good quality and is here catalogued as 'Style of Salomon Koninck'.

1. See for example the *Scholar in his study* in Berlin, Dahlem Gemäldegalerie, inv. no. 819; and the *Philosopher* sold at Christie's, 12 March 1976, lot 111.

JAN LAGOOR active in Haarlem 1645-1659 Amsterdam

His date and place of birth are unknown and he is first recorded in 1645 when he became a member of the Guild of St. Luke in Haarlem. He was still in Haarlem in 1649 when he was cited as a hoofdman *in the Guild. In 1659, while he was living in Amsterdam, bankruptcy proceedings were taken against him. As his works show in particular the influence of Cornelis Vroom, he may have been his pupil, and his development as an artist paralleled that of Jacob van Ruisdael (q.v.).*

JAN LAGOOR and ADRIAEN VAN DE VELDE
(For biography of van de Velde see p. 159).

515 The ferry boat (Fig. 91).

Oil on canvas, 88 × 79.7 cms. (34⅝ × 31⅜ ins.).

SIGNED: on the boat, *A V Velde f* (the AV in monogram) (Fig. 254); and falsely, bottom left: *J. Ruysdael f.*

REVERSE: label on stretcher, *Ruysdael, Jacques + 1681. The Ferry Boat. Figures by Adrien van de Velde. Signed by both masters.*

CONDITION: the edges of the original canvas have been slightly trimmed. Paint layer in good condition. Some abrasion top left and in the tree in that area. Cleaned in 1982.

PROVENANCE: Wynn Ellis sale, Christie's, 27 May 1876, lot 108, bt. Johnson; Sir Henry Page Turner Barron, by whom bequeathed, 1901.

LITERATURE: van der Haagen 1932, no. 171S, p. 103; Keyes 1979, n. 13, p. 41 and no. 12, p. 41.

No. 515 was sold in 1876 as Jacob van Ruisdael, by whom it is falsely signed, and bequeathed to the Gallery as Hackaert.[1] It appears in Armstrong's *ms.* catalogue as Joris van der Hagen and was so catalogued by him in 1908. It was accepted as Joris van der Hagen by van der Haagen.[2] In a verbal communication of 1975 Nieuwstraten rejected the attribution to van der Hagen and proposed Jan Lagoor. No. 515 was published by Keyes in 1979 as Lagoor with staffage by Adriaen van de Velde.[3] He related no. 515 to two signed paintings by Lagoor, one in Budapest[4] and one formerly in Vienna,[5] and points to the 'elongated trees with attenuated branches . . . each treated as a separate entity, in a forest that assumes more the character of a well-kept parkland'.[6] He dates no. 515 about 1655.[7]

1. It is recorded as such in the *ms.* Register of the Gallery.
2. van der Haagen 1932, no. 171S.
3. Keyes 1979, no. 12, p. 41.
4. Szépmüvészeti Múzeum, inv. no. 261. Repr. Keyes 1979, fig. 7, p. 41.
5. In the Gallery Sanct Lucas, 1971. Repr. Keyes 1979, fig. 8, p. 43.
6. Keyes 1979, p. 38.
7. *Ibid.*, n. 13, p. 41.

PIETER LASTMAN ? Amsterdam ? 1583-1633 Amsterdam

He was the son of Pieter Zeegersz. but took the name Lastman, and was probably born in Amsterdam. He was apprenticed to the mannerist painter, Gerrit Pietersz., called Sweelinck and according to van Mander travelled in Italy in 1603-4 where he worked first in Venice and later in Rome. In 1607 he is recorded in Amsterdam and seems to have remained there for the rest of his life, and was buried on 4 April 1633. Under the influence of Hans Rottenhammer in Venice and the Carracci, Elsheimer and Caravaggio in Rome he developed a personal style of history painting. His pupils included Jan Lievens (q.v.) from about 1619-21, and Rembrandt (q.v.) in 1623.

890 Joseph selling corn in Egypt (Fig. 92).

Oil on panel, 57.6 × 88.2 cms. (22⅝ × 34⅝ ins.).

SIGNED AND DATED: on the step, right, *1612 P Lastman fecit* (P L in monogram) (Fig. 255).

CONDITION: the support is cradled. Paint surface in good condition underneath discoloured varnish.

PROVENANCE: probably Iman Pauw sale, The Hague, 23 November 1779, lot 107; on the market in Britain, 1913;[1] Bernard McCoy, Belfast, 1923;[2] purchased from him, 1927, for £300.

EXHIBITED: 1938, *Seventeenth Century Art in Europe*, Royal Academy, London, no. 145.

LITERATURE: Freise 1911, no. 20, p. 38, p. 94; Freise 1913, p. 610; Hofstede de Groot 1923-24, p. 110; Valentiner 1934, no. 634, p. 411; Stechow 1969, p. 148; Tümpel 1974, pp. 93-96; Broos 1975-76, p. 212; Sumowski 1979-, vol. 3, pp. 1432-33.

The subject is from *Genesis* ch. 42-47. Jacob sent ten of his sons, the brothers of Joseph, into Egypt to buy corn, but kept at home with him the youngest son Benjamin. Joseph recognised them, and, keeping one of the brothers hostage, demanded that they bring Benjamin to him. On their return with Benjamin, Joseph sold them corn. The subject is relatively rare in painting, but relevant to no. 890, it was painted by Jacob Pynas,[3] Jacob de Wet[4] (q.v.) and Jan Victors[5] (q.v.).

Lastman painted at least two other pictures with subjects drawn from the story of Joseph[6] but only no. 890 is now known. A painting of the same subject as no. 890 by him, dated 1612 and measuring 62.1 × 91.8 cms., was in the Iman Pauw sale, The Hague, on 23 November 1779, lot 107,[7] and Freise has justifiably identified no. 890 as being identical with that picture.[8] His view was substantiated by Hofstede de Groot.[9] Freise[10] also first drew attention to a drawing by Rembrandt (Fig. 93), now in Vienna,[11] which is a copy of no. 890. The drawing, in style 'angular, and striving for cubic synthesis of the figures',[12] repeats the composition of no. 890 exactly. Rembrandt made drawings of three other paintings by Lastman, all of which date from the same period as no. 890, i.e. 1612-14;[13] and the date of the Rembrandt drawings is variously assigned to sometime in the 1630's.[14] As Lugt has pointed out[15] a drawing now attributed to Gerbrandt van den Eeckhout (Fig. 94) of about 1664-66 in the Louvre[16] derives its composition from the central part of no. 890. The composition of no. 890 also influenced C. C. Moeyaert in his treatments of the same subject, as has been pointed out by Tümpel;[17] and Moeyaert also used the motifs of the temple and the triumphal column in several of his pictures.

1. When published by Freise 1913, p. 610.
2. When published by Hofstede de Groot 1923-24, p. 110.
3. Dated 1618, see Pigler 1974, vol. 1, p. 90.
4. National Museum, Warsaw, inv. no. 1437, repr. *Warsaw, National Museum, cat. 1969-70*, vol. 2, p. 190.
5. In Posen. Exh. *Rembrandt et ses contemporains*, National Museum, Warsaw, 1956, no. 65.
6. *Joseph thrown in the well by his brothers*, and *Joseph fleeing*, Freise 1911, nos. 18, 19, p. 38.
7. Freise 1911, no. 20, p. 38.
8. Freise 1913, p. 610.
9. Hofstede de Groot 1923-24, p. 110.
10. Freise 1913, p. 610.
11. Albertina, inv. no. 40039. Repr. Freise 1913.
12. Benesch 1954-57, vol. 3, no. 446.
13. Benesch 1954-57, vol. 3, nos. 447, 448 and 449.
14. *Ibid.* and Stechow 1969, p. 148.
15. Lugt 1933, vol. 3, no. 1224, p. 40.
16. *Ibid.*, pl. lxvii; see also Sumowski 1979-, vol. 3, pp. 1432-33.
17. Tümpel 1974.

JUDITH LEYSTER Haarlem 1609-1660 Heemstede

She was baptised in Haarlem on 28 July 1609. Nothing is known of her early training but she is recorded as an artist as early as 1627. About 1628 her family moved to Vreeland near Utrecht and the following year to Zaandam near Amsterdam. About that time she may have returned to Haarlem where she may have become a pupil of Frans Hals (q.v.). By 1633 she had entered the Guild of St. Luke in Haarlem. She married the painter Jan Miense Molenaer (q.v.) in 1636 and shortly thereafter they moved to Amsterdam where they lived until 1648. In that year they bought a house in Heemstede, where they lived, with occasional visits to Amsterdam and Haarlem, until her death in 1660.

468 A woman sewing by candlelight (Fig. 95).

Oil on circular panel, 28 cms. (11⅛ ins.) diameter.

CONDITION: very thinly painted. Abraded centre in the area of the woman's shadow. Minor paint losses at the edges.

PROVENANCE: Colnaghi, from whom purchased, 1897, for £30.

LITERATURE: Harms 1927, p. 150-51; Poensgen 1929, p. 176; Hofrichter 1973, no. LII, p. 46.

No. 468 is one of a pair of small circular candlelight scenes with full-length figures, painted by Leyster and referred to by Harms as pendants.[1]

Its pendant, which is signed and dated 1633, was, in 1927, in the Adolphe Schloss collection, Paris, and is reproduced (together with no. 468) by Harms.[2] Harms places them among a group of 'full-length genre paintings of smaller size' by Leyster, which he describes as better and more careful in execution than her earlier portrait-like genre paintings in the style of Frans Hals. He refers to them as combining the charm of Hals's animation with the light effects of van Honthorst.

As the pendant to no. 468 is dated 1633, the same date may be proposed for no. 468.

1. Harms 1927, pp. 150-51.

2. *Ibid.*, figs. 10 and 11.

JAN LIEVENS Leiden 1607-1674 Amsterdam

He was born on 24 October 1607 the son of Lieven Hendricx who came from Ghent. In 1615 he was apprenticed to Joris van Schooten in Leiden and about 1619-21 to Pieter Lastman (q.v.) in Amsterdam. From 1625 until about 1631, Lievens and Rembrandt (q.v.) worked together in Leiden and then in 1632 Lievens went to England where he remained for about three years. By 1635 he was in Antwerp where he became a member of the Guild of St. Luke and in 1638 he married in Antwerp. In December 1640 he became a citizen of Antwerp and his sons were baptised there in 1642 and 1644. In 1644 he moved to Amsterdam where he was based for the rest of his life. He married for a second time in 1648. Between 1654 and 1658 he spent some time in The Hague and Berlin. He was again in The Hague 1670-71 but returned to Amsterdam in 1672 where he died on 4 June 1674. He painted biblical and mythological subjects, still-life, portraits and landscapes.

607 Head of an old man (Fig. 96).

Oil on panel, 59.7 × 48 cms. (23½ × 18⅞ ins.).

SIGNED: left, *L*

REVERSE: *ms.* label *D 890 Lievens*; and another *ms.* label: *by Maas a pupil of Rembrandt (? April) 84 Roma (? for) ?? C.*

CONDITION: the support consists of three members joined on verticals at 9.5 cms. and 33.5 cms. from the right. The joins are repaired by balsa wood inserts. Some old form of repair (probably cradling) has been removed from the reverse. The joins in the panel are visible on the surface. Some wearing in the area of the neck and cheek. Paint surface in fair to good condition. Cleaned and restored in 1970.

PROVENANCE: Henry J. Pfungst, London; Sir Cecil Miles sale, Christie's, 13 May 1899, lot 117, bt. McLean; Sir Edgar Vincent, Esher, Surrey, by whom presented, 1910.

LITERATURE: Schneider 1929, p. 214; Schneider 1973, no. 158, p. 132.

No. 607 may once have been attributed to Maes[1] but the signature is clear and authentic and it would be unreasonable to doubt the attribution. Referred to in the Register of the Gallery as a *Portrait of Rembrandt's father*, and said in the 1928 catalogue to be 'usually believed to be Rembrandt's father, although the identification is by no means certain'. There are numerous portraits by Rembrandt and his circle which are called Rembrandt's father; but, as Münz has pointed out, there is 'for the moment no picture that can be considered with some reason as an authentic portrait of Rembrandt's father'.[2]

The treatment of no. 607, with a well-lit head presented in profile against a dark, plain background, compares with a *Portrait of Rembrandt's mother* by Lievens in a private collection.[3] That painting has been dated to about 1629[4] and a date of about the same time may be proposed for no. 607.

1. See 'Reverse' above.
2. Münz 1953, p. 141.
3. Repr. Schneider 1973, pl. 18.

4. In Braunschweig 1979, under cat. no. 18, p. 70.

JOHANNES LINGELBACH Frankfurt 1622-1674 Amsterdam

He was the sixth son of a Frankfurt family and was baptised there on 10 October 1622. Between September 1633 and November 1634 the family moved to Amsterdam. According to Houbraken he left Amsterdam for Italy in 1642, spending two years in France on the way. It is not known when he arrived in Rome, possibly in 1644, but he was definitely there by 1647, and according to Houbraken left Rome in May 1650, travelling back to Amsterdam via Germany. He possibly returned to Rome that same year, but was back in Amsterdam by April 1653 when he married. He remained in Amsterdam for the rest of his life and was buried there on 3 November 1674.

He painted scenes very much in the manner of Philips Wouwerman (q.v.) and also Italianate landscapes and harbour scenes in the manner of Jan Baptist Weenix (q.v.). He collaborated with a number of other artists, including Jan Wynants (q.v.), by painting the figures in their landscapes.

348 A hunting party (Fig. 97).

Oil on panel, 37.3 × 43.2 cms. (14⅝ × 17 ins.).

SIGNED: bottom right, *J. lingelbach.* (Fig. 256).

CONDITION: good. Some discoloured retouchings in the sky.

PROVENANCE: Reginald Cholmondeley of Condover Hall by 1876; by descent to the Rev. R. H. Cholmondeley, from whom purchased, through S. Gooden of London, 1894, for £50.

EXHIBITED: 1876, *Art Treasures exhibition*, Wrexham, no. 119.

LITERATURE: Zülch 1929, p. 252; Burger-Wegener 1976, no. 186, p. 316.

They have been shooting. Hofstede de Groot referred to no. 348 as being 'very much in the manner of Wouwerman,[1] and Thesiger[2] has also suggested that the painting could be an early Wouwerman. Such a suggestion is apt, as the composition of no. 348 is certainly in the manner of Wouwerman, for example, the *Cavaliers in a military camp* in the Louvre,[3] and the *Cavalrymen halted at a sutler's tent* in London.[4] The handling of no. 348 is, however, not like Wouwerman, and such compositions were also painted by Lingelbach. The composition of no. 348 may be compared with Lingelbach's signed *Return from the hunt* in Amsterdam.[5]

1. Hofstede de Groot's notes are quoted by Burger-Wegener 1976, p. 316. His precise words were 'sehr Wouwermans artig'.
2. On a visit to the Gallery in 1968.
3. Inv. no. 1961. Repr. *Paris, Louvre, cat. 1979,* p. 153.

4. National Gallery, cat. no. 878. Repr. *London, National Gallery, cat. 1973,* p. 810.
5. Rijksmuseum inv. no. C. 172. Repr. *Amsterdam, Rijksmuseum, cat. 1976,* p. 349.

ANTHONIE DE LORME Tournai c.1610-1673 Rotterdam

de Lorme's date of birth is unknown and he is first recorded in Rotterdam in 1627 when he acted as a witness for his teacher, Jan van Vucht. He married in Rotterdam in 1647 and died there in 1673. His earliest known picture dates from 1639 and depicts a church interior that is derived from, although not identical with, the St. Laurenskerk in Rotterdam. Throughout the 1640's he painted only imaginary church interiors, and in these he was influenced by the work of his teacher van Vucht, and also by Bartholomeus van Bassen. About 1652 de Lorme painted his first real view of the interior of the St. Laurenskerk and, thereafter, his oeuvre consists almost entirely of paintings of that church. While he was influenced by the Delft painters of church interiors, Gerard Houckgeest (q.v.) and Hendrick van Vliet (q.v.), the example of Saenredam was of paramount importance to him throughout his life.

516 An interior of a church (Fig. 99).

Oil on panel, 92 × 124.7 cms. (36⅛ × 49⅛ ins.).

SIGNED AND DATED: bottom right, *1650 A. de Lorme.*

REVERSE: label in the handwriting of Sir Henry Page Turner Barron as follows, *Tableau sur chêne peint et signé par A. de Lorme 1650. Avec figures par Palamedes ou Teniers reprʼes. l'interieur de la vieille Eglise de Delft avec le tombeau de l'amiral van Tromp. Provient de la vente de Baedts à Gand. H. Barron Bruxelles 1873 50-70.*

CONDITION: fair. Worn in places throughout. The support consists of three members joined on horizontals at 32 cms. and 62.2 cms. from the top. Cleaned and restored in 1973.

PROVENANCE: Corneille de Badts sale, Brussels, 27 November-4 December 1871;[1] Sir Henry Page Turner Barron, by whom bequeathed, 1901.

No. 516 was believed by Barron to represent the Old Church at Delft with the tomb of Admiral van Tromp.[2] This is incorrect. The church shown is an imaginary Gothic building similar in some respects to the church shown in the painting by de Lorme at Oldenbourg.[3] Liedtke has pointed out that the pulpit and choirstalls are in a general way similar to those in the Laurenskerk in Rotterdam.[4] The psalm for the day, shown on the front of the pulpit is Psalm 71 Pause (i.e. verse) 2. That verse reads 'Deliver me in thy righteousness, and rescue me: bow down thine ear unto me, and save me'. In several of de Lorme's paintings the psalm number and verse are inscribed prominently on the pulpit;[5] and it is fairly certain that the artist's choice of psalm was not random but intended to be interpreted by the viewer.

The figures in the painting are almost certainly by a different hand: in the 1928 catalogue they are said to be probably by E. van Tilborch. The 1928 catalogue also gives the information that the picture was once attributed to Pieter Neefs.

1. No. 516 is not listed in the main sale catalogue. At the end of the catalogue is the information 'un supplément donnera la liste des tableaux omis'; but the compiler has not been able to consult this supplement. On account of the label on the reverse of no. 516, however, it is fairly certain that the painting was in the de Badts sale.

2. See 'Reverse' above.
3. Oldenbourg, cat. 1966, p. 101.
4. On a visit to the Gallery in 1983.
5. See for example the painting of the *Interior of*

the St. Laurenskerk, Rotterdam in the Museum Boymans-van Beuningen, Rotterdam, repr. Liedtke 1982, fig. 64.

558 Interior of the St. Laurenskerk, Rotterdam (Fig. 98).

Oil on canvas, 87.1 × 73.7 cms. (34⅜ × 29 ins.).

CONDITION: fair. Some small damages throughout. Cleaned and restored in 1968.

PROVENANCE: Lord Northwick, Thirlestane House by 1846; Thirlestane House sale, Phillips, 26 July-30 August 1859, lot 241, bt. Agnew; E. A. Leatham, Misarden Park, Cirencester, 1895; G. Donaldson sale, Christie's, 20 June 1903, lot 155, bt. Patterson; W. B. Patterson, London, from whom purchased, 1903, for £120.

EXHIBITED: 1895, *Loan Collection of Pictures*, Guildhall Art Gallery, London, no. 117; 1985, *Masterpieces from the National Gallery of Ireland*, National Gallery, London, no. 29.

LITERATURE: Thirlestane 1846, no. 478; Waagen 1854, vol. 3, p. 209; London 1985, no. 29, p. 74.

The painting was described by Waagen[1] as 'Delorme, *Interior of a church*; of a transparency and effect approaching de Witt. The figures by Lingelbach are very skilful'; and exhibited in 1895 as the *Porch of Antwerp Cathedral*, painted by J. Lingelbach with figures by Adriaen van de Velde. It has always been catalogued at the Gallery correctly, as the *Interior of the St. Laurenskerk (Grote Kerk) Rotterdam* by de Lorme. The view is looking east along the southern ambulatory; the choir is on the left. The church is a Gothic building dating from 1409-1525. It was badly bombed in the Second World War and, although now restored, none of the memorials visible in no. 558 are still in existence.

de Lorme painted many views of the interior of the St. Laurenskerk of which thirteen are listed by Jantzen.[2] The French nobleman, Balthasar de Monconys, who travelled in Holland in the 1660's, wrote of de Lorme in 1663, '(Il) ne fait que l'Eglise de Rotterdam en diverses vues, mais il les fait bien'.[3] Liedtke[4] has drawn attention to the fact that de Lorme, having previously painted imaginary church interiors, only turned to painting real views about 1652 and used as his subject matter his local church. In this development he was influenced by contemporary architectural painting in nearby Delft, notably the work of Gerard Houckgeest and Hendrick van Vliet, although neither of these painters actually painted in Rotterdam. Throughout his career de Lorme also seems to have been aware of the work of Saenredam, and it is the latter's influence, rather than that of the Delft painters, that is most apparent in the present picture.

It is generally recognised that many paintings of church interiors in seventeenth-century Holland have *vanitas* overtones. The chronicler Dirck van Bleyswyck, writing in Delft in 1667, urged his readers to visit tombs every day to contemplate death and the vanities of life;[5] and the visitors to the St. Laurenskerk in de Lorme's painting are doing just that. It would seem very unlikely that these figures were painted by Lingelbach who is, however, known to have painted figures in paintings by a number of different artists. As he worked in Amsterdam a collaboration with de Lorme is not very likely.

In his earliest paintings of the St. Laurenskerk, dating from 1652-53, de Lorme uses a close vantage point and emphasises the fall of light. In a late painting of 1669 in Rotterdam,[6] the view is more distant and the composition simplified. A date some time in the early 1660's might be suggested for no. 558.

1. Waagen 1854, vol. 3, p. 209.
2. Jantzen 1979, pp. 226-27.
3. Quoted by Liedtke 1982, p. 69.
4. *Ibid.*, p. 69ff.

5. Wheelock 1975-76, p. 181.
6. Museum Boymans-van Beuningen, inv. no. ST12.

DIRCK MAES Haarlem 1656-1717 Haarlem

He was born in Haarlem on 12 September 1656 and was a pupil of Hendrick Mommers and Nicolaes Berchem (q.v.) and a friend and follower of Jan van Huchtenburg. He became a member of the Guild of St. Luke in Haarlem in 1678 and of the Guild of St. Luke in The Hague in 1697. He went to England with William III. He was in particular a painter of horses and included them in portraits, hunting scenes and riding-school pictures. He was also an engraver. He died in Haarlem on 25 December 1717.

147 William III hunting at Het Loo (Fig. 100).

Oil on canvas, 42 × 36 cms. (18½ × 25¼ ins.).

CONDITION: some small paint losses in the area of the man kneeling, left. Also paint losses in the horse on the left and in the tail of the horse on the right. Cleaned, lined and restored in 1968.

PROVENANCE: Christie's, where purchased, 1875, for £10.[1]

LITERATURE: Henkel 1929, p. 544; Leeuwarden/'S-Hertogenbosch/Assen 1980, no. 195, p. 113.

William III, Prince of Orange, the posthumous son of William II and his consort Mary (daughter of Charles I of England) became King of England, Scotland and Ireland in 1689. In 1686 he built, as a royal residence, the palace of Het Loo which is near Appeldoorn. In no. 147 the King is shown wearing the Garter star. Both he and his horse are shown in the exact pose (with the exception of his right arm) which Maes used for Plate 1 of a series of nine etchings, *The riding school.*[2] The rider and horse on the extreme left of no. 147 are shown almost exactly in the pose depicted in Plate V of the series, *Horseman making his horse curvet.*[3]

No. 147 is comparable in subject matter with two paintings at the Palace of Het Loo, Appeldoorn: both show William III at the hunt. In one of these pictures[4] he is shown stag hunting; in the other[5] he is hunting boar. In all three he wears similar costume to that worn in no. 147. *The boar hunt* is dated 1696. The landscape and view are similar in all three pictures and no. 147 may also be dated about 1696.

1. The Director of the Gallery placed no. 147 before the Governors and Guardians at their meeting on 13 May 1875 as having recently been purchased. No. 147 is entered in the *ms.*

Register of the Gallery in March 1875 as having been purchased at Christie's. The compiler has been unable to trace the painting in the sale catalogues.

2. Repr. Hollstein 1949-, vol. 11, p. 149.

3. *Ibid.*
4. Inv. no. 242.
5. Inv. no. 271. Repr. Leeuwarden/'S-Hertogenbosch/Assen 1980, p. 112.

Style of DIRCK MAES

1972 A coach party with a classical building (Fig. 196).

Oil on canvas, 55 × 65 cms. (21½ × 25½ ins.).

CONDITION: paint surface in fair condition. Damaged in the area of the architrave surmounting the columns and also, bottom left.

PROVENANCE: Patrick Sherlock, by whom bequeathed, 1940 (Sherlock Bequest).

Always hitherto catalogued as Dutch School, the composition of no. 1972 with a coach party in the countryside with classical buildings is of a type painted by Dirck Maes.[1] No. 1972 is of poor quality, although probably eighteenth century in date.

1. See for example the *Portrait of Joan Ortt and his family on horseback* in a Dutch private collection, repr. Leeuwarden/'S-Hertogenbosch/Assen 1980, no. 25, p. 68.

NICOLAES MAES Dordrecht 1634-1693 Amsterdam

He was born in January 1634. According to Houbraken, Maes learned drawing from 'an ordinary master' and painting from Rembrandt (q.v.) with whom he studied in Amsterdam in the late 1640's or early 1650's. By the end of 1653 Maes had returned to Dordrecht where he remained for about twenty years. He married in Dordrecht in 1654. According to Houbraken he travelled to Antwerp to study the works of Rubens, van Dyck, Jordaens and other Flemish painters; and this visit probably took place in the mid-1660's. By 1673 Maes had moved to Amsterdam where he died in December 1693. His earliest dated work is of 1653. He painted some biblical subjects early in his career and domestic genre scenes in the late 1650's. He began painting portraits by 1655 and after 1660 confined himself to portraiture; and in those the influence of the Flemish painters is apparent.

204 Portrait of a lady (Fig. 101).

Oil on canvas, 55.2 × 42.7 cms. (21¾ × 16¾ ins.).

REVERSE: label on stretcher inscribed *Duchess of Portsmouth*.

CONDITION: good. Large damage above the left shoulder.

PROVENANCE: Sir Henry Page Turner Barron, by whom presented, 1898.

LITERATURE: Hofstede de Groot 1908-27, vol. 6, no. 443, p. 577.

A label on the stretcher describes the sitter as the Duchess of Portsmouth, and the painting was known as such to Sir Henry Page Turner Barron.[1] If that were the case she would be intended as Louise Renée de Penancoet de Kéroualle (1649-1734) who was created Duchess of Portsmouth in 1673. There are many portraits, both presumed and real, of that Duchess of Portsmouth, but the portrait in the British Royal Collection[2] by Simon Verelst may be cited for comparison with no. 204. It dates from about 1670-72 and shows a lady whose mien and pose have something in common with no. 204. For that reason no. 204 may have been thought to have been the Duchess of Portsmouth, although she clearly is not. The sitter in no. 204, however, does bear something of a striking resemblance to Catherine Dierquens (1664-1715) whose portrait by Maes, of similar size to no. 204, is in the Mauritshuis.[3] Maes used the device of the dolphin fountain in numerous portraits of women.

On the basis of the costume, a date late in the 1680's might be proposed.

1. In a letter to the Director of the Gallery, Henry Doyle, dated 13 June 1898, he described the painting as *The Duchess of Portsmouth*.

2. Millar 1963, no. 294, p. 132.
3. Inv. no. 718. Repr. *The Hague, Mauritshuis, cat. 1977*, p. 143.

347 Vertumnus and Pomona (Fig. 102).

Oil on panel, 48.5 × 60.4 cms. (18½ × 24 ins.).

SIGNED AND DATED: falsely, on the base of the balustrade, right, *N Maes 1673*

CONDITION: the support, which is cradled, consists of three members joined on horizontals at 5.6 cms. and 25 cms. from the top. The upper member (48.5 × 5.6 cms.) consists of two members joined on a vertical 9 cms. from the right. The upper member is also an addition to the original support, and, on the surface, has been integrated into the overall composition: it is, however, part of another picture and is painted over. The paint surface is in fair condition. Cleaned in 1981.

PROVENANCE: possibly W. Smits and others sale, The Hague, 18 May 1785, lot 175 (as Lastman) bt. Carré;[1] Lord Northwick, Thirlestane House by 1846; his sale, 26 July-30 August 1859, lot 160, bt. P. Norton; J. C. Robinson sale, Paris, 7-8 May 1868, lot 29; Thoré Burger sale, Paris, 5 December 1892, lot 29, bt. Bourgeois, from whom purchased, 1894, for £120.

LITERATURE: Thirlestane 1846, no. 151; Waagen 1854, vol. 3, p. 207; Hofstede de Groot 1908-27, vol. 6, nos. 11 and 11a, p. 481; Wichman 1929, p. 547; Potterton 1982, p. 106 and n. 23-27, p. 107.

The subject is from Ovid's *Metamorphoses* (14: 623-97). Vertumnus, God of the Seasons, tried to woo Pomona, who was a skilled gardener and grower of fruit, in various disguises and finally as an old woman. When this failed he revealed himself to her in his true shape, as a youthful God, and Pomona was conquered. The subject, which was always popular with painters, was treated by most of the painters in the circle of Rembrandt including Bol,[2] Flinck,[3] van den Eeckhout[4] and Aert de Gelder.[5] None of the pictures by these painters, however, bear any compositional relationship to no. 347. The composition does, however, relate in a general way to a drawing by Rembrandt of *Vertumnus and Pomona*.[6] The drawing shows Pomona seated on the left of Vertumnus with her arms arranged similarly to the manner of no. 347; her basket of fruit is on the ground before her and Vertumnus leans towards her, his staff standing on the ground behind him. The drawing is of about 1643.

The picture was described in 1846 as 'painted on copper. Two females seated on a bench, with a basket of fruit before them on the ground — very highly coloured, by Nicolas Maes'.[7] Waagen[8] called it 'Nicolas Maes — two women conversing; very lively' and it was referred to in the Thirlestane House sale catalogue as 'a fine work of this admired master (Maes)'. In the Robinson sale catalogue it was said to be 'characterised by a size and simplicity of style, together with a strength of colour and transition of effects from dark to light that even Rembrandt did not surpass. It is signed and dated as follows: N. Maes, 1673'. Hofstede de Groot[9] called it 'somewhat crudely painted; early in style' and he refers to the signature as a forgery.

No. 347 is indeed an early work and probably dates from about 1650-55.

1. No. 347 was erroneously described in 1846 (Thirlestane 1846) as painted on copper. A now lost *Vertumnus and Pomona*, said to have been painted on copper and measuring 18.9 × 24.3 ins., therefore similar in size to no. 347, was included in this sale as Lastman (Freise 1911, no. 109, p. 81); and it is not impossible that it was no. 347.
2. Cincinnati Art Museum, inv. no. 212 Repr. Blankert 1982, pl. 7.

3. Coll. Count Potocki, Paris, 1911. Repr. von Moltke 1965, fig. 101, p. 86.
4. Szépmüvészeti Múzeum, Budapest, inv. no. 228. Repr. Sumowski 1983-, vol. 2, p. 836.
5. National Gallery, Prague, inv. no. 197. Repr. Sumowski 1983-, vol. 2, p. 1215.
6. Repr. Benesch 1954-57, vol. 3, fig. 683.
7. Thirlestane 1846, no. 151.
8. Waagen 1854, vol. 3, p. 207.
9. Hofstede de Groot 1908-27, vol. 6, p. 481.

GABRIEL METSU Leiden 1629-1667 Amsterdam

He was the son of the Flemish painter Jacques Metsue and was born in Leiden, probably in January 1629. According to Houbraken he was apprenticed to Gerard Dou. In March 1648 he was one of the founder members of the Guild of St. Luke in Leiden. By mid-1657 the artist had moved to Amsterdam where he married in April 1658 and became a citizen there in January 1659. He died in Amsterdam in 1667 and was buried in the Nieuwe Kerk on 24 October. He was mainly a painter of genre scenes but also painted some few portraits, still-life and game-pieces.

After GABRIEL METSU

1996 A cavalier and lady (Fig. 197).

Oil on panel, 36.8 × 92.6 cms. (14⅜ × 11⅝ ins.).

CONDITION: fair. Heavily discoloured varnish.

PROVENANCE: purchased in London, in 1863, for £10.[1]

No. 1996 is a copy after a painting by Metsu in the Louvre[2] and indeed was purchased as such. It is probably late eighteenth century in date.

1. The Director of the Gallery, Mulvany, reported to the Governors and Guardians at their meeting on 3 December 1863 that on 16th October 1863 he had attended a sale in London and purchased no. 1996. No such sale is listed in Lugt. See also Style of de Moucheron no. 337, after A. van de Velde no. 1883 and after Wouwerman no. 1386.

2. Inv. no. 1461. Repr. *Paris, Louvre, cat. 1979,* p. 88.

HENDRIK DE MEYER active in Rotterdam c.1620-1690

He painted landscapes and beach scenes with many figures, horsemen etc. His river landscapes are somewhat in the manner of Jan van Goyen (q.v.). In his landscapes he uses a warm tone and in these follows the manner of Aelbert Cuyp (q.v.).

1706 A seacoast with figures (Fig. 103).

Oil on panel, 62.5 × 92.7 cms. (24⅝ × 36⅞ ins.).

SIGNED: bottom left, *H D Meÿer* (Fig. 257).

CONDITION: the support consists of three members joined on horizontals at 8.8 cms. and 40 cms. from the top. Paint surface much worn in the darks and possibly also in the sky. Discoloured varnish.

PROVENANCE: by descent in the family of the Earls of Milltown to Geraldine, Countess of Milltown, by whom presented in memory of her husband, the 6th Earl of Milltown (Milltown Gift) 1902.

In the deed of the Milltown Gift, no. 1706 is attributed to Hendrick van Balen and it has always been so called at the Gallery and said to be signed *H B*. It is, however, signed by Hendrik de Meyer. There is no record as to when the painting was acquired for the Milltown Collection, and there is no obvious mention of it in the earliest Milltown inventory, that published by Neale in 1826.[1]

The composition is related to a signed and dated painting by de Meyer of 1640 which was in the Galerie Sanct Lucas, Vienna in 1954.[2] The horse and cart in the centre of no. 1706 are repeated exactly in the Vienna painting and there are other similarities in the staffage as well. It is possible that the scene depicted is Zandvoort.[3]

In view of the similarity of no. 1706 to the painting mentioned above which is dated 1640, a date of about that time may be suggested.

1. Neale 1826, no pagination.
2. Photograph in the RKD.

3. The mount of the photograph of the Vienna picture in the RKD is inscribed 'Zandvoort'.

Style of HENDRIK de MEYER

1674 Shipping in inland waters (Fig. 199).

Oil on panel, 41 × 70 cms. (16⅛ × 27½ ins.).

CONDITION: very poor. The paint surface has been badly rubbed throughout. The support consists of two members joined on a horizontal 20 cms. from the top. Cleaned, but not restored, and the join refixed, 1985.

PROVENANCE: by descent in the family of the Earls of Milltown, Russborough, county Wicklow to Geraldine, Countess of Milltown, by whom presented in memory of her husband, the 6th Earl of Milltown, (Milltown Gift), 1902.

The view may be intended as Dordrecht.[1]

No. 1679 was ascribed to Jan van Os in the Milltown Deed of Gift prepared by Armstrong and always so catalogued at the Gallery. It is of very poor quality and also in very poor condition and no secure attribution would be possible. It could originate from the last quarter of the seventeenth century and Hendrik de Meyer did paint such compositions.[2]

1. Compare for example the *Shipping near Dordrecht* by C. W. Schut in the Kunsthalle, Hamburg. Repr. Bol 1973, fig. 274, p. 271.

2. See for example the *View on the Maas* formerly with Brian Koetser, London, Repr. Bol 1973, fig. 272, p. 269.

MICHIEL VAN MIEREVELD Delft 1567-1641 Delft

According to van Mander he was born in Delft on 1 May 1567 and studied with Willem Willemsz. and 'Augustijn' in Delft and, when he was about fourteen, with Anthonie van Bloklandt at Utrecht for about two and a quarter years. With Bloklandt's death in 1583 he returned to Delft and devoted himself to portraiture. He married in Delft in 1589 and was a member of the Guild of St. Luke there sometime before 1613. He painted many portraits for members of the Stadhouder's court at The Hague and became a member of the Guild of St. Luke at The Hague in 1625; but apparently he continued to live at Delft where he remarried in 1633 and died on 27 June 1641. He was exclusively a portrait painter, and there is in general often more than one version of his works, many of which were also engraved, notably by Willem Jacobsz. Delff who was his son-in-law.

Ascribed to MICHIEL VAN MIEREVELD

39 Portrait of a lady (Fig. 104).

Oil on panel, 69.2 × 55.3 cms. (27¼ × 21¾ ins.).

CONDITION: the support consists of three members joined on verticals at 13 cms. and 43 cms. from the right. The paint surface is in poor condition and considerably worn throughout. The hand may be entirely overpainted and there is much overpaint throughout. Cleaned in 1970.

PROVENANCE: purchased in London, 1872, for £50.[1]

LITERATURE: Armstrong 1890, p. 288; de Jonge 1938, no. 32, p. 134.

ENGRAVING: by Jonnard, 1890.[2]

On acquisition no. 39 was catalogued as a *Portrait of a lady* of the Audley family. In 1898 Armstrong identified her as probably Elizabeth Brydges (d.1684) daughter of the 5th Baron Chandos of Sudeley, who married James, 3rd Earl of Castlehaven and Baron Audley. This identification of the sitter is most unlikely.

No. 39 was acquired as the work of Cornelius Jonson, and so catalogued until 1898 when Armstrong 'ascribed' the portrait to Moreelse. In 1904 he gave it to van Miereveld. In 1928 it was returned to Moreelse. The attribution to Moreelse was rejected by de Jonge[3] on stylistic grounds and she suggested Cornelius Jonson. On the basis of a photograph, Aileen Ribiero[4] accepts the attribution to van Miereveld. She has described the sitter as upper-class and fashionable and suggests that, on account of the veil, no. 39 may be a betrothal portrait.

Ribiero suggests a date of about 1625-30 on the basis of the costume.

1. No. 39 is recorded in the Director's Annual Report for 1872 as having been purchased in that year. There is no formal minute of the purchase; but the minutes of the meeting of the Governors and Guardians on 6 June 1872 are annotated in pencil in the margin, 'Portrait of a Lady. C. Janssens. £50'. No. 39 was first catalogued in 1875 and the provenance given as 'purchased in London in 1872 at the sale of some pictures belonging to the Audley family'. The compiler has been unable to trace such a sale and has only been able to confirm that no such sale took place at Christie's (information from Margaret Christian in Christie's).
2. Published in *Magazine of Art* (1890), p. 288.
3. de Jonge 1938, p. 134.
4. In a communication in 1985.

After MICHIEL VAN MIEREVELD

640 Portrait of Hugo Grotius (1583-1645) (Fig. 105).

Oil on panel, 65 × 54.5 cms. (25⅛ × 21½ ins.).

CONDITION: the paint surface is in fair condition. The support consists of three members joined on verticals at 17 and 39.5 cms. from the right.

PROVENANCE: Mrs. Lecky of Dublin, by whom bequeathed, 1912.

LITERATURE: van Beresteyn 1929, no. 22, p. 50.

Hugo Grotius or de Groot, who was an infant prodigy, read classical languages and sciences at Leiden University from 1595-98. At the age of sixteen he took the oath as an advocate at The Hague, and was part of a diplomatic mission to England in 1613. He was imprisoned after the defeat of the Synod of Dordrecht in 1618, and escaped in 1621 to Paris where he entered the service of the Queen of Sweden as Ambassador in 1634. He wrote numerous theological, philological and legal works and was one of the founding fathers of International Law.[1]

No. 640 has previously been catalogued as Moreelse. It is one of the many versions of a well-known portrait of Hugo Grotius dated 1631 and inscribed with the sitter's age, 48.[2] The original portrait, which according to van Beresteyn is in the Stadhuis, Delft, was engraved by W. Delff in 1632.[3] van Beresteyn lists nine copies or versions of the portrait including no. 640. There are others in the Rijksmuseum, Amsterdam, the University Library, Leiden, the Musée Condé, Chantilly, the Gemeentemuseum, The Hague, and formerly at Rossie Priory, Scotland.

No. 640 is probably contemporary or near contemporary with the original.

1. See London 1964, under cat. no. 55.
2. van Beresteyn 1929, erroneously gives the

sitter's age as 58 on this picture.
3. Hollstein 1949-, vol. 5, no. 30.

JAN MIENSE MOLENAER Haarlem c.1610-1668 Haarlem

He was born in Haarlem about 1610, and is often referred to as a pupil of Frans Hals (q.v.) although nothing certain is known of his training. In June 1636 he married the painter Judith Leyster (q.v.) in Heemstede and he is at that time recorded as a resident of Haarlem. Shortly after the marriage the couple moved to Amsterdam, where they are recorded until 1648: in 1644 the painter Jan Lievens (q.v.) is recorded living in their house. In October 1648 they returned to Heemstede where they bought a house. They continued to live in the Haarlem-Heemstede area, although they bought a house in Amsterdam in 1655 and in the same year bought another house in Haarlem. Molenaer was buried in Haarlem on 19 September 1668. He is principally known as a painter of genre scenes of low and high life; but also painted some few portraits, allegorical works and theatre scenes.

45 Peasants teaching a cat and dog to dance (Fig. 106).

Oil on panel, 54.6 × 71.2 cms. (21½ × 28⅛ ins.).

SIGNED: on the stretcher of the table, *J. Molenaer.* (Fig. 258).

REVERSE: collector's seal (Fig. 288). *Ms.* labels: *no. 19* and *Mr. Doyle (1).*

CONDITION: the support consists of two members joined on a horizontal 28.2 cms from the top. Paint surface in good condition. Cleaned in 1982.

PROVENANCE: H. E. Wyatt sale, Foster's, London, 19 March 1873, lot 119, bt. Waters on behalf of the Gallery for 20 guineas.

LITERATURE: Armstrong 1890, p. 284.

They are shown in a peasant interior. On the right, a woman tending a fire in the next room is visible. The children, although the boy and girl in the centre must be at least teenaged, are making a cat and dog dance to the music of the youngest child beating a morion with spoons. A similar detail occurs in Molenaer's *Two boys and a girl making music* dated 1629 in London.[1]

Molenaer painted many paintings showing children making music, and some few of them show them dancing with cats and dogs.[2] In such scenes he also included, on occasion, adults. Molenaer was the main practitioner of this type of genre in seventeenth-century Dutch painting[3] although such scenes were taken up by Jan Steen later in the century.[4] Molenaer's paintings have been justifiably compared to the contemporary work of the brothers Le Nain in France,[5] but one essential difference between the two is that Molenaer's children enjoy themselves, whereas the Le Nain children are preoccupied and serious. An important element in such compositions by Molenaer is the sense of parody: the children parody adult pastimes such as music making, dancing and drinking;

the child, second from left in no. 45, holds a beaker in a very adult gesture. It has been suggested[6] that such scenes are intended to convey a sense of dissipation and impropriety, which is all the more obvious as it is demonstrated by children parodying the adult world. The dancing of the cat and dog serve merely as a source of amusement for the children; it holds no rewards for the animal itself, and it conveys dominance and servility. To the compiler, however, such scenes would seem more appropriate as demonstrations of the carefree life of children. An engraving after a painting by Molenaer's wife, Judith Leyster[7] shows two children with a cat, and the verse on the print celebrated the children's freedom from care.

The type of interior depicted in no. 45 (and indeed the children themselves) is very much less elegant than what one finds in Molenaer's early works. No. 45 is painted under the influence of Adriaen van Ostade and a date in the late 1630's may be suggested. A stylistic comparison may be made between the picture and *The Five Senses* by Molenaer in The Hague[8] which are dated 1637.

1. National Gallery, cat. no. 5416. Repr. *London, National Gallery, cat. 1973*, p. 471.
2. For example, the painting sold at Christie's, 8 July 1983, lot 32, repr. Durantini 1983, fig. 158, p. 285; the painting sold at Sotheby's, Amsterdam, 2 April 1973, lot 146, repr. Durantini 1983, fig. 159, p. 286; and the painting with Agnew 1976, repr. *Burlington Magazine* vol. 118 (1976), p. 429.
3. See de Mirimonde 1964, pp. 270-73.
4. For example Steen's painting of *Children*
teaching a cat to dance in the Rijksmuseum, Amsterdam, inv. no. A718, repr. *Amsterdam, Rijksmuseum, cat. 1976*, p. 523.
5. By de Mirimonde 1964, p. 273; and by Nicolson in *Burlington Magazine* vol. 118 (1976), p. 443.
6. By Durantini 1983, pp. 280-87.
7. Repr. Brown 1978, fig. 25A, p. 37.
8. Mauritshuis inv. nos. 572-76, repr. *The Hague, Mauritshuis, cat. 1977*, pp. 158-59.

KLAES MOLENAER Haarlem c.1630-1676 Haarlem

He was a cousin of Jan Miense Molenaer (q.v.). He became a member of the Guild of St. Luke in Haarlem in 1651 and worked there throughout his life. He painted some genre scenes, but mainly river or winter landscapes following the manner of Jacob van Ruisdael (q.v.). His winter landscapes are also somewhat in the manner of Adriaen van Ostade (q.v.).

682 A winter scene (Fig. 107).

Oil on panel, 47 × 62.6 cms. (18½ × 24⅞ ins.).

SIGNED: on the sledge, bottom left: *K. Molenaer* (Fig. 259).

REVERSE: collector's seal. (Fig. 289).

CONDITION: the support consists of two members joined on a horizontal 23 cms. from the top. Worn in parts throughout, particularly in the area of the building in the centre. Cleaned in 1984.

PROVENANCE: Mrs. Vincent Nugent of Castleconnel, county Limerick, by whom bequeathed, 1914.

Unlike many paintings of winter scenes, no. 682 does not show skaters enjoying themselves on the ice, but instead people going about their business during winter. The buildings on the right are possibly intended as the walls of Molenaer's native Haarlem. On the extreme right is an inn; the wreath hanging from the pole above the door indicates that refreshments were available there. A horse-drawn sledge carries fodder for animals and several other figures push sledges across the ice. This type of composition which was influenced in particular by the work of Isack van Ostade was repeated by Molenaer with some variation in many of his pictures.

PIETER DE MOLIJN London 1595-1661 Haarlem

He was the son of Flemish parents and was baptised in London on 6 April 1595. He became a member of the Guild of St. Luke in Haarlem in 1616. He was Dean of the Haarlem Guild of St. Luke in 1633, 1638 and 1646 and was Commissioner of the Guild in 1631, 1637, 1645 and 1649. He was buried in Haarlem on 23 March 1661. His earliest landscapes are somewhat in the style of Cornelis Vroom who was the leading landscape painter in Haarlem at the time. He probably knew Jan van Goyen (q.v.) who was, in 1617, a pupil of Esaias van de Velde in Haarlem; and de Molijn himself was also influenced by the latter. His development as a landscape painter paralleled that of van Goyen.

8 Prince Maurits and Prince Frederik Hendrik going to the chase (Fig. 108).

Oil on panel, 34.9 × 55.9 cms. (13¾ × 22 ins.).

SIGNED AND DATED: in the foreground, right of centre: *P de* (in monogram) *Molÿn fecit 1625.* (Fig. 260).

CONDITION: good. The support has been extended by about 2.5 cms. along the bottom: the extension is most probably original. Cleaned in 1986.

PROVENANCE: purchased in Paris in 1864, for 30 guineas.[1]

LITERATURE: Hofstede de Groot 1908-27, vol. 8, p. 9; Fokker 1931, p. 49.

No. 8 was purchased as and has since been called *The Stadholder going to the chase;* and the principal figures on horseback have been identified by de Bruyn Kops[2] as, on the left, Maurits, Prince of Orange, and on the right, Frederik Hendrik, Prince of Orange. Maurits, Prince of Orange (from 1618) and Count of Nassau, was born in Dillenburg in 1567 and died at The Hague in 1625. He was the son of William the Silent by his second wife, Anne of Saxony. Following the assassination of his father in 1584 he became Stadhouder of the United Provinces. Under his rule the United Provinces rose to be the greatest sea power in the world with extensive colonies in the East and West Indies and consequent wealth at home. Frederik Hendrik, Prince of Orange and Count of Nassau, was born in Delft in 1584 and died at The Hague in 1647. He was the youngest son of William the Silent by his fourth wife, Louise de Coligny. Following the assassination of his father in 1584, his mother took him to France where he spent his youth at the court of Henry IV. With the death of his half-brother Maurits in 1625, he became Stadhouder and at the same time Commandant General of the Dutch armies. His success in leading

the Dutch to a number of victories on the field forced Spain's recognition of the Independence of the United Provinces, but he died shortly before the Treaty of Münster (which gave that Independence) was signed in 1647. He married Amalia van Solms in 1625 and his son by that marriage succeeded him as William II. Both Prince Maurits and Prince Frederik Hendrik were avid sportsmen.[3] In no. 8 the figures wearing dark green breeches and capes and carrying wide-brimmed grey hats are the personal bodyguard of Prince Maurits who wore such uniforms.[4] The tower in the background, centre, is probably intended as the St. Jacobskerk (or Grote Kerk) in The Hague.

No. 8, which was painted in the year of Prince Maurits's death and Prince Frederik Hendrik's marriage, is of a type, a cavalcade, painted by several artists in early seventeenth-century Holland.[5] Among the artists who painted such cavalcades were Adriaen Pietersz. van de Venne (1589-1662),[6] Pauwels I van Hillegaert (1595/96-1640)[7] and Hendrik Ambrosius Pacx (1602/03-after 1658).[8] The pictures were intended as ceremonial portraits and, not infrequently, included both posthumous and living portraits of members of the House of Orange; in doing so they were intended to underline the dynastic ambitions of the Stadhouders.[9] By showing the cavalcade in a landscape setting, de Molijn's composition has some affinity with a *Cavalcade of the Nassaus*, by Pauwels I van Hillegaert,[10] which also includes portraits of Prince Maurits and Prince Frederik Hendrik.

No. 8, which is one of de Molijn's earliest dated paintings, is also highly unusual within his *oeuvre*. He is best known as a landscape painter and only early in his career did he include figures in his landscapes,[11] and no. 8 may be the only example of him including portraits. In his landscape paintings, de Molijn was influenced by the work of Esaias van de Velde[12] who, having worked in Haarlem, moved to The Hague in 1618.[13] There in 1625, that is in the same year as no. 8 was painted, van de Velde also painted a cavalcade painting of Prince Maurits and Prince Frederik Hendrik, showing them at the Rijswijk horse fair.[14] Although there is no documentary evidence that de Molijn worked at The Hague, the style and subject matter of no. 8 would indicate fairly strongly that he did so, and, furthermore, that he was still in contact with Esaias van de Velde in 1625.

1. The Gallery Director's Annual Report for 1864 states that no. 8 was purchased in Paris during the year. There is no further record in the archive of the Gallery as to its provenance.
2. On a visit to the Gallery in 1968.
3. As pointed out by Sullivan 1980, pp. 236 ff. He cites for information A. B. Wigman, *Halali, Cultuurhistorische notities van Wild en Wildwerk* (Utrecht 1963).
4. See Keyes 1984, under no. 17, p. 123.
5. See Sluijter-Seijffert 1983-84, *passim* and also Leeuwarden / 'S-Hertogenbosch / Assen 1980, pp. 15-17.
6. For example, *Prince Maurits and Prince Frederik Hendrik at the Valkenburg Horse Fair* in the Rijksmuseum, Amsterdam, inv. no. A676, repr. *Amsterdam, Rijksmuseum, cat. 1976*, p. 565.
7. *Cavalcade of the Nassaus*, Oranje-Nassau Museum, The Hague, on loan to the Rijksmuseum Paleis Het Loo, Appeldoorn, repr. Leeuwarden / 'S-Hertogenbosch / Assen 1980, fig. 15, p. 16.
8. *The Princes of Orange and their family on the Buitenhof*, Mauritshuis, The Hague, inv. no. 5456, repr. Sluijter-Seijffert 1983-84, p. 53.
9. See Sluijter-Seijffert 1983-84, p. 52.
10. See n. 7 above.
11. See for example the signed and dated *Landscape with figures* of 1626 in the Amalienstift, Dessau, inv. no. 99, repr. Bernt 1948-62, vol. 2, no. 546.
12. Keyes 1984, p. 42.
13. *Ibid.*, p. 33.
14. Six Foundation, Amsterdam. Repr. Keyes 1984, pl. 129.

97

MONOGRAMMIST IS active 1642-1652

The identity of the artist has not been established. He is known to be Dutch and there are dated paintings from 1642 (no. 247 below) until at least 1652.

247 A Dutch kitchen interior (Fig. 109).

Oil on panel, 42.5 × 38.1 cms. (16¾ × 15¹⁄₁₆ ins.).

DATED: bottom, left of centre, *1642.*

REVERSE: collector's seal. (Fig. 290).

CONDITION: good, underneath heavily discoloured varnish.

PROVENANCE: Rev. T. Bacon sale, Christie's, 27 June 1885, lot 92, where purchased for 145 guineas.

LITERATURE: Armstrong 1890, p. 283; Armstrong 1891, pp. 111-12; Hofstede de Groot 1927a, fig. 1, p. 184; Stechow 1973, n. 1, p. 75.

She is seated, her feet on a footwarmer, at a spinning-wheel although the actual wheel is hidden behind her. There is no flax on the spindle indicating that her work is done, an impression that is enhanced by the fact that the various churns and pans seem to have been tidied away.

No. 247 was sold in 1885 as Brekelenkam, catalogued as such at the Gallery and so published by Armstrong.[1] It was attributed to Isaack Koedijk by Hofstede de Groot.[2] The attribution to the Monogrammist IS was first suggested by Renckens,[3] accepted by van Thiel and de Bruyn Kops,[4] and published as such by Stechow.[5]

The artist, who was first identified by von Frimmel,[6] is known through some few paintings which are signed by the monogram IS. There is a variety in the type of scene portrayed by him[7] ranging from half-length figures and heads of old men and women to more unusual pieces showing figures in pseudo-eastern costume. All of his works are characterised by a sense of loneliness or isolation which is also apparent in no. 247. No. 247 is the only straightforward interior genre scene at present known by him and, as it is dated 1642, it is also a decade earlier than any other so far identified work.

1. Armstrong 1890, p. 283 and Armstrong 1891, pp. 111-12.
2. Hofstede de Groot 1927a, fig. 1, p. 184.
3. In a letter dated 18 January 1966 now in the archive of the Gallery.
4. On a visit to the Gallery in 1968.
5. Stechow 1973, n. 1, p. 75.

6. von Frimmel 1904, pp. 132-33.
7. See Bernt 1948-62, vol. 4, nos. 194 and 195; also ascribed to him is *An old man seated at a table* in Braunschweig, inv. no. 551, repr. *Braunschweig, Anton-Ulrich Museum, cat. 1983,* p. 144.

PAULUS MOREELSE Utrecht 1571-1638 Utrecht

He was born in Utrecht in 1571, and is said to have been a pupil of Michiel van Miereveld (q.v.) in Delft. He visited Italy, possibly in 1598-1602, but was back in Holland by June

of 1602 when he married. He took a prominent part in the foundation of the Guild of St. Luke in Utrecht in 1611, and served the Guild as Dean on a number of occasions between 1611 and 1619. In 1618 he joined the town council in Utrecht, in 1627 became an alderman and was treasurer in 1637. He painted some religious and mythological pictures, but he was mainly a portraitist.

263 Portrait of a child (Fig. 110).

Oil on canvas, 105.3 × 82.3 cms. (41½ × 32½ ins.).

SIGNED AND DATED: left, *Moreel fe 1623*. (Fig. 261).

CONDITION: the figure is in good condition. There are numerous line damages at each side giving the impression that the canvas may once have been rolled at the edges. Cleaned and restored in 1983.

PROVENANCE: Collins sale, Christie's, 12 December 1885, lot 82, where purchased for 5 guineas.

LITERATURE: Armstrong 1890, p. 282; Stechow, Ozinga 1931, pp. 131-32; de Jonge 1938, pp. 24, 33 and no. 68, p. 87.

No. 263 was described by Armstrong[1] as 'a *Portrait of a child* in which some charm of conception is combined with Moreelse's usual academic sufficiency'.

The sitter was identified tentatively by de Jonge[2] as Elisabeth van Nassau (1620-28) the daughter of Ernst Casimir van Nassau-Dietz (d.1632) and his wife Sophia Hedwig van Nassau-Brunswijk-Wolfenbuttel (1592-1642). Elisabeth van Nassau's appearance in 1623 is known through an inscribed and dated portrait of that year by Wybrand de Geest;[3] and a comparison between that picture and no. 263 makes it quite clear that the sitter in no. 263 is not Elisabeth van Nassau.

The medallion on the chain worn by the child is not identifiable. It could reasonably represent Prince Maurits of Orange who was, at the time the picture was painted, Stadhouder of the Netherlands.

1. Armstrong 1890, p. 282.
2. de Jonge 1938, pp. 24, 33 and 87.
3. Coll. Stichting Historische Verzamelingen

van het Huis Oranje Nassau. Repr. Paris 1986, fig. 2, p. 205.

FREDERIK DE MOUCHERON Emden 1633-1686 Amsterdam

According to Houbraken he was born in Emden in 1633 and was early a pupil of Jan Asselijn in Amsterdam. He visited France and was in Lyons and Paris in 1656. After a brief stay in Antwerp he returned to Amsterdam by 1659 and he remained there for the rest of his life. He was buried in Amsterdam on 5 January 1686. He painted Italianate landscapes in the style of Jan Both (q.v.). According to Houbraken the figures in his landscapes were often painted by Adriaen van de Velde (q.v.).

52 An Italianate landscape (Fig. 111).

Oil on canvas, 114 × 92 cms. (45 × 36¼ ins.).

SIGNED: bottom, left of centre, *Moucheron*

CONDITION: good. Somewhat worn in the darks and in the area of the mountain. Cleaned and restored in 1972.

PROVENANCE: the Ven. Charles Thorp, Archdeacon of Durham sale, Christie's, 6-7 May 1863, lot 810, where purchased for £58.

No. 52 was sold in 1863 as 'Moucheron' and first catalogued at the Gallery as Frederik de Moucheron. It remained as Frederik until 1882 when Doyle gave it to Isaac de Moucheron and it remained so attributed until 1971 when it was returned to Frederik. It is a characteristic work by Frederik of good quality and on the basis of style may be dated to the late 1670's.

Style of FREDERIK DE MOUCHERON

337 An Italianate landscape with muleteers (Fig. 198).

Oil on panel, 38 × 33.5 cms. (14⅞ × 13³⁄₁₆ ins.).

SIGNED: falsely, bottom right: *Mouch....n f*

REVERSE: a printed cutting as follows: *Moucheron 83. Peasants with laden mules under a wooded height on which is a Roman ruin lightened by a warm evening sky.*[1]

CONDITION: poor. Very thin throughout in the darks; probably much overpaint.

PROVENANCE: purchased in London in 1863 for £18 7s. 6d.[2]

The false signature has not previously been recorded. No. 337 is of very poor quality. It may be the remnant of an autograph work by Frederik de Moucheron. Its format and composition suggests that it may be the severed left hand side of a larger (horizontal) composition.

1. A painting by de Moucheron was exhibited, no. 83 at the British Institution in 1852, lent by the Earl of Falmouth. The printed entry in the catalogue reads simply '83. Landscape with figures. Moucheron, Earl of Falmouth'; so there is no means, other than the number 83, of positively identifying no. 337 with that picture.
2. See After Metsu, no. 1996, n. 1.

JAN MYTENS The Hague c.1614-1670 The Hague

He was the nephew and pupil of Daniel Mytens the Elder and father and teacher of Daniel Mytens the Younger. In 1639 he became a member of the Guild of St. Luke in The Hague and in 1656 one of the founders of 'Pictura' a confraternity of painters in The Hague. He was the most fashionable portraitist working in the capital city of Holland in the mid-

seventeenth century and was patronised by the Court, Government and the newly rich burghers. His style was influenced by his uncle and teacher, Daniel Mytens the Elder, who himself had worked at the Court of Charles I in England. Although Mytens the Elder was in England long before the arrival of van Dyck in 1632, his style of painting was very much influenced by Rubens and van Dyck; and he passed on to his pupil Jan Mytens the elegance one associates with those two great Flemish portraitists.

62 A family group (Fig. 112).

Oil on canvas, 135.5 × 169.5 cms. (53⅜ × 66¾ ins.).

SIGNED AND DATED: at the shoulder of the lady on the right, *A° 1661 Mytens F* : (Fig. 262).

REVERSE: a manuscript label on the stretcher as follows: *L'Electeur de Brandenbourg, la Princesse sa femme fille de Frederic Henri Prince d'Orange avec leurs enfants, la gouvernante et leur precepteur tous d'apres nature. Peinte par N. Maas 1667.*

CONDITION: paint surface in very good condition. Cleaned in 1968.

PROVENANCE: Marquis de Rocheb (rousseau) sale, Paris 5 May 1873, lot 181, where purchased for £160.

LITERATURE: Moes 1897-1905, vol. 2, no. 4645:14, p. 39.

No. 62 was sold in 1873 as a portrait of Friedrich Wilhelm, the last Elector of Brandenburg and his first wife, Louisa Henrietta, Countess of Nassau (1627-67) daughter of Frederik Hendrik, Prince of Orange, their son Frederick, afterwards first King of Prussia, and daughter. It was referred to as such by Moes[1] deriving his information from the Rochebrousseau sale catalogue, and so listed in the early catalogues of the Gallery. The appearance of Friedrich Wilhelm (1620-88) and his wife, Louisa Henrietta, is recorded in a full length portrait by Gerrit van Honthorst, dated 1647, in the Rijksmuseum, Amsterdam,[2] and comparison with no. 62 makes it quite clear that the sitters in no. 62 are not the Elector of Brandenburg and his family. The sitters in no. 62 remain unidentified but van Kretschmar[3] has pointed out that they are almost certainly members of the nobility or haute-bourgeoisie of The Hague. In common with other similar group portraits painted by Mytens at this time,[4] it is likely that no. 62 contains portraits of deceased relatives who are recognisable on account of their positioning outside the main group in the picture or their fancy costume. In no. 62 the man on the left, who wears a robe-de-chambre or Japanese robe, is probably the deceased father of the central figure, and the young boy by his side, also in fancy drapes, is probably a son who died young. They are linked to the group of living members of the family by the gesture of the central figure. The composition of no. 62 is related to another group portrait by Mytens, *The Family of Jacques Martini*, dated 1647, in New Orleans.[5] That picture shows a father with his second wife in the year of their marriage, and the three living children from his first marriage; his deceased wife with her children who died in infancy are also included in the portrait. As the two ladies in no. 62 appear to be of approximately the same age it is possible that the seated lady is the second wife of the man, and the standing lady is his daughter by his first marriage. The young girl may be a child by the present marriage. In Dutch seventeenth-century painting the gesture of holding a bunch of grapes by the stem is a symbol of chastity[6] that is often included in marriage portraits, indicating that fidelity

within marriage is a form of chastity. In no. 62 the man's (?) daughter by his first marriage extends this symbol of chastity to her stepmother. The dog, a King Charles spaniel, which was at the time a very fashionable breed, is also a symbol of fidelity. The peaches proffered by the young girl are a symbol of fertility.

No. 62 was sold in 1873 as the work of Nicolaes Maes (q.v.) by whom it was then falsely signed. It was so catalogued at the Gallery until 1898 when Armstrong gave it to Mytens, the signature of whom he stated appeared on the removal of the forged signature of Maes. It is one of a number of large scale group portraits in a landscape which Mytens painted from at least the late 1630's.[7]

1. Moes 1897-1905, vol. 2, no. 4645:14, p. 39.
2. Inv. no. A874. Repr. *Amsterdam, Rijksmuseum, cat. 1976,* p. 285.
3. In a letter dated 14 August 1984 now in the archive of the Gallery.
4. See under n. 7 below.
5. New Orleans Museum of Art, inv. no. 79:216, see Caldwell 1979, *passim.*
6. See further the commentary under

Ochtervelt no. 435 in this catalogue.
7. For example the painting in New Orleans referred to above, n. 5; other examples are a painting at Versailles, inv. no. 1590, signed and dated 1638; a portrait with the Leger Galleries, London in 1969, signed and dated 1641; and a portrait at Jagdschloss Grunewald, Berlin, signed and dated 1667.

150 A lady playing a lute (Fig. 113).

Oil on canvas, 79 × 63 cms. (31⅛ × 24¾ ins.).

SIGNED AND DATED: top right, *Mytens pincxit 1648.* (Fig. 263).

CONDITION: good. Cleaned in 1984.

PROVENANCE: acquired between 1827 and 1835 by Joseph Strutt of Derby;[1] thence by descent to Howard Galton of Hadzor by 1854; thence by descent to Hubert Galton; his sale (Hadzor sale), Christie's, 22 June 1889, lot 51, where purchased for 40 guineas.

LITERATURE: Waagen 1854, vol. 3, p. 222; Boydell 1985, pp. 29-32; London 1985, no. 33, p. 82.

EXHIBITED: 1857, *Manchester Art Treasures Exhibition,* no. 618 (definitive catalogue); 1882, *Worcestershire Exhibition,* Worcester, no. 358; 1969, *L'Art et la Musique,* Galerie des Beaux Arts, Bordeaux, no. 51; 1985, *Masterpieces from the National Gallery of Ireland,* National Gallery, London, no. 33.

No. 150 was exhibited in Worcester in 1882 as a *Portrait of the Countess of Derby,* and sold in 1889 as *Charlotte de la Tremouille, Countess of Derby, playing a guitar.* Waagen[2] referred to it as 'Mytens — a female portrait with a guitar'. The lady in fact plays a theorbod lute typical of the mid-seventeenth century and known in England as a French lute.[3] The lute has two distinct pegboxes. In the painting the number of strings does not correspond to the number of pegs, and the pegs are painted at random. There seems to be no evidence to support the identification of the sitter as Charlotte de la Tremouille, Countess of Derby: that Lady Derby (d.1663/64) was the daughter of the Duke of Thouars and grand-daughter of William of Nassau, Prince of Orange. Her portrait, together with her husband and daughter, by van Dyck is in the Frick Collection,[4] and shows a lady who bears no physical resemblance to the lady in no. 150. A signed and dated painting of 1652 by Gerrit van Honthorst[5] shows a lady as Minerva, and that portrait bears an inscription

identifying the sitter as Charlotte de la Tremouille; but the lady as Minerva does not appear to be one and the same as the lady in no. 150.

The composition of the painting would indicate fairly strongly that it was painted as one of a pair of portraits, and its pendant would have shown the lady's husband. While music is in general regarded as the accompaniment of love, the lute in particular was used to denote harmony.[6] The lute was, therefore, appropriate to paintings of married couples. An emblem by Jacob Cats,[7] first published in 1618, shows a man tuning a lute with a second lute on a table beside him, and he remarks that the strings of one lute resound to the tuning of the other. According to the emblem this resonance demonstrates that 'two hearts resound in one tone'. That the lute was specifically associated with marital harmony in seventeenth-century Northern painting is demonstrated in a painting by Theodoor van Thulden in Brussels.[8] In that picture a lady playing a lute is crowned by Hymen, God of Marriage.

Mytens painted a great number of pair portraits of married couples and often included some form of allegory. He was also familiar with the emblem literature of the period, in particular that of Jacob Cats.

1. Information from C. E. W. Deacon in a letter dated 6 April 1973 now in the archive of the Gallery.
2. Waagen 1854, vol. 3, p. 222.
3. Boydell 1985, p. 29-32.
4. Repr. *New York, Frick, cat. 1968*, vol. 1, p. 187.

5. Sold at Christie's, 4-5 June 1984, lot 171.
6. See Amsterdam 1976, p. 105-07.
7. Repr. Amsterdam 1976, fig. 21b, p. 106.
8. Musées Royaux des Beaux-Arts de Belgique. Repr. Amsterdam 1976, fig. 21a, p. 105.

AERNOUT (AERT) VAN DER NEER
? Gorinchem 1603 or 1604-1677 Amsterdam

According to Houbraken he was steward to a family at Gorinchem and did not devote himself entirely to painting until he moved to Amsterdam sometime before 1634. His teacher is not known but he could have studied under Raphael Camphuysen in Gorinchem; and the latter witnessed the baptism of van der Neer's children in Amsterdam in 1642. He remained in Amsterdam until the end of his life and died there on 9 November 1677. During the years 1659-62 he kept an inn in Amsterdam but became bankrupt in December 1662. He was the father of Eglon Hendrik van der Neer (q.v.). He is chiefly known for his moonlight landscapes, winter scenes and pictures with nocturnal fires. Very few of his paintings are dated.

66 A riverside town on fire (Fig. 114).

Oil on canvas, 55.1 × 66.2 cms. (21¾ × 26¹⁄₁₆ ins.).

CONDITION: poor. Worn throughout. Cleaned and restored in 1968.

PROVENANCE: Henry Farrer, decd. sale, Christie's, 16 June 1886, lot 319, where purchased for 67 guineas.

LITERATURE: Hofstede de Groot 1908-27, vol. 7, no. 457, p. 431.

No. 66 was sold in 1866 as 'a conflagration of a town on a river with boats and figures. A fine example'. The rather exaggerated sense of depth in the picture might suggest a date towards the end of the 1640's.

Style of AERT VAN DER NEER

1992 A town on fire (Fig. 200).

Oil on panel, 32.6 × 41.6 cms. (12⅞ × 13⅜ ins.).

CONDITION: fair.

PROVENANCE: unknown.

No. 1992 was catalogued in 1981 as 'School of van der Neer'; it is of poor quality and almost certainly later in date than van der Neer. It is possibly of the early nineteenth century and need not necessarily be Dutch, although here catalogued as 'Style of Aert van der Neer'.

EGLON VAN DER NEER Amsterdam c.1634-1703 Düsseldorf

According to Houbraken he was born in 1643 but this is generally taken to be a misprint for 1634. He studied with his father, the moonlight and winter-landscape painter Aert van der Neer (q.v.), and also with Jacob van Loo. About 1654 he went to France where he became painter to the Dutch Governor of the Orange Principality. By 1659 he was back in Holland and on 20 February that year he married: at the time he was living in Amsterdam where his first child was baptised in February 1660. He is recorded in Rotterdam on 20 June 1664 and on various occasions until 1679. During these years he paid visits to Amsterdam and The Hague where he was admitted to the confraternity of painters, Pictura, in 1670. On 31 December 1678 he witnessed the marriage in Amsterdam of the painter Willem van Aelst (q.v.). After the death of his wife in 1677 he went to Brussels where he was living from 1679-89 and where in 1681 he remarried. On 18 July 1687 he was appointed Court Painter to Charles II of Spain although he does not seem to have gone to Spain as he is recorded in Amsterdam in 1689. In 1690 he was appointed Court Painter to Johann Wilhelm, the Elector Palatine in Düsseldorf and he held that post, living in Düsseldorf, until his death in 1703.

He painted elegant genre interiors, history paintings, portraits and landscapes. He was the teacher of Adriaen van der Werff.

61 Portrait of a man as a hunter (Fig. 115).

Oil on copper, 56.7 × 49.9 cms. (22⁵/16 × 19⁵/8 ins.).

REVERSE: inscribed *G.M.*

CONDITION: good. Some small paint losses at the edges.

PROVENANCE: Henry Farrer, decd. sale, Christie's, 16 June 1886, lot 320, where purchased for 41 guineas.

LITERATURE: Thieme, Becker 1907-50, vol. 25, p. 375.

The man is shown with a greyhound and two spaniels in the grounds of a large country house. Hunting and the chase were governed by very strict laws and subject to a number of restrictions in seventeenth-century Holland.[1] The pursuit of game was limited for the most part to the nobility and other officers of State and even they might, for example, kill only one hare and two rabbits per week during the season, 15 September to 2 February. The use of a greyhound was permitted only once a week and the number of other dogs was limited to two or three. Bannered nobles only were permitted to hunt stags and they, only once a year. Although hunting portraits were known, for example in Italy in the sixteenth century,[2] it was only in the mid-seventeenth century that the genre begins to appear in the Netherlands when it was introduced by Rembrandt and his pupils.[3] From that time the hunting portrait became very popular and was painted by a number of artists.[4] Sullivan[5] has suggested that many of these must have been commissioned by the wealthy bourgeoisie who, although not legally entitled to participate in the hunt (except perhaps on their own land), assumed a guise of nobility by having themselves painted as huntsmen.

No. 61 was sold in 1866 as Eglon van der Neer and described in the sale catalogue as 'a beautiful specimen'. It is not included by Hofstede de Groot,[6] but the attribution need not be doubted. On the basis of a photograph it is accepted by Otto Naumann[7] who has compared it with a *Portrait of a gentleman on horseback* dated 1677[8] by van der Neer which is also painted on copper and is of the same size as no. 61. A date of the same time, i.e. 1677 may be suggested for no. 61.

1. The topic is treated extensively in Sullivan 1980, pp. 236 ff. Sullivan uses as sources for his information two seventeenth-century publications which contain the ordinances governing hunting and falconry: Paulus G.F.P.N. Merula, *Placatan ende ordonnancien op 'tsuck vande Wildernissen* (The Hague 1605) and Anon, *Het Jachts-Bedeejff ms.* of 1636 in the Royal Library, The Hague, published in *Nederlandsche Jager* (1898-1900), nos. 169-238.
2. Sullivan 1980, p. 240 cites as examples Holbein's *Nobleman with a falcon* and *Portrait of Robert Cheseman* both in the Mauritshuis, The Hague; Titian's *Gentleman with a falcon* in the Joslyn Art Museum, Omaha; Titian's *Charles V with a hound* in the Prado, Madrid; and Frans Floris's *The Falconer* in the Anton-Ulrich Museum, Braunschweig.
3. For example, Rembrandt's *Self-portrait with a dead bittern* in Dresden and his *Portrait of a man with a falcon*, coll. The Duke of Westminster. Flinck's portraits of this type are von Moltke 1965, nos. 131-36. A similar painting by Bol is the *Young man as a hunter* in Toledo, repr. Blankert 1982, pl. 74.
4. Sullivan 1980, p. 241 mentions Karel Dujardin, Michael Sweerts, Abraham van den Tempel and Bartholomeus van der Helst.
5. Sullivan 1980, pp. 241-42.
6. Hofstede de Groot 1908-27, vol. 5.
7. In a letter dated 13 July 1983, now in the archive of the Gallery.
8. Sold at Sotheby's, 13 July 1977, lot 43.

JACOB OCHTERVELT Rotterdam 1634-1682 Amsterdam

He was baptised in Rotterdam in February 1634. According to Houbraken, he was, with Pieter de Hooch (q.v.), a pupil of Nicolaes Berchem (q.v.) in Haarlem. The dates of his apprenticeship are not known but he was back in Rotterdam in 1655. He is further recorded in Rotterdam between 1661 and 1672, but the earliest record of him in the Guild of St. Luke there is in 1667. He is last recorded in Rotterdam in July 1672 and by 1674 is mentioned in Amsterdam. He painted domestic interiors with wealthy burghers, merry-company scenes and portraits.

435 A lady in a window holding a bunch of grapes (Fig. 116).

Oil on panel, 26.6 × 21 cms. (10½ × 8¼ ins.).

CONDITION: paint surface generally in good condition although the background has at some stage been overcleaned. Cleaned in 1982.

PROVENANCE: said to have been purchased by D. J. J. Cookes from a Dutch emigrant in the time of the war of 1808 or 1809,[1] consigned by the Executors of the late Rev. Denham Cookes to Christie's, 1893, withdrawn before sale; Thomas Henry Cookes sale, Foster's, London, 8 May 1895, lot 98, where purchased by Gooden for the Gallery for 30 guineas.

LITERATURE: Gerson 1931, p. 556; Kuretsky 1979, no. 49, p. 74.

The main action of the picture, a hand holding a bunch of grapes by the stem, is derived from an emblem of Jacob Cats which he used in three publications dating from 1618, 1625 and 1637.[2] The bunch of grapes symbolises virginity or marital fidelity and the fact that it is held by the stem refers to the vulnerability of those virtues. As Cats's publications were disseminated widely in seventeenth-century Holland, and any number of painters employed the emblem in their paintings, its meaning would have been generally understood by contemporaries. As it is questionable whether the most appropriate method of professing one's virginity is to lean out of a window in a decolleté dress, it is not unlikely that some wit is intended in no. 435.

The compositional device of a figure at a window or in a niche is found in the work of Rembrandt (e.g. his *Self-portrait* in London[3]). Its popularity was due to the influence of Gerard Dou and his pupil Frans van Mieris the Elder, who painted a number of pictures using this device.[4] The influence of such pictures was enormous. Dou's window-niches were also frequently framed by vines, as in no. 435 and on at least two occasions he had painted a lady in a window holding a bunch of grapes.[5]

No. 435 was sold in 1895 as van Mieris but accessioned at the Gallery as Ochtervelt and has always been so catalogued. Dated pictures by Ochtervelt of 1666 and 1668 in Glasgow[6] and Frankfurt[7] respectively show figures in a window niche and Kuretsky justifiably groups other paintings using a similar compositional device in the decade 1665-1675. She places no. 435 about 1668 which seems likely.

1. According to the 1895 sale catalogue.
2. Jacob Cats, *Maechden-plicht ofte ampt der ionck-*

vrouwen, in eerbaer liefde, aenghewesen door sinne-beelden (Middelburg 1618); *Houwelick: dat is de*

gansche gelegentheyt des echten staets (Middelburg 1625); *Werelts begin, midden, eynde, besloten in den trou-ringh, met den proef-steen van den selven* (Dordrecht 1637). For the subject see de Jongh 1974, pp. 166-91.

3. National Gallery, cat. no. 672. Repr. *London, National Gallery, cat. 1973*, p. 599.

4. See Robinson 1974, pp. 89-100.

5. Galleria Sabauda, Turin, inv. no. 377, repr. Martin 1913, p. 110; British Royal Collection, repr. White 1982, pl. 38.

6. Art Museum and Gallery, inv. no. 590, repr. Kuretsky 1979, fig. 61, p. 148.

7. Städelsches Kunstinstitut, inv. no. 606, repr. Kuretsky 1979, fig. 70, p. 153.

641 A lady with a dog (Fig. 117).

Oil on panel, 23.9 × 19 cms. (9⅜ × 7½ ins.).

SIGNED: faint traces of what appears to be a signature in the background, right.

REVERSE: collector's seal (Fig. 291); label inscribed OCH B 3.

CONDITION: good. Some parts of the paint film are worn and oxidised. Cleaned in 1983.

PROVENANCE: Sir Walter Armstrong, by whom presented.[1]

LITERATURE: Kuretsky 1979, no. D-4, p. 99.

Dogs feature in many of Ochtervelt's paintings. They traditionally represent fidelity, but in no. 641 as in many of the artist's pictures, it is more an obedient plaything, a substitute for a lover who is controlled by a vain woman's charms.[2] Dogs were among the pets traditionally kept by courtesans and it has been shown that in seventeenth-century Dutch painting a dog may indicate unchastity.[3] On the right is an open music score. The combination of music and the dog would have conveyed to Ochtervelt's contemporaries a meaning that was in general erotic.

No. 641 was seen by Kuretsky[4] in its pre-cleaning state, and she overestimated the amount of damage and retouching, as the painting is actually in very good condition. She noted the gesture of the figure as meaningless and the pose (perhaps justifiably) as awkward. Kuretsky was, however, of the opinion that the facial type was characteristic of Ochtervelt's style of the late 1660's. Her conclusion about no. 641, in listing it among 'disputed works', was that it may be an extensively reworked fragment of an originally larger work either by Ochtervelt or by a later imitator. Since cleaning, this conclusion would seem to be untenable on all counts; and the painting may indeed actually be signed.

1. The date of presentation is not recorded in the *ms.* catalogue or register of the Gallery. No. 641 was first catalogued in 1908 and was probably acquired sometime before that but after 1904, when the previous catalogue, from which it is excluded, was published.

2. See Philadelphia/Berlin/London 1984, pp. 259-60.

3. de Jongh 1968-69, p. 22.

4. Kuretsky 1979, p. 99.

ADRIAEN VAN OSTADE Haarlem 1610-1685 Haarlem

He was baptised in Haarlem on 10 December 1610 and was the son of a weaver. According to Houbraken he studied with Frans Hals (q.v.) about 1627: if this is correct, he and Adriaen

Brouwer may have been fellow pupils. He is first documented as a painter in 1632. He was a member of the Guild of St. Luke in Haarlem by 1634 and in 1636 was a member of the militia company Oude Schuts. He married in Haarlem in 1638. On 30 March 1640 it is recorded that he was sued by Salomon van Ruysdael (q.v.) for default in payment of fourteen guilders for tuition and board. His wife died in 1642 and he remarried in 1657. He was a hoofdman *of the Guild of St. Luke in 1647 and 1661 and Dean in 1662. He died in April 1685. He painted a few history pieces and portraits, but he is principally known as a painter of peasant genre. He was enormously prolific and was also an etcher. Many of his drawings also survive. Among his pupils were his brother Isack, Cornelis Dusart (q.v.), Cornelis Bega (q.v.) and Jan Steen (q.v.).*

32 Boors drinking and singing (Fig. 118).

Oil on panel, 32.4 × 50.9 cms. (12¾ × 20 ins.).

REVERSE: indecipherable collector's seal and an old inventory number 979.

CONDITION: good. A horizontal split in the support (visible on the surface) 6.5 cms. from the top has been repaired. Cleaned in 1970.

PROVENANCE: Executors of The Hon. Marmaduke Constable Maxwell, Terregles, Dumfriesshire, sale, Christie's, 1 March 1873, lot 111, where purchased for 20 guineas.[1]

LITERATURE: Armstrong 1890, p. 283; Hofstede de Groot 1908-27, vol. 3, no. 563, p. 314.

VERSION: Kohler collection, Marssen, with an attribution to Victoryns.

The type of subject matter, peasants carousing in an interior, is related to the work of Adriaen Brouwer who worked in Haarlem, where van Ostade was also active, until about 1631. When he painted such scenes, however, van Ostade conveyed the sense of the picture more through the physical actions of his figures, rather than by facial expressions as Brouwer did. In no. 32 the drunken figures are enjoying themselves with a fair degree of abandon. The uncouth peasants' abandonment to pleasure through drink and tobacco-smoking exemplified the comic and undignified consequences of intemperance; and certainly in the case of such paintings by Brouwer, and possibly also with van Ostade, the intention of the artist was satirical.

Called by Armstrong[2] 'a fair sample of Ostade's early grey, somewhat spiritless manner', no. 32 was described by Hofstede de Groot[3] as rather sketchy early work. It may be compared with, for example, a signed painting by van Ostade in Munich[4] of similar subject matter and from the same period. A date of about 1635 is likely.[5]

1. From Gallery records it is possible to be certain that no. 32 was purchased sometime shortly before July 3, 1873; Gallery records have always stated that no. 32 was purchased at Christie's. The description of the van Ostade, 'An interior with six peasants', in the Constable Maxwell sale fits no. 32. In Christie's records, however, that painting was sold to Hirsch for £12 1s. 6d.; and it may be that Hirsch acted on behalf of the Gallery, but at the same time charged a considerable commission, as the Gallery paid 20 guineas.
2. Armstrong 1890, p. 283.
3. Hofstede de Groot 1908-27, vol. 3, no. 563, p. 314.
4. Alte Pinakothek, inv. no. 133, repr. *Munich, Alte Pinakothek, cat. 1983*, p. 372.
5. For similar works see Schnackenburg 1970, pp. 158ff.

ANTHONIE PALAMEDSZ. Delft 1601-1673 Amsterdam

Shortly after his birth in Delft in 1601, his father, a lapidary, is recorded in the service of James I of England and the family presumably moved there as the artist's younger brother was born in London. He was apprenticed to Michiel van Miereveld (q.v.) in Delft and on 6 December 1621 was admitted to the Guild of St. Luke there. He was a hoofdman of the Guild in 1635, 1658, 1663 and 1672. He married for the first time on 30 March 1630 and again about 1660. He died on 27 November 1673 in Amsterdam where he was probably living with his son. He painted elegant interiors, merry-companies and guardroom scenes. These are in the same style as similar pictures by the Haarlem and Amsterdam painters, Dirck Hals (q.v.), Pieter Codde (q.v.) and Willem Duyster (q.v.). He also painted portraits, landscapes and still-life. He painted figures in the pictures of Anthonie de Lorme (q.v.) and Dirck van Delen (q.v.); and he was the teacher of Ludolf de Jongh (q.v.).

531 Interior of a guardroom (Fig. 119).

Oil on panel, 30 × 37.9 cms. (11⅝ × 14⅝ ins.).

SIGNED: at the top of the gate, on the right: *A. ?alamedes*

REVERSE: collector's seal (Fig. 292).

CONDITION: good. The background is thin.

PROVENANCE: Ayerst H. Buttery, London, from whom purchased, 1901, for £40.

LITERATURE: Schneider, Hofstede de Groot 1932, p. 155.

The rich dress of the principal figure would identify him as an officer. The soldier in the centre is a pikeman and he is shown wearing a cuirass. The sword held by the figure in the background, right, is a pappenheimer. On the background wall is a rack for muskets. The men are shown mustering out.

The composition is related to a signed and dated *Soldiers in a guardroom* of 1647 by Palamedesz. in the Rijksmuseum, Amsterdam;[1] and to a pair of paintings in the Liechtenstein collection, Vaduz, one of which is signed and dated by Palamedesz., 1648. In one of the Liechtenstein pictures the soldier putting on his boot, the pikeman and the boy holding the pappenheimer are all repeated as a group, but in different poses.

In view of the comparisons cited above, a date about 1647 may be proposed.

1. Inv. no. A.3024. Repr. *Amsterdam, Rijksmuseum, cat. 1976,* p. 434.

ABRAHAM DE PAPE Leiden, before 1621-1666 Leiden

He is mentioned in the records of the Guild of St. Luke in Leiden from 1644 and was one of the founders of that Guild in 1648. He was a hoofdman of the Guild in 1649-50,

1654-55, 1659-60 and 1664-65. He was Dean in 1651, 1656, 1661 and 1666. He died at Leiden on 15 September 1666. There are few surviving works. He painted genre scenes in a style derived from Gerard Dou and Brekelenkam (q.v.).

149 The repast (Fig. 120).

Oil on panel, 49.2 × 40.2 cms. (19⁵⁄₁₆ × 15¾ ins.).

REVERSE: bookplate of John Howard Galton inscribed *'no. 14'*.

CONDITION: good. Some damages in the area of the bed curtains. Thinly painted. Cleaned in 1985.

PROVENANCE: acquired by Joseph Strutt of Derby between 1827 and 1835;[1] by descent to Howard Galton of Hadzor by 1854;[2] thence by descent to Hubert Galton; his sale, (Hadzor Sale) Christie's, 22 June 1889, lot 10, where purchased for 60 guineas.

LITERATURE: Waagen 1854, vol. 3, p. 221; Armstrong 1890, p. 283; Armstrong 1893, pp. 18-19; von Wurzbach 1906-11, vol. 2, p. 303; Thieme, Becker 1907-50, vol. 26, p. 217.

No. 149 was called Brekelenkam when in the Hadzor collection and described by Waagen as 'Brecklenkampf *(sic.)* — a man and woman at a meal; a good picture by him'.[3] It was sold as Brekelenkam in 1889 but accessioned at the Gallery as de Pape. Armstrong published it in 1890[4] and again in 1893[5] as de Pape and drew attention to the similarity of the composition to de Pape's *Tobit and Anna (?)* in the National Gallery, London.[6] That picture, which is signed and dated 1658 or 9, shows the interior of a room that is somewhat similar to that shown in no. 149: the chimney piece is the same (although there is no coving at the ceiling) and there is a cupboard on the wall to the left: the London picture shows, however, the left-hand door closed. A curtain in the foreground of the London picture conceals the area of the bed in no. 149. MacLaren[7] suggests that the subject of the London picture may be Tobit and Anna on account of its similarity to a picture of that subject by Dou also in London.[8] A similar suggestion, though probably one that is untenable, might be made with regard to no. 149: the bare interior of the cupboard being an allusion to Tobit's poverty while the dog may refer to that which accompanied Tobias on his wanderings.

In view of the picture's similarity to the *Tobit and Anna* which is cited above and which is dated 1658 or 1659, a date of about that time may be proposed for no. 149.

1. Information from C. E. W. Deacon in a letter dated 6 April 1973 now in the archive of the Gallery.
2. When seen by Waagen 1854, vol. 3, p. 221.
3. *Ibid.*
4. Armstrong 1890, p. 283.
5. Armstrong 1893, pp. 18-19.
6. Cat. no. 1221. Repr. *London, National Gallery, cat. 1973*, p. 545.
7. MacLaren 1960, p. 291.
8. Cat. no. 4189. Repr. *London, National Gallery, cat. 1973*, p. 604.

EGBERT VAN DER POEL Delft 1621-1664 Rotterdam

He was baptised in Delft on 9 March 1621 and entered the Guild of St. Luke there in October 1650. He married at Maassluis, near Rotterdam, in 1651 but was still living in Delft at the time of the explosion there in October 1654. He had settled in Rotterdam before November 1655 and he was buried there on 19 June 1664. Before 1654 he painted mainly barn and cottage interiors, canal and winter landscapes and coastal scenes. His later work is generally of moonlight and nocturnal scenes.

9 An interior with a woman ironing (Fig. 121).

Oil on panel, 39.9 × 50.2 cms. (15⅝ × 19¾ ins.).

CONDITION: the support consists of two members joined on a horizontal 18.5 cms. from the top. The paint surface is in good condition under heavy varnish. Worn in the area of the male figure. The join in the support is visible on the surface.

PROVENANCE: John Branston Stane sale, Christie's, 21 July 1888, lot 29, where purchased for 4 guineas.

No. 9 was sold in 1888 as Brouwer but accessioned at the Gallery as van der Poel and has always been so catalogued. It may be compared with a signed and dated *Interior* by van der Poel of 1647 in The Hermitage;[1] and the woman is somewhat similar to a woman in another painting by van der Poel that is signed and dated 1645.[2]

In view of the comparisons cited above a date in the late 1640's may be suggested for no. 9.

1. Leningrad. 1901 cat., no. 978. 2. Sold at Christie's, 16 December 1977, lot 115.

22 Scene on the ice (Fig. 122).

Oil on panel, 43.2 × 62.7 cms. (18⅛ × 24¾ ins.).

REVERSE: an engraved view of an oriental city is pasted to the back of the support together with the bookplate of a Duke.

CONDITION: the support consists of two members joined on a horizontal 22 cms. from the top. The surface gives the impression that the original support was an oval but the incision of the oval (visible on the surface) is not carried through the support. Paint surface in fair condition, thin in the area of the sky.

PROVENANCE: purchased in London, 1864, for £25.[1]

No. 22 was purchased as the work of Aelbert Cuyp and so catalogued until 1898 when Armstrong gave it to van der Poel. The town in the background was identified in the earlier catalogues as Dordrecht; but Armstrong called it Delft. The view is intended to resemble Delft in a general way. On the left the tower of the Nieuwe Kerk and in the centre the Oude Kerk; but the twin spires on the right are not accurate: they occupy the space where the single spire of the Sint Joris Chapel should be. Also missing between the Oude Kerk and the Nieuwe Kerk is the Rathaus. It should also be said that neither of the church towers shown are depicted accurately.

It could be that no. 22 had been intended as an oval composition, and at least one so-shaped composition by van der Poel is known,[2] the proportions of which resemble the incised oval on no. 22.

van der Poel is perhaps best known for his views of Delft after the explosion of 1654, which depict the city accurately.[3] These were painted in 1654. No. 22 is earlier than that and probably dates from the early 1650's or late 1640's.

1. The Gallery Director's Report for 1864 states that no. 22 was purchased in London (in the months of April, May or June) for £25. There is no further record of the provenance in the archive of the Gallery.

2. The painting was engraved by E. Plin in Le Brun 1792, vol. 2, p. 73.
3. See, for example, the painting in the National Gallery, London, cat. no. 1061. Repr. *London, National Gallery, cat. 1973*, p. 565.

GERRIT POMPE active in Rotterdam 1670-1690

His dates of birth and death are unknown. His works are rare but there are dated paintings of 1670, 1671, 1680 and 1690. According to Bol he was a pupil of Ludolf Bakhuizen (q.v.).

850 A Dutch yacht with fishing boats off a jetty (Fig. 123).

Oil on panel, 38.2 × 46.8 cms. (15 × 18⅜ ins.).

SIGNED AND DATED: on the top of the paling, right, *G Pompe 1690* (Fig. 264).

REVERSE: inscribed in manuscript, *Mr Baxter*.

CONDITION: the support consists of two members joined on a horizontal 18.5 cms. from the top. Paint surface in good condition. Cleaned and the join refixed, 1985.

PROVENANCE: Dyer & Sons, Dublin, from whom purchased, 1923, for £50.

LITERATURE: Thieme, Becker 1907-50, vol. 27, p. 236; Bodkin 1924, p. 143; Bernt 1948-62, vol. 4, no. 226; Bol 1973, p. 312; Preston 1974, p. 36..

The principal ship is a yacht with fishing vessels alongside it. To the left, offshore, are Dutch Indiamen; in the foreground is a barge with passengers setting out in the light air.[1] On the horizon is a distant view of a town which was identified by Bodkin[2] as presumably a distant view of Rotterdam from the further bank of the Maas. As Pompe was active in Rotterdam this is not unlikely.

Bodkin also discerned the influence of Willem van de Velde the Younger in no. 850, 'although in colour it is slightly more theatrical'. Bol[3] has pointed out that the subject is thematically linked with the work of van de Velde the Younger, but 'the stark contrasts between the warm colours in the foreground and the dark grey tone of the horizon shows the influence of Ludolf Bakhuysen'.

1. The shipping has been identified by Harley Preston formerly of the National Maritime Museum, Greenwich.

2. Bodkin 1924, p. 143.
3. Bol 1973, p. 312.

WILLEM DE POORTER Haarlem 1608-after 1648 ? Haarlem

His father came from Flanders. He worked in Haarlem where he is documented a number of times from 1630-48, and also at Wijck after 1645. His style is derived from Rembrandt's paintings of the early 1630's and he may have been Rembrandt's pupil either in Leiden or Amsterdam. Apart from biblical scenes he also painted some few portraits and still-life.

380 The robing of Esther (Fig. 124).

Oil on panel, 39.4 × 30.8 cms. (15½ × 15 ins.).

REVERSE: two collector's seals. (Figs. 293 and 294).

CONDITION: good. Cleaned in 1981 when additions, probably dating from the nineteenth century, to the curtain were removed. The background had also been strengthened.[1]

PROVENANCE: Sir Walter Armstrong, by whom presented, 1893.

LITERATURE: Duncan 1906-07, p. 15; Juynboll 1933b, p. 258; Potterton 1982, p. 105 and n. 15, p. 107.

ENGRAVING: by Leopold Beyer, active in Vienna, 1784-after 1870.[2]

The subject is taken from the book of *Esther*, ch. 5, vs. 1. Esther, the Jewish queen of Ahasuerus, was forbidden to enter the King's presence without being summoned. In order to intercede with Ahasuerus on behalf of the Jewish people, who had been condemned to death, she put on her finest apparel and entered the king's chamber. Sumowski[3] has rightly drawn attention to the fact that, under the general title, *The toilet of Esther*, two different episodes may be depicted. In the one instance Esther robes for her marriage to Ahasuerus, and in the other she robes in order to intercede for her people. The book of Esther was immensely popular among the Dutch in the seventeenth century. In earlier Catholic art, Esther had been regarded as a prefiguration of the Virgin, but among Dutch Protestants the book owed its popularity more to their identification of the story with the Jews of the bible. Among Jews the book of Esther is probably the best-known book of the bible. It is read twice on the Feast of Purim and there is an apocryphal addition to the book with which some Dutch artists were familiar. Josephus gave an elaborate account of the story and a whole tractate of the Talmud is devoted to it.[4] Although the story of Esther was popular with painters in the seventeenth century, and not least among the circle of Rembrandt, the episode of her robing is more unusual. It was treated by de Poorter on at least one other occasion[5] and also by Aert de Gelder.[6]

In a general way the concept of no. 380, with the figures strongly lit against a plain background wall, is dependent on Rembrandt's work about 1629-30, for example *David playing the harp to Saul* in Frankfurt.[7] A somewhat similar picture by de Poorter of *A woman weighing gold* is in Raleigh:[8] several details, specifically the chain draped on the covered table, compare with no. 380.

A painting by de Poorter of the subsequent episode of *Esther before Ahasuerus* is in Dresden and is dated 1645.[9] No. 380 is stylistically earlier than that painting. His earliest dated work is of 1633, and a date towards the end of the 1630's may be suggested for no. 380.

113

1. See Potterton 1982, p. 105.
2. Repr. Potterton 1982, fig. 6, p. 106.
3. Sumowski 1983-, vol. 2, p. 1165 under no. 745.
4. See further on the subject Milwaukee 1976, p. 132.
5. In a painting known to Bernt in 1953: his letter dated 17 March 1953 and a photograph of the painting is in the archive of the Gallery. The present whereabouts of the painting is unknown. The composition relates only in a general way to no. 380 although the sizes of both pictures are the same.
6. Sanssouci, Potsdam, inv. no. GK1,5255. Repr. Sumowski 1983-, vol. 2, no. 745, p. 1205.
7. Städelsches Kunstinstitut, inv. no. 498. Repr. RRP 1982-, vol. 1, p. 258.
8. North Carolina Museum of Art, inv. no. 64. Repr. RRP 1982-, vol. 1, p. 496.
9. Gemäldegalerie, inv. no. 1389. Repr. Bernt 1948-62, vol. 2, no. 650.

FRANS POST Haarlem 1612-1680 Haarlem

He was the son of the Leiden glass-painter Jan Jansz. Post and younger brother of the architect and painter, Pieter Post, who was probably also his teacher. In 1636, when the West Indies Company appointed Count Johan Maurits van Nassau-Siegen, Governor-General of Brazil, he took with him a personal suite of painters, naturalists and cartographers including the young Frans Post; and Post stayed in Brazil until Johan Maurits himself returned to Holland in 1644. On his return, Post settled in Haarlem and became a member of the Guild of St. Luke there in 1646. Only six paintings, later presented to Louis XIV of France, and one drawing, survive from Post's work executed in Brazil; but nevertheless, throughout his life, he continued to paint only Brazilian scenes. Post's distinctive use of colour, with vivid blues and greens, reflects early Dutch and Flemish painting; and his exotic subject matter gives his pictures an appearance of naivety. Although the compositions of his later paintings reflect contemporary developments in Dutch landscape painting, Post's subject matter was unique in seventeenth-century Holland.

847 A Brazilian landscape (Fig. 125).

Oil on panel, 48.3 × 62.2 cms. (19 × 24¾ ins.).

SIGNED: bottom right, *F. Post.* (Fig. 265).

CONDITION: the support is cradled. Paint surface in very good condition with some few small isolated damages in the sky. Cleaned in 1984.

PROVENANCE: Robert Langton Douglas, by whom presented, 1923.

EXHIBITED: 1952-53, *Dutch Pictures 1450-1750*, Royal Academy, London, no. 337; 1985, *Masterpieces from the National Gallery of Ireland*, National Gallery, London, no. 28.

LITERATURE: de Sousa-Leão 1948, no. 82, p. 101; Guimarães 1957, no. 175; Larsen 1962, no. 96, p. 199; de Sousa-Leão 1973, no. 72; London 1985, no. 28, p. 72.

As the picture was probably painted some twenty years after Post returned to Haarlem from Brazil, the view is not real but uses elements of landscape and buildings typical of the Brazilian countryside. The wide well-watered terrain was especially suited to the

cultivation of sugar cane and is similar to that shown in many of Post's paintings of both real and imaginary views. Dotted through the landscape on the far side of the river are several sugar plantations; and part of one is shown in detail on the right. On the extreme right is the furnace house where negroes are shown fuelling the wood-fired boilers. To the left of the furnace is the drying platform with other negroes laying out the cane, which is being brought to them in a chest. The oxen-cart in the foreground would have been used for transporting the sugar chests. The building on the left is similar to chapel buildings in many of Post's paintings; but as there is no cross this is not likely. Nor is it likely to be the plantation master's house, as in a plantation that was usually built at some short distance away from the main plantation buildings. The man and woman walking towards the river are probably intended as the master and his wife. On the extreme left is a papaya tree, next to it a macaúba palm, then a coco palm, with, towards the centre, other palms and trees. In the foreground vegetation are a crocodile, armadillos, anteaters, a monkey, a snake, herons and other animals and birds.

The composition of no. 847 is of a type categorised by Stechow[1] as 'one wing panorama'. It is of a format used by Post throughout his career; but the one wing in his later landscapes is more densely foliated and its inhabitants are generally more exotic and more numerous than in his earlier landscapes. In his later paintings Post also stratifies the colour more intensely into green, green-blue and blue zones. No. 847 may be dated to the first half of the 1660's on stylistic grounds and compared with, for example, the *Landscape with a church* in Detroit by Post which is dated 1665.[2] Larsen[3] also dates it after 1660.

1. Stechow 1966, pp. 38 ff.
2. Repr. de Sousa-Leão 1973, no. 48.
3. Larsen 1962, p. 199.

Hendrick Gerritsz. Pot ? Haarlem, about 1585-1657 Amsterdam

He was probably born in Haarlem about, or shortly before 1585. He was, before 1603, a pupil of Carel van Mander. In van Mander's studio he would have encountered Frans Hals (q.v.) whose influence is apparent in Pot's earlier works. In 1625 he became a Sergeant in the Civic Guard in Haarlem and in 1628 he was one of the Regents of the Poorhouse in Haarlem. In 1626, 1631, 1634 and 1648 he was Commissioner of the Guild of St. Luke in Haarlem and in 1635 Dean. In 1632 Pot lived in London where he painted portraits of King Charles I and his queen Henrietta Maria. He returned to Haarlem in 1633 where he was painted by Frans Hals as a lieutenant in his group portrait of the Officer and Sergeants of the St. Hadrian Civic Guard Company. He was again in Haarlem in 1648 but shortly thereafter moved to Amsterdam where he died shortly before 16 October 1657. With the exception of a few allegorical paintings he was exclusively a portrait painter, generally on a small scale. He also painted some merry-company scenes in the style of Dirck Hals (q.v.) and Willem Buytewech.

115

443 Portrait of a man (Fig. 126).

Oil on panel, 36 × 29.5 cms. (14⅛ × 11⅝ ins.).

SIGNED: bottom left, *H P* (in monogram).

REVERSE: indecipherable collector's seal.

CONDITION: good. A possible pentimento to the right of the head.

PROVENANCE: C. H. T. Hawkins, Portland Place, London, sale, Christie's, 11 May 1896, lot 99, where purchased by Agnew for the Gallery for 46 guineas.

The sitter is presumably from Haarlem and is shown as a learned gentleman with a globe and books. He wears a chain about his neck and as no. 443 is a portrait this is presumably the insignia of some honour or decoration. No. 443 was sold in 1896 as 'H.R.' on the basis of the signature which was read as *HR* in monogram; but registered at the Gallery as Pot. The painting is similar in format and composition to a *Portrait of a man* by Pot which is signed with a similar monogram and which was, in 1939, in the collection of I. de Bruyn, Spiez.[1]

On the basis of costume no. 443 may be dated to the late 1640's.[2]

1. RKD photograph negative no. L57627.

2. Information from Marÿke de Kinkelder of the RKD, 1983.

PAULUS POTTER Enkhuizen 1625-1654 Amsterdam

He was a son of the painter Pieter Symonsz. Potter (q.v.) and was baptised on 20 November 1625 in Enkhuizen. In 1631 his family moved to Amsterdam where, according to Houbraken, Paulus was a pupil of his father. Possibly he was also apprenticed to Claes Moeyaert. From August 1646 Potter lived in Delft where he became a member of the Guild of St. Luke in that year and married in 1650. He returned to Amsterdam in 1652 where he was buried on 17 January 1654. Almost all his paintings are of animals in a landscape and with few exceptions are on a small scale.

Imitator of PAULUS POTTER

56 Head of a white bull (Fig. 127).

Oil on canvas, 78.8 × 61.5 cms. (31 × 24¼ ins.).

CONDITION: the canvas has been cut all round.[1] The top edge, which is straight for 11 cms., is all that remains of the original edges. The canvas has at some time been folded horizontally on a line through the left eye. Damaged in the background to the right of the head and also some damages above the head. The fold is clearly visible and retouched.

PROVENANCE: J. van der Linden sale, Dordrecht, 22 August 1785, lot 319, bt. Vinne;[2] 'Pictures from the Continent' sale, Christie's, 13 June 1807, lot 15, bt. Lord de Dunstanville;[3] Lord de Dunstanville sale,

Christie's, 8 May 1824, lot 33, bt. Peacock;[4] Peacock, London, 1834;[5] G. H. Morland sale, Christie's, 9 May 1863, lot 146, bt. Nipp;[6] H. D. Seymour, 1867;[7] T. M. Whitehead, London, from whom purchased, 1868, for £500.

LITERATURE: Smith 1829-42, Part 5, no. 75, p. 149; van Westrheene 1867, no. 49, p. 160; Armstrong 1890, p. 287; Hofstede de Groot 1908-27, vol. 4, no. 174, p. 662; von Arps-Aubert 1932, no. 79, p. 41; von Arps-Aubert 1933, p. 307; Paris 1986, pp. 281-82.

No. 56 has at various times since 1807 been described as Jupiter.[8] Ovid[9] tells how Europa, the daughter of the King of Tyre, was beloved by Jupiter who, in the guise of a white bull, came to where she played with her attendants on the seashore. Beguiled by him, she garlanded his horns with flowers and climbed upon his back. Thereupon he bore her off to Crete. The scene is enacted in the Gallery's painting by Maratta.[10] There is no reason to suppose that no. 56 represents Jupiter: the bull's neck rather than his horns, is garlanded with flowers; and Smith's contention[11] that no. 56 could represent a prize bull of Holland is probably more apt. It has recently been suggested that no. 56 could have been painted for a Corporation of Butchers, and that it could represent their finest bull who would have been so decorated and paraded once a year through the town. At least one such portrait of a prize bull is known,[13] painted in 1564, and showing him garlanded with a chaplet of leaves about his neck.

No. 56 has been known as Potter since at least 1785[14] and has been accepted and indeed praised, in all the literature on the painter. The attribution has, however, been rejected by van Thiel[15] who has suggested that the painting may be the work of Jacob Cuyp. It is justifiable to doubt the attribution. The general coarseness of the painting is unlike Potter's style and indeed is also much too crude for Cuyp. The technique and composition should be compared with Potter's most famous painting, *The young bull* of 1647 in the Mauritshuis.[16] There are superficially striking similarities in the treatment of no. 56 and the heads of both the bull and the cow in the Mauritshuis painting. The artist of no. 56 has clearly understood the arrangement of the hair on the face of the animal; but the head in no. 56 is disproportionally small to the neck and body, and the neck is too long. These inadequacies, together with the wreath of flowers, gives no. 56 an overriding silliness that may not be associated with the work of Paulus Potter. The handling of the paint in the Mauritshuis picture is much softer whereas the flowers in no. 56 are extremely crude in execution. No. 56 is consciously derived from the Mauritshuis picture — the pose is an amalgam of the heads of the bull and cow in that picture; but it is almost certainly by an imitator of Paulus Potter.

No. 56 was dated 1643 in the van der Linden sale catalogue of 1785.[17] von Arps-Aubert[18] places it 1644-45. As the painting from which it is probably derived is dated 1647 it may be reasonably close to that time.

1. If no. 56 is identical with the painting in the van der Linden sale in 1785 (see 'Provenance', below), the canvas was presumably cut after that time as the painting in that sale was slightly larger than no. 56. See further n. 2 below.
2. Canvas Ht. 41 Wt. 31 duin 'A more than life size head of a bull' by Potter and dated in the sale catalogue 1643.
3. 'Jupiter in the form of a bull, his neck decorated with a garland of natural flowers inimitably painted. Nothing can exceed the vigor and spirit with which this singular picture is executed; the handling is truly masterly'.

4. 'Head of a milk white bull with a chaplet as prepared for sacrifice'.
5. When seen by Smith 1829-42, Part 5, no. 75, p. 149.
6. As *Jupiter*.
7. When seen by van Westrheene 1867, no. 49, p. 160. Seymour also owned another apparently similar picture which was seen by Waagen in 1857 and described by him as *A Cow's Head* 'worthy of the master; but the landscape background is not of the same character', Waagen 1857, p. 385. van Westrheene 1867, p. 160, describes no. 56 as follows: 'Taureau, dont on voit la tête de face et les épaules. Grandeur naturelle. L'animal est très animé et orné d'une garlande de fleurs. 76 × 61. Toile. Oval.'
8. In the 1807 sale catalogue (see 'Provenance' above) it is called *Jupiter*; and Smith 1829-42, Part 5, no. 75, p. 149, hesitated to decide

whether it was Europa's lover or a prize bull of Holland.
9. *Metamorphoses* II: 836-75.
10. Cat. no. 81. Repr. *Dublin, National Gallery, cat. 1981*, p. 102.
11. See n. 8 above.
12. Paris 1986, pp. 281-82.
13. By an anonymous painter, but inscribed *A° 1564*. The picture is in the Amsterdams Historisch Museum, Amsterdam, inv. no. A 3016 and repr. Paris 1986, fig. 4, p. 281.
14. See 'Provenance' above.
15. On a visit to the Gallery in 1968. The attribution to Potter is also doubted in Paris 1986, p. 281.
16. Inv. no. 136. Repr. *The Hague, Mauritshuis, cat. 1977*, p. 186.
17. See 'Provenance' above.
18. von Arps-Aubert 1932, p. 41.

PIETER SYMONSZ. POTTER ? Enkhuizen c.1597-1600 - 1652 Amsterdam

He was probably born in Enkhuizen. He was first a glass painter and worked as such in Leiden between 1628 and 1630 where he was influenced by the still-life paintings of Jan Davidsz. de Heem (q.v.) who at that time also worked in Leiden. On 11 November 1630 he enrolled at the University of Leiden; and about 1631 settled in Amsterdam where he probably lived for the rest of his life, although a 'Pieter Potter, painter' was enrolled in the Guild of St. Luke at The Hague in 1647. He was buried in Amsterdam on 4 October 1652. He was the father of Paulus Potter (q.v.). He painted vanitas subjects, corps-de-garde scenes, some merry-company subjects, landscapes and biblical subjects: the latter being somewhat in the style of Pieter Lastman (q.v.).

323 Soldiers in a guardroom (Fig. 128).

Oil on panel, 26.3 × 33.5 cms. (10⅜ × 13⅛ ins.).

SIGNED: bottom left, *P Potter f.* (Fig. 266).

REVERSE: collector's seal (Fig. 295).

CONDITION: much abraded in the area to the left of the group of figures and also in the area of the figures. The signature has been strengthened.

PROVENANCE: R. S. Millner of Dublin, by whom presented, 1893.

On the left stands a musketeer with a musket, probably a matchlock, on his shoulder. In his right hand he holds the fork for supporting it, and he is wearing a bandolier: a belt with bottles of premeasured gun powder. The soldier on the right wears some form

of rapier; he would be an officer. On the floor are playing cards and the board which would have been used for scoring.

Such interior scenes with soldiers, called *cortegaerdjes* (or corps-de-garde scenes), are particularly associated with the Amsterdam painters, such as Duyster (q.v.) and Codde (q.v.) in the 1620's and 1630's. In such paintings the life of the soldier is generally depicted as a fairly dissolute one. The Dutch Republic was at war with Spain until 1648 when her independence was granted under the Treaty of Münster. In 1628 there were as many as about 120,000 soldiers in the United Provinces including town militia and foreign mercenaries: as a result the military formed a very large proportion of Dutch society. In contemporary Dutch literature, soldiers are often represented in comic terms: the common infantryman as a drunken lout and officers as foppish and overdressed; and painters also depicted them in those ways.[1] In no. 323 the officer who has been gambling with the peasants is now proceeding to get drunk.

The composition of no. 323, with the crowded right-hand side of the picture contrasted with the single figure on the left, may be compared with a similar composition by Potter, *A lady and a gentleman with servants in an interior*,[2] which is signed and dated 1633. Stylistically no. 323 may be dated to that time, that is within a few years of Potter's settling in Amsterdam where he came in contact with such painters as Duyster and Codde.

1. See Brown 1978, pp. 38ff. 2. Sold Christie's, 16 March 1956, lot 144.

445 A mounted cavalier (Fig. 129).

Oil on panel, 14.6 × 16.3 cms. (5¾ × 6⅜ ins.).

SIGNED AND DATED: bottom, left of centre, *P. Potter F. 1640.*

CONDITION: good. Worn in the sky. Cleaned and restored in 1968.

PROVENANCE: Julia, Lady Fitzgerald, by whom bequeathed and received in the Gallery, 1896.

LITERATURE: Juynboll 1933a, p. 308; Leeuwarden/'S-Hertogenbosch/Assen 1980, no. 249, p. 117.

Potter is not generally known as a painter of horses. However, no. 445 is remarkably similar in subject, composition, size, and style to a signed and dated painting of 1634 by Jan Asselijn[1] (Fig. 213) that was painted in Amsterdam where Potter had settled about 1631. Asselijn's painting was also the model for two drawings by Jan Martsen de Jonge[2] and it certainly seems possible, if not highly likely, that there was some vogue for such small-scale pictures of mounted cavaliers in Amsterdam in the late 1630's and early 1640's.

1. Akademie der Bildenden Künste, Vienna, inv. no. 709. Repr. Steland-Stief 1971, p. vi.
2. As pointed out by Steland-Stief 1971, p. 26.

The drawings are in Berlin-Dahlem, Kupferstichkabinett inv. no. 13313.

JOHANNES HUBERT PRINS The Hague 1757-1806 Utrecht

He worked in The Hague where he became a member of the painters' confraternity Pictura in 1785. He painted townscapes and views in both oil and watercolour and was also an engraver.

681 The weigh-house on the Buttermarket, Amsterdam (Fig. 130).

Oil on panel, 33.9 × 43 cms. (13$^5/_{16}$ × 14$^{15}/_{16}$ ins.).

CONDITION: good. Discoloured varnish and engrained dirt.

PROVENANCE: Lord Willoughby d'Eresby;[1] Henry G. Bohn sale, Christie's, 19ff. March 1885, lot 373, bt. J. H. Lovegrove; his sale, Christie's, 28 May 1914, lot 25, bt. Sir Hugh Lane for Sarah Purser, by whom presented, 1914.

The building was built in 1655 to the designs of Hendrick Rusius as the Regulierspoort. With the extension of the canals in 1658 the building was no longer required for its original purposes and became the Schutterswachtpost. It later became the weigh-house for the Buttermarket situated in front of it. The Buttermarket was on the site of what is now the Rembrandtsplein. The building was demolished in 1874.

1. According to the Bohn sale catalogue, 1885.

JAN MAURITS QUINKHARD Rees-am-Rhein 1688-1772 Amsterdam

He was born on 28 January 1688: his father, Julius Quinkhard, was also a painter and was his first teacher. He was later a pupil of Arnold Boonen and Nicolas Verkolje. From 1710 he worked in Amsterdam and became a citizen there in 1723. He died in Amsterdam on 11 November 1772. Although he painted some conversation-pieces and history subjects, he was principally a portraitist and also painted miniatures. A number of his portraits were engraved. A contemporary in Amsterdam of Cornelis Troost (q.v.), he was much sought after as a portrait painter.

238 Portrait of an old lady (Fig. 131).

Oil on canvas, 90.4 × 70 cms. (35½ × 28½ ins.).

CONDITION: good, underneath discoloured varnish.

PROVENANCE: Viscount Powerscourt, by whom presented, 1873.

LITERATURE: Bredius 1933, p. 524.

In the early catalogues of the Gallery the sitter in no. 238 was said to bear a strong resemblance to the Electress Sophia, by whom was presumably intended Frederika Sophia Wilhelmina of Prussia (1751-1820). This identification is impossible.

No. 238 was presented to the Gallery as Adriaen van der Werff and was so catalogued until 1898 when Armstrong gave it to Quinkhard. Although not of very high quality, the attribution is reasonably possible.

ARNOLDUS VAN RAVESTEYN The Hague ?1615-1690 The Hague

He was probably the son of Anthonie van Ravesteyn who was also a painter and likely to have been the teacher of Arnoldus. He is first recorded in 1646 in Delft and from 1649 onwards is recorded in the records of the Guild of St. Luke in The Hague. He was a hoofdman *in the Guild from 1667-69 and from 1680-82. He died in The Hague on 7 October 1690.*

Ascribed to ARNOLDUS VAN RAVESTEYN

571 Portrait of a young lady (Fig. 132).

Oil on panel, 72.6 × 59.2 cms. (28⁹/₁₆ × 23¼ ins.).

CONDITION: the support consists of three members joined on verticals at 22.5 cms. and 45.5 cms. from the right. The joins have been repaired by balsa wood inserts. The paint surface is in fair condition. Background worn on the left. Possibly some overpaint in the area of the left cheek. Cleaned and the support repaired, 1970.

PROVENANCE: Lady Ferguson, by whom bequeathed, 1905.

No. 571 was bequeathed as School of Ravesteyn, first catalogued by Armstrong in 1914 as 'Ascribed to Jan Anthonisz van Ravesteyn', and called Jan van Ravesteyn in 1981. van de Watering[1] has suggested an attribution to Arnoldus van Ravesteyn (nephew of Jan) and offered as comparison a signed and dated painting of 1651 in Enschede[2] that is attributed to Arnoldus.[3] Although the sitter in that portrait is quite different in mien to the sitter in no. 571 (who is noticeably modest in her dress), the handling of both portraits is very similar.

The sitter in no. 571 wears a cape which was worn for modesty and her chemise is also visible at the throat. On the basis of costume no. 571 could be dated to about 1650-52.[4]

1. Verbal communication, 1983.
2. Rijksmuseum Twenthe, inv. no. 156. Repr. *Enschede, Rijksmuseum Twenthe, cat. 1974-76,* fig. 151.
3. The picture is signed *ARavesteijn* and was formerly attributed to J. A. van Ravesteyn. For the Ravesteyn family see Bredius, Moes 1892, pp. 48 and 51.
4. Information from Marÿke de Kinkelder of the RKD.

REMBRANDT Leiden 1606-1669 Amsterdam

Rembrandt Harmensz. van Rijn was born, the son of a miller, in Leiden reputedly on 15 July 1606. In May 1620 he enrolled as a student at Leiden University. He was a pupil first of Jacob Isaacsz. van Swanenburgh at Leiden with whom he remained for about three years and then a pupil of Pieter Lastman (q.v.) in Amsterdam for about six months. According to Houbraken he was also a pupil of Jacob Pynas. He set up as a painter on his own in 1624 or 1625. For a time Rembrandt was a close associate of Jan Lievens (q.v.) with whom he may have shared a studio in Leiden. Gerrit Dou became Rembrandt's pupil in 1628 and remained with him for three years and Willem de Poorter (q.v.) may also have studied with him during these years. He is recorded still living in Leiden in June 1631 but by July 1632 he was in Amsterdam where he painted in that year The anatomy lesson of Dr. Tulp *and from that time was very successful as a portrait painter in Amsterdam. In June 1634 he married Saskia van Ulenborch, who brought him a large dowry and by whom he had four children only one of whom, Titus, survived. Saskia died in June 1642. From the late 1630's he received fewer portrait commissions and in time his business declined and he became insolvent in 1656. His property, including a large art collection, was sold in 1658. By about 1649 he was living with Hendrickje Stoffels, who in 1654 was admonished before the Council of the Reformed Church for living in sin with the artist; and on his insolvency she and his son Titus formed a partnership to employ him in order to protect him from further financial losses. His last dated painting is of 1669 and he died in Amsterdam on 4 October that year and was buried in the Westerkerk on 8 October.*

215 Landscape with the rest on the flight into Egypt (Fig. 133).

Oil on panel, 34 × 48 cms. (13⅞ × 18¾ ins.).

SIGNED AND DATED: bottom left, *Rembrandt f. 1647.* (Fig. 267).

CONDITION: a small section of the support is missing from the bottom right hand corner. Paint surface in good condition. Radiographs taken in 1985 show that the artist made no significant changes.

PROVENANCE: Henry Hoare, Esq., Stourhead, Wiltshire by 1752;[1] thence by descent; Stourhead Heirlooms sale, Christie's, 2 June 1883, lot 68, where purchased for £514.[2]

EXHIBITED: 1870, *Old Masters*, Royal Academy, London, no. 29; 1894, *Old Masters*, Royal Academy, London, no. 91; 1899, *Rembrandt*, Royal Academy, London, no. 51; 1929, *Dutch Art 1450-1900*, Royal Academy, London, no. 140; 1932, *Rembrandt*, Rijksmuseum, Amsterdam, Museum Boymans-van Beuningen, Rotterdam, no. 57; 1969, *Rembrandt*, Rijksmuseum, Amsterdam, no. 8; 1985, *Masterpieces from the National Gallery of Ireland*, National Gallery, London, no. 24.

LITERATURE: Walpole 1762, p. 42; Smith 1829-42, Part 7, no. 603, pp. 190-91; Waagen 1854, vol. 3, p. 172; Dutuit 1883-85, no. 55, p. 45; Bode 1883, pp. 491-92 and no. 261, p. 592; von Wurzbach 1886, no. 197; Armstrong 1890, p. 286; Michel 1893, pp. 366 and 555; Michel 1894, vol. 2, p. 234; Rosenberg 1904, p. 157; Rosenberg 1906, p. 239; Bode, Hofstede de Groot 1897-1906, no. 342; Duncan 1906-07, pp. 15-16; Valentiner 1909, p. 290; Hofstede de Groot 1908-27, vol. 6, no. 88, p. 73; Bredius 1935, no. 576; Bauch 1966, no. 80, p. 6; Gerson 1968, no. 220, p. 324; Gerson 1969, no. 576, p. 609; Lecaldano 1973, no. 278; Larsen 1983, pp. 22-24, 71-72 and no. 10, p. 98; London 1985, no. 24, pp. 62-65. (Note: as the painting

is included in almost all the literature on the artist, the bibliography is very extensive. An attempt is made here to list as completely as possible the major monographs up to Bredius (1935): thereafter the literature cited is selective.)

ENGRAVING: 1. By J. Wood in 1752 and reissued by Boydell in 1779.[3] 2. Also engraved, according to Waagen[4] by P-C Canot (c.1710-77) a French engraver who worked in England. 3. Anonymous engraving published in *Gems of Ancient Art* (London, 1827).[5] 4. Anonymous engraving published in *Magazine of Art*, 1890, p. 284.

The painting, which is untitled in Wood's engraving of 1752,[6] was called *A Nightpiece* by Horace Walpole in 1762.[7] It was called *Two gypsies by moonlight* by Waagen[8] and described by Smith[9] as 'a company of travellers at the base of a hill'. It was apparently Bode[10] who first referred to it as *The rest on the flight into Egypt* and all authorities have called it that since his time.

In an eloquent appreciation of the picture, Armstrong[11] described it as follows in 1890: 'In its way it is one of the most perfect Rembrandts in existence. Very seldom did the master put so much delicate but spirited work on to so narrow a surface, and never did he more subtly illustrate the rich mysteries of chiaroscuro. In general aspect the panel has a curious affinity with his etchings, while in quality it bears about the same relation to the rest of his landscapes — if indeed it should be called a landscape — as the *Adulteress* of the National Gallery (London) does to the mass of his small religious interiors'.

Bode[12] first drew attention to the fact that the composition is derived from Elsheimer's *Rest on the flight into Egypt* painted in 1609[13] where the scene is also shown taking place at night. Elsheimer's picture was engraved by Hendrick Goudt in 1613,[14] and all authorities are agreed that Rembrandt must have known the engraving if not the original picture itself. Elsheimer shows a group of figures illuminated by a blazing fire among trees and uses the detail of a kneeling boy tending the fire that was also used by Rembrandt. The fire is reflected in a pool, and a dark mass of trees, forming a diagonal across the picture as in no. 215, is silhouetted by moonlight.

Rembrandt painted the subject of *The flight into Egypt* on at least two other occasions[15] but his treatment of the theme in both of those pictures has little relevance to our painting. He also made etchings of the subject, and one of those dating from 1645[16] shows the Holy Family grouped in a composition somewhat similar to no. 215. Although he painted several dark stormy landscapes, there is no obvious comparison between any of these and *The rest on the flight into Egypt*. Gerson[17] suggests that some of the background details recall the vigorously painted trees in *A landscape* in The Louvre;[18] but as far as the painting may be compared with any other in Rembrandt's oeuvre it is perhaps most appropriate to consider it in the context of his small interior scenes.

The engraving of the painting made by Wood in 1752 shows clearly many details which are difficult to decipher on account of the dark tonality. A herdsman is visible on the left (of the engraving) leading his cattle and the water is seen to stretch fully along the foreground. It has been remarked[19] that the print was published at a time when English taste in landscape was almost entirely concentrated on Italian pictures; and indeed it is only in the print that one notices fully how Italianate such a detail as the Claudian building on the hilltop is, or, for that matter, how much the composition as a whole owes to Italian

sources. In this respect it is worth recalling that Rembrandt may have studied in his early years in Amsterdam with Jacob Pynas, an artist who had worked in Rome at the beginning of the century.

1. When the painting was engraved by J. Wood. See further under n. 3 below.
2. Armstrong 1890, p. 286 gives the information that when no. 215 was known to be up for auction 'a keen fight was expected'. He continued, 'I have been told on unimpeachable authority, that the Berlin Museum gave a commission for its purchase at considerably more than double what it actually realised. The agent bungled, and Ireland triumphed at a cost of no more than five hundred pounds'.
3. An impression of Wood's engraving is in the National Gallery of Ireland cat. no. 11,427. It is repr. London 1985, fig. C, p. 65. The reference to Boydell's print is given in Yale 1983 under no. 92, p. 55.
4. Waagen 1854, vol. 3, p. 172.
5. An impression of this engraving is in the National Gallery of Ireland, cat. no. 20,708 (19).
6. See n. 3 above.

7. Walpole 1762, p. 42.
8. Waagen 1854, vol. 3, p. 172.
9. Smith 1829-42, Part 7, no. 603, pp. 190-91.
10. Bode 1883, no. 261, p. 592.
11. Armstrong 1890, p. 284.
12. Bode 1883, pp. 491-92.
13. Alte Pinakothek, Munich, inv. no. 216. Repr. Andrews 1977, pl. 91.
14. The engraving is repr. Andrews 1977, pl. 92.
15. Musée des Beaux-Arts, Tours. Repr. Gerson 1969, p. 447; and coll. Lord Wharton, London, repr. Gerson 1969, p. 465.
16. Bartsch, no. 58. Repr. London 1985, fig. A, p. 64.
17. Gerson 1969, p. 609.
18. Inv. no. R.F. 1948-35. Repr. Gerson 1969, p. 358.
19. Yale 1983, no. 92, p. 55.

Studio of REMBRANDT

808 Portrait of a lady holding a glove (Fig. 134).

Oil on canvas, 72 × 62 cms. (28⅜ × 24⅜ ins.).

CONDITION: good. The support has almost certainly been cut down (see further below).

PROVENANCE: Anon sale, Paris, 1809;[1] The Count Pourtales sale, Phillips, London, 19-20 May 1826, lot 53, bt. C. Maud; Anon (Charles Maud) sale, Sotheby's, Wilkinson & Hodge, London, 2 July 1873, lot 53, bt. Agnew; Prince Demidoff sale, San Donato, Florence, 15 ff. March 1880, lot 1139; Madame Isaac Perière, Paris by 1897[2] and until at least 1909;[3] Sir Hugh Lane, from whom purchased by Max Michaelis, 1913; received back by Sir Hugh Lane,[4] by whom bequeathed, 1915, and received in the Gallery, 1918.

EXHIBITED: 1857, *Art Treasures*, Manchester, no. 681 (provisional catalogue); 1868, *National Exhibition of Works of Art*, Leeds, no. 602 or 603; 1913, *The Max Michaelis Gift to the Union of South Africa*, Grosvenor Gallery, London, cat. p. 18; 1918, *Pictures by Old Masters given and bequeathed to the National Gallery of Ireland by the Late Sir Hugh Lane*, National Gallery of Ireland, Dublin, no. 57; 1952-53, *Dutch Pictures 1450-1750*, Royal Academy, London, no. 173.

LITERATURE: Smith 1829-42, Part 7, no. 514, p. 165; Dutuit 1883-85, p. 22; Bode, Hofstede de Groot 1897-1906, vol. 2, p. 7 and no. 92, p. 64; Valentiner 1909, p. 99; Hofstede de Groot 1908-27, vol. 6, no. 862A, p. 395; Wood 1913, p. 18; van Gelder 1953, p. 38; Gregory 1973, pp. 115-19; Sumowski 1983-, vol. 1, no. 159, p. 310.

ENGRAVING: anonymous engraving published in the San Donato sale catalogue, 1880, p. 253

Smith[5] called no. 808 'a young woman, represented in nearly a front view, with a glove in her hand'. Subsequent to 1826 it was referred to as *The Pourtales portrait*[6] and during the nineteenth century it acquired the sobriquet *The Burgomaster's daughter*.[7] Following

the Demidoff sale at San Donato, Florence in 1880, when it reputedly created a sensation by realising the highest sum that had hitherto been paid for a Dutch picture,[8] no. 808 became known and celebrated as *The Demidoff Rembrandt*. In the catalogue of the San Donato sale it was suggested that the sitter was probably the first wife of the artist (i.e. Rembrandt). Smith detected in 1836 'that the pre-eminent powers of this artist (i.e. Rembrandt) in portraiture are particularly distinguishable in this specimen of his art'; and the painting was the highlight of the Maud sale in 1873 when it was called a *'chef d'oeuvre* of the great Dutch master' (i.e. Rembrandt). No. 808 was included by Bode and Hofstede de Groot in their monumental eight-volume *Complete Works of Rembrandt* published between 1897 and 1906 as an important work by the artist, 'the head painted very delicately with no trace of timidity in the handling'. The painting was purchased by Sir Hugh Lane[9] sometime between 1909 and 1913 and was part of the collection of Dutch and Flemish paintings which he formed that was later purchased by Max Michaelis and presented by the latter as a gift to the Union of South Africa. No. 808 was the only painting attributed to Rembrandt in that collection and prior to its being sent to South Africa was exhibited with the Collection in London in 1913[10] where it was shown as the masterpiece of the Collection. At the time of the Exhibition doubt was, however, cast as to the authenticity of the attribution to Rembrandt by Sir Claude Phillips, writing in *The Daily Telegraph*,[11] and others. Lane immediately offered Michaelis the opportunity of returning the picture in exchange for other pictures, and on the advice of Bode, Michaelis took up Lane's offer.[12] Aspersions continued to be cast about the painting's authenticity and in 1914 Lane wrote to *The Times*[13] asking that 'inaccurate statements in regard to the *Demidoff Rembrandt'* which had appeared in the South African press and in England be contradicted. He reported that having received the painting back from Michaelis he had sent it to be cleaned by Professor Hauser in Berlin 'where it was examined by Dr. Bode who wrote on 28 July 1913: I was most astonished to learn that at the exhibition in London the picture was doubted and that F. Bol has been named as the artist . . . At Hauser's . . . I have been able to study it in detail for a whole week both before and after the cleaning. I assert that it is incredible to me how Rembrandt could be doubted and Bol be named as the artist unless one believes with Dr. Bredius that a masterpiece of Rembrandt's like *Mrs. Bas*, was painted by F. Bol. The *Lady with the glove* is in conception a characteristic Rembrandt portrait, as painted by him from 1632 to 1636, and occasionally also from 1640-42. There is quite the simple attitude, the brilliant lighting, as in most of these pictures. The effect is so fresh and fine, such as is never the case with Bol. . . . Above all however, the execution is only that of Rembrandt: the brilliant black of the dress, the artistic handling of the pattern and of the gloves etc., the impasto application of the paint, e.g. in the left hand with the bracelet and glove. The warm brown tone of the flesh is particularly characteristic of Rembrandt about 1640, in which also, in particular, the famous female portrait in Buckingham Palace is painted. Therefore I believe the more that your picture also dates from about 1640'. The publication of Bode's comments drew a response from Bredius who wrote to Lane sending a copy to *The Times* which was published on 19 February 1914. Bredius wrote: 'I have been very much astonished to read a letter published by you in *The Times* of February 7.[14] When the picture in question, a portrait of a young lady, without a signature, in the Demidoff sale, sold as a Rembrandt, and published by Dr. Bode as such in his Rembrandt work, was exhibited in the Grosvenor Galleries I had

an opportunity of examining it thoroughly; and I had seen the picture before. I considered it formerly to be an early work by Rembrandt. But since I discovered that several pictures attributed to the great master are early works by his pupil Ferdinand Bol, and some of them are even celebrated 'Rembrandts' like the portrait of Elizabeth Bas, so I studied this interesting unsigned painting with double care. As I have been comparing the details of some early Bols constantly with those of contemporary pictures by Rembrandt, I have become, perhaps more familiar with them than other art critics. And so I have found in the painting of the wrist, in the modelling and thin painting of the face, the painting of the costume, and other peculiarities more of Bol's and less of Rembrandt's manner. I agree that in the hands, the impasto of the glove, Bol is here nearer than anywhere else to Rembrandt. But the cuffs, the collar are again identical with . . . Bol portraits . . . What surprised me is that Bode now again calls *Mrs. Bas* a masterpiece by Rembrandt. The last time Bode saw the picture we stood together before it, and he agreed with me that it was too weak for Rembrandt. We were discussing if it could be either Jacob Backer or Flinck. . . . Bol followed in 1638-1640 . . . the manner of Rembrandt's earlier works of about 1635. . . . In some pictures he is very near his master, but there is always some weakness; less genial brush-work, poorer drawing, betrays the hand of the clever pupil. . . . I know it is a question how is it possible that Bol, who became such a weak painter, painted earlier such masterpieces as *Mrs. Bas* and *The lady with the glove.'*

In his argument for giving no. 808 to Bol, Bredius refers to the the *Portrait of Elisabeth Bas* in the Rijksmuseum, Amsterdam.[15] This picture was long established as a Rembrandt and its attribution by Bredius to Bol occasioned fierce public debate in the first quarter of this century.[16] The question has never fully been settled, although after many years as Bol, there is now being formed a consensus of opinion which supports an attribution to Rembrandt.[17] It might also be pointed out that Bredius made his examination of no. 808 shortly before it was necessary to have it cleaned.

Bode's co-author, Hofstede de Groot, included no. 808 in his Rembrandt catalogue raisonné in 1916; but although the picture has remained always at Dublin as Rembrandt, it has never been accepted by any Rembrandt scholar since 1914, although van Gelder in 1953 thought the portrait 'may be by Rembrandt'.[18] van Gelder also justifiably remarked that no. 808 was a fragment of a larger picture. The compiler is also of the view that this is indeed the case and that no. 808 would originally have been considerably larger and possibly measuring about 100×80 cms. with the picture plane extended at both the top and bottom and at each side. Recently no. 808 has been published in full, and for the first time, as the work of Ferdinand Bol by Sumowski, and dated by him to about 1640-42.[19]

No. 808 is of very high quality — even Bredius considered it a masterpiece.[20] In Dublin it is exhibited alongside signed and dated paintings by Bol of 1643 and 1644;[21] that is with paintings which were painted a year or so later than no. 808 if it is the work of Bol. In composition and subject matter no. 808 compares directly with Bol's *Portrait of a lady* (Fig. 17); but there the affinity ends. No. 808 is greatly superior in quality and the compiler does not believe that the same artist can possibly have painted the two pictures and at the same time. No. 808 is here catalogued as 'Studio of Rembrandt', meaning that

it was painted in his studio and under his tutelage if not actually painted by the master himself, and a date of about 1632-33 is suggested.[22]

1. According to Smith 1829-42, Part 7, no. 514, p. 165.
2. Bode, Hofstede de Groot 1897-1905, vol. 2, no. 92, p. 64.
3. Valentiner 1909, p. 99.
4. See further in the text, below.
5. Smith 1829-42, Part 7, p. 165.
6. Said in the Maud sale catalogue, 2 July 1873, to be 'commonly known as *The Pourtales Portrait'*.
7. *Ibid.*
8. According to Wood 1913, p. 18. The price no. 808 fetched at the Demidoff sale in 1880 was, according to Hofstede de Groot 1908-27, vol. 6, p. 395, 137,000 francs. Higher prices than this sum had previously been realised for paintings by Rembrandt, see Michel 1893, p. 550.
9. It is not known from whom he purchased the painting but according to Lady Gregory he paid £25,000 for it. Gregory 1973, p. 116.
10. See 'Exhibited' above.
11. See the letter to Sir Hugh Lane from Bredius published in *The Times* 19 February 1914: 'I note that such an eminent art critic as Sir Claude Phillips in an article in *The Daily Telegraph* doubted whether *The lady with the glove* is painted by Rembrandt'.
12. See the letter to *The Times* from Max Michaelis, 13 February 1914: 'After the adverse criticisms of the Rembrandt appeared, I communicated with Dr. Bode whom I had consulted in connection with the purchase of the whole collection, and he advised me to return the picture. Sir Hugh Lane had previously offered to take it back and subsequently . . . the exchange referred to was effected'.
13. *The Times,* 12 February 1914. In his letter Lane quoted a letter from Bode (see below): the original of this letter is in the archive of the Gallery.
14. In his apoplexy Bredius refers to the date incorrectly: Lane's letter was in fact published on 12 February 1914.
15. Inv. no. A714. Repr. *Amsterdam, Rijksmuseum, cat. 1976,* p. 126.
16. All the literature relating to the controversy is collected and preserved in a dossier in the RKD.
17. The literature on the painting is cited in *Amsterdam, Rijksmuseum, cat. 1976,* p. 126. See also Blankert 1982, p. 57 who gives the picture to Rembrandt.
18. van Gelder 1953, p. 38.
19. Sumowski 1983-, vol. 1, no. 159, p. 310.
20. In his letter to *The Times* 19 February 1914.
21. See this catalogue no. 47, *David's dying charge to Solomon* and no. 810, *Portrait of a lady.*
22. van Gelder 1953, p. 38, suggests a date of about 1632.

School of REMBRANDT, c.1628-30

439 **Interior with figures** (Fig. 135).

Oil on panel, 21 × 27 cms. (8¼ × 10½ ins.).

REVERSE: collector's seal. (Fig. 294).

CONDITION: very good. Radiographs (Fig. 136) show that that picture is painted over another composition, a bust portrait of a man facing the spectator. That painting was an upright composition, with the top of the man's head at the left of the picture in its present form. Cleaned in 1981.

PROVENANCE: Horace Buttery, London, from whom purchased, 1896, for £20.

EXHIBITED: 1985, *Masterpieces from the National Gallery of Ireland,* National Gallery, London, no. 25.

LITERATURE: Duncan 1906, p. 15; Collins Baker 1926, p. 42; Bauch 1933, n. 26, p. 188; Benesch 1935, p. 260; Benesch 1940, p. 2; van Gelder 1953, n. 6, p. 37; Bauch 1960, pp. 243-45; Potterton 1982, pp. 105-06 and n. 16-22, p. 107; Brown 1984, pp. 205, 211; London 1985, no. 25, p. 66.

The subject was identified by Walter Armstrong in 1904[1] as *Playing La Main Chaude.* Since that time the picture has always been so called at Dublin and recently published by Brown[2] as such. That game is played by placing one's head in the lap of a seated woman and one's hand behind one's back. The object of the game is to guess which of the other players has touched one's hand and at the same time smacked one's bottom. The game was very popular in seventeenth-century Holland and was depicted by a number of painters, including Cornelis de Man in a painting in the Mauritshuis.[3] Little in no. 439 would suggest that the figures are playing *La Main Chaude.* The solemnity of their expression, in spite of the music from the violinist on the stairs at the right, would indicate fairly strongly that they are not playing a game at all; and indeed one is at a loss to propose any parlour-game that is played exclusively by adult males.

The painting was purchased by the National Gallery of Ireland in 1896 as Willem de Poorter and catalogued by Armstrong in 1898 as 'Ascribed to de Poorter'. In 1904 he retained the attribution to de Poorter but described the painting as 'greatly superior to the average work of de Poorter'. In 1906, Duncan[4] described no. 439 as 'A Dutch interior at present ascribed to Willem de Poorter, which is so far above that painter's usual work in imagination and quality and has so much in common with the earliest works of Rembrandt, especially the *Reposo* at The Hague, that the possibility that it too, should have the greater name below it lingers in the mind'. In 1914 Armstrong catalogued the picture as Rembrandt. No. 439 was published in 1926 by Collins Baker[5] as Gerard Dou; and then tentatively considered as Rembrandt by Bauch in 1933.[6] In doing so he compared it to Dou's *Rembrandt in his studio*[7] which he also gave to Rembrandt and dated both pictures about 1628, offering as a comparison *The foot operation* by Rembrandt.[8] Later, however, Bauch doubted the validity of his attribution of no. 439 to Rembrandt.[9] Benesch[10] also published no. 439 as Rembrandt and made the same comparisons as Bauch. He also compared the group of figures on the left with a similar group in a drawing in the Musée Bonnat, Bayonne[11] which he attributed to Rembrandt. van Gelder in 1953 implied that he believed no. 439 to be an early work by Rembrandt.[12] The painting was ascribed by the compiler to Gerard Dou in 1982[13] but later called 'School of Rembrandt'.[14] In doing so a comparison was made with Rembrandt's *The risen Christ at Emmaus*[15] of about 1628-29 which shows Christ seated in profile and silhouetted dramatically against a background wall in a manner very similar to the figure on the left in no. 439. Brown[16] referred to no. 439 as 'Leiden School'. Otto Naumann, who has examined a photograph of no. 439, has compared it with Rembrandt's *Artist in his studio* in Boston and has written[17] that no. 439 has 'a chance as a Rembrandt'. Seymour Slive,[18] again on the basis of a photograph, has related the painting to *Christ washing the feet of his disciples* in Chicago which carries a disputed attributed to Lievens;[19] and has tentatively proposed early Lievens as a possible attribution for our painting. No. 439 is here catalogued as 'School of Rembrandt' meaning that it was painted by an artist very closely associated with the master in the years 1628-30.

The portrait which is revealed by radiographs to be underneath the composition is similar in style to Rembrandt's self-portraits of the late 1620's and early 1630's; and a date of about 1628-30 may be suggested for no. 439.

1. In the 1904 Catalogue of the Gallery.
2. Brown 1984, pp. 205 and 211.
3. Inv. no. 91. Repr. *The Hague, Mauritshuis, cat. 1977*, p. 145.
4. Duncan 1906-07, p. 15.
5. Collins Baker 1926, p. 42.
6. Bauch 1933, p. 188, n. 26.
7. Museum of Fine Arts, Boston. Repr. Gerson 1969, p. 336.
8. Private coll., Zurich. Repr. Gerson 1969, p. 339. The attribution of this picture to Rembrandt is now disputed and it has been proposed as Lievens, see Reznicek 1964, no. 61.
9. Bauch 1960, pp. 243-45.
10. Benesch 1940, p. 2.
11. Repr. Benesch 1940.
12. van Gelder 1953, n. 6, p. 37, reviewing the exhibition *Dutch Pictures 1450-1750* at the Royal Academy, London, remarked, 'Rembrandt's paintings of the years between 1624 and 1629 are not represented in England. *La Main Chaude* in Dublin, a picture little-known even to art historians, might well have been borrowed for the Exhibition'.
13. Potterton 1982, pp. 105-06.
14. London 1985, no. 25, p. 66.
15. Musée Jacquemart-André, Paris. Repr. Gerson 1969, p. 452.
16. Brown 1984, pp. 205 and 211.
17. In a letter dated 13 July 1983 now in the archive of the Gallery.
18. In a letter dated 29 June 1983 now in the archive of the Gallery.
19. Schneider 1973, p. 356.

Imitator of REMBRANDT, 18th Century

4307 **Portrait of a man** (Fig. 137).

Oil on canvas, 81 × 65.3 cms. (32 × 25⅝ ins.).

SIGNED: falsely, right, *Rembrandt f.*

CONDITION: good. Radiographs (Fig. 138) reveal that no. 4307 is painted over another portrait (see discussion below).

PROVENANCE: Miss Ivy Peale Wellington, by whom bequeathed, 1978.

Radiographs of no. 4307 reveal that it is painted over another composition, a *Portrait of a man in armour.* The portrait underneath, which shows the sitter facing to the left, is almost certainly French and seventeenth-century. In style, no. 4307 has every appearance of being eighteenth-century in date; but the costume of the sitter is fanciful and deliberately Rembrandtesque. This factor would lead one to suppose that the picture was painted deliberately in imitation of the work of Rembrandt whose name is inscribed as a signature to the right. An alternative hypothesis would be that no. 4307, which is of some quality, was an original eighteenth-century painting to which the false signature was added at a later date; but this is less likely.

Imitator of REMBRANDT, 19th Century

48 **Head of an old man** (Fig. 139).

Oil on panel, 47.2 × 62.7 cms. (18⅝ × 25⅝ ins.).

SIGNED: falsely, left, *Rembrandt f.*

CONDITION: the support, which is oak, consists of two members joined on a vertical 25.8 cms. from the right. The edges of the support are bevelled all round although the bevelling is not uniform on all four sides. In addition, the right-hand member is bevelled along its left-hand edge, that is, along the join

with the other member. This would indicate fairly strongly, if not absolutely positively, that the two components of the support derive from separate sources; although both appear to be seventeenth-century in date. The paint surface is in good condition underneath heavily discoloured varnish. Analyses of the pigment and of the wood in the support, carried out in 1970, provided no conclusive proof as to the date of the picture; and radiographs taken at the same time established that no. 48 is not painted over another composition.

PROVENANCE: Charles Warner Lewis sale, Christie's, 3 June 1871, lot 14, where purchased for 105 guineas.

EXHIBITED: 1899, *Winter Exhibition: works by Rembrandt*, Royal Academy, London, no. 100.

LITERATURE: Michel 1893, p. 555; Bode, Hofstede de Groot 1897-1906, vol. 5, no. 372, pp. 154-55; Rosenberg 1904, p. 176; Duncan 1906-07, p. 15; Rosenberg 1906, p. 269; Valentiner 1909, p. 357; Hofstede de Groot 1908-27, vol. 6, no. 378, p. 210; Bredius 1935, no. 231; Goldscheider 1960, pl. 62; Bauch 1966, no. 200, p. 11; Gerson 1969, pp. 185 and no. 231, p. 566.

No. 48 was described by Michel[1] as 'probably a study for the head of the father of Tobit'; by Bode and Hofstede de Groot[2] as 'a study of an old man, aged about sixty-five with a white beard looking down'; Hofstede de Groot added that he 'was opening his mouth as if to utter a groan'.[3] Michel noted that 'aside from parts which are certainly by the hand of the master (i.e. Rembrandt) others appear to be by N. Maes'. The attribution to Rembrandt was also accepted by Rosenberg (1904), Valentiner (1909), Hofstede de Groot (1908-27), Bredius (1935), Goldscheider (1960) and Bauch (1966) — who, however, noted that the signature might be false. Nor had Bauch ever seen the painting. Although the attribution to Rembrandt had for some time been doubted, it was Gerson[4] who first published the suggestion that no. 48 was a fake: 'the attribution to Rembrandt is out of the question. It is not even a Dutch picture of the seventeenth century'. No. 48 was examined by van Thiel and de Bruyn Kops in 1968 who formed the opinion that 'the handling of the paint differs considerably from seventeenth-century Dutch painting. The broad touches in the face have no function in relation with the spatial forms. The many (too many) colour shades are used rather disorderly. Transparent shadows are lacking altogether, although they seem to be imitated at the right. The patchy browns and dark greys in the background are very unusual also. Apart from these observations with the naked eye, the X-ray also looks unusual in the distribution of thickly applied patches of lead white.'[5]

No. 48 is clearly a fake and contains all the elements that the late-nineteenth-century critic appreciated most in the painter:[6] deep-red hues and dark background, while the brightly-lit face of the time-worn old man appeals to the spectator's humanity.[7] But in detail the picture is entirely lacking in definition: the beard is formless and the mouth and left eye in particular are completely without shape.

When considered a Rembrandt, no. 48 was placed by most authorities about 1650. It is most likely to have been painted some time in the twenty or so years before its purchase by the Gallery in 1871; and as it is painted on what is probably a seventeenth-century support, was almost certainly deliberately painted to simulate Rembrandt's work of about 1650.

1. Michel 1893, p. 555.
2. Bode, Hofstede de Groot 1897-1905, vol. 5, pp. 154-55.

3. Hofstede de Groot 1908-27, vol. 6, no. 378, p. 210.
4. Gerson 1969, p. 566. It is possible that

Armstrong had doubts about the attribution. In the English edition of Michel 1893, the editor Wedmore acknowledges that he has 'made certain corrections and additions to that Appendix of Monsieur Michel's which deals with the whereabouts of great Rembrandt pictures in the United Kingdom', and he acknowledges the assistance of Armstrong, (Michel 1894, vol. 1, p. vi). In his revised Appendix (Michel 1894, vol. 2, p. 234) he does not include no. 48 although he refers to the Gallery's catalogue of 1890 in which no. 48 is included as Rembrandt. Armstrong, however, always catalogued no. 48 at the Gallery as

Rembrandt, but this may have been out of deference to his predecessor as Director, Henry Doyle, who had purchased the painting, rather than from any firm belief that the picture was autograph.

5. Letter from van Thiel dated 11 June 1969 now in the archive of the Gallery.

6. See for example the comments of Michel and Hofstede de Groot quoted above.

7. It is perhaps worth mentioning that no. 48 still has enormous public appeal and before being removed from exhibition was among the most popular pictures in the Gallery.

WILLEM ROMEYN Haarlem c.1624-after 1694 Haarlem

The exact dates of his birth and death are unknown. He is mentioned in the records of the Guild of St. Luke in Haarlem in 1642 when he is called a pupil of Nicolaes Berchem (q.v.). In 1646 he was a Master in the Guild. From 1650/51 until 1655 he was in Italy and then back in Haarlem. He possibly also worked in Amsterdam. He painted Italianate landscapes somewhat in the manner of Karel Dujardin (q.v.) with herds of cattle and sheep in a landscape.

345 Landscape with cattle (Fig. 140).

Oil on panel, 36.3 × 31.5 cms. (14^{5}/16 × 12⅜ ins.).

CONDITION: good.

PROVENANCE: H. Bingham Mildmay sale, Christie's, 24 June 1893, lot 63, where purchased for 35 guineas.

A view, similar to that shown on the left hand side of no. 345 is depicted, nearer to the foreground, in a picture by Romeyn in Orleans,[1] and cows in similar poses to those of the cows in the centre and on the right appear in a signed picture by Romeyn in Hannover.[2]

There are relatively few dated works by the artist. A picture in Leipzig[3] is dated 1647. No. 345 appears much later than that and closer, although possibly later than a dated painting of 1754.[4]

1. Musée des Beaux-Arts.
2. Landesmuseum, cat. 1930, inv. no. 139.
3. Museum der Bildenden Künste, cat. 1924, inv. no. 304.

4. Slot sale, Frankfurt, 3 May 1931, lot 97.

JAN VAN ROSSUM Vianen c.1630-after 1673

Little is known about him but he painted in the manner of ter Borch. Dated works from the years 1654-1673 are known. Today only portraits by him are known but a landscape by him is mentioned in an eighteenth-century sale catalogue.

623 Portrait of a man (Fig. 141).

Oil on canvas, 47.8 × 66.8 cms. (30⅝ × 26¼ ins.).

CONDITION: fair to good; some wearing throughout. There is a vertical tear in the canvas to the right of the head, 28 cms. long, leading from the top.

PROVENANCE: William Beckford of Fonthill sale, Phillips, London, 10 October 1823, lot 67, bt. Walker; Admiral Lord Radstock sale, Christie's, 12-13 May 1826, lot 29, bt. Emmerson; Thomas Emmerson sale, Phillips, London, 2 May 1829, lot 129, bt. King; A. H. Buttery, London, from whom purchased, 1912, for £262.

LITERATURE: Smith 1829-42, Part 1, no. 172, p. 154; Moes 1905, vol. 2, nos 5628:1, 2 and 3, pp. 171-72; Hofstede de Groot 1908-27, vol. 3, nos. 874 and 875a, p. 410; Hofstede de Groot 1935, p. 79; Waller 1938, pl. xl; van Hall 1963, pp. 239-40.

ETCHING: in reverse by L. B. Coclers.[1]

He wears a black cape; the white collar that is visible belongs to his shirt. On the table, a bust of the Emperor Hadrian.

No. 623 was purchased as a portrait of Adriaen van Ostade by Jan van Rossum and has always been so catalogued at the Gallery. It was, however, etched by J. B. Coclers as a *Self-portrait of Adriaen van Ostade*; and the painting was known as such from at least the time it was in the Beckford Collection and indeed also in the early part of the nineteenth century.[2] Smith[3] justifiably drew attention to the fact that the bust of Hadrian (Adrianus) was probably introduced as an allusion to van Ostade's christian name; although of course the portrait could represent some other sitter whose first name was also Adriaen. There are several images of Adriaen van Ostade[4] and he includes his self-portrait in a group portrait of the de Goyer family of about 1655 in The Hague.[5] From a comparison of no. 623 with these images, and in particular the de Goyer portrait which is about contemporary with no. 623, it would not be impossible to identify the sitter in no. 623 as van Ostade who would have been about forty-five at the time the picture was painted.

There is, however, no likelihood that no. 623 was painted by van Ostade. Smith[6] indeed refers to the fact that no. 623 was the only picture of the size of life by van Ostade that he had seen. The handling of the paint is quite unlike anything in his work and nor does it compare with any of his signed portrairts.[7] No. 623 is however similar to certain signed works by Jan van Rossum such as the portraits of Dr. Joan Blaen and his wife in the Amsterdams Historisches Museum[8] which are signed and dated 1663 and the *Portrait of a young man* signed and dated 1673 in Utrecht.[9] A similar example is the *Portrait of a lady* signed and dated 1662 in the Rijksmuseum, Amsterdam.[10] In all of these portraits van Rossum favours the use of a background curtain, a carpet — either on a table or thrown

over a balustrade; and he shows an elegant deployment of the hands. Invariably he uses some other prop in a manner similar to the bust of Hadrian here included.

On the basis of the costume no. 623 may be dated about 1655.[11] In that year Adriaen van Ostade would have been forty-five years old.

1. Repr. Waller 1938, pl. xl.
2. See Moes 1905, vol. 2, nos. 5628:1, 2 and 3, pp. 171-72.
3. Smith 1829-42, Part 1, no. 1172, p. 154.
4. See van Hall 1963, pp. 239-40, who lists fifteen portraits including no. 623, but questions whether it is a self-portrait; and mentions the attribution to van Rossum.
5. Museum Bredius, inv. no. 121. The detail of the artist's self-portrait is reproduced in Schnackenburg 1981, vol. 1, p. 17.
6. Smith 1829-42, Part 1, no. 1172, p. 154.

7. For example the *Portrait of a girl*, signed and dated 1652 in the Hermitage, Leningrad (cat. 1958, no. 2811); or the group *Portrait of a family* in the Louvre, inv. no. 1679, which is signed and dated 1654, repr. *Paris, Louvre, cat. 1979*, p. 100.
8. Inv. nos. A28706 and A28705.
9. Centraal Museum, inv. no. 238.
10. Inv. no. A1283. Repr. *Amsterdam, Rijksmuseum, cat. 1976*, p. 481.
11. Information from Marÿke de Kinkelder of the RKD.

JAN ALBERTSZ. ROTIUS (or ROOTIUS) Medemblik 1624-1666 Hoorn

He was a pupil of Pieter Lastman (q.v.) and was active mainly in Hoorn. He was a still-life and portrait painter and painted a number of children's portraits, generally showing them in a landscape under a tree. He was the father of the still-life painter, Jacob Rotius.

Ascribed to JAN ALBERTSZ. ROTIUS

639 Portrait of a boy (Fig. 142).

Oil on panel, 109.5 × 85 cms. (43⅛ × 35½ ins.).

CONDITION: the support consists of four members joined on verticals at 10, 28 and 54.5 cms. from the left. The joins have been reinforced by splats on the reverse. Splits in the support at the top and the bottom have been similarly repaired. Paint surface in poor condition: thin and considerably worn throughout.

PROVENANCE: Mrs. Lecky, by whom bequeathed, 1912.

On acquisition in 1912, it was recorded that no. 639 was traditionally said to represent Aelbert Cuyp; and this tentative identification of the sitter has been maintained in all subsequent catalogues of the Gallery. As the portrait may be dated on the basis of the costume to about 1640, and as Aelbert Cuyp would have been twenty at that time, this identification of the sitter does not seem likely. Nor does the sitter in the portrait bear any resemblance to Cuyp's own youthful self-portrait.[1]

No. 639 was bequeathed as 'Dutch School' and so catalogued until 1971 when it was given to Jan van Bijlert. van Kretschmer[2] sees no. 639 as more provincial in style than any known portraits by van Bijlert and he has suggested an attribution to either J. G. Cuyp in Dordrecht or Jan Albertsz. Rotius in Hoorn. Of these two suggestions, no. 639

comes closer in style to the work of Rotius. The composition and subject matter is of a type painted by him; and the rather mannered elegance of the sitter's stance is also found in his work. A comparison might be made with a *Portrait of a boy with a billygoat* by Rotius in the Rijksmuseum, Amsterdam,[3] in which the boy also holds a staff which is similar to that shown in no. 639.

As stated above, no. 639 may be dated on the basis of costume to about 1640.

1. Museum Bredius, The Hague, inv. no. 157-46. Painted about 1637-38. Repr. Eckardt 1971, no. 28.
2. On the basis of a photograph in a letter

dated 24 June 1983 now in the archive of the Gallery.
3. Inv. no. A995. Repr. *Amsterdam, Rijksmuseum, cat. 1976*, p. 482.

JACOB ISAACKSZ. VAN RUISDAEL Haarlem c.1628/29-1682 Amsterdam (or Haarlem)

He was born in Haarlem the son of a painter Isaack Jacobsz. van Ruysdael who was also a frame-maker and picture dealer. His precise date of birth is not known, but a document of June 1661 says his age at that time was 32. He was probably taught first by his father; but he could also have been apprenticed to his uncle Salomon van Ruysdael (q.v.). In 1648 he was a member of the Guild of St. Luke in Haarlem. About 1650 he visited Bentheim in Germany perhaps in the company of Nicolaes Berchem (q.v.). In June 1657 he set himself up in Amsterdam where he lived for the remainder of his life. Although he probably died in Amsterdam, he was buried in Haarlem on 14 March 1682. According to Houbraken he studied medicine and Latin; and he is recorded in the register of doctors in Amsterdam with the information that he qualified from Caen in 1676. He was perhaps the finest Dutch landscape painter of the seventeenth century.

37 A wooded landscape (Fig. 143).

Oil on canvas, 61 × 76 cms. (24 × 30 ins.).

SIGNED AND DATED: bottom right, *J Ruisdael (J R in monogram) 166(?1 or 4)).* (Fig. 268).

CONDITION: good. Some wearing throughout. The signature has been strengthened. Before cleaning, the strengthened date read distinctly 1678. This strengthening was removed in the cleaning and the last two numerals of the date are indistinct. Under ultra violet light the date could read 1664 or, more possibly 1661. Relined in 1968. Cleaned in 1976.

PROVENANCE: William Beckford of Fonthill sale, Phillips, London, 10 October 1823, bt. Emmerson;[1] Daniel Wade Acraman of Bristol by 1835;[2] T. Norris sale, Christie's, 9 May 1873, lot 107, where purchased for 420 guineas.

LITERATURE: Smith 1829-42, Part 6, no. 197, p. 62; Armstrong 1890, pp. 286-87; Hofstede de Groot 1908-27, vol. 4, no. 456, p. 146 and no. 721d, p. 229; Rosenberg 1928, p. 63 and no. 404, p. 97; Simon 1930, n. 49, p. 48; Simon 1935b, p. 191; Schmidt 1981, p. 75.

COPY: Hilderbrandt sale, Berlin, 7 May 1912.[3]

The previously false date of 1678 on no. 37 was accepted by Armstrong, Hofstede de Groot, Rosenberg, Simon and Schmidt. This has led to considerable confusion as no. 37 was then the last dated picture by the artist and as such very rare. Rosenberg[4] notes, however, that no. 37 exhibits no new ideas but is a stylistic repetition of pictures painted as early as the 1650's. According to Hofstede de Groot the figures were inserted by a later hand; Rosenberg regards them as autograph.

1. The reference to this sale comes from Hofstede de Groot 1908-27, vol. 4, p. 146. There were three paintings by van Ruisdael in the Beckford sale, none of which is easily identifiable as no. 37. They were, lot 174, *A beautiful landscape with river and fishermen*; lot 175, the companion (to lot 174); and lot 247, *A woody landscape with lake and figures fishing*.
2. When seen by Smith 1829-42, Part 6, no. 197, p. 62.
3. According to Simon 1930, n. 49, p. 48.
4. Rosenberg 1928, p. 63.

JACOB VAN RUISDAEL AND THOMAS DE KEYSER
(For biography of Thomas de Keyser see pp. 75-76).

287 Cornelis de Graeff with his wife and sons arriving at Soestdijk (Fig. 144).

Oil on canvas, 118.2 × 170.5 cms. (46½ × 67⅛ ins.).

CONDITION: there is a large damage above the carriage. The canvas has been torn at the top of the trees in the centre; and there are other tears above the tall trees on the left, beneath the front hooves of the horse on the right and beneath the front hooves of the horses second from left. Somewhat thin in the trees in the centre. Cleaned in 1984.

PROVENANCE: the Trustees of W. H. Aspinwall of New York, decd. sale, Christie's, 25 June 1887, lot 133, where purchased for 380 guineas.

EXHIBITED: 1937, *Der Holländische Nationaldichter Joost van den Vondel*, Wallraf-Richartz-Museum, Cologne, no. 221.

LITERATURE: Armstrong 1890, pp. 284, 286; Duncan 1906-07, p. 18; Rosenberg 1928, no. 495, p. 103; Slive 1981-82, pp. 23-24.

VERSION: by Thomas de Keyser of the section showing Jacob de Graeff and the servant in the Szépmüvészeti Múzeum, Budapest, inv. no. 4271 (Fig. 214).

On the basis of the monograms on the carriage, the sitters were identified in 1933 by Schmidt-Degener and Roell of the Rijksmuseum, Amsterdam, as Cornelis de Graeff (1599-1664) and his wife Catherine Hooft (1618-91).[1] On horseback, to the right, their sons Pieter (1638-1707) — nearest to the carriage — and Jacob (1642-90). Cornelis de Graeff and his wife are shown in a type of carriage, which is probably Dutch, that the States General in Holland retained for official use during the mid-seventeenth century.[2] It is, for example, similar to that shown in a painting by ter Borch of about 1646 of the *Arrival of Adriaen Pauw in Munster*.[3] de Graeff is sitting on the 'hang', a type of window seat in the doors of the carriage that was quite usual in the seventeenth century.

Schmidt-Degener and Roell also identified the house in the background as Soestdijk which was the country home of Cornelis de Graeff. Soestdijk is situated north-west of Amersfoort

between Soest and Baarn. It was sold by de Graeff to William III who replaced the lodge shown in no. 287 by a Royal Palace designed by Maurits Post which still stands. Cornelis de Graeff,[4] Lord of Zuid-Polsbroek was many times Burgomaster of Amsterdam. He was a friend and confidant of Johann de Witt (and also his uncle by marriage) whose nomination as Grand Pensionary of Holland in 1653 he supported. Together with de Witt he was appointed, in 1660, to the Commission for the Education of William III. He helped plan the programme and select the architect for the new Town Hall and he gave financial support for its construction. His portrait as Captain of his company, the Arquebusiers' Civic Guard, by J. A. Backer, dated 1642, is in the Rijksmuseum, Amsterdam.[5] Also in the Rijksmuseum, Amsterdam are portraits of Pieter de Graeff by Caspar Netscher[6] and Wallerand Vaillant[7] and Jacob de Graeff by Gerard ter Borch.[8] Documented portraits of both Pieter and Jacob by Thomas de Keyser are now apparently lost.[9]

Slive[10] has observed that no. 287 could be used to illustrate the poem by Joost van den Vondel included with his verse translation of the *Aeneid* which he dedicated to Cornelis de Graeff and published in 1660. van den Vondel wrote that the Burgomaster sought welcome relaxation in Soestdijk's bucolic setting after working night and day in the service of his city and country in Amsterdam's Town Hall.

It was exceptional for van Ruisdael to paint a picture in collaboration with another artist.[11] Apart from an eighteenth-century reference to a collaboration with the portrait painter Bartholomeus van der Helst[12] (q.v.), no. 287 would appear to be the only example of such a collaboration. In no. 287 the figures, animals and carriage are painted by Thomas de Keyser.

Both Rosenberg[13] and Slive[14] date no. 287 to about 1660.

1. In a letter dated 18 February 1933 now in the archive of the Gallery.
2. For information on the carriage, the compiler is indebted to H. B. Vos of the Nationaal Rijtuigmuseum, Nienoord.
3. Landesmuseum, Münster, inv. no. 210. Repr. Gudlaugsson 1959-60, text vol., fig. 43, p. 214.
4. For information on Cornelis de Graeff the compiler is indebted to Dr. P. J. van Thiel. See also Slive 1981-82, p. 23.
5. Inv. no. C1174. Repr. *Amsterdam, Rijksmuseum, cat. 1976*, p. 93.
6. Inv. No. A3977. Repr. *Amsterdam, Rijksmuseum, cat. 1976*, p. 412.
7. Inv. no. C22. Repr. *Amsterdam, Rijksmuseum, cat. 1976*, p. 552.
8. Inv. no. A3963. Repr. *Amsterdam, Rijksmuseum , cat. 1976*, p. 131.
9. Slive 1981-82, p. 24.
10. *Op. cit.*, p. 23.
11. *Ibid.*
12. *Ibid.*
13. Rosenberg 1928, no. 495, p. 103.
14. Slive 1981-82, p. 23.

After JACOB ISAACKSZ. VAN RUISDAEL

916 A stormy sea (Fig. 145).

Oil on canvas, 89.7 × 123.6 cms. (35½ × 48⅝ ins.).

CONDITION: fair. Paint surface thin in parts throughout. Cleaned in 1982.

PROVENANCE: Anon sale, Amsterdam, 17 July 1782, lot 98; Earl of Orford, Wolverton by 1854;[1] his sale, Christie's, 26 June 1856, lot 269, bt. Norton; H. A. J. Munro of Novar sale, Christie's, 1 June 1878, lot

97, bt. Graves; Sedelmeyer, Paris, before 1898;[2] Léopold Goldschmidt, Paris, 1898; James Ross of Montreal sale, Christie's, 8 July 1927, lot 24, bought in;[3] sold by Alec Martin of Christie's privately to Mr. Campbell; by descent to the latter's sister, Harriet Campbell, from whom purchased, 1929, for £650.

EXHIBITED: 1906, *Rembrandt Exhibition*, Montreal, no. 10; 1909, *Hudson-Fulton Celebration*, Metropolitan Museum, New York, no. 112.

LITERATURE: Waagen 1854, vol. 3, p. 434; Frost n.d., no. 22, p. 46; Sedelmeyer 1898; Hofstede de Groot 1908-27, vol. 4, no. 960, p. 296; Rosenberg 1928, no. 595, p. 109; Slive 1981-82, pp. 88-89.

VERSION: private collection, formerly at Bowood, Wiltshire.[4]

No. 916 is said to have been copied by Turner in a painting which that artist called *Port Ruysdael*.[5] According to Burnett,[6] Turner's title is said to have been suggested to him by 'a dark sea view by Ruisdael belonging to Monro of Novar'. Monro of Novar was a collector of paintings by Turner and also owned a number of pictures by van Ruisdael, including no. 916.[7] Two paintings by Turner, one now in Yale and another in the Tate Gallery bear the title *Port Ruysdael*;[8] but neither of these bears any compositional relationship to no. 916. Apart from that, no. 916 was not acquired by Munro until 1856 and Turner's *Port Ruysdael* paintings date from 1827 and 1844 respectively.

No. 916 was accepted as autograph by Hofstede de Groot[9] and Rosenberg.[10] However, Slive[11] has published a version of the composition, slightly larger than no. 916, which he justifiably believes to be van Ruisdael's original and he refers to no. 916 as a copy of that picture. Although Slive knew of no. 916 only before cleaning, he correctly referred to the fact that the painter of no. 916 had 'missed the extraordinary range of greys of the original'. There are some small differences between no. 916 and the original: most noticeably the beacon is shown upright in the original and there is a variation in the number of rungs shown on it. Although everything in the original is included in no. 916, the spatial effect is much more heightened in the original.

As no existing seascape by van Ruisdael is dated there is disagreement about their dating. Slive has suggested that the original of no. 916 was painted towards the end of the 1650's.

1. When seen by Waagen 1854, vol. 3, p. 434. Hofstede de Groot 1908-27, vol. 4, p. 296 gives the provenance as 'Wolverton, London' prior to the collection of the Earl of Orford: this is an error as the Earl of Orford lived at Wolverton.
2. Sedelmeyer 1898, in which no. 916 is described and illustrated. The pictures described in the Catalogue were formerly in the Sedelmeyer Gallery and no. 916 is given as 'now in the collection of Léopold Goldschmidt'.
3. The information that follows concerning the provenance is contained in the archive of the Gallery.

4. Repr. Slive 1981-82, no. 27, pp. 88-89.
5. The information is given in the James Ross sale catalogue, 1927, and repeated in the 1932 Catalogue of the Gallery.
6. Burnett 1852, pp. 29-30 and no. 139, p. 115.
7. Frost n.d., no. 22, p. 46.
8. Butlin, Joll 1977, no. 237, pl. 264 and no. 408, pl. 420.
9. Hofstede de Groot 1908-27, no. 960, p. 296.
10. Rosenberg 1928, no. 595, p. 109.
11. Slive 1981-82, pp. 88-89.

SALOMON VAN RUYSDAEL Naarden c.1600-1670 Haarlem

He was born, Salomon de Gooyer, in Naarden in about 1600 and enrolled in the Guild of St. Luke in Haarlem under that name in 1623. By 1628 he was already known as Ruysdael (or Ruijsdael or Ruyesdael) and in that year was praised as a landscape painter by Samuel Ampzing in his Beschrijvinge ende Lof der Stad Haerlem. *He served in the Guild of St. Luke as a* hoofdman *in 1647 and 1669 and as Dean in 1648. It is not certain who was his teacher but he was influenced in his early years by Esaias van de Velde who was working in Haarlem between 1610 and 1618. Until the mid-1640's his development paralleled that of Jan van Goyen (q.v.). His later paintings are more dramatic with sharper contrasts of light and dark and greater variety of colour. His son Jacob Salomonsz. van Ruysdael was also a painter and he was the uncle of Jacob van Ruisdael (q.v.).*

27 Alkmaar with the Grote Kerk, winter (Fig. 147).

Oil on panel, 53.1 × 89.3 (21 × 35 ins.).

SIGNED AND DATED: bottom left: *S.vRuysdael 1647* (the vR in monogram).

PROVENANCE: de Heuval, Brussels (label on reverse); Marquis de la Rochebrousseau sale, Paris, 5 May 1873, lot 201, where purchased for £122.

CONDITION: the back of the support has been planed down and cradled probably sometime in the nineteenth century. The support has also been extended by the addition of a section 15 × 89.3 cms. at the top: the measurements given above are of the entire panel. This addition could be nineteenth century and the sky has been painted to blend in with the original: it is, however, clearly by a different (and later) hand. In good condition. Cleaned in 1982.

LITERATURE: Simon 1935a, p. 190; Stechow 1975, no. 21, p. 72.

The Grote Kerk (or St. Laurenskerk) is a Gothic edifice dating from 1470-1520. No. 27 is one of the relatively small number of winter landscapes by van Ruysdael.[1] Prior to its cleaning in 1982 the bottom left-hand corner was overpainted concealing the detail of the animals devouring carcasses. The significance of this scene is not clear; but it could be that the area in the foreground left was associated with the city's abattoir.

The support has been enlarged (see 'Condition' above). George Keyes has remarked[2] a similarly enlarged panel by van Ruysdael that was formerly in the Dr. Geus van den Heuval collection.[3] The signature and date, revealed in the recent cleaning, have not previously been recorded.

1. Stechow 1975, lists only twenty-four out of a total catalogue of six hundred and twelve works.

2. In a letter dated 3 January 1977 now in the archive of the Gallery.
3. Stechow 1975, no. 14, p. 71.

507 The halt (Fig. 146).

Oil on canvas, 99 × 153 cms. (39 × 60¼ ins.).

SIGNED AND DATED: on the back of the carriage on the right: *SVR* (in monogram) *1661* (Fig. 269).

REVERSE: the page from the San Donato catalogue is pasted to the stretcher.

CONDITION: good. There are paint losses in the area of the trees on the right. Cleaned and restored in 1982.

PROVENANCE: Prince Demidoff sale, San Donato, Florence, 15 March 1880, lot 1123; Charles William Harrison Pickering sale, Christie's, 11 June 1881, lot 158, bt. Sir Henry Page Turner Barron, by whom bequeathed, 1901.

EXHIBITED: 1952-53, *Dutch Pictures 1450-1750*, Royal Academy, London, no. 282; 1985, *Masterpieces from the National Gallery of Ireland*, National Gallery, London, no. 27.

LITERATURE: Duncan 1906-07, p. 18; Stechow 1975, no. 164, p. 93; London 1985, no. 27, p. 70.

The composition is of a type, a halt of carriages before an inn, which van Ruysdael made his own; so much so that Stechow[1] in categorising the paintings of the artist, uses the type as a specific category in which he lists over thirty paintings. The earliest of these,[2] present whereabouts unknown, is dated c.1635 and van Ruysdael continued with the subject until the 1660's. The inn in no. 507 is depicted with minor variation of details in several paintings including one in the Norton Simon Museum, Pasadena, which is dated 1643[3] and two paintings in the Rijksmuseum, Amsterdam, dated 1655 and 1660.[4] In the case of the 1660 painting, which is considerably smaller than no. 507, the landscape and other details are also similar.

No. 507 is one of the largest and finest of all van Ruysdael's paintings of this subject. The date, which is clearly 1661, has always been misread as 1667: a date that would make the picture uncomfortably late in his career. The correct date of 1661 means that no. 507 is a year later than the painting in the Rijksmuseum, Amsterdam[5] with which it compares so aptly.

1. Stechow 1975, pp. 89-95.
2. Stechow 1975, no. 145.
3. Stechow 1975, no. 147 and repr. *ibid.* fig. 21, pl. 15.
4. Inv. no. A713, repr. Stechow 1975, fig. 43, pl. 31 and inv. no. A352, repr. Stechow 1975, fig. 67, pl. 48.
5. Inv. no. A352.

CORNELIS SAFTLEVEN Gorinchem c.1607-1681 Rotterdam

He was the son of the artist Herman Saftleven. He was brought up in Rotterdam and remained there until about 1632 when he travelled to Antwerp. By 1634 he was in Utrecht and is next recorded in Rotterdam in 1637. He was Dean of the Guild of St. Luke in Rotterdam in 1667 and died in that city on 1 June 1681. Apart from being a painter he also made a number of etchings and a corpus of drawings by him survives. He painted landscapes, barn interiors, religious subjects and peasant genre. According to Houbraken, Ludolf de Jongh (q.v.) was his pupil.

449 The return of Tobias with the angel (Fig. 148).

Oil on panel, 50.7 × 65.5 cms. (20 × 25⅞ ins.).

REVERSE: the printed cutting from the 1857 sale catalogue is pasted to the support.

CONDITION: fair. Some damages throughout. Abraded in parts.

PROVENANCE: Henry Cruger Price, decd. sale, Christie's, 21 March 1857, lot 28, bt. Adams; Sir Walter Armstrong, by whom presented, 1896.

LITERATURE: Stechow 1935, p. 309; Schulz 1978, no. 685, p. 238.

The subject is from the apocryphal book of *Tobit*. Tobit, a devout Jew, and his wife Anna had a son, Tobias. In his later years Tobit lost his sight and, feeling that death was near, asked Tobias to make a journey for him to collect a debt. On his journey Tobias encountered the Archangel Raphael who agreed to accompany him. On the Archangel's instructions, Tobias gutted a fish from the River Tigris and on his return used the gall from the fish to cure his father's blindness. On the left in no. 449 is the blind Tobit. Although Saftleven painted some few pictures with religious subject matter, it was fairly exceptional for him to introduce a specific subject into one of his barn-interiors. On occasions he did depict the *Adoration of the shepherds* in such a setting.

No. 449 was sold in 1857 as Camphuijsen and was presumably thought to be the work of Govert Camphuijsen, an artist who painted similar subject matter. The painting was presented as Saftleven, and the attribution is accepted by Schulz,[1] and indeed need not be disputed. Saftleven, who painted such subjects throughout his career was one of a group of artists working in Rotterdam, who, from the 1630's painted stable interiors in a style which paralleled the work of David Teniers the Younger.[2] In no. 449 there is rather less still-life detail than in many of Saftleven's barn interiors. It is a mature work possibly dating from the 1650's.

1. Schulz 1978, no. 685, p. 238.

2. See Heppner 1946, *passim.*

GODFRIED SCHALCKEN Made 1634-1706 The Hague

He was the son of the parish minister of Made, near Dordrecht where he was born in 1634. In 1654 the family moved to Dordrecht where his father was appointed Rector of the Latin school. According to Houbraken, Schalcken studied with Samuel van Hoogstraten in Dordrecht between 1656 and 1662 and then with Gerard Dou in Leiden. By 1665 Schalcken had returned to Dordrecht where he is registered as an ensign in a militia company. He married in Dordrecht on 31 October 1679. In 1691 Schalcken was in The Hague where he paid his dues to Pictura in February; but by November of that year he was again in Dordrecht. From 1692-97 Schalcken was in London where he painted several portraits of William III. By June 1698 he was again in The Hague and the following year became a citizen there. Apart from a visit to Düsseldorf in 1703, he remained in The Hague

until his death in November 1706. He was primarily a portrait painter, but he also painted genre scenes a number of which are nocturnal and illuminated by candlelight. He is the subject of a short story, Schalcken the Painter *by the Irish writer, Joseph Sheridan LeFanu.*

476 Pretiose recognised (Fig. 149).

Oil on panel, rounded at the top, 44.2 × 31.2 cms. (17⅞ × 12¼ ins.).

SIGNED: bottom, left of centre, *G. Schalcken.* (Fig. 270).

CONDITION: very good.

INSCRIBED: on the paper at the bottom: *'het jong ic den.*

PROVENANCE: in the collection of Phillipe, Duc d'Orléans (the Regent) at the Palais-Royal, Paris[1] which was formed in the quarter of a century before the Duke's death in 1723. It remained at the Palais-Royal until the Flemish and Dutch paintings of the collection were sold by the great-grandson of the Duc d'Orléans ('Philippe-Égalité') in 1791 or 1792 to Thomas Moore Slade, acting on behalf of Lord Kinnaird, Mr. Morland and Mr. Hammersley.[2] These paintings were brought to England in 1792 and no. 476 was exhibited with them for sale by private contract in London, April-June 1793. It was sold for £100 at that time;[3] 'A Gentleman of Surrey' (Stephenson) sale, Christie's, 26 May 1818, lot 156, bt. in; Albert Levy sale, Christie's, 6 April 1876, lot 367, bt. Pearson; P & D Colnaghi, from whom purchased, 1898, for £150.

EXHIBITED: 1793, *The Orléans Gallery*, The Great Rooms (formerly Royal Academy) Pall Mall, London, no. 38.

LITERATURE: de Saint Gelais 1727, pp. 443-44; Smith 1829-42, Part 4, no. 95, p. 286; Hofstede de Groot 1908-27, vol. 5, no. 88, p. 334; Gaskell 1982, p. 270 and n. 63, p. 270.

No. 476 was referred to as *La Reconnaissance de la Bohemienne* when in the Orléans collection,[4] described as such by Smith,[5] called *Preciosa recognised* by Hofstede de Groot[6] and purchased by the Gallery as *The lost daughter restored*. The subject is taken from Cervantes's short story *La Gitanilla* (the little gipsy) which was published first among a group of stories, *Novelas ejemplares*, in 1613. In Holland the theme of the story was used by Jacob Cats as one of the exemplary poems in his book *Trou-Ringh* published in 1637.[7] Cervantes's original poem was published in Dutch in 1643 and two Dutch plays by Mattheus Tengnagel and Catharina Dusart, which were derived from Cats's poem, were performed in Amsterdam in 1644.[8] The story is of Constance, the daughter of a noble house, who is stolen from her parents when a child by a gypsy woman, Majombe. She is given the name Pretiose and brought up among the gypsies. When Don Juan later falls in love with her, she demands that he give up his noble status and live as a gypsy for two years. During that time he is maliciously accused of a theft, kills one of those arresting him, and is imprisoned. Pretiose pleads with the magistrate's wife to intercede for him. Majombe then confesses that Pretiose is none other than the magistrate's daughter whom she had stolen. In no. 476 Pretiose is seated in the centre wearing a gypsy costume which she draws down to reveal a mole on her left breast which confirms her identity to her mother. Her mother, Giomaer, stares in amazement, while her father, the magistrate Don Ferdinando, turns away open-mouthed. Behind her another woman, who may be her old nurse, wipes her eyes with a handkerchief, as she cries with joy. In the foreground there is a necklace of pearls and a gold chain with a medallion attached to it: these are the jewels which Constance (Pretoise) was wearing at the time she was stolen. The

crumpled paper is the notice of the theft. In the poems of both Cervantes and Cats, Pretiose refers to an unpicked rose as a symbol of an unblemished maiden; and in no. 476 roses are shown in a marble vase in the foreground. As Gaskell[9] has shown, the subject was treated by a number of Dutch painters in the seventeenth century, and both of Schalcken's most famous contemporaries in Leiden, Frans van Mieris and his son Willem, painted it.

No. 476 was referred to as 'the very celebrated cabinet chef d'oeuvre' of Schalcken — 'an exquisite bijou', when sold in 1818. Both style and costume would indicate that it was painted in the late 1660's.

1. de Saint Gelais 1727, pp. 443-44.
2. Slade's own account of the transaction is given in Buchanan 1824, vol. 1, pp. 158-64.
3. A manuscript list of the Orléans pictures sold at the time of the 1793 Exhibition is in Barclays Bank, Pall Mall, London: a photocopy is in the National Gallery, London. The list, presumably prepared by Slade, lists the pictures sold, with the maximum and minimum prices at which they were on offer and the prices realised. No. 476 was offered at a price between £80 and £120 and sold for £100.
4. de Saint Gelais 1727, p. 443.
5. Smith 1829-42, Part 4, p. 286.
6. Hofstede de Groot 1908-27, vol. 5, p. 334.
7. See Gaskell 1982, p. 263.
8. *Ibid.*
9. Gaskell 1982, *passim.*

Pieter van Slingeland Leiden 1640-1691 Leiden

According to Houbraken he was born in Leiden on 20 October 1640. He was a pupil of Gerard Dou. He was a member of the Guild of St. Luke in Leiden from 1661 and dean in the year of his death. He painted portraits, genre scenes, mythological subjects and still-life.

267 Portrait of a lady (Fig. 150).

Oil on panel, 36.8 × 29.5 cms. (14½ × 11⅝ ins.).

SIGNED: on the base of the column, right: *P V. Slingeland* (Fig. 271).

REVERSE: a printed description in French which implies that no. 267 was one of a pair of paintings and stating that they passed from the van Slingeland family to Hooft.[1]

CONDITION: good. Some retouchings in the sky and trees. Line damage about one inch long to the right of the head. Line damage to the right of the dog rising from the bottom about 15 cms. long. Cleaned in 1967.

PROVENANCE: by descent in the van Slingeland family to Hooft; D. Hooft sale, Amsterdam, 30 October 1860, lot 3, bt. Nieuwenhuys; C. J. Nieuwenhuys, decd. sale, Christie's, 17 July 1886, lot 97, where purchased for 77 guineas.

LITERATURE: Hofstede de Groot 1908-27, vol. 5, nos. 161, p. 465 and 166, pp. 467-68.

The information contained in the inscription on the reverse is correct in stating that no. 267 is one of a pair of pictures. Its pendant,[2] which shows a man standing and leaning towards the left was sold in the Hooft sale in 1860 and is now in the Metropolitan Museum, New York[3] (Fig. 215). As the paintings may have belonged to the van Slingeland family,

it is possible that they are portraits of members of that family: and certainly probable that they represent a man and his wife.

On the basis of the lady's hairstyle, no. 267 may be dated to the early 1670's.

1. The description must date from after 1857 as it refers to the fact that there was no painting by van Slingeland in the Manchester *Art Treasures* exhibition.

2. Hofstede de Groot 1908-27, vol. 5, no. 156, p. 464.
3. Inv. no. 71.70. Repr. Baetjer 1980, vol. 3, p. 450.

JAN FRANS SOOLMAKER Antwerp c.1635-after 1665 Italy

He was born in Antwerp and became a member of the Guild of St. Luke there in 1654. He is recorded in Amsterdam in 1665 when he made a testament prior to his departure for Italy. It is probable that he visited Portugal and Spain on his way to Italy where he died. His date of death is unknown. He painted Italianate landscapes with shepherds and animals very much in the style of Nicolaes Berchem (q.v.) with whom he may have studied. He is sometimes called Solemackers.

225 Cattle in a hilly landscape (Fig. 151).

Oil on canvas, 38 × 33 cms. (15 × 13 ins.).

SIGNED: on the cross bar of the stile on the left, *F. Solemackers* (Fig. 272).

CONDITION: good.

PROVENANCE: van Camp sale, Antwerp, 12-14 September 1853, lot 198, bt. Viscomte du Bus de Gisignies; his sale, Brussels, 9-10 May 1882, lot 69, where purchased for £96.

LITERATURE: Fétis 1878, pp. 142-44; Armstrong 1890, p. 282; von Manteuffel 1937, p. 284.

ENGRAVING: by C. Carter, 1890.[1]

No. 225 is a typical work of the artist and of good quality. Armstrong[2] remarked that 'neither Soolmaker nor even his exemplar Berchem ever produced a more delightful little work.'

1. Published in *Magazine of Art*, 1890, p. 282.

2. Armstrong 1890, p. 282.

HENDRICK SORGH Rotterdam 1609-11 - 1670 Rotterdam

Hendrick Martensz. Sorgh was born in Rotterdam between 1609 and 1611. He also signed his works Sorch and de Sorch. He was the son of Marten Rochusse or Rokes who acquired the sobriquet Zorg (meaning careful) because of the care with which he handled cargo as

a bargeman. According to Houbraken, Sorgh studied with the Antwerp painter David Teniers and also with Willem Buytewech. He married in 1633 and had at least five children. He seems to have been well-to-do as he bought an expensive house in Rotterdam in 1637; and he also enjoyed a somewhat elevated social standing as, in 1657, he was appointed to the honorary municipal post of Bread Weigher, and, in 1659, Fire Chief; he is also recorded in 1646 at a rabbit hunt with the Sheriff of Rotterdam. He was a hoofdman *of the Guild of St. Luke in Rotterdam in 1659. He lived all his life in Rotterdam and died there in 1670 when he was buried in the Grote Kerk. He specialised in painting peasant interiors, although later he also painted market scenes, some few portraits, marine and history paintings. He helped develop a peasant painting tradition in Rotterdam related to the work of Teniers in Antwerp and Adriaen Brouwer (q.v.) and Adriaen and Isaack van Ostade in Haarlem.*

269 The breakfast (Fig. 152).

Oil on panel, 31.3 × 24.8 cms. (12⅝ × 9¾ ins.).

SIGNED AND DATED: on the stool, right: *H.M. Sorgh 1656* (H M in monogram). (Fig. 273).

REVERSE: inscribed with monogram *I C.*

CONDITION: good. There is a split in the support left of centre from top to bottom. Some overpaint with craquelure in the background left. Cleaned in 1970.

PROVENANCE: J. B. P. Le Brun, Paris, 1792; C. J. Nieuwenhuys, decd. sale, Christie's, 17 July 1886, lot 120, where purchased for £160.[2]

LITERATURE: Le Brun 1792, vol. 1, p. 81; Armstrong 1890, p. 287; Armstrong 1893, pp. 18-19; Juynboll 1937, p. 294; Schneeman 1982, no. 65, pp. 224-25.

ENGRAVING: by H. Guttenberg, 1792.[1]

Described by Armstrong as follows:[3] 'a pair of boors at a meal of herrings and schiedam. The pots on the table, the structure of which is not a little precarious, are painted with veracity; but the figures are *posé*. For its want of ease, the picture must be an early one, but in quality I know none to beat it.'

Although no. 269 was described on Guttenberg's engraving of 1792 as signed and dated 1656, the date was read by Armstrong[4] as 1636 and it was so dated in the earlier catalogues of the Gallery. Juynboll,[5] however, gave 1656; and van Thiel[6] also accepted the later date. Schneeman[7] finds difficulty in reconciling the style of no. 269 with either date; but at the same time accepts the later date as, without question, the more plausible. She points out, however, that 'the large size of the figures and a certain awkwardness in their handling, as well as the facial types, are not common in Sorgh and suggest a collaborative effort. Certain still-life elements such as the earthenware pitcher with white dots, and the ornamented wine jug, also suggest another hand'. She concludes that no. 269 may be a work executed in largest part by a pupil and repainted or finished by Sorgh.

1. The engraving is published in Le Brun 1792, vol. 1, p. 81.
2. The annotated sale catalogue in the National Gallery, London gives the price as 125 guineas; the Gallery Register and manuscript catalogue give £160.

3. Armstrong 1890, p. 287.
4. Armstrong 1893, p. 19.
5. Juynboll 1937, p. 294.

6. On a visit to the Gallery in 1968.
7. Schneeman 1982, p. 227.

JAN STEEN Leiden 1625/26-1679 Leiden

His exact date of birth has not been established but at the age of twenty in 1646 he enrolled in the university at Leiden. According to Houbraken he was a pupil of Jan van Goyen (q.v.); and he is also said to have studied with Nicolaes Knüpfer in Utrecht and Adriaen van Ostade (q.v.) in Haarlem. He became a member of the Guild of St. Luke in Leiden in March 1648 and in September of the following year he married the daughter of Jan van Goyen (q.v.) in The Hague and remained there until 1654. His father leased a brewery for him in Delft between 1654 and 1657; but, as he is mentioned in records in Leiden in 1654 and from 1656-60 lived in Warmond outside Leiden, he does not seem to have spent much time in Delft. By 1661 he was settled in Haarlem where he became a member of the Guild of St. Luke; but in 1670 moved to Leiden where he inherited his father's house. In 1672 he was given permission to open an inn. His wife died in May 1669 and Steen married again in 1673. He was a hoofdman of the Guild of St. Luke in Leiden in 1671, 1672 and 1673 and in 1674, Dean. He died early in 1679. He was extremely productive but is not recorded as having any pupils. His style was imitated by other painters, in particular Richard Brakenburgh (q.v.) in Haarlem.

226 The village school (Fig. 153).

Oil on canvas, 110.5 × 80.2 cms. (43½ × 32¼ ins.).

CONDITION: there are damages in the area of the books on the shelf and also above the head of the centre child. Cleaned and lined in 1970.

PROVENANCE: Izaak Hoogenbergh sale, Hayman, Amsterdam, 10 April 1743, lot 42, bt. W. Lormier;[1] W. Lormier sale, The Hague, 4 July 1763, lot 246;[2] probably Greffier Fagel, The Hague; thence by descent to the Countess of Holderness;[3] probably Countess of Holderness, decd. sale, Christie's, 6 March 1802, lot 110, bt. Dermer;[4] 'Property of a Gentleman' sale, Christie's, 8 February 1806, lot 105;[5] G. J. Cholmondeley by 1818;[6] G. J. Cholmondeley sale, Squibb, London, 23 April 1831, lot 15;[7] Colnaghi, from whom purchased, 1879, for £420.

EXHIBITED: probably 1818, British Institution, no. 108; 1883, *Winter Exhibition*, Royal Academy, London, no. 249; 1929, *Dutch Art*, Royal Academy, London, no. 241; 1952-53, *Dutch Pictures 1450-1750*, Royal Academy, London, no. 573; 1956-57, *Il Seicento Europeo*, Palazzo del Espozizione, Rome, no. 286; 1958-59, *Jan Steen*, Mauritshuis, The Hague, no. 311; 1966-67, *The Age of Rembrandt*, Palace of the Legion of Honor, San Francisco; Toledo Museum of Art, Toledo, Ohio, and Museum of Fine Arts, Boston, no. 90; 1984, *Masters of Seventeenth Century Dutch Genre Painting*, Philadelphia Museum of Art; Gemäldegalerie, Berlin (West) and Royal Academy, London, no. 107.

LITERATURE: Hoet 1752, vol. 2, p. 438; Buchanan 1824, vol. 1, no. 63, p. 316; Smith 1829-42, Part 4, nos. 21 and 22, pp. 7-8; van Westrheene 1856, no. 240, p. 148; Armstrong 1890, p. 283; Duncan 1906-07, p. 18; Hofstede de Groot 1908-27, vol. 1, nos. 285, p. 81 and 300, p. 84; Bredius 1927a, p. 23; Rosenberg,

Slive, ter Kuile 1968, p. 135; de Vries 1977, p. 57 and no. 116, p. 164; Braun 1980, no. 198, p. 114; Durantini 1983, p. 120 and pp. 158-60; Philadelphia/Berlin/London 1984, no. 107, pp. 318-20.

ENGRAVING: by C. Carter in *Magazine of Art*, 1890, p. 285.

COPIES: 1. On panel, 40 × 30 cms. coll. J. P. Geelhand de Labistrate, exh. Kums Museum, Antwerp, 1878, sold 17 May 1889, lot 130, and in the Museum at Mulhausen in 1956 (Hofstede de Groot, no. 284); 2. On panel, 33 × 28 cms. With Brod, London and then sold Spik, Berlin, 28 February 1957 and again sold Muller, Amsterdam, 18 June 1957; 3. On panel, 40 × 31 cms. Hünenberg sale, Brunswick, 8 September 1960; 4. Formerly coll. Count Bobrinskoy, London; 5. With the dealer D. Katz, Dieren, Holland before 1939. This picture was a horizontal composition, the left hand side of which was a copy of no. 226, and the right hand side showed other children in the classroom.

The boy, whose untidy and blotted writing sheet lies on the floor, cries as he holds out his hand to be slapped by the schoolmaster with a ferule. The little girl is in a state between laughing and crying at his predicament, perhaps in the knowledge that she may be next. Two other children approach with their lessons and appear to be more confident that they are correct. In the background other pupils work at their desks and one takes a slate from the wall. Hanging on the background wall behind the schoolmaster are shears, a bottle-type jug and an hourglass. In the niche are some bottles and on the shelf above some books. The boxes hanging on the wall at the right are candle boxes; but they were used by children to bring their pencils and other equipment to school. The little girl, the boy being punished and the boy holding a paper have been identified by Braun[8] as the three children of the painter, Catherina, Cornelis and Johannes. Steen depicted them also in another painting of a schoolmaster now in the collection of the Marquess of Northampton[9] (Fig. 216). The suggestion which has been made[10] that the model for the schoolmaster in no. 226 was also depicted by Steen in the Northampton painting as well as in another schoolroom painting[11] and in his *Village alchemist*[12] and *Satyr and peasants*[13] is untenable to the compiler: the man in all those pictures is much older than the schoolmaster in no. 226. It has been pointed out[14] that the schoolmaster wears an 'unhistorical, semi-theatrical costume' consisting of a sleeveless frock, yellow jacket with striped sleeves, short ruff and black cap; and that such a costume is neither mid-seventeenth century nor antiquated sixteenth century.

No. 226 is one of several schoolroom pictures painted by Steen, the largest and most elaborate of which is the painting in the collection of the Duke of Sutherland on loan to the National Gallery of Scotland.[15] The system of education in seventeenth-century Holland, which formed the background to such pictures has been excellently summarised by Sutton,[16] and is here quoted verbatim: 'By the pitiable standards of the day, literacy was relatively high in the Netherlands, but the quality of elementary education varied greatly depending on the schoolmaster, whose position was neither well paid nor prestigious. Valcooch, who taught at Barsigherhorn and wrote a handbook in 1591 for village schoolmasters, complained bitterly about the low wages and the lack of thought given to the selection of teachers. Insufficient pay forced many schoolmasters to take supplemental jobs. In some cases, teaching jobs were awarded as social service positions, mere sinecures for those unable to do other work. In 1620 the communities of Schore and Vlake complained of a teacher who, despite a decade at his post, was virtually illiterate, knew nothing about mathematics, and apparently had no inclination to teach. Some improvements were made by mid-century; an edict of 1655 required all teaching candidates

to be able to read, write, perform four basic calculations and know the tunes of hymns. The Reformed Church had decreed that the schoolmaster's duty was primarily religious and not scholastic; teachers took an oath of allegiance to the Church (to eliminate Catholics or forbidden books) and were required to teach the Catechism. Despite these requirements, complaints of teachers corrupting the young were perennial. Schoolmasters were accused of everything from failing to offer religious instruction to fighting, visiting brothels, and operating a tavern for their pupils; drinking was, however, the most frequent complaint. In fairness, the life of a pedagogue in the seventeenth-century Netherlands was often ungratifying because of low pay, sporadic student attendance (particularly in rural areas), narrow curriculum, long hours (in the summer 6.00 a.m. to 7.00 p.m.), short vacations and unbearably noisy classrooms resulting from oral recitation. The physical punishment depicted in Steen's painting in Dublin is neither excessive nor brutal by seventeenth-century standards. Use of the rod or ferule to discipline students was an accepted educational practice. Valcooch, who recommended their use, advised only that a teacher not strike in anger. (But) by a regulation of 1682, teachers were instructed to exchange the rod or ferule for other methods, such as keeping children after hours or shaming them in front of their peers.'

The bottles in the niche in no. 226 could be included as a suggestion that the schoolmaster was prone to drunkeness. The hourglass, symbolising the passing of time, suggests that the children's time at school must not be wasted, but used well. It has been suggested[17] that the shears could serve as an illustration of an expression used by the Dutch in defence of spoiling their children: 'Cut off the nose and spoil the face'. The books on the shelf could be an allusion to an emblem of Roemer Visscher published in 1618[18] with the legend that books were 'food for the wild spirit' and, therefore, the means of taming the unruly, the unmannered and the unlearned.

No. 226 has been dated about 1663-1665[19] and compared stylistically with Steen's *Beware of luxury* dated 1663 in Vienna[20] and *The feast of St. Nicolas* in Amsterdam[21] which is placed about 1663-1665. Braun[22] gives the same date for no. 226.

1. Described as 'een Schoolmeester, door denzelven (by the same, i.e. Jan Steen) Breed 2 voet 10 duym, hoog 3 voet 8 duym (width 2 feet 10 ins., height 3 feet 8 ins.). The annotated sale catalogue in the RKD gives the purchaser as W. Lormier for fl. 190. The picture is described in Lormier's collection in 1752 by Hoet 1752, vol. 2, p. 438.

2. Described as 'een Schoolmeester met Verscheide Kindren, D(oek) Breed 2 V en 3d. hoog 3 V en 7d.' (A Schoolmaster with different children, canvas, . . .).

3. Buchanan 1824, vol. 1, p. 308 says that the collection of the late Countess of Holderness descended from Greffier Fagel; and see further under n. 4.

4. Dermer is given as the purchaser in Buchanan 1824, vol. 1, p. 308. The Provenance

of no. 226 as given in Hofstede de Groot 1908-27, vol. 1, (under no. 285) which is derived from Smith 1829-42, (under no. 21) is, from the time no. 226 came to England, confused and for the most part incorrect; and it has been followed by all authorities since the time of Hofstede de Groot. There were two paintings entitled *The Schoolmaster* by Jan Steen in England in Smith's time. These are Smith 1829-42, nos. 21 and 22 and Hofstede de Groot 1908-27, nos. 285 and 300. One picture measured, according to Smith, 42 × 32½ ins. on canvas, the other 16 × 12 ins. on panel. The two pictures shall be referred to here as (1) the Holderness picture, and (2) the Baring picture. Our no. 226 is here identified as most probably the Holderness picture. The Baring picture was actually seen by Smith: he describes it as 'now

(i.e. in 1833) in the collection of Alexander Baring' and gives its measurements as 16 × 12 ins. on panel. The Baring picture was lent by A. Baring to the British Institution in 1819 (no. 106), and not in 1826 as stated by both Smith and Hofstede de Groot. It is most likely that it was also the painting in the 'Pictures recently imported from the Continent' sale, Phillips, London 19-20 July 1815. (This sale, the catalogue of which the present writer has not been able to consult, is referred to by Hofstede de Groot under no. 285 as H. Phillips sale, London). The Holderness picture cannot have been the *Schoolmaster* by Steen in that sale as it was not, in 1815, recently imported from the continent. The Baring picture is now in the collection of the Marquess of Northampton (see further under n. 9 below) and measures 16 × 12 ins.: it is painted on canvas although the Baring picture was consistently stated to be on panel.

5. Described in the sale catalogue as 'from the Holderness collection'.

6. When lent to the British Institution.

7. Described in the sale catalogue as 'from the collection of Lady Holderness'. Hofstede de Groot, 1908-27, vol. 1, p. 81, describes our no. 226 as bought by Squibb at the Cholmondeley sale.

8. Braun 1980, no. 198, p. 114.

9. Repr. Braun 1980, no. 248.

10. Philadelphia/Berlin/London 1984, p. 319 and n. 17, p. 320.

11. Present whereabouts unknown. Repr. Philadelphia/Berlin/London 1984, fig. 1, p. 319.

12. Wallace Collection, London, cat. no. P. 209. Repr. *London, Wallace, cat. 1979*, p. 239.

13. Museum Bredius, The Hague, inv. no. 157. Repr. *The Hague, Bredius, cat. 1980*, p. 127.

14. Philadelphia/Berlin/London 1984, p. 319.

15. Repr. Philadelphia/Berlin/London 1984, fig. 3, p. 319.

16. In Philadelphia/Berlin/London 1984, pp. 318-19.

17. *Ibid.*

18. As suggested by Durantini 1983, p. 120 who reproduces the emblem, fig. 122, p. 122.

19. Philadelphia/Berlin/London 1984, p. 319; and by de Vries 1977, p. 57, to Steen's Haarlem period, i.e. 1661-65.

20. Kunsthistorisches Museum, inv. no. 791. Repr. Philadelphia/Berlin/London 1984, pl. 80.

21. Rijksmuseum, inv. no. A385. Repr. *Amsterdam, Rijksmuseum, cat. 1976*, p. 522.

22. Braun 1980, no. 198, p. 114.

Follower of JAN STEEN

227 A woman mending a stocking (Fig. 154).

Oil on panel, 33 × 27.5 cms. (13 × 10¾ ins.).

REVERSE: two indecipherable collector's seals.

CONDITION: the support consists of two members joined on a diagonal from points 5 cms. from the right (top) to 8.8 cms. from the right (bottom). There are numerous small paint losses in the area of the woman. The background appears to have been overpainted but this is probably original and radiographs show that there were no changes to the composition. Cleaned and restored in 1986.

PROVENANCE: Anon sale, Amsterdam, 14 November 1791, lot 130; S. J. Stinstra & others sale, Amsterdam, 22 May 1822, lot 164;[1] Anon sale, Robinson and Fisher, London, 29 April 1875, lot 15,[2] where purchased for £24.

LITERATURE: Duncan 1906-07, p. 18; Hofstede de Groot 1908-27, vol. 1, no. 332, p. 90 and no. 334, p. 91; Braun 1980, no. B-85, p. 168; Stone-Ferrier 1985, p. 103.

The man was thought by Armstrong[3] to bear a resemblance to Jan Steen himself and called by Duncan[4] a self-portrait of the artist. Steen included his own portrait in many of his pictures but the man in no. 227 does not particularly resemble him. The woman, who has removed both her stocking and her shoe, sits with her bare foot on a foot warmer.

She is in the process of threading a needle. In Dutch seventeenth-century paintings a woman removing her shoes and her stockings has erotic implications.[5] The action suggest a movement towards undress and it has been shown,[6] by reference to Steen's *Morning toilet* in Amsterdam[7] that the image of a young woman pulling on or off her stockings plays on the metaphor of the stocking as an immoral woman in general or a woman's genitals in particular, and of the foot as a phallic symbol.[8] The Dutch word for stocking *(kous)* was also used in seventeenth-century Holland to describe the female genitals.[9] The heat derived from the footwarmer alludes to the heat to be derived from passion. Even the useful activity of doing needlework had erotic implications.[10] An emblem published by Jacob Cats in 1662 shows a woman sewing attended by her suitor.[11] Underneath the emblem, the legend reads 'I spoke last with my love, while she sat and sewed. I placed her before my grief, hear, yet how she captured me. Watch what I am doing, she spoke, notice how it all goes. First the needle makes a hole that is filled there with the thread.'

The attribution to Steen of no. 227 is rejected by Braun.[12] The figures in the painting are both of a type found in the work of Steen; but although competently painted, the quality of the work does not suggest the artist himself. It is almost certainly contemporary with him and is here catalogued as having been painted by a follower.

1. The provenance so far is derived from Hofstede de Groot 1908-27, vol. 1, no. 334, p. 91, as from his description that painting was identical with no. 227. Braun 1980, no. B-85, p. 168, also identifies no. 227 with Hofstede de Groot's no. 334; but he then erroneously identifies the picture as also Hofstede de Groot's no. 335 which the latter describes as 'The needlewoman asleep — the wife of Jan Steen sits asleep in a room at a table, on which is a sewing cushion'. Whatever activity the lady in no. 227 may be engaged upon, it is certainly not sleeping; and no. 227 cannot be identified with Hofstede de Groot's no. 335.
2. There were two paintings called Steen in this sale: lot 15, *An interior with figures carousing,* and lot 45, *An interior with figures,* signed.

Although the title of the latter would describe no. 227 more accurately, there is no question of no. 227 being signed.
3. In the 1898 catalogue of the Gallery.
4. Duncan 1906-07, p. 18.
5. See Philadelphia/Berlin/London 1984, p. 259.
6. In Amsterdam 1976, p. 245.
7. Rijksmuseum, inv. no. A4052. Repr. *Amsterdam, Rijksmuseum, cat. 1976,* p. 522.
8. For a discussion of no. 227 in these terms see Stone-Ferrier 1985, p. 100 and n. 38, p. 257; also p. 103 where no. 227 is reproduced as 'Private English Collection'.
9. As pointed out by de Jongh 1971, p. 174.
10. Stone-Ferrier 1985, pp. 95 ff.
11. Repr. Stone-Ferrier 1985, fig. 40, p. 98.
12. Braun 1980, no. B-85, p. 168.

Matthias Stomer ? Amersfoort c.1600-? c.1650 Sicily

He is said to have come from Amersfoort although the strong Flemish influences in his work would indicate that he may have had contact with Antwerp. He is recorded in Rome in 1630-32; and then worked for some years in Naples before moving to Sicily where he was by 1641. He was active in Messina and Palermo and seems to have died in Sicily.

425 The arrest of Christ (Fig. 155).

Oil on canvas, 201 × 279 cms. (79⅛ × 108⅞ ins.).

CONDITION: a considerable number of damages throughout. Cleaned and restored in 1970.

PROVENANCE: Sir George Donaldson of Sussex, by whom presented in memory of his mother, a native of county Wicklow, 1894.[1]

LITERATURE: Hoogewerff, 1924, p. 14; Porcella, 1931, pp. 91, 210; Henry, 1937, fig. 1, p. 1; Isarlo, 1941, p. 231; Pauwels, 1953, pp. 160, 162, 187; L.M., 1954, p. 127; Zeri, 1954, p. 89; Judson, 1959, p. 162; Nicolson, 1977, no. 120, p. 242; Nicolson 1979, p. 94.

The episode of the *Arrest of Christ* is told in all four Gospels. Jesus went with his disciples into the Garden of Gethsamene. Having been identified by the kiss of Judas he was arrested by the soldiers of the Chief Priests and Pharisees. Simon Peter drew his sword and cut off the ear of the High Priest's servant, Malchus. Only in *St. John* (ch. 18, vs. 10) is Malchus's name given. In the centre of no. 425, illuminated by the flaming torch of the youth on the left is Christ whose hands are being bound by a soldier. On the right, Simon Peter lifts his sword to cut off the ear of Malchus who has fallen to the ground. In the background, to the left of Jesus, is Judas, holding a bag of money.

No. 425 was presented to the Gallery as the work of van Honthorst, was published as such by Hoogewerff[2] and erroneously described by Porcella[3] as a replica of an *Arrest of Christ* attributed to van Honthorst in the Galleria Spada, Rome.[4] It was catalogued at the Gallery as van Honthorst until 1951 when it was said to be Neapolitan School.[5] It had, however, been published by Françoise Henry in 1937[6] as 'Sturm', and as Stomer by Isarlo in 1941.[7]

Pauwels[8] compared no. 425 with a signed and dated *Miracle of St. Isidore* by Stomer of 1641, formerly in the church of S. Agostino at Caccamo in Sicily[9] and with two pictures also by Stomer of *Christ among the doctors* then in Worcester, Mass.[10] and Munich.[11] In particular the model for the figure of Malchus is the same as that used for S. Isidore; and the bald headed figure of St. Peter in no. 425 appears also in the Caccamo, Munich and Worcester paintings. Pauwels also points out that the servant with the taper in no. 425 is the same as the servant holding the candle in the *Flagellation* by Stomer in the Oratorio del Rosario in Palermo;[12] and both the figures of Christ and his flagellant in that picture are similar to Christ and the two principal soldiers in no. 425. A further figure in the background of *The Flagellation* compares with Judas in no. 425. Pauwels also drew attention to the fact that the figure of Malchus in no. 425 is based on a drawing by Stomer in the Uffizi (Fig. 156). The drawing was previously attributed to Morazzone but given to Stomer by Longhi[13] on the basis of a comparison with an *Arrest of Christ* by Stomer in a Milanese private collection. Reznicek[14] has compared the drawing to an *Arrest of Christ* in Ottawa;[15] but none of the details in that picture compare with the drawing as the figure of Malchus does in our painting.

No. 425 was dated by Pauwels as possibly about 1640; by Nicolson[16] to the Sicilian period, i.e. 1640-50. A date at the beginning of the decade and close to the *St. Isidore* of 1641 is here proposed.

1. An untraced *Arrest of Christ* attributed to van Honthorst was lent to the *Loan Exhibition: works of Old Masters & Scottish National Portraits*, Royal Institution, Edinburgh, 1883, no. 376, lent by Mrs. Nisbet Hamilton Ogilvy. That picture cannot, however, be no. 425 as it was sold at Dowell's, Edinburgh, 16 April 1921, lot 30. Information from Hugh Macandrew in a letter dated 17 January 1986 now in the archive of the Gallery.
2. Hoogewerff 1924, p. 14 as a *Betrayal of Judas*.
3. Porcella 1931, pp. 91 and 210.
4. That picture, which is now catalogued as 'School of van Honthorst' shows quite a different composition. See Zeri 1954, no. 289, p. 89.
5. *National Gallery of Ireland Illustrations* (Dublin 1951).
6. Henry 1937, fig. 1, p. 1.
7. Isarlo 1941, p. 231.
8. Pauwels 1953, pp. 160 and 162.
9. Repr. Fokker 1929, fig. 1, p. 7. The painting was stolen in 1971.
10. Repr. Voss 1909, p. 400. The painting is no longer in the Museum.
11. Repr. Voss 1909, p. 401. The painting was lent by the Bayerische Staatsgemäldesammlungen to the exhibition, *Dutch Painting; the Golden Age*, Metropolitan Museum, New York, Toledo Museum of Art, Art Gallery of Toronto, 1954-55, repr. in catalogue, no. 79; it is not included in the 1983 catalogue of the Alte Pinakothek, Munich.
12. Repr. Fokker 1929, fig. 6, p. 12.
13. Longhi 1943, p. 60.
14. Reznicek 1964, p. 63.
15. National Gallery of Canada, Repr. Cleveland 1971, no. 64, pp. 168-69.
16. Nicolson 1977, no. 120, p. 242.

DIRCK STOOP ? Utrecht c.1618-1686 Utrecht

He was the son of a glass-painter, Willem Jansz. van den Stoop, in Utrecht and his father was also probably his teacher. He entered the Guild of St. Luke in Utrecht in 1638/39. He may have visited Italy sometime between 1635 and 1642 and there may have worked with Jan Baptist Weenix (q.v.). He was certainly in Utrecht in August 1647. In 1661/62 he became Court Painter to the Infanta Catherine of Braganza in Lisbon and in 1662 followed her to London for her marriage to Charles II. He remained in London until 1678 when he returned to Holland and died in 1686. He painted cavalry engagements, hunting scenes and seaports, all generally in an Italianate manner. He was also a view painter and painted some few portraits. He was a talented engraver.

285 A hunting party in a landscape (Fig. 157).

Oil on panel, 58 × 71 cms. (22⅞ × 27⅞ ins.).

CONDITION: good. Cleaned and restored in 1970.

PROVENANCE: the late W. J. Newall sale, Christie's, 29 June 1889, lot 104, where purchased for 24 guineas.

LITERATURE: Armstrong 1890, p. 283; Trautscholdt 1938, p. 114.

They are setting out falconing. The boy on the right holds the falcon (which is hooded) on his right, gloved hand. Falconry in seventeenth-century Holland was restricted to the nobility or to those otherwise permitted to hunt. It was generally considered the most sportsmanlike manner of hunting as even in the early seventeenth century the use of

bows and guns was looked upon with a certain amount of disdain.[1] Falconers usually hunted game birds such as wild geese, duck, swans, heron, partridge and pheasants.

No. 285 was described by Armstrong[2] as 'A Hunting Party which shows him (i.e. Stoop) at his very best'. Compositionally it relates to a somewhat larger picture by Stoop in Copenhagen[3] (Fig. 217). A number of the figures are the same in both pictures although they are placed differently within the composition. The lady on the horse in no. 285 is repeated exactly in the Copenhagen painting although placed in the centre of the canvas with her horse drinking from a trough. The man to her left in no. 285 is repeated exactly. The man on horseback, extreme left in no. 285, is also repeated but on the right hand side of the Copenhagen picture. The man fastening his boots, together with the dogs beside him, is also repeated, but again on the right hand side of the painting. The spotted dog in the foreground of no. 285 is shown in the centre of the Copenhagen picture in an exactly similar pose, although in fact he is not spotted; and a similarly posed dog is shown in an etching by Stoop.[4] The horse and rider on the extreme left of no. 285 are also repeated in a painting by Stoop in the Rijksmuseum, Amsterdam.[5] In paintings of this type, Blankert[6] has shown that Stoop was influenced both in technique and subject matter by Pieter van Laer whose pictures Stoop is documented as having copied. Blankert compares the Copenhagen picture with a composition by van Laer recorded in a drawing by Leonard Bramer in the Rijksprentenkabinet, Amsterdam.[7]

The Copenhagen painting is dated 1643. In view of the similarity of no. 285 to that picture, and taking into account that the Rijksmuseum painting is dated 1649, a date some time in the 1640's and probably fairly close to 1643 may be suggested for no. 285.

1. See Sullivan 1984, p. 36.
2. Armstrong 1890, p. 283.
3. Royal Museum of Fine Arts, inv. no. Sp. 595. The painting is signed and dated *D.Stoop f. 1643.*
4. Repr. Bartsch 1979, no. 12 (98), p. 118.
5. Inv. no. A395. Repr. *Amsterdam, Rijksmuseum, cat. 1976*, p. 526. The painting is signed and dated *D. Stoop f 1649.*
6. Blankert 1968, p. 130.
7. Inv. no. A704. Repr. Blankert 1968, fig. 5.

ABRAHAM STORCK Amsterdam 1644-1708 Amsterdam

He was the son of the Amsterdam painter Jan Jansz. Sturck who later called himself Sturckenburch. Abraham was baptised in Amsterdam on 17 April 1644. In 1663, when he was still living with his father he was still called Sturckenburch but later always called himself Storck or Sturck. He was a member of the Guild of St. Luke in Amsterdam certainly in 1688 and he married a widow in 1694. He was buried in the Sint Anthoniskerkhof on 8 April 1708. He painted mainly seascapes and Dutch harbour scenes in the manner of Willem van de Velde the Younger (q.v.), and Bakhuizen (q.v.) and imaginary Italianate harbour scenes in the style of Jan Baptist Weenix (q.v.). He may have painted the figures in van Kessel no. 933 (q.v.).

228 Shipping (Fig. 158).

Oil on canvas, 75 × 89 cms. (29½ × 35 ins.).

SIGNED: on the side of the jetty, *A. Storck fecit*. (Fig. 274).

CONDITION: good. Some retouchings bottom right.

PROVENANCE: Henry Dawson Damer, 3rd Earl of Portarlington, by whom presented, 1878.

LITERATURE: Gerson 1938, p. 119; Bol 1973, n. 586, p. 339; Preston 1974, p. 48.

On the left is a *galjoot*; behind it a Dutch merchantman. On the right, off a jetty with a beacon, are a flute and other craft.

FRANS SWAGERS Utrecht 1756-1836 Paris

He was born in Utrecht on 1 September 1756 and in 1804 was a member of the Painters' College in Utrecht. About 1810 he settled in Paris. He painted landscapes and river views.

448 Landscape (Fig. 159).

Oil on canvas, 25 × 20 cms. (9⅞ × 7⅞ ins.).

SIGNED: bottom right, *Swagers*

REVERSE: an indecipherable stencil of a Paris dealer.

CONDITION: good.

PROVENANCE: Julia, Lady Fitzgerald, by whom bequeathed and received in the Gallery, 1896.

No. 448, although of poor quality, is fairly typical of the painter.

ABRAHAM VAN DEN TEMPEL Leeuwarden 1622/23-1672 Amsterdam

He was a pupil of his father, Lambert Jacobsz., a painter and Mennonite preacher at Leeuwarden. He is recorded in Amsterdam in 1637 and from that year until 1641 was in Emden, Germany. As his style resembles that of Jacob Backer (who had been a pupil of van den Tempel's father) it is possible that Abraham studied with Backer. From 1646-47 he lived in Leiden where he married in 1648 and in the same year joined the Guild there. He was alderman in the Leiden Guild in 1657-58, and Dean in 1659. In 1660 he removed to Amsterdam where he remained for the rest of his life. There are some few history paintings by him; but otherwise only portraits are known.

1062 Portrait of a lady (Fig. 160).

Oil on canvas, 87.2 × 71.7 cms. (34¼ × 28¼ ins.).

SIGNED: bottom left above the fan, *A V Tem (?)* the remainder indistinct.

REVERSE: inscribed on the lining canvas in manuscript, *By A. K. Mengs.*

CONDITION: fair. Worn in places throughout. The hair on her right hand side (the spectator's left) is completely repainted. Damage in the area of the lips. Cleaned and restored in 1972.

PROVENANCE: Patrick Sherlock, by whom bequeathed, 1940.

No. 1062, which may once have been attributed to Mengs,[1] was bequeathed to the Gallery as 'Dutch School'. An attribution to van den Tempel was suggested by van Thiel and de Bruyn Kops in 1968[2] and by Denis Mahon in 1970[3]. The picture is signed by van den Tempel.

The composition of no. 1062 would indicate fairly strongly that it was painted as one of a pair of portraits of a married couple. Such a pair of portraits by van den Tempel of about the same date are portraits of Jan Antonides van der Linden and his wife in the Mauritshuis.[4] In this context the fan which the lady is holding would be relevant. It was not unusual for van den Tempel to show his sitters holding an attribute intended to give meaning to their portraits. A portrait at Grenoble[5] shows a lady holding a posy of roses on her lap; a portrait in the Louvre[6] shows a girl holding with some prominence an orange; and a portrait in The Hermitage[7] shows a lady holding a flower; and a portrait in the Palazzo Reale, Naples has a lady holding orange leaves. All of these objects have an accepted meaning when shown in portraits. The chief connotation of the fan has traditionally been erotic and the meaning that may be attached to an open fan is fairly obvious. In portraiture, however, fans are most associated with married ladies[8] who, by holding them discreetly closed, as in no. 1062, demonstrate marital fidelity.

On the basis of the costume no. 1062 may be dated to the early 1660's.

1. See 'Reverse' above.
2. On a visit to the Gallery.
3. On a visit to the Gallery.
4. Inv. nos. 396 and 397. Repr. *The Hague, Mauritshuis, cat. 1977*, p. 231.
5. Musée des Beaux-Arts, cat. 1935, no. 47 as Cornelius Jonson but now given to van den Tempel.
6. Inv. no. RF903. Repr. *Paris, Louvre, cat. 1979*, p. 135.
7. Cat. 1958, vol. 2, no. 2825.
8. On the subject of fans in conjunction with marriage portraits see Smith 1982, pp. 81 ff.

There are several examples of pendant portraits of married couples in Dutch seventeenth-century painting where the lady is shown holding a fan. The portraits of Willem Jacobsz. Baert and his wife by Caesar van Everdingen, dated 1671 in the Rijksmuseum, Amsterdam, inv. nos. A1339 and A1340 (repr. *Amsterdam, Rijksmuseum, cat. 1976*, p. 222) and the portraits of Roelof Meulenaer and his wife by Ferdinand Bol, dated 1650 also in the Rijksmuseum, Amsterdam, inv. nos. A683 and A684 (repr. *Amsterdam, Rijksmuseum, cat. 1976*, p. 123) may be cited.

CORNELIS TROOST Amsterdam 1696-1750 Amsterdam

He was the son of an Amsterdam goldsmith, Johannes Troost and sometime between 1710 and 1720, for a period of two years, was a pupil of Arnold Boonen, then the most sought-after portrait painter in Amsterdam. He married Susanna Maria van Duyn, the daughter of an actress and singer, in Zwolle in 1720; and he himself is recorded as an actor in Amsterdam in 1718 and again in the 1720's. Troost was a master of portraiture in all its forms: both single and double portraits, group portraits and conversation pieces. He also painted stage sets and several pictures which show scenes from plays. There are some outdoor scenes by him which are somewhat, although not exactly, in the fête-champêtre tradition; and at least one room decorated by him survives. He was as skilled as a draughtsman as he was a painter in oils, and he particularly excelled when working in pastel.

497 Portrait of Jeronimus Tonneman and his son, Jeronimus: 'The Dilettanti' (Fig. 161).

Oil on panel, 68 × 58 cms. (26¾ × 22¾ ins.).

SIGNED AND DATED: on the skirting board beneath the statue, *C. Troost 1736.* (Fig. 275).

CONDITION: very good. There is a small damage between the legs of the older man. Cleaned in 1984.

PROVENANCE: Jeronimus Tonneman the Younger; by descent to his daughter Mrs. P. H. de la Court; thence by descent; coll. Douaire de la Court-Ram, Utrecht, 1894; J. van Citters sale, Christie's, 12 June 1899, lot 78, bt. Dowdeswell; coll. Ward, London; S. Richards, London, from whom purchased, 1909, for £120.

EXHIBITED: 1894, *Oude schilderkunst*, Utrecht, no. 440; 1948, *Cornelis Troost en zijn tijd*, Museum Boymans-van Beuningen, Rotterdam, no. 106; 1952, *Drie Eeuwen Portret in Nederland*, Rijksmuseum, Amsterdam, no. 169; 1954-5, *European Masters of the eighteenth century*, Royal Academy, London, no. 113; 1971-2, *Dutch Masterpieces from the eighteenth century*, Institute of Arts, Minneapolis; Museum of Art, Toledo and Museum of Art, Philadelphia, no. 89; 1985, *Masterpieces from the National Gallery of Ireland*, National Gallery, London, no. 34.

LITERATURE: Duncan 1906-07, p. 18; Henkel 1939, p. 426; Knoef 1947a, p. 20; Knoef 1947b, pp. 14-15; Staring 1956, p. 110; Rosenberg, Slive, ter Kuile 1966, p. 213; Niemeijer 1973, no. 136S, pp. 204-05; de Jongh 1972-73, p. 79; Boydell 1985, pp. 32-33; London 1985, no. 34, p. 84.

The sitters had traditionally been called Allard de la Court and his son-in-law, Jeronimus Beeldsnijder, but on the basis of a comparison with a miniature portrait of Jeronimus Tonneman by Henriette Wolters-van Pee in an Amsterdam private collection,[1] Knoef[2] correctly identified them as Jeronimus Tonneman and his son, also Jeronimus. The father was christened in Amsterdam on 19 October 1687 and died there on 26 March 1750. His wife, Adriana van Assenburg, whom he married in 1711, died four years after their marriage. Their son's date of birth is unknown but he must have been between twenty-five and twenty-eight at the time the picture was painted in 1736. In 1742 the Tonneman family lived on the Keizersgracht adjacent to Utrechtse straat in Amsterdam.

Jeronimus Tonneman the Elder was one of Troost's most important patrons; he owned the artist's self-portrait now in the Rijksmuseum, Amsterdam[3] and also his major

conversation-piece, *The Spendthrift*.[4] He also owned a number of drawings by Troost and a set of twelve stage scenes in pastel. The interior shown in no. 497 is not real, but idealised and in general reflects a French idiom.[5] On the table is van Mander's *Het Schilder-boeck* first published in 1604 and the most important source book on the lives of the early Dutch painters. The younger Tonneman plays a contemporary flute for the period with a single key and four-piece construction, while the silver mountings and the slim and elegant profile suggest quality and expense.[6]

The stucco relief on the background wall shows *Time revealing Truth and banishing Slander* and above the chimneypiece a stucco relief in a roundel shows *Mercury killing Argus*. According to Ovid,[7] Mercury did this by first of all lulling Argus to sleep with piped music; but in van Mander's *Wtleggingh op den Metamorphosis Pub. Ovidii Nasonism*, which formed part of his *Het Schilder-boeck*, and a copy of which is known to have been in Tonneman's library,[8] van Mander links the episode of Mercury killing Argus with the human trait of being lured by desire towards wealth and idle fame, the consequence of which is that reason, justice and virtue are destroyed. The plaster statue in the niche on the right is modelled from Duquesnoy's *St. Susanna*, a saint whose story is generally taken as illustrating the triumph of virtue over vice. Troost included the statue in another composition, *Blind Man's Buff* in Rotterdam.[9]

The choice of subject matter for the plaster reliefs and statue can hardly have been accidental and it is probable that the elder Tonneman wished to have himself depicted not just as a connoisseur and patron, but one who was aware of the vanity of such a role. de Jongh[10] in fact has suggested that contrary to his custom, and probably on the orders of his patron, Troost worked a complex symbolic 'programme' into the painting and in doing so would have made reference to Poot and Ouwens' *Het groot natuuren zedekundigh werelttonsel* which was published in Delft in three volumes between 1726 and 1750. By a curious irony, the year after the picture was painted the younger Tonneman is recorded in the diary of Jacob Bicker Raye[11] as having stabbed his mistress, who had borne him a child, with a pair of scissors and shortly thereafter left Holland as a midshipman on a voyage to the East Indies.

A possible preparatory drawing for the painting was sold in Amsterdam on 20 November 1899, lot 663.[12] Described as 'Jeronimus Tonneman. Art Lover, friend of Cornelis Troost. Half-length seated in front of a table', its present whereabouts is unknown.

1. Repr. Knoef 1947b, fig. 1, p. 14.
2. Knoef 1947b, pp. 14-15.
3. Inv. no. A4225. Repr. *Amsterdam, Rijksmuseum, cat. 1976*, p. 544.
4. Rijksmuseum, Amsterdam, inv. no. A4209. Repr. *Amsterdam, Rijksmuseum, cat. 1976*, p. 547.
5. Staring 1956, p. 110.
6. Boydell 1985, p. 33.
7. *Metamorphoses*, 1:668-721.

8. Among the books in Tonneman's library were three copies of van Mander, see Niemeijer 1973, n. 1, p. 205.
9. Museum Boymans-van Beuningen, inv. no. 447a. Repr. van Luttervelt 1967, p. 258.
10. de Jongh 1972-73, p. 79.
11. Quoted by Niemeijer 1973, pp. 14 and 205.
12. According to Niemeijer 1973, p. 205.

WALLERAND VAILLANT Lille 1623-1677 Amsterdam

He was baptised at Lille on 30 May 1623 and was the son of a merchant who settled in Amsterdam about 1642. He is said to have studied under Erasmus Quellin in Antwerp. In 1647 he joined the Guild of St. Luke at Middleburg and was in Amsterdam in 1649 and 1652. He was in Frankfurt in 1658 and he may also have visited England. From 1659-65 he was in Paris and then returned to Amsterdam where he is recorded in 1668 and 1672; but he was back in Middleburg in 1675. He died in Amsterdam on 28 August 1677. He is known as a mezzotint engraver and also for his chalk portraits. He also painted in oil, mainly portraits but there are a few genre and still-life paintings by him.

Ascribed to WALLERAND VAILLANT

270 Portrait of a man (Fig. 162).

Oil on canvas, 85.2 × 68.9 cms. (33⅛ × 27⅛ ins.).

REVERSE: an inscription on canvas attached to the stretcher as follows, *This is written between the lining and the picture. Van G. Terburg aan de jonk Heer Henricksen van Zwolle als een Kline Gedinkinis voor zyn geduldige goedheid Lijnde zijn beste model.*[1]

CONDITION: fair. The canvas had at some time been folded over by about 2.5 cms. all round. The background is thin and the hair beside the face, left, has been abraded.

PROVENANCE: Ellison collection; Rev. C. P. Terrot, decd. sale Christie's, 25 May 1886, lot 189, where purchased for £8.

LITERATURE: Armstrong 1890, pp. 283-84; Duncan 1906-07, p. 17; Hellens 1911, p. 124; Hofstede de Groot 1908-27, vol. 5, no. 234, p. 81; Gudlaugsson 1960, cat. vol. no. D46, pp. 280-81.

ENGRAVING: by Jonnard in *Magazine of Art* (1890), p. 281.

No. 270 was purchased as ter Borch and at one time thought to have been painted 'with all the refinement of which Terburg is capable'[2] and has always been so catalogued at the Gallery. Armstrong had, in 1890, perhaps reservations by stating that the painting 'cannot be accepted as fully characteristic'.[3] The attribution is rejected by Gudlaugsson[4] who remarks that the spelling 'Terburg' in the inscription is unusual,[5] and he suggests that no. 270 may be by Godart Kamper, with whose paintings of about 1660 it is comparable in style. van Thiel has suggested an attribution to Hendrick ten Oever.[6] If the sitter came from Zwolle as the inscription states, then ten Oever who was born and worked in Zwolle would be most likely as the painter of the portrait.[7] It would be wrong, however, to place too much emphasis on the information contained in the inscription. ten Oever did, at about the time of no. 270 was painted, paint portraits in ovals, for example the *Portrait of Rabo Herman Schele* which is signed and dated 1657.[8] No. 270 however, seems much more polished in style than that picture. If Kamper is considered, the portrait would compare to an earlier *Portrait of a man*[9] signed and dated 1651, by him. Blankert[10] has suggested an attribution to Wallerand Vaillant, and of all proposed attributions this would seem the most tenable. Comparison may be made with his *Portrait of Pieter de Graeff* in the Rijksmuseum, Amsterdam[11] which is datable to 1674.[12]

That portrait is placed in an oval, has the same glossy treatment of the costume and hair as in no. 270; and the sitter engages the spectator in the same manner in both.

The sitter in no. 270 wears Rhingrave costume which may be dated to the early 1660's.[13] As he is clearly fashionable a date in the early 1660's may be proposed.

1. 'From G. Terburg to the young Heer Hendricksen of Zwolle, as a slight memento of the patient kindness of his best model'.
2. Duncan 1906-07, p. 17.
3. Armstrong 1890, p. 284.
4. Gudlaugsson 1960, cat. vol., p. 281.
5. The spelling Terburg was in fact fairly commonplace in nineteenth-century England.
6. On a visit to the Gallery in 1968.
7. For ten Oever see Zwolle 1957.
8. Overijssels Museum, Zwolle. Repr. Zwolle 1957, no. 1.

9. Sold at Christie's, 9 April 1937, lot 89. Repr. *The Connoisseur*, (June 1922), p. 112.
10. In a verbal communication, August 1983.
11. Inv. no. C22. Repr. *Amsterdam, Rijksmuseum, cat. 1976*, p. 552.
12. Its pendant, also in the Rijksmuseum, Amsterdam, inv. no. C23, depicting Pieter de Graeff's wife is dated 1674.
13. Information from Marÿke de Kinkelder of the RKD.

DIRCK VALKENBURG Amsterdam 1675-1721 Amsterdam

He was born in Amsterdam where he was a pupil of Jan Weenix (q.v.). In 1695 he travelled through Frankfurt to Augsburg where he met a patron Baron Knebel van Katznellenbogen. He was, about two years later, in Vienna where he painted animal pictures for Prince Adam von Liechtenstein. By 1702 he was back in Amsterdam where he married in that year. He painted hunting canvasses for William III for the Palace of Het Loo. In 1706 he was commissioned to travel to Surinam where he painted rare plants and animals on the plantation of Jonas Witsen; but on account of sickness he returned to Holland later the same year. There are very few signed works and he was the last great practitioner of the Dutch game-piece.

625 Birds with an urn in a landscape (Fig. 163).

Oil on canvas, 132 × 99 cms. (52 × 39 ins.).

SIGNED: on the urn, right, *D Valckenburg pinxit.* (Fig. 276).

PROVENANCE: W. S. Gubleton of Belgrove, county Cork, by whom bequeathed, 1911.

LITERATURE: Thieme, Becker 1907-50, vol. 34, p. 52.

The birds have been identified as follows:[1] in the foreground from left to right a hill myna (*Gracula religiosa*), a kingfisher (*Alcedo atthis*), a drake wigeon (*Anas penelope*), a domestic drake, crested variety (*Anas platyrhynchos*). In the middle ground, two domestic hens and a domestic cock (*Gallus gallus*). The bird on the urn is a parakeet of the genus *Psittacula*, probably the Alexandrine Parakeet (*Psittacula eupatria*).

No. 625 is one of Valkenburg's very grandest compositions. In general he painted groups of dead game arranged as in no. 625 but more often with the dog or cat which has killed them.[2] A relief, similar to that on the urn in no. 625 is on a pedestal in a picture by Valkenburg formerly with van Diemen, Berlin. The view of the chateau in the background is fairly typical of the artist's work of the first decade of the eighteenth century and may be compared with, for example, a signed and dated painting of 1703 in Leipzig.[3]

A date in the first decade of the eighteenth century may be suggested.

1. By D. Goodwin of the British Museum (Natural History) in a letter dated 3 April 1981 now in the archive of the Gallery.
2. See for example the painting in the Philadelphia Museum of Art, inv. no. W'12-1-3.
3. Museum der Bildenden Künste, inv. no. 1590. See also the painting in the Lord Leigh sale, Christie's, 5 April 1963, lot 63.

ADRIAEN VAN DE VELDE Amsterdam 1636-1672 Amsterdam

He was the son of Willem van de Velde the Elder. He painted winter and beach scenes and also some portraits.

ADRIAEN VAN DE VELDE and JAN LAGOOR

515 The ferry-boat (Fig. 91).

(See under Jan Lagoor and Adriaen van de Velde, p. 80).

After ADRIAEN VAN DE VELDE

1888 Scene on the ice (Fig. 201).

Oil on panel, 36.4 × 43.8 cms. (14¼ × 17¼ ins.).

CONDITION: the support consists of two members joined on a horizontal 18.5 cms. from the bottom. Paint surface in very poor condition with bitumen cracking throughout. Heavily discoloured varnish.

PROVENANCE: purchased in London in 1863.[1]

No. 1888 is of poor quality and probably painted in the early nineteenth century. It is a copy after a signed and dated painting on canvas of 1669 by Adriaen van de Velde in Dresden.[2]

1. See After Metsu no. 1996, n. 1.
2. Gemäldegalerie inv. no. 1659. Repr. *Dresden,* *Gemäldegalerie, cat. 1979,* p. 330.

ESAIAS VAN DE VELDE Amsterdam c.1590-1630 The Hague

He worked in Haarlem from 1610 and at The Hague from 1618 until the end of his life.
He was one of the founders of realistic landscape painting in seventeenth-century Holland.
His most important pupil was Jan van Goyen (q.v.) and he influenced in particular Pieter
de Molijn (q.v.).

Follower of ESAIAS VAN DE VELDE

1175 St. John preaching in the wilderness (Fig. 202).

Oil on panel, 44 × 65 cms. (17¼ × 25½ ins.).

CONDITION: fair. Worn in places throughout. Cleaned in 1985.

PROVENANCE: Mrs. J. I. Morgan de Groot, by whom bequeathed, 1948.

LITERATURE: Tümpel 1974, n. 233, p. 131; Keyes 1984, cat. no. Rej. 1, p. 193.

The subject is from *St. Luke*, ch. 3, vs. 1-18. In fulfilment of the prophecy of Isaiah, the word of God came to St. John in the wilderness and he went into the region around Jordan and preached the baptism of repentance for the remission of sins.

No. 1175 was bequeathed as 'Dutch School' and attributed to Claesz. Moeyaert in 1956 by David Röell.[1] It was so catalogued in 1971 and 1981. At least four somewhat similar paintings of the subject by Moeyaert are known.[2] The attribution to Moeyaert was rejected by Tümpel[3] who gave it confidently to Esaias van de Velde. Keith Andrews[4] proposed the same attribution. Tümpel draws a comparison (unsatisfactory to the compiler) between no. 1175 and a *Namaan washing in the Jordan* which she also gave to van de Velde, but which is possibly a copy.[5] The composition of no. 1175 might be compared to a *St. John the Baptist* by van de Velde in Vienna[6] which Keyes dates to about 1620.

No. 1175 is of poor quality and Keyes[7] justifiably refers to it as painted by a 'very poor follower' of Esaias van de Velde.

1. On a visit to the Gallery.
2. See Tümpel 1974, cat. nos. 94-97, pp. 257-58.
3. Tümpel 1974, n. 233, p. 131 and fig. 184, p. 134.
4. In a letter dated 6 December 1972 now in the archive of the Gallery.
5. Tümpel 1974, fig. 186, p. 135. The picture is referred to by Keyes 1984, cat. no. Rej. 2, p. 193 as 'possibly a copy after Esaias'.
6. Kunsthistorisches Museum, inv. no. 6991. Repr. Keyes 1984, fig. 122.
7. Keyes 1984, cat. no. Rej. 1, p. 193.

WILLEM VAN DE VELDE THE YOUNGER Leiden 1633-1707 London

He was the son of Willem van de Velde the Elder (d.1693) and older brother of Adriaen
van de Velde (q.v.) and was baptised in Leiden on 18 December 1633. By 1636, the family
had settled in Amsterdam. He probably studied with his father and according to Houbraken,

he was a pupil of Simon de Vlieger. He worked in Amsterdam until 1672 when, with the French invasion of Holland, he and his father came to England. Early in 1674, both he and his father were taken into the service of Charles II, the father for 'taking and making Draughts of seafights' and the son for 'putting the said Draughts into Colours'. He continued to live in England and remained in the service of Charles II, and later James II. He died at Westminster on 6th April, 1707.

Throughout his life he worked with his father and they also employed a large studio. The father would spend time at sea making numerous sketches of individual ships and engagements, and on his return these drawings were placed at the disposal of the son who used them as a basis for oil paintings. The Studio artists, of which there were probably quite a number, produced versions, variations and copies of the Younger's original compositions. Among the artists in the Studio were his son Willem (born 1667), and Cornelis who may have been either his son or his brother.

Studio of WILLEM VAN DE VELDE THE YOUNGER

276 Calm: the English ship Britannia at anchor (Fig. 164).

Oil on canvas, 231 × 160 cms. (91 × 62½ ins.).

CONDITION: paint surface in good condition, although somewhat rubbed in the sky. Cleaned in 1980.

PROVENANCE: James Wise of Rostellan Castle, county Cork Sale, Christie's, 23rd April, 1887, lot 118, where purchased for 42 guineas.

LITERATURE: Hofstede de Groot 1908-27, vol. 7, no. 599, p. 147; Robinson *forthcoming*, no. R499.

RELATED COMPOSITIONS: 1. Collection Lord Sandys, Ombersley, Robinson *forthcoming*, no. R370; 2. Collection Marvyn Carton, New York, Robinson *forthcoming*, no. R500.

The principal ship is the *Britannia*. On the left in the foreground, a fishing pink; on the right, a royal yacht; and in the background, right, a two-decker firing a gun to port.

The *Britannia* was an English ship of 100 guns built in 1682. Her design was not successful and she did not serve in action until Admiral Russell made her his flagship at the battle of Barfleur in 1692. In spite of modifications and 'a great repair' in 1700-01, she still had defects and was broken up in 1715. The *Britannia's* appearance as originally built is known through an engraving by J. Sturt after a drawing by Willem van de Velde the Elder; and her appearance after the rebuilding of 1700-01 through a model at Annapolis. The details of the ship as shown in no. 276 come closest to Sturt's engraving.

About 1695, Willem van de Velde the Younger painted a picture of the *Britannia* for Admiral Russell,[1] and the composition of that picture is similar to that shown in no. 276; and Robinson has drawn attention to the fact that van de Velde again used the composition for his painting of the *Royal Sovereign* at Greenwich[2] which is signed and dated 1703. Robinson is of the opinion that there is an, as yet untraced, painting of the *Britannia* by van de Velde the Younger on which the composition of no. 276 is based; and that no. 276 is a later painting by an artist working in the Studio. In this context, he has pointed out that the fore staysail on the ship in the background is a feature which could be seen

as early as 1700 but is rare until 1715. He compares no. 276 stylistically with the similar composition showing the *Britannia* in the collection of Marvyn Carton, New York,[3] which is signed both on the surface and on the reverse, *C.V.Velde*; and he concludes that no. 276 is also probably painted in its entirety by Cornelis van de Velde after drawings and paintings by Willem van de Velde the Elder and Younger.[4]

1. Collection Lord Sandys, Ombersley; in 1985, at Clifton Castle, Yorkshire. Robinson *forthcoming*, no. R370.
2. National Maritime Museum, inv. no. 33-41.
3. Robinson *forthcoming*, no. R500.

4. The information on no. 276 above is from material made available by the National Maritime Museum, Greenwich kindly communicated by M. S. Robinson.

Studio of WILLEM VAN DE VELDE THE YOUNGER

1742 The Royal Visit to the Fleet in the Thames Estuary, 6 June 1672 (Fig. 165).

Oil on canvas, 33.3 × 58 cms. (13⅛ × 22¾ ins.).

REVERSE: inscribed with the number 3064 on the lining canvas.

CONDITION: fair. Cleaned and restored 1968.

PROVENANCE: possibly the painting reputed to have been given by Charles II to Sir Anthony Deane;[1] possibly by descent to Deane's son William and his daughter-in-law, Elizabeth (née Morgan); possibly thence by descent to their son, Morgan Deane (or Morgan Morgan) when engraved by Elisha Kirkall, c.1725; possibly C. Purvis 1842;[2] possibly the late Thomas Purvis sale, Christie's, 2 June 1849, lot 109, bt. Woodin; Executors of Mrs. Bentley of Sloane Street, London, sale, Christie's, 28 June 1879, lot 41, where purchased for £8 18s. 6d.[3]

LITERATURE: Robinson *forthcoming*, nos. R414(2) and R414(3).

RELATED COMPOSITIONS: 1. National Maritime Museum, Greenwich, inv. no. 36-43, Robinson *forthcoming*, no. R414(1); 2. National Gallery of Ireland, cat. no. 58, Robinson *forthcoming*, no. R414(4); 3. Musée des Beaux-Arts, Grenoble, inv. no. MG112, Robinson *forthcoming*, no. R414(5); 4. National Maritime Museum, Greenwich, inv. no. 30-16, Robinson *forthcoming*, no. R414(6); 5. Carlton Club, London, Robinson *forthcoming*, no. R414(7); 6. Collections W. Barnett, Belfast, 1968, and G. M. Osborne, Guthrie, Angus, 1957 — the painting being cut in two parts, Robinson *forthcoming*, no. R414(8); 7. Collection Sir Nicholas Bacon, Robinson *forthcoming*, no. R414(9); 8. Sale, Phillip's, London, 16 July 1973, lot 67, Robinson *forthcoming*, no. R414(10); 9. Collection J. Johnson, London, 1826, Robinson *forthcoming*, no. R414(11). 10. Robinson *forthcoming* refers to a further five pictures which bear some relation to the composition: two of these are by J. K. D. van Beecq and three he tentatively attributes to Isaac Sailmaker.

ENGRAVING: possibly the painting engraved in the same direction in mezzotint by Elisha Kirkall, c.1725.

DRAWINGS RELATED TO THE COMPOSITION: 1. In reverse, of the yacht *Kitchen* in the foreground, Fitzwilliam Museum, Cambridge, inv. no. PD811-1963. 2. Of the French ship's barge, Museum Boymans-van Beuningen, Rotterdam, inv. no. MB1959/T8; 3. Of the *Kitchen*, National Maritime Museum, Greenwich, inv. no. 395; 4. Of the *Kitchen*, Fitzwilliam Museum, Cambridge, inv. no. PD794-1963; 5. Of the composition, Institut Néerlandais, Paris, inv. no. 1311.

After the battle of Solebay on 28 May 1672, the English and French ships returned to the Thames to refit. Charles II went down the Thames to visit the fleet and to hold a council-of-war on board the *Prince*.

On the right is the *Prince* at anchor with a number of boats both French and English pulling towards her in response to the signal for a council-of-war of all flag officers. She is lying

a little across the wind in a weather-going tide, which is the cause of the choppy sea. She has the royal standard at the main, the Admiralty flag at the fore and the Union flag at the mizzen. There is a common pendant at each masthead below the flags and there are pendants also at the main and main topsail yardarms. There is a yacht, apparently the *Kitchen,* starboard bow view passing under the ship's stern. In the centre foreground is a French ship's barge pulling towards the *Prince.* Alongside the *Prince* is the King's barge with the royal standard in the bow. To the right, a French boat appears to be in collision with an English boat. In the left foreground is probably the *Anne* yacht and further away on the *Anne's* starboard bow is the *Cleveland* yacht. In the background, there are ships at anchor. In the centre is the new admiral of the blue, Sir Edward Spragge, in the *London.* A ship in the right background with a red flag at the fore is the *Royal Sovereign,* Sir Joseph Jordan, promoted after the battle to vice-admiral of the red. On the extreme right is the fore part of a Dutch bezan yacht, presumably the *Bezan* given by the Dutch to Charles II in 1661. There are no other yachts, the vessels under sail in the background being mostly ketches. The low land of Essex is shown in the distance.

The occasion is probably that described by Captain John Narbrough in his journal[4] on the 5 June 1672, when he was on board the *Prince* as flag captain. On that day, it was a fresh breeze and the *Prince* was ready to weigh, when the King appeared from up river in the *Cleveland* yacht:

> 'Wedensday being the fifth day hasey Cloudy weather the wind at: SWBW: a fresh gale we Rode Ready to way at the first of the flood, this Day, the King & seuerall of the noble men Cam aBoard the Prince, his R:Highness: Caused the Standard to be struck when the Kings Standard was in Sight, and when ye King was aboard, ye Standard, was hoisted At ye Mainetopmasthead and the Red Standard with ye anchor in it at the fore topmasthead and the Vnion Flagg: at the misson topmasthead to day we waied & turned up the Swin Chanill & anchored betwen the Medle Ground & the Shoo beacon the tide being done and ye fleete followed us and Anchored below us this night it Blew a Stout gale at :SW: we rode fast'

The King at this time usually used the *Cleveland* yacht: the Duke of York usually used the *Anne* yacht in 1672 and 1673. If the King was not present, the Duke flew the royal standard but he changed this for the Admiralty flag in the King's presence, being Lord High Admiral. On the council-of-war being called, the Duke would rightly have flown the Admiralty flag on board the *Prince.* The Union flag usually signified the presence of Prince Rupert.

The King came down the Thames in the *Cleveland.* The *Kitchen* yacht, Captain William Wright, had been sent up from the fleet to Gravesend on the 3rd June and she stayed there until the 5th when according to the *Kitchen's* log 'att:7: A Clocke the King Cam downe and went one Boord of the Cleveland yacht so we Cam to saill and att:3: afternoon we Cam to An Anckor. In shoare was the flete not Being Com vp. 6th Att:2: in the Morning wee saild out of shoare was the wind att:S:S:Et: Wee Being Bound down to the fleate att:9: before noon we gate down to the fleate Below the midell and the King went one Boord of the Royall prence att:11: all the fleat waied and that flod gate vp to the shew and thare Anckored all night. 7th att:4 A Clocke this Morning the wind Cam

vp att:S:Wt: and att:11: Befor noon wee waied from the shew and plyed all the flod and att:6: aclocke Afternoon we Cam to an Anckor att the ours edg and Ride thare till the :9: day with the wind att:S:Et: and so to :Et: and Et:no;Et: Litell wind.

9th Att one in the Morning wee waied with Litell wind att Et:No:Et And: the ann and Cleveland in our Compeney Being Bound vp with the King att:9: att night wee Cam to An Anckor att triptcoke trees'[5]

Sir Edward Spragge's journal[6] in the *London* confirms the date the King arrived in the fleet lying in the Middle Ground as the 6 June, '6 Thursday about 8 clock his Majesty with many of his noblemen came on bord of his RH: in ye Prince. Same day we Turnd up with all ye fleete Ancord short of ye show Beakon'.

As the occasion was one of the last when the Duke of York (later James II) was in command of the fleet, it is reasonable to suppose that both the King and the Duke would have wished to commemorate it; and it is probable that a picture of the subject was commissioned from the van de Veldes soon after they arrived in England at the end of 1672 or the beginning of 1673, even though the artists had not been present on the occasion. Michael Robinson refers to Vertue's account[7] of about 1715 that

> 'Willm Vandevelde Junior was by the Order of K. Charles 2d to paint a veiw of the English and French Fleet joynd together as they appeared at the Buoy & Nore when the King went to see them as they lay there. this picture he painted being a large painting nine foot in lenght & when he had done it as the King directed him most curiously the King being there represented going aboard his own Yacht 2 (written above *some*) of the commissioners of the Admiralty came to see the picture likeing of it very well they said before Vande Velde that (they) would beg it of the King & cutt it in Two & each take a part. as soon as they were gone Welde took the picture off the Frame & rold it up, resolving they never shoud have it. nor they never had. sometime after the King's death. he again straind it on a frame & offerd to Mr. Bulfinch (*my Author* in margin) to sell it him cheap for 80 guineas nay 80 pounds beleaving (*saying* written above *beleaving*) it was worth as much more he took time to Consider of it when he came to see Van Welde to buy he had already sold it to a Nobleman who gave him for it 130 pounds. . . .

Robinson suggests that the picture seen by the commissioners of the Admiralty is probably the version at Greenwich[8] which is painted partly by van de Velde the Younger.

Robinson is of the opinion[9] that no. 1742 could be the painting used by Kirkall for his mezzotint published c.1725 and that it could have been painted for Kirkall (who needed a small original of the composition to work from) by someone in the van de Velde studio; and he suggests that it is quite well enough painted to be by Cornelis van de Velde who was still alive at the time Kirkall's print was made.

No. 1742 was sold in 1879 as 'W. van de Velde' and so registered at the Gallery on acquisition. It was, however, never included in any of the published catalogues of the Gallery until 1971.[10]

1. According to Smith 1829-42, Part 9, under no. 41, p. 768.

2. When seen by Smith 1839-42, Part 9, no. 40, pp. 767-68.

3. Christie's stock number, 243K, on the reverse of the picture identifies no. 1742 as the painting sold in this sale; and Christie's records list the Director of the Gallery, Henry Doyle, as the purchaser. However Doyle did not submit no. 1742 to the Governors and Guardians until their meeting on 11 November 1880; and he included the picture in his Annual Report for 1880 as having been purchased in that year.
4. Pepysian Library, Cambridge, *Ms.* 2555, p. 61.
5. Public Record Office, London, Adm. 51/3876. 'Triptcoke trees' refers to Tripcock Ness which is on the south bank of the Thames below Woolwich.

6. Dartmouth, *Ms.* 7, in the National Maritime Museum, Greenwich. The discrepancy in the dates is due to Narbrough using the nautical day beginning at noon and Spragge, whose journal shows signs of having been written up later, using the civil day beginning at midnight.
7. British Library, *Add. Ms.* 21111, f.56.
8. National Maritime Museum, inv. no. 36-43.
9. In a communication dated 9th February 1986.
10. The information on no. 1742 given above is from material made available by the National Maritime Museum, Greenwich kindly communicated by M. S. Robinson.

After WILLEM VAN DE VELDE THE YOUNGER

58 The Royal Visit to the Fleet in the Thames Estuary, 6 June 1672 (Fig. 166).

Oil on canvas, 113 × 182.5 cms. (44½ × 72 ins.).

REVERSE: *ms.* label on back of lining canvas: *W – Velde. The arrival of Charles (? Solebay) previous to the Restoration. This picture was formerly in the possession of the Late Colonel Greaves a most intimate friend of the late Sir Robt. . . . [1] originally . . . (?)*

CONDITION: paint surface in fair condition. There is retouching throughout the sky and damages in the sails of the yacht on the left, and from that point a line damage in the centre of the canvas. Damages in the sky behind the sails of the principal ship. A number of damages in the area of the water. Cleaned in 1970.

PROVENANCE: Colonel Greaves;[2] 'Property of a Lady' (Miss Dyer) sale, Christie's, 7 February 1874, lot 117, where purchased for 50 guineas.

LITERATURE: Robinson *forthcoming*, no. R414(4).

RELATED COMPOSITIONS: see under Studio of Willem van de Velde the Younger, no. 1742.

DRAWINGS RELATED TO THE COMPOSITION: see under Studio of Willem van de Velde the Younger, no. 1742.

For the subject, see under Studio of Willem van de Velde the Younger, no. 1742.

No. 58 was purchased in 1874 as the work of Willem van de Velde the Elder and so catalogued until 1904 when Armstrong gave it to Peter Monamy (1681-1749). In 1971, it was given to the Studio of Willem van de Velde the Elder and also so catalogued in 1981. Robinson[3] believes that it is likely to be a copy after an original painting by Willem van de Velde the Younger by one of the better English marine painters of the eighteenth century. He points out that the composition is related most closely to a large drawing of the subject at Greenwich which is probably by Dominic Serres;[4] and that stylistically no. 58 is related to a close copy by Dominic Serres at Greenwich,[5] signed and dated 1771, of a picture in Cape Town,[6] *A kaag in a fresh breeze*, which is signed and dated 1672 by van de Velde the Younger.

1. 'Sir Robt.' presumably refers to Sir Robert Peel who himself formed a noted collection of Dutch pictures. Peel's collection was purchased by the National Gallery, London in 1871, see MacLaren 1960, p. 501.
2. Colonel Richard Greaves died on 22 May 1872 and by his will left all his property to his wife who died on 11 July 1875. Information from M. S. Robinson.

3. Information communicated, January 1986.
4. See *Annual Report* of the Society for Nautical Research, 1930, opp. pp. 52 and 53.
5. National Maritime Museum, inv. no. 1974-20L.
6. National Gallery of South Africa, inv. no. 53/48.

After WILLEM VAN DE VELDE THE YOUNGER

1964 Calm: an English sixth-rate ship firing a salute (Fig. 167).

Oil on canvas, 43 × 55 cms. (17 × 21⅝ ins.).

CONDITION: fair. Cleaned and restored, 1974.

PROVENANCE: Patrick Sherlock, by whom bequeathed, 1940.

LITERATURE: Robinson *forthcoming*, no. R273(3).

RELATED COMPOSITIONS: 1. Collection Sir Thomas Coke, c.1725 recorded in a mezzotint by Elisha Kirkall, Robinson *forthcoming*, no. R273(1); 2. Wiesbaden Museum, inv. no. M22, Robinson *forthcoming*, no. R273(2).

The principal vessel is an elaborately decorated English sixth-rate ship. She has a Union flag at the main and is firing a salute as a ship's boat or barge filled with people pulls away from her. On the left, in the background, is a two-decker at anchor. The Union flag signifies the presence on board of an important person, although not the sovereign. Such a flag is unusual in a small ship and it must be assumed that the ship was being used to transport an ambassador or other important person. However, as the composition of the picture is such that it demands a flag at the masthead its presence need not be taken too literally as there are examples of the van de Veldes including a flag by way of artistic licence in order to improve a composition. Additionally, in no. 1964, the painting of the Union flag has been misunderstood: the lower part should be the other side of the flag and the red vane at the foremast has been interpreted as part of the Union flag. There are also inaccuracies in the painting of the two-decker: the flagstaff at the bowsprit end should be in the same line as the spritsail topmast.

The ship in no. 1964 has not been identified. She is the same as that shown in a similar composition signed and dated 1706 by Willem van de Velde the Younger at Greenwich.[1]

In Robinson's view no. 1964 is likely to be an eighteenth century copy after a now lost painting by Willem van de Velde the Younger which may have been an upright composition.[2]

1. National Maritime Museum, inv. no. 63-33.
2. The information on no. 1964 given above is from material made available by the National

Maritime Museum, Greenwich, kindly communicated by M. S. Robinson.

PIETER VERELST Probably Dordrecht c.1618-after 1668

He was probably born in Dordrecht in or shortly before 1618 and he enrolled as a Master in the Guild of St. Luke of Dordrecht in 1638. Early in 1653 he settled at The Hague, obtained citizenship in the next year, and in 1656 was among the founders of the artists' society, Pictura. *He apparently left The Hague before the end of 1668 on account of bad debts. The place and year of his death are unknown. Nor is his teacher known: both Rembrandt and Dou have been proposed but it is more likely he trained with J. G. Cuyp (q.v.) or Paul Lesire, both of whom worked in Dordrecht. His early work in Dordrecht consists mainly of portraits and* corps-de-garde *scenes. After his move to The Hague the influence of Rembrandt and Dou is apparent, particularly in his portrait style. At the same time he started to paint scenes of peasant life in a style reminiscent of Saftleven (q.v.), Sorgh (q.v.) and van Ostade (q.v.). In the 1660's he painted a number of* bambocciante *scenes in the manner of Lingelbach (q.v.) and Jan Wyck. His later portraits show the influence of the fashionable Hague portraitists such as Mytens (q.v.) and Hanneman (q.v.). His sons, Herman, Simon and Johannes were all painters; and all three settled in England where Simon was successful as a flower painter.*

Ascribed to PIETER VERELST

346 Portrait of an old lady (Fig. 168).

Oil on panel, 74.3 × 60 cms. (29¼ × 23⅝ ins.).

CONDITION: fair. A number of discoloured retouchings particularly in the face. The background, left, may be strengthened.

PROVENANCE: W. Abraham, London, from whom purchased, 1894, for £100.

No. 346 was acquired and has always been catalogued as J. G. Cuyp. The attribution was accepted by Hofstede de Groot.[1] van de Watering[2] has proposed an attribution to Pieter Verelst and he convincingly compared the picture to an unsigned *Portrait of an old woman*[3] that he also attributed to Verelst. That picture he compared[4] with signed paintings of 1646-48 in which he sees the influence of Rembrandt and Dou as well as 'reminiscences of Dordrecht (Jacob Cuyp)'.

If the attribution to Verelst is accepted, a date of about 1646-48 would be likely.

1. His notes now in the RKD referred to in a letter from van de Watering dated 9 November 1982 now in the archive of the Gallery.
2. In a letter dated 19 January 1983 now in the archive of the Gallery.
3. *Ibid.* The portrait was exhibited in 1983, see Amsterdam/Groningen 1983, no. 62.
4. The catalogue entry in Amsterdam/Groningen 1983 is by van de Watering.

ANDRIES VERMEULEN Dordrecht 1763-1814 Amsterdam

He was born in Dordrecht on 23 March 1763 and was a pupil of his father Cornelis. He painted marines and winter landscapes and was also an imitator and copyist of Aelbert Cuyp (q.v.).

432 Scene on the ice (Fig. 169).

Oil on panel, 32.5 × 45.1 cms. (12½ × 17¾ ins.).

CONDITION: very good. Cleaned and restored in 1968.

PROVENANCE: G. P. Salmon sale, Christie's 22 June 1889, lot 143, where purchased for 10 guineas.

VERSION: Prinz Leopold von Preussen sale, Lucerne, 23 August 1928, lot 355.

No. 432 was sold in 1889 as one of a pair attributed to Paul Ferg and so catalogued by Armstrong in 1898. In 1968 it was attributed to Vermeulen by Renckens;[1] and this attribution is correct.

1. In a letter dated 10 July 1968 now in the archive of the Gallery.

LIEVE PIETERSZ. VERSCHUIER ? Gorinchem ?1623-1686 Rotterdam

He is generally said to have been born in Rotterdam about 1630 although recently stated to have probably been born in Gorinchem in 1623. He was the son of Pieter Verschuier who worked as a wood-carver and stone sculptor for the Admiralty in Rotterdam. Before 1652 he spent some time in Amsterdam where he was probably a pupil of Simon de Vlieger, and thereafter spent some time in Italy. He married in Rotterdam on 24 September 1656. On 25 October 1674 he was nominated Sculptor and Painter to the Admiralty of the Maas in Rotterdam and in 1678 he became Dean of the Guild of St. Luke in Rotterdam. He was buried in Rotterdam on 17 December 1686. His style is variable but he painted exclusively marines and particularly characteristic is his treatment of water, with the surface ripples painted in a formal and stylised way.

Ascribed to LIEVE VERSCHUIER

743 A seaport with a vessel firing a salute (Fig. 170).

Oil on panel, 41 × 54 cms. (16⅛ × 21¼ ins.).

CONDITION: good. Cleaned in 1968.

PROVENANCE: by descent in the family of the Earls of Milltown, Russborough, county Wicklow to Geraldine, Countess of Milltown, by whom presented in memory of her husband, the 6th Earl of Milltown (Milltown Gift), 1902.

No. 743 may be the *Seaport* seen by Neale[1] in the Saloon at Russborough in 1826 and said by him to have been painted by 'Vanube' *(sic.)*. In the Milltown Deed of Gift, 1902, Armstrong called it Bonaventura Peeters but in the 1914 Catalogue of the Gallery gave it to Lieve Verschuier. Subsequently it has been catalogued as Peeters. The positioning of the vessel, the dark mass of the land on the left and the foreground figures may be compared with a signed painting by Verschuier in a Dutch private collection;[2] and the stylistic treatment of the water, which is characteristic of Verschuier, is found in any number of the artist's works. No. 743 is here 'ascribed to Lieve Verschuier'.

1. Neale 1826, no pagination.
2. Exhibited, *A Collectors' Choice*, Mauritshuis,

The Hague, 1982, no. 90.

JAN VICTORS Amsterdam c.1619-1676 or later, Dutch East Indies

He was a native of Amsterdam and his approximate date of birth is conjectured from the fact that at the time of his betrothal in 1642 his age was given as twenty-two. He was probably a pupil of Rembrandt (q.v.) sometime before 1640 and he is recorded in Amsterdam from 1642 onwards. He is last mentioned in Amsterdam in January 1676 and later that year travelled to the Dutch East Indies where he apparently subsequently died. Until the mid-1650's his paintings are mainly portraits and religious subjects and painted in a Rembrandtesque manner; thereafter he painted peasant genre scenes.

879 The Levite and his concubine at Gibeah (Fig. 171).

Oil on canvas, 103.6 × 136.5 cms. (41 × 54 ins.).

CONDITION: paint surface in good condition. Cleaned in 1983.

PROVENANCE: Martin collection, Ham Court, probably by 1854, and thence by descent; E. Bromley Martin, Ham Court sale, Christie's, 4 December 1925, lot 14, bt. Buttery; A. H. Buttery, London, from whom purchased, 1926, for £450.

EXHIBITED: 1983, *Rembrandt: the Impact of a Genius*, Waterman Gallery, Amsterdam and Groninger Museum, Groningen, no. 64.

LITERATURE: Waagen 1854, vol. 3, p. 225; Lugt 1933, under no. 1233, p. 42; Amsterdam/Groningen 1983, no. 64, p. 220.

The painting, which was sold as *Eleazor bringing Rebecca to Abraham* in 1925, is probably that seen by Waagen at Ham Court in 1854 and described by him as 'van den Eeckhout — a genuine and good work, though the subject is not clear to me'.[1] No. 879 was purchased by the Gallery as Victors and was first catalogued in 1922 as Jan Victors, *Elkhannah and his wife Hannah before Eli*. Its real subject is from *Judges*, ch. 19, vs. 15-20. A Levite and his concubine arrive at Gibeah at sunset. They wish to spend the night there but are unable to find lodgings. At length an old peasant invites them to spend the night at his home. In no. 879 the Levite is telling the old man of his difficulties: 'And there

is no man that receiveth me to house, yet there is both straw and provender for our asses; and there is bread and wine also for me and for thy handmaid and for the young man'.

The subject is rare in painting and indeed seems to have been treated almost exclusively by painters in the circle of Rembrandt.[2] van den Eeckhout painted the theme on at least three occasions, in paintings in Berlin,[3] Moscow[4] and New York;[5] a version by Jan van Noordt is in Budapest;[6] and a drawing by an anonymous pupil of Rembrandt in The Louvre.[7] Another treatment of the theme by Victors, which shows a similar composition to no. 879, is in Malibu.[8] It has been questioned why the subject, which is relatively obscure, would have appealed so strongly to painters in the circle of Rembrandt;[9] and Blankert[10] has proposed that it reflects the interest of the artists in *Staetveranderinge* which was a Dutch translation of the Greek word *peripeteia* (meaning sudden reversal of circumstances) that was used by literary theoreticians in Holland at that time. Rembrandt and his followers chose subjects which illustrated a moment in a story when a change of mood takes place: from security to fear, from grief or despair to hope. The Levite and his concubine are a perfect example as the precise subject is the moment when the Levite's desperation is resolved.

The compositional device of the house at the side, the doorsteps and the figure leaning out of the window may also be particularly associated with the Rembrandt School. It was used by many painters including the master himself in etchings of 1639[11] and 1641;[12] and other painters who featured such compositions in their work included Bol[13] and van der Eeckhout.[14]

No. 879 has been compared[15] compositionally and stylistically with a *Jacob shown Joseph's bloodstained cloak* by Victors in Warsaw[16] which is dated 1649.[15] In that painting there is a view into the distance and a house on the right as in no. 879. The comparison is apt and a date of about the same time, i.e. 1650 may be proposed for no. 879.

1. Waagen 1854, vol. 3, p. 225.
2. See Blankert 1982, p. 36.
3. Dahlem Gemäldegalerie, inv. no. 1771, dated 1645. Repr. Sumowski 1983-, vol. 2, no. 402, p. 765.
4. Puschkin-Museum, datd 1658. Repr. Sumowski 1983-, vol. 2, no. 426, p. 789.
5. Coll. Emil Wolf. Repr. Sumowski 1983-, vol. 2, no. 425, p. 788.
6. Szépmüvészeti Muzeum, Repr. Sumowski 1983-, vol. 1, p. 164.
7. Inv. no. 23.004. Repr. Lugt 1933, vol. 3, no. 1233, p. 42. Lugt also discusses the subject matter and lists treatments of the theme, including no. 879, by different painters.
8. The J. Paul Getty Museum. Repr. in the exh. cat. *Rembrandt's influence in the Seventeenth Century*, Matthiessen Gallery, London, 1953, no. 64.
9. By Blankert 1982, p. 36; and also in

Amsterdam/Groningen 1983, under no. 64, p. 220.
10. Blankert 1982, p. 36.
11. *The dismissal of Hagar*, Bartsch no. 30.
12. *The angel departing from Tobit*, Bartsch no. 43.
13. *Elisha receiving the gifts of Namaan*, Amsterdams Historisch Museum, inv. no. A7294, dated 1661. Repr. Sumowski 1983-, vol. 1, no. 103, p. 342.
14. In paintings in The Hermitage, Leningrad, dated 1656. Repr. Sumowski 1983-, vol. 2, no. 422, p. 785; and in the North Carolina Museum of Art at Raleigh, dated 1666. Repr. Sumowski 1983-, vol. 2, no. 458, p. 821.
15. In Amsterdam/Groningen 1983, p. 220.
16. National Museum, inv. no. 1378. Repr. *Warsaw, National Museum, cat. 1969-70*, vol. 2, p. 170.

ROELOF VAN VRIES Haarlem 1630 or 1631-after 1681 ? Amsterdam

He was born in Haarlem probably in 1630 or 1631 as he was said to be twenty-eight in 1659, in which year he was in Amsterdam. He entered the Guild of St. Luke in Leiden in 1653 and the Guild of St. Luke in Haarlem in 1657. He is also mentioned in Amsterdam in 1681. He was a follower of Jacob van Ruisdael (q.v.).

972 A landscape with figures (Fig. 172).

Oil on panel, 60 × 84.2 cms. (23⅝ × 33⅛ ins.).

SIGNED AND DATED: bottom, left of centre, *?RV* (in monogram) *Vries 16(?8) (?1).*

REVERSE: printed label in German: 'de Vries 259' with a description of the picture.

CONDITION: good. Cleaned and restored in 1972.

PROVENANCE: Louis Wine of Dublin, from whom purchased by the Friends of the National Collections of Ireland and presented, 1934.

The composition is fairly typical of van Vries and may be compared with paintings in Bonn,[1] Prague[2] and elsewhere.[3] A tree somewhat similar to the decaying tree on the right of no. 972 appears in a signed painting in Budapest.[4]

The third and fourth digits of the signature on no. 972 are not clearly decipherable. The third digit could be a six, but is more likely as eight. The last digit is most likely as '1'.

1. Landesmuseum, inv. no. G.K. 316.
2. National Gallery, inv. no. DO-4622.
3. For example Adolf Schloss sale, Charpentier,

Paris, 5 December 1951, lot 61.
4. Szépmüvészeti Múzeum, inv. no. 267.

JAN WEENIX Amsterdam 1642-1719 Amsterdam

He was the son of Jan Baptist Weenix (q.v.) and was born in Amsterdam in 1642. He was a member of the Utrecht painter's college from at least 1664 until 1668; but thereafter lived in Amsterdam where he married in 1679. From about 1702 until 1712 he was Court Painter to the Elector Palatine Johann Wilhelm and made a series of paintings of game for Schloss Bensberg. He was buried in Amsterdam on 19 September 1719. He painted Italianate scenes in the style of his father, some portraits and genre; but he is principally known for his game-pieces.

35 A Japanese crane and king vulture (Fig. 173).

Oil on canvas, 117 × 141.8 cms. (45⅞ × 55⅞ ins.).

CONDITION: paint surface in fair condition. There is a corner tear in the area of the neck of the crane and a vertical join down the centre of the canvas. A horizontal tear in the centre, in the area of the crane's

back. Other minor damages and some wearing throughout. Cleaned, lined and restored in 1970.

PROVENANCE: Anthony, London, from whom purchased, 1867, for £84.

The birds are, on the left a Japanese crane *(Grus japonosis)* and on the right, a king vulture *(Sarcoramphus papa)*. The small bird in the centre is intended as a parrot although its species is not easily identifiable: its general shape suggests one of the short crested cockatoos but the entirely bright red colour would rule out the roseate cockatoo or galah. It may be a red lory although its head plumage is not that which is usually found on the lory. In the background a peacock *(Pavo cristatus)* and what is probably intended as a peahen, although the peahen's crest has been omitted. The birds on the right and those between the peacock and hen are unidentifiable.[1]

No. 35 was purchased as the work of Jan Weenix and so catalogued until 1904 when Armstrong attributed it to de Hondecoeter and it has been so attributed ever since. It is, however, quite unlike the work of de Hondecoeter, and it is here re-attributed to Jan Weenix. It compares directly with a painting by Weenix of a *King vulture and other birds* in Budapest[2] (Fig. 218) which is signed and dated 1702. In that painting the setting, with architecture and a park receding in the distance is similar; and the king vulture is repeated almost exactly although shown in a pose which is the reverse of that in which he is depicted in no. 35.

In view of the similarity between no. 35 and the painting in Budapest which is dated 1702, a date of about the same time may be suggested for no. 35.

1. The birds have been identified by D. Goodwin of the British Museum, Natural History in a letter dated 3 April 1981 now in the archive of the Gallery.

2. Szépmüvészeti Müzéum, inv. no. 194.

488 In the Campagna (Fig. 174).

Oil on panel, 43.5 × 34.7 cms. (17⅛ × 13⅝ ins.).

REVERSE: seal of Sedelmeyer, Paris. (Fig. 296).

CONDITION: good. Some wearing. Craquelure on the left in the darks. Cleaned and restored in 1972.

PROVENANCE: Sedelmeyer, Paris, from whom purchased, 1899, for £60.

LITERATURE: Kreplin 1942, p. 246.

No. 488 was purchased, and has always been catalogued, as the work of Jan Baptist Weenix.[1] It is, however, more acceptable as Jan Weenix. It may be compared to a *Landscape with three children playing* by Jan Weenix which is dated 1669.[2] In that picture, which has been suggested as a group portrait of children, a boy is playing with a goat; and the treatment of the boy and the animal is similar to no. 488. A date of about the same time may be suggested for no. 488, i.e. c.1669.

1. It is described as such by Kreplin 1942, p. 246.

2. With Douwes, Amsterdam, 1983. Repr. Schloss 1983, fig. 10, p. 78.

947 Game-piece: the garden of a château (Fig. 175).

Oil on canvas, 122 × 106 cms. (48 × 41⅝ ins.).

CONDITION: very good. Cleaned c.1969-70.

PROVENANCE: Gerret Braamkamp, Amsterdam, 1752;[1] his sale, Amsterdam, 31 July 1771, lot 259, bt. J. de Bosch Jeronz.; Adrian Hope sale, Christie's, 30 June 1894, lot 69, bt. R. C. Isaacs; Sir W. Hutcheson Poë, by whom presented, 1931.

LITERATURE: Hoet 1752, vol. 2, p. 511; Kreplin 1942, p. 245; Bille 1961, vol. 2, pp. 62 and 128; Ginnings 1970, no. 192, p. 270.

When in the collection of Gerret Braamkamp, no. 947 was one of a pair of game-pieces by Jan Weenix.[2] The present whereabouts of its pendant, which showed *A goose attacked by a spaniel*, is not known.[3] The game in no. 947 has been identified[4] as follows: left to right, a domestic cock *(Gallus gallus)*, a brown hare and two domestic pigeons *(Columba livia)*. It has been pointed out[5] that such compositions as no. 947, which only became commonplace in the second half of the seventeenth century, were created to satisfy the demands of the newly-rich bourgeoisie. The subject is linked with hunting and the strict laws which governed it in Holland in the seventeenth century. For example, the nobility and other officers of State only were permitted to hunt and even they were permitted to kill only one hare per week. The background of no. 947 is typical of such pictures and shows a lavish garden of a country house. There were no laws which prevented the bourgeoisie acquiring country houses — which they did; and in time furnished them with such paintings as no. 947 which implied that they had access to the hunt, which in fact they did not.[6]

1. Hoet 1752, vol. 2, p. 511.
2. See Bille 1961, vol. 2, pp. 62 and 128. No. 947 was described by Hoet 1752, vol. 2, p. 511 as on canvas; but in the Braamkamp sale both it and its pendant were described as on panel.
3. It was last in the Sedelmeyer sale, Paris, 25 May 1907. It is repr. by Bille 1961, vol. 1, no. 258.
4. By D. Goodwin of the British Museum, Natural History in a letter dated 3 April 1981 now in the archive of the Gallery.
5. By Sullivan 1980, pp. 236ff.; and see further under Eglon van der Neer, no. 61 in this Catalogue.
6. This hypothesis is put forward by Sullivan 1980.

Style of JAN WEENIX

533 Game-piece (Fig. 203).

Oil on canvas, 79 × 63 cms. (31⅛ × 24¾ ins.).

CONDITION: the weave of the canvas is very coarse. Heavily discoloured varnish.

PROVENANCE: Mr. J. C. Nairn of Dublin, from whom purchased, 1902, for £10.

No. 533 is of poor quality although probably reasonably old. It is in the style of Jan Weenix and probably by an inferior imitator.

JAN BAPTIST WEENIX Amsterdam 1621-c.1660-61 Huis ter Mey, nr. Utrecht

According to Houbraken he was born in Amsterdam in 1621 and was first a pupil of Jan Micker in Amsterdam, later of Abraham Bloemart in Utrecht and then of Nicolaes Moeyart in Amsterdam. He was still in Amsterdam in October 1642 when he made his will before setting out for Italy. He went to Italy at that time, where, according to Houbraken he stayed for four years, mainly in Rome. He was still in Rome in June 1646 but by June of the following year was back in Amsterdam. By 1649 he was settled in Utrecht. He died in his country house, Huis ter Mey near Utrecht about 1660-61. Before 1643 he signed himself Johannes Weenincks or Weenincz, but after his return from Italy, as Gio Batta Weenix. After his return from Italy he painted Italian seaports and still life with dead game. He was the father of Jan Weenix (q.v.).

511 The sleeping shepherdess (Fig. 176).

Oil on canvas, 72.5 × 61.1 cms. (28½ × 24¼ ins.).

SIGNED: on the architrave above the left hand column, *Gio : Batta Weenix.*(Fig. 277).

CONDITION: the original canvas has been slightly trimmed at the edges. Paint surface in good condition. There is a damage in the red dress in the area of the girl's thigh. Cleaned in 1983.

REVERSE: the seal of Etienne Le Roy. (Fig. 297).

PROVENANCE: Duke of Brunswick-Wolfenbuttel, Salzthalum until 1795;[1] François-Xavier de Burtin, 1808;[2] Etienne Le Roy, from whom acquired in 1855 by Viscomte du Bus de Gisignies;[3] his sale, Brussels, 9-10 May 1882, lot 91, where purchased by Sir Henry Page Turner Barron, by whom bequeathed, 1901.

LITERATURE: de Burtin 1808, vol. 2, p. 347; Fétis 1878, p. 196; Kreplin 1942, p. 246; Ginnings 1970, no. 67, p. 185; Blankert 1978, n. 2 of no. 102, p. 182 and n. 2 of no. 105, p. 184.

No. 511 was described by de Burtin in 1808 as 'one of the best paintings by this great artist'[4] — a view endorsed by Fétis in 1878[5] who called it 'one of the principal ornaments of the Gallery of the Duke of Brunswick-Wolfenbuttel at Salzthalum. . . .' A painting somewhat similar in composition by Jan Baptist's son, Jan Weenix, is in Munich[6] and was painted under the influence of Jan Baptist. It shows a girl asleep at the base of an urn with a dog standing beside her. In the case of that painting, however, as Schloss[7] has pointed out, the artist has intended to point a moral: the girl is a spinner who is neglecting her work through sleep and idleness. No such moral is intended in no. 511 where the artist has been primarily concerned to convey the appearance and atmosphere of Italy. A further painting by Jan Weenix of *A shepherdess*[8] (this time awake) is also similar in composition to no. 511; and Ginnings[9] has referred to the similarity of the setting in no. 511 and that in Jan Baptist Weenix's *Landscape with an inn* which is dated 1658 in the Mauritshuis.[10]

Ginnings[11] suggests a date of 1656-58 for no. 511.

1. According to de Burtin 1808, vol. 2, p. 347.
2. *Ibid.*
3. Fétis 1878, p. 196.

4. de Burtin 1808, vol. 2, p. 347.
5. Fétis 1878, p. 196.
6. Alte Pinakothek, inv. no. 246. Repr. *Munich,*

Alte Pinakothek, cat. 1983, p. 558.
7. Schloss 1983, p. 79.
8. Present whereabouts unknown. It is repr. Schloss 1983, fig. 11, p. 79.

9. Ginnings 1970, no. 67, p. 185.
10. Inv. no. 901. Repr. *The Hague, Mauritshuis, cat. 1977,* p. 255.
11. Ginnings 1970, p. 185.

Ascribed to JAN BAPTIST WEENIX

1394 **The Holy Women at the tomb** (Fig. 177).

Oil on canvas, 102.2 × 122.5 cms. (40¼ × 48¼ ins.).

REVERSE: labels in manuscript as follows, *Augustus Smith (no. 11) The Marys at the sepulcre by Eckhout. (sic) Eckhout* . . . (and a description of the picture). . . .

CONDITION: good. There is a damage, bottom left.

PROVENANCE: Augustus Smith;[1] Henry Naylor sale, Murphy, Buckley and Keogh, Dublin, 16-17 September 1959, lot 1538, where purchased for £840.

LITERATURE: Blankert 1982, no. R32, pp. 165-66.

The episode of the Holy Women who were the first to discover the empty tomb after Christ's resurrection, is told in all four Gospels. The exact identity of the women is uncertain but *St. Mark,* ch. 16, vs. 1, names Mary Magdalene, Mary the mother of James and Mary Salome. On reaching the sepulcre they were greeted by an angel in a white robe who told them that Christ had risen.

No. 1394 was sold in 1959 as van den Eeckhout and so called on accession by the Gallery. On a visit in 1960 van Gelder[2] proposed an attribution to Ferdinand Bol and the painting has been so catalogued since that time. The attribution to Bol is rejected by Blankert[3] who proposes that no. 1394 is probably an early work by Jan Baptist Weenix. On a visit to the Gallery in 1968 de Bruyn Kops also suggested that no. 1394 might be an early work by Jan Baptist Weenix or alternatively Gabriel Metsu; and at the same time van Thiel identified it as early Metsu. In a subsequent letter[4] de Bruyn Kops confirmed his belief that the painting was most probably an early Metsu. Robinson[5] rejects the attribution to Metsu seeing no similarity between no. 1394 and Metsu's 'rare but beautiful religious paintings'.

Sumowski[6] on the basis of a photograph also believes the painting to be an early Jan Baptist Weenix and Haverkamp Begemann[7] (also on the basis of a photograph) suggests early Jan Baptist Weenix as well. He points out that 'the composition, light, background, foreground motif of plants are all found in Jan Baptist's *Circumcision of the son of Moses* in Warsaw'[8] and that no. 1394 could be a little later than the Warsaw picture. He also draws a comparison between no. 1394 and *The sleeping Tobit* by Jan Baptist Weenix in Rotterdam[9] which was formerly dated 1642, and suggests that no. 1394 may be about contemporary. Additionally Haverkamp-Begemann draws attention to the hollow-eyed features of the woman on the left and points out that Jan Baptist Weenix often painted women with such features in his later (post-Italian) works.

1. See 'Reverse' above.
2. van Gelder's opinion is noted in the *ms.cat.* of the Gallery.
3. Blankert 1982, no. R32, pp. 165-66.
4. Dated 3 October 1968 now in the archive of the Gallery.
5. Franklin W. Robinson who has examined a photograph of the painting. His views are expressed in a letter dated 23 May 1983 now in the archive of the Gallery.

6. In a letter dated 8 May 1983 now in the archive of the Gallery.
7. In a letter dated 6 February 1986 now in the archive of the Gallery.
8. National Museum, inv. no. 1427, Repr. *Warsaw, National Museum, cat. 1969-70*, vol. 2, p. 186.
9. Museum Boymans-van Beuningen, inv. no. 1204. Repr. *Rotterdam, Boymans, cat. 1972*, p. 93.

JACOB DE WET THE ELDER Haarlem c.1610-after 1675 Haarlem

His date of birth is not certain but he married for the first time in 1635 so that a date of birth of about 1610 is generally put forward. His earliest dated picture is of 1633. He is recorded frequently in Haarlem from 1638 to 1668: he was a hoofdman *of the Guild of St. Luke there in 1645 and 1660 and Dean in 1661. He is last mentioned in Haarlem in 1675. His date of death is unknown. He painted religious and mythological subjects, generally in a landscape. These are very much in the style of Rembrandt (q.v.) whose pupil he may have been in the 1630's.*

1315 Abraham and Melchizedek (Fig. 178).

Oil on panel, 59.1 × 81.2 cms. (23¼ × 32 ins.).

SIGNED: right, *J d Wet.*

REVERSE: Matthiessen Gallery and Colnaghi labels. Label in ms. *W.A.G. Cunliffe coll. list no. 20.*

CONDITION: the support consists of two members joined on a horizontal 28.5 cms. from the top. The paint surface is in fair condition with some overpainting throughout.

PROVENANCE: W. A. G. Cunliffe;[1] Sir Foster Cunliffe, Acton Hall, Wrexham, his sale Sotheby's, 1 February 1950, lot 141, bt. Thesiger; Alfred Brod, 1953;[2] P & D Colnaghi from whom purchased, 1955, for £250.

EXHIBITED: 1953, *Rembrandt's influence in the 17th Century*, Matthiessen Gallery, London, no. 67; 1955, *Paintings by Old Masters*, Colnaghi, London, no. 2.

The subject is from *Genesis*, ch. 14, vs. 18-24. On their return from Egypt, Lot settled in Sodom, Abraham in Canaan. Subsequently when Lot was captured and his possessions seized by raiders, Abraham recovered the goods and secured the release of Lot. Returning in triumph he was received at Jerusalem by Melchizedek who brought out bread and wine and blessed Abraham. In return Abraham ceded him one tenth of his booty. The episode was interpreted as a prefiguration of The Last Supper. The subject is not common in painting but was treated by other painters in the circle of Rembrandt including Lastman in a now lost composition which is recorded in a drawing by van den Eeckhout;[3] and van den Eeckhout also painted the subject in pictures in Mänttä,[4] Budapest[5] and New York.[6]

No other version of the subject by Jacob de Wet is known but a picture of Abraham and Melchizedek by him was included in the possessions of the dealer Hendrick Meyeringh in Amsterdam in 1687;[7] and it could be that this picture is no. 1315. The landscape in the background right, including the tower, is repeated as the right half of a landscape by de Wet in the National Gallery, London.[8]

1. See 'Reverse' above.
2. When lent to the exhibition at the Matthiessen Gallery, see 'Exhibited' below.
3. Musées Royaux des Beaux-Arts de Belgique, Brussels. Repr. Sumowski 1979-, vol. 3, p. 1612.
4. Gösta Serlachuis Museum, inv. no. 381. Repr. Sumowski 1983-, vol. 2, no. 406, p. 769.
5. Szépművészeti Múzéum, inv. no. 69.44.

Repr. Sumowski 1983-, vol. 2, no. 445, p. 808.
6. New York Historical Society, inv. no. 752. Repr. Sumowski 1983-, vol. 2, no. 475, p. 838.
7. Bredius 1915-22, vol. 1, no. 5, p. 335.
8. As pointed out by MacLaren 1960, p. 454. It is cat. no. 1342, repr. *London, National Gallery, cat. 1973*, p. 803.

EMANUEL DE WITTE Alkmaar c.1617-1691/92 Amsterdam

He was born in Alkmaar but the exact year of his birth has not been established. He joined the Guild of St. Luke in Alkmaar in 1636 but by July of 1639 he was in Rotterdam and is mentioned there again in 1640. By October 1641 he was in Delft and joined the Guild of St. Luke there in June 1642. He is recorded in Delft in 1644, 1646, 1647 and 1649 but by January 1652 he was in Amsterdam where he was betrothed in September 1655 and where he probably lived for the rest of his life. According to Houbraken he committed suicide (by hanging himself from a canal bridge) and his body was found in a canal that had been frozen over since his disappearance eleven weeks previously. Initially de Witte was a figure painter and he painted some biblical and mythological compositions. About 1650 he turned to painting architectural interiors; he also painted some domestic interiors and, from 1660, market scenes.

805 Interior of a Protestant classical church (Fig. 179).

Oil on canvas, 127 × 135 cms. (50¼ × 53⅛ ins.).

SIGNED AND DATED: perhaps falsely, on the base of the column, right, *E De Witt A° 1660*.

CONDITION: there is a damage in the area of the round window, centre. Paint surface in fair to poor condition. Cleaned and restored in 1969.

PROVENANCE: Sir Hugh Lane, by whom bequeathed, 1915, and received in the Gallery, 1918.

EXHIBITED: 1918, *Pictures by Old Masters given and bequeathed to the National Gallery of Ireland by the Late Sir Hugh Lane*, National Gallery of Ireland, Dublin, no. 53.

LITERATURE: Trautscholdt 1947, p. 125; Manke 1963, no. 136, p. 111.

The large stained glass window in the centre of the composition shows the *Supper at Emmaus*. No. 805 is a view of the interior of an imaginary church and similar to that shown

in a painting by de Witte in Hamburg.[1] The staffage in no. 805 and the Hamburg painting are also the same. The main difference between the two paintings is that the Hamburg picture is an upright composition and shows the arch which is carried by the foreground columns. In the case of the Hamburg painting, Liedtke[2] has drawn attention to the fact that de Witte employed elements of the architecture of the Westerkerk and Zuiderkerk in Amsterdam, both of which were designed by Hendrick de Keyser. No. 805 is accepted with some reservations by Manke;[3] and she also justifiably questions the authenticity of the signature.

The date on no. 805 reads 1660 which would be far too early for the painting, and both it and the signature may be false. The Hamburg painting is dated by Manke, 1680-85; and by Liedtke, c.1685. A date of about that time would be more reasonable for no. 805.

1. As noted by Manke 1963, p. 111. The painting is in the Hamburg Kunsthalle, inv. no. 206, repr. Manke 1963, pl. 109.

2. Liedtke 1982, p. 96.
3. Manke 1963, no. 136, p. 111.

After EMANUEL DE WITTE

450 The interior of the New Church at Delft with the tomb of William the Silent (Fig. 180).

Oil on panel, 42.8 × 32.8 cms. (16⅛ × 12¹⁵/₁₆ ins.).

SIGNED: falsely, bottom left, *Witte*

CONDITION: fair. Some damages to the column right.

PROVENANCE: F. Muller, Amsterdam, from whom purchased, 1896, for £50.

LITERATURE: Jantzen 1909, pp. 191-92; Jantzen 1910, no. 647, p. 176; Manke 1963, no. 27C, p. 85; Jantzen 1979, no. 647, p. 242.

The Nieuwe Kerk was built between 1384 and 1496. The view is from the ambulatory looking towards the apse containing the tomb of the Stadhouder William I, Prince of Orange (1533-84). The tomb, by Hendrick de Keyser (1565-1621), was commissioned in 1614 and completed in 1622. It consists of a stone *baldacchino* with a recumbent effigy in marble of the Prince. At his head and feet, not visible in no. 450, are a seated statue of himself and a statue of *Fame* respectively. At the four corners are statues representing *Liberty, Justice, Religion* (visible in no. 450) and *Valour*. The man in the foreground draws the attention of the lady (who is distracted by the beggar child) to the tomb. The picture is one of many showing the tomb by de Witte, Gerard Houckgeest (1600-61), Hendrik van Vliet (1611-75)[1] and other artists painted in 1650 or shortly thereafter. Wheelock[2] has drawn attention to the political significance of the view and its popularity at this particular time. The tomb was a symbol of the glory and fame of the House of Orange. William the Silent's grandson, the Stadhouder William II had died at the age of twenty-four in 1650. Opposed by the States of Holland, William II by attempting to draw the Netherlands

into war with England, had sought to enhance his own position of leadership, and at the same time re-establish the House of Stuart, to which his wife belonged, in England. His policies led to considerable civic unrest, before his premature death of smallpox in that year. He was succeeded by his son William III who was born eight days after his death. In the popular mind the tumultous reign of William II compared ill to that of the popular William I, and Wheelock concludes that it is for this reason that the tomb of the latter became, from 1650, a popular subject with painters. The tomb was, in itself, an obvious symbol of the inevitability of death; but further, because of the large number of paintings of it and other tombs dating from this time, there was, following the events of 1650, a specific market for church interiors with specific *vanitas* overtones.

de Witte painted several views of the interior of the Nieuwe Kerk in Delft with the tomb of William the Silent. Examples are formerly in Wiesbaden,[3] Hamburg,[4] Salzburg[5] and Lille.[6] Of these no. 450 comes closest to the picture in Lille, which is larger, and it was described by Jantzen[7] as an obviously later, but autograph derivative from that painting. However, he referred to the signature as a forgery. Manke[8] calls it probably an eighteenth-century copy of the Lille picture. The staffage and general view are similar, although not identical in both paintings; but the treatment of the perspective in no. 450 is not similar and nor is it satisfactory or entirely convincing. There are minor differences in the staffage of the two paintings: the composition of the Lille picture is extended slightly to the right to show additional figures; and the boy on the left is accompanied by two dogs in the Lille picture.

1. See After Gerard Houckgeest no. 530 in this catalogue.
2. Wheelock 1975-76, pp. 179 ff.
3. With Galerie Heinemann, 1963, repr. Manke 1963, pl. 11.
4. Kunsthalle inv. no. 203, repr. Manke 1963, pl. 10.
5. Residenz-Galerie, inv. no. 144, repr. Manke 1963, pl. 59.
6. Musée de la Ville, inv. no. 902, repr. Manke 1963, pl. 35.
7. Jantzen 1910, p. 120.
8. Manke 1963, p. 85.

PHILIPS WOUWERMAN Haarlem 1619-1668 Haarlem

He was the eldest son of the painter Paulus Wouwerman, who may also have been his teacher. He is also reputed to have studied with Frans Hals (q.v.). He is said to have run away to Hamburg in order to marry at the age of nineteen and he worked there for some weeks with Evert Decker, a painter of religious and mythological subjects. He joined the Guild of St. Luke in Haarlem in 1640, became an officer in the Guild in 1645 and apparently remained in Haarlem until his death in 1668. Wouwerman was extremely prolific and also very successful. He specialised in scenes with horses — hunting, in battle and military encampments; horses are included in many of his paintings on religious subjects, the majority of which show the Annunciation *to the shepherds (see no. 582 below).*

170 Cavalry halted at a sutler's tent (Fig. 181).

Oil on panel, 35.8 × 41 cms. (14⅛ × 16⅛ ins.).

SIGNED: bottom left, *P S W*

CONDITION: good. Discoloured varnish.

PROVENANCE: Robert Prioleau Roupell sale, Christie's, 25 June 1887, lot 44, where purchased for 255 guineas.

LITERATURE: Armstrong 1890, p. 284; Hofstede de Groot 1908-27, vol. 2, no. 851, p. 532; Thieme, Becker 1907-50, vol. 36, p. 266.

In the foreground are officers watering their horses, one of them seated on the ground lighting his pipe. To the right are a trumpeter, seen from the back and a mounted trooper draining a flagon. The tent is pitched and supported in part by the tree: the wreath and tankard hanging from the pole was the usual method of advertising that it was a place of refreshment.

No. 170 was described by Hofstede de Groot[1] as 'a genuine work of mediocre quality'. The painting is somewhat similar to paintings by Wouwerman on panel of the same size once at Waddeston[2] and in Frankfurt.[3]

1. Hofstede de Groot 1908-27, vol. 2, no. 851, p. 532.
2. Hofstede de Groot 1908-27, vol. 2, no. 670, p. 464.

3. Städelsches Kunstinstitut, inv. no. 1072. Hofstede de Groot 1908-27, vol. 2, no. 422, p. 376.

582 The Annunciation to the shepherds (Fig. 182).

Oil on panel, 47.5 × 40.6 cms. (18⅛ × 15¹⁵/₁₆ ins.).

REVERSE: collector's seal (Fig. 298).

CONDITION: very good. Cleaned and restored in 1969.

PROVENANCE: van Sacegham, Ghent, 1839;[1] van Sacegham of Ghent sale, Brussels, 2 June 1851, lot 84, bt. Styart van Brugge;[2] Sir Edgar Vincent, by whom presented, 1907.

LITERATURE: Hofstede de Groot 1908-27, vol. 2, no. 16, p. 260.

No. 582 fits the description of a painting listed by Hofstede de Groot as sold in the van Sacegham of Ghent sale in Brussels in 1851 and may therefore be identified with it.[3] Smith had, in 1839, listed the picture without any description.

There are very few dated works by Wouwerman and he does not seem to have painted pictures of the *Annunciation to the shepherds* exclusively at any one time during his career. No. 582 is possibly about 1645-50.

1. According to Smith 1829-42, Part 1, nos. 24, p. 209 and 65, pp. 219-20, an *Annunciation to the shepherds* was in this collection.
2. The reference to the sale is given in Hofstede de Groot 1908-27, vol. 2, no. 16, p. 260.

3. In his own annotated copy of Hofstede de Groot 1908-27 in the RKD, Hofstede de Groot confirms that he believes that his no. 16 is no. 582.

After PHILIPS WOUWERMAN

1386 The collision (Fig. 206).

Oil on panel, 44.5 × 57.4 cms. (17½ × 22½ ins.).

PROVENANCE: purchased in London in 1863 for £10.[1]

CONDITION: the support consists of three members joined on verticals at about 18.5 and 30 cms. from the right. The joins have been strengthened by buttons. Paint surface in quite good condition. Retouched along the joins.

No. 1386 is a copy in reverse of a painting by Wouwerman in Dresden.[2] That painting was engraved in 1732 by Le Bas when in the De Piles collection, Paris and called, on the engraving, *Le Pot au Lait*. No. 1386 is almost certainly copied from the engraving and is probably French, eighteenth century. It is of fine quality.

1. See After Metsu, no. 1996, n. 1.
2. Gemäldegalerie. It is Hofstede de Groot

1908-27, vol. 2, no. 366, p. 359, repr.
Mullenmeister 1981, vol. 3, no. 552.

After PHILIPS WOUWERMAN

1699 Horses watering: a landscape (Fig. 205).

Oil on panel, 47.7 × 66 cms. (18¾ × 26 ins.).

CONDITION: the support, which has been planed down, consists of two members joined on a horizontal 24 cms. from the top. The join is repaired with a balsa wood insert. Paint surface in fair condition. Worn throughout. The figures are in reasonably good condition. The join in the support is visible on the surface. Cleaned and restored in 1970.

PROVENANCE: at Russborough possibly by 1826;[1] thence by descent to Geraldine, Countess of Milltown, by whom presented in memory of her husband, the 6th Earl of Milltown (Milltown Gift), 1902.

No. 1699 is probably that seen by Neale[1] at Russborough in 1826 and described by him with the above title. It is a copy of a painting by Wouwerman at Petworth.[2]

1. When seen by Neale 1826, vol. 3, no pagination, and described by him with the title as here.

2. Oil on panel, 17½ × 22 ins. Repr. Collins Baker 1920, no. 35, p. 138.

Style of PHILIPS WOUWERMAN

1702 Horses and figures at a sutler's tent (Fig. 204).

Oil on panel, 63 × 48 cms. (24¾ × 18⅞ ins.).

CONDITION: the support is cradled and painted yellow all over on the reverse. Paint surface in very poor condition with bitumen cracking throughout the darks. Heavily discoloured varnish.

PROVENANCE: by descent in the family of the Earls of Milltown, Russborough, county Wicklow to Geraldine, Countess of Milltown, by whom presented in memory of her husband, the 6th Earl of Milltown (Milltown Gift), 1902.

No. 1702 may have been at Russborough by as early as 1826.[1] It was described with the title given here in the Milltown Deed of Gift in 1902 in which it is listed as no. 2. It is of very poor quality although in the style of Wouwerman and is probably early nineteenth century in date.

1. Five paintings were listed as Wouwerman at Russborough by Neale 1826, vol. 3, no pagination. They are: *Horses watering, a landscape; Two neat landscapes and figures; Hunting-piece; Horses watering*. In the Milltown Deed of Gift, 1902 five paintings are also listed as Wouwerman, as follows: 2. *Horses and figures at a sutler's tent* 24½ × 19 ins. (cat. no. 1702); 208. *Landscape and figures* 18 × 25 ins. (now cat. no. 1699); 161. *Man and horse* 11½ × 18 ins.; 214. *Landscape with figures* 11 × 15 ins. (now cat. no. 1755); 168. *Men and horses* 14½ × 20 ins. (now cat. no. 1712). In the present catalogue there are only four 'Wouwerman' paintings with Milltown Gift as provenance. None of the Milltown paintings attributed to Wouwerman are of quality and none were included by Armstrong in his catalogue of the Gallery in 1914.

Style of PHILIPS WOUWERMAN

1712 Huntsmen with horses (Fig. 208).

Oil on panel, 38 × 53 cms. (15 × 20¾ ins.).

CONDITION: large areas of paint loss in the figures and horses. The reverse of the support has been painted yellow all over.

PROVENANCE: by descent in the family of the Earls of Milltown, Russborough, county Wicklow to Geraldine, Countess of Milltown, by whom presented in memory of her husband, the 6th Earl of Milltown (Milltown Gift), 1902.

No. 1712 is of very poor quality and probably early nineteenth century in date.

Style of PHILIPS WOUWERMAN

1755 Halt with caravans (Fig. 207).

Oil on panel, 29.9 × 39.5 cms. (11¾ × 15½ ins.).

REVERSE: label in *ms. Wouwermans Ph.*

CONDITION: paint surface in poor condition.

PROVENANCE: by descent in the family of the Earls of Milltown, Russborough, county Wicklow to Geraldine, Countess of Milltown, by whom presented in memory of her husband, the 6th Earl of Milltown (Milltown Gift), 1902.

No. 1755 is of very poor quality having little to do with the hand or period of Wouwerman.

J. P. VAN WIJCK active 1651-1670

He is hardly known but he may be identical with the Pieter van Wijck who was active in Utrecht in the mid-century.

894 Portrait of a lady (Fig. 183).

Oil on canvas, 81.2 × 64 cms. (31⅛ × 25¼ ins.).

SIGNED: right, *J P* (in monogram) *Wijck* (Fig. 278).

CONDITION: fair to good. The colour of a curtain in the top right hand corner has either faded or oxidised. The chain is not contemporary with the original. Cleaned in 1986.

PROVENANCE: Eden sale, Christie's, 17 December 1926, lot 53, bt. Collings; W. B. Patterson, London, from whom purchased, 1927, for £350.

No. 894 was sold in 1926 as Jan Wyck, registered in the Gallery on acquisition as Thomas Wijck and has always been so catalogued. It is however signed by J. P. Wijck. It may be compared with a *Portrait of Jos. Andrea Leydecker*, by J. P. Wijck which is signed and dated 1658, in the Museum Meermanno Westreenianum, The Hague. On the basis of the costume, no. 894 may be dated 1665-70.[1]

1. Information from Marȳke de Kinkelder of the RKD, 1983.

THOMAS WIJCK Beverwijk, near Haarlem 1616-1677 Haarlem

According to Houbraken he was born in Haarlem in 1616. He is first mentioned in the records of the Guild of St. Luke in Haarlem in 1642. He married in Haarlem on 22 May 1644. He was Commissioner of the Guild in 1658 and Dean in 1660. He visited England about 1660. Although Houbraken says that he visited Italy, this is not certain. Had such a trip taken place it would have been before 1642; and it is also said that he was a pupil of Pieter van Laer in Rome. He painted tavern scenes and interiors but also Italianate landscapes — generally harbour and market scenes in the manner of Jan Asselijn or Jan Weenix (q.v.). He was the father of Jan Wyck.

349 Interior of a weaver's cottage (Fig. 184).

Oil on panel, 39.7 × 35.6 cms. (15½ × 14 ins.).

CONDITION: good. Very discoloured varnish.

PROVENANCE: S. Bourgeois, Paris, from whom purchased, 1894, for £80.

LITERATURE: Stone-Ferrier 1985, pp. 41-56.

The subject of no. 349 has been particularly associated by Heppner[1] with the Haarlem paintings of Cornelis Decker who painted a number of pictures showing the interiors of weavers' cottages.[2] Other artists who painted similar compositions are Cornelis Bega, Cornelis Beelt and Johannes Dircksz. Oudenrogge. Haarlem was a very important centre of the linen industry and such pictures which show weavers at work in their cottages were only painted by Haarlem artists.

A painting by Wijck of the *Interior of a weaver's cottage* in Mainz[3] is close in composition to no. 349; and a drawing in Amsterdam[4] by him shows a weaver at work on a loom and may also be compared with no. 349.

Paintings of the subject which are dated were painted by the different artists exclusively in the 1650's and generally towards the early part of the decade. A date at that time may also be suggested for no. 349.

1. Heppner 1935, pp. 155ff.
2. See also Stone-Ferrier 1985 who reproduces five of Decker's paintings of weavers' cottages, figs. 13-17, pp. 43-47 and also several paintings by other artists of similar subject matter,

including no. 349 on p. 51.
3. Mittelrheinisches Landesmuseum, inv. no. 741.
4. Rijksprentenkabinet. Repr. Stone-Ferrier 1985, p. 55.

JAN WIJNANTS active in Haarlem 1643-1684 Amsterdam

The date of his birth is not certain but he was a native of Haarlem and lived there until 1659. He had removed to Amsterdam by December 1660 where he is described in 1672 as a painter and innkeeper. He is recorded in Amsterdam on several occasions until his death in 1684. The subject of almost all his pictures is the dune scenery around Haarlem. The figures in his paintings are usually by other artists including Lingelbach (q.v.), Philips Wouwerman (q.v.), Dirck Wijntrack (q.v.), and by his pupil, Adriaen van de Velde (q.v.).

280 The dunes near Haarlem (Fig. 185).

Oil on canvas, 21.4 × 26 cms. (8^{7}/$_{16}$ × 10¼ ins.).

SIGNED AND DATED: bottom right, *J. Wijnants 1667* (Fig. 279).

CONDITION: the original canvas has been extended by about 1 cm. all round. Paint surface in good condition. Cleaned in 1985.

PROVENANCE: Sir William Knighton, Blendworth Lodge, Hampshire sale, Christie's, 22-23 May 1885, lot 506, where purchased for 41 guineas.

LITERATURE: Armstrong 1890, p. 284; Hofstede de Groot 1908-27, vol. 8, no. 12, p. 432; Wolff 1947, p. 330.

No. 280 was called by Armstrong[1] a scene in the neighbourhood of Haarlem 'into which capital figures have been inserted by Berchem'. Hofstede de Groot[2] called it *The dunes*

near Haarlem and gave the figures to Lingelbach (q.v.). Wolff[3] also suggested Lingelbach for the figures.

1. Armstrong 1890, p. 284.
2. Hofstede de Groot 1908-27, vol. 8, no. 12, p. 432.
3. Wolff 1947, p. 330.

508 A wooded landscape with a river (Fig. 186).

Oil on canvas, 94 × 116 cms. (37 × 45⅝ ins.).

SIGNED: bottom left, *J wijnants F.* (Fig. 280).

REVERSE: the extract from the 1887 sale catalogue is pasted to the reverse, and this is inscribed in *ms.: Sale at Christie's 25 June 1887 Guin. 270 . . . and of Mr. Nieuwenhuys £283. 10s. bought in by the executors at the sale in 1886 for 330 guineas, the reserved price having been 400-420. No. 28 in Sir H. Barron's collection.*

CONDITION: very good. Cleaned in 1986.

PROVENANCE: J. Witsen sale, Amsterdam, 16 August 1790, lot 85, bt. Yver; Marquis de Montcalm sale, London, 4 May 1849, lot 113, bt. Farrer; Sir Hugh Hume Campbell, Marchmont House, Berwickshire by 1856;[1] C. J. Nieuwenhuys, decd. sale, Christie's, 17 July 1886, lot 118, bought in by the executors; C. J. Nieuwenhuys, decd. sale, Christie's, 25 June 1887, lot 99, bt. Sir Henry Page Turner Barron, by whom bequeathed, 1901.

EXHIBITED: 1856, British Institution, no. 12.

LITERATURE: Waagen 1857, p. 442; Hofstede de Groot 1908-27, vol. 8, no. 458, p. 533.[2]

No. 508 was described by Waagen[3] as 'a fine specimen of the master in his free manner'; Hofstede de Groot[4] gave the figures to Lingelbach. No. 508 is late work and the signature is of a type used by Wijnants about 1679.[5]

1. When lent to the British Institution, see 'Exhibited' above. No. 508 is said by Redford 1888, vol. 2, p. 349 to have been in the Sir Hugh Hume Campbell sale in 1872 where it was purchased by Nieuwenhuys for £399. No such sale is listed by Lugt. Hofstede de Groot 1908-27, vol. 8, p. 533, referring to Redford suggests a Campbell sale on 8 June 1871; but again no such sale is listed by Lugt and no. 508 does not appear to have been included in any Campbell sale.

2. Hofstede de Groot 1908-27, vol. 8, p. 533 suggests that no. 508 is possibly identical with his no. 449, p. 531, a picture that was in the Meynts sale, Amsterdam, 15 July 1823, lot 149; but the size of that picture does not accord with no. 508.
3. Waagen 1857, p. 442.
4. Hofstede de Groot 1908-27, vol. 8, p. 533.
5. See Bredius 1911, p. 184.

DOMENICUS VAN WIJNEN called ASCANIUS
Amsterdam 1661-c.1700 ?

He was born in Amsterdam in 1661 and in 1674 he studied in The Hague with Willem Doudyns, a history painter. Between 1680 and 1690 he was in Rome where he became a member of the Schildersbent, *an association of Netherlandish artists which held boisterous*

festivals at which new members were initiated through rites of mock baptism and given 'Bent' names. van Wijnen was given the name of 'Ascanius' which means son of Aeneas. An account of the Bent festivals was published in 1698 by Cornelis de Bruyn who had visited Rome in 1675; and his account was illustrated with engravings by M. Pool, three of which were after paintings by van Wijnen. Very few paintings by van Wijnen are known.

527 The temptation of St. Anthony (Fig. 187).

Oil on canvas, 72 × 72 cms. (18½ × 18½ ins.).

SIGNED: left, on the stone steps *DVW* (in monogram) *Æscanius*. (Fig. 281)

CONDITION: good. Cleaned in 1980.

PROVENANCE: J. M. de Birckenstock sale, Artaria, Vienna, (n.d.) March 1811, lot 121; S. Sharp, Esq., 1868; Arthur Kay of Glasgow, by whom presented, 1901.

EXHIBITED: 1868, *National Exhibition of Works of Art*, Leeds, no. 835; 1957, *Bosch, Goya et la Fantastique*, Galerie des Beaux-Arts, Bordeaux, no. 168; 1980-81, *Gods, Saints and Heroes: Dutch Painting in the Age of Rembrandt*, National Gallery, Washington, Detroit Institute of Arts, Rijksmuseum, Amsterdam, no. 88.

LITERATURE: von Frimmel 1913-14, vol. 1, no. 121, p. 127; Hoogewerff 1923, vol. 3, p. 235; Noack 1927, vol. 1, p. 217 and vol. 2, p. 659; Thieme, Becker 1907-50, vol. 36, p. 332; Bernt 1948-62, vol. 4, no. 332; Washington/Detroit/Amsterdam 1980-81, no. 88, p. 228.

St. Anthony, considered the father of monasticism, was a third-fourth century hermit who withdrew to the desert to escape the temptations of the flesh, which he called his 'demons'. In no. 527 he is shown, holding his rosary and crucifix, at the bottom left. Kuretsky[1] has explained the iconography of no. 527 as follows: 'The human skull, books and candle beside him serve as *vanitas* allusions to the evanescence of earthly life and endeavour. Carnal temptation (Lust) is offered by the young woman behind him who holds a lantern illuminating her naked breasts. The other Deadly Sins seem to be represented by figures in the middleground: the chained man at the left with moneybags (Avarice), the old woman with serpentine hair (Envy), the nude woman borne aloft by men (Pride or Lust), the drinkers in the centre (Gluttony), the men in combat at the right (Anger). A pig, one of the saint's attributes, may represent Gluttony, Lust, Sloth or the devil himself. The horse (?) skull in the centre middleground, a symbol of folly often featured in carnival processions in the Low Countries, was also used to drive away demons and evil spirits. The drunken man astride the wine cask at the centre of the composition is clearly an allusion to Bacchus, god of wine and revelry, who may also be considered a kind of anti-Christ inspiring false worship. van Wijnen's Bacchus is not nude but wears contemporary dress and has an open book before him. Possibly a reference is being made here to initiation rituals of the Schildersbent in Rome of which van Wijnen was a member. An engraving of a Bent initiation by M. Pool after van Wijnen depicts Bacchus riding a wine cask. The display of cosmic fireworks in the background, representing the fall of the damned, recalls passages in the biography of St. Anthony ''. . . there came a brightness out of Heaven which enveloped him entirely and healed all his wounds, and drove forth his devils as dust flies before the wind. . . .'' The bubble, most commonly a symbol of transience, may also represent the sphere of Heaven'.

van Wijnen painted the subject on at least one other occasion in a painting now in a private collection in Czechoslovakia[2] which is similar in size, format and composition to no. 527; although, as there are a number of differences between the two pictures, it is by no means a version of no. 527.

No. 527 was sold in 1811 as one of a pair of pictures correctly attributed to Dominique van Wynen (sic.) called Ascanius. Its pendant, lot 120, was of identical size and represented 'the vanity of human life; one sees on the right a young man asleep beside the sea, surrounded by emblems; a man makes bubbles of soap above his head, another holds a skull on which there is a burning coal; on the left is the Goddess of Truth, many figures swimming in the sea'. The present whereabouts of that painting is not known.

In the late nineteenth century, the signature on no. 527 was interpreted as that of Laurent van der Vinne, as whom no. 527 was shown in the Leeds exhibition in 1868.

1. In Washington/Detroit/Amsterdam 1980-81, p. 288.
2. Information on the painting, kindly conveyed by P. J. J. van Thiel, comes from Alexander Kemény, Bojnice, Czechoslovakia. A photograph of the picture is in the archive of the Gallery.

DIRCK WIJNTRACK ? Drenthe before 1625-1678 The Hague

He was mainly active at The Hague but in 1654-55 is recorded in Gouda. He painted birds, animals and some kitchen interiors. He painted the animals in the works of several artists including Joris van der Hagen, Hobbema (q.v.) and Jan Wijnants (q.v.).

29 Rabbits at the mouth of a burrow (Fig. 188).

Oil on panel, 49 × 38.8 cms. (19¼ × 15¼ ins.).

CONDITION: the rabbits are in good condition, but the landscape is much rubbed. Cleaned in 1985.

PROVENANCE: Thomas Howard sale, Christie's, 10 May 1873, lot 65, bt. Waters; C. Waters, London, from whom purchased, 1874, for £28.

LITERATURE: Duret 1882, p. 182; Armstrong 1890, p. 287; van der Haagen 1932, no. 399S, p. 135; Thieme, Becker 1907-50, vol. 36, p. 334.

No. 29 was sold in 1873 as Wijntrack although purchased as Paulus Potter by the Gallery and so catalogued until 1898 when Armstrong gave it to Wijntrack. It had earlier been referred to as 'a charming little picture representing rabbits that the catalogue does not know to whom it should be attributed, but which could be Paul Potter';[1] and it was called Potter by Armstrong in 1890.[2] In the earlier catalogues the background landscape was attributed to Jacob van Ruisdael and later given to Joris van der Hagen, who did paint the landscapes in a number of Wijntrack's pictures. No. 29 was once identified in the Gallery with a picture of *A rabbit warren* by Paulus Potter that had been described by Smith;[3] but that picture included two donkeys and a family of goats and could not conceivably have been no. 29.

The group of rabbits in no. 29 is repeated exactly in the foreground of a large composition of the interior of a barn by Wijntrack which is signed and dated 1650;[4] (Figs. 219 and 220); and similar pictures with three rabbits in a landscape by Wijntrack are known.[5] These have variously been attributed to Paulus Potter and Karel Dujardin.

In view of the comparison cited above a date of about 1650 may be suggested for no. 29.

1. Duret 1882, p. 182.
2. Armstrong 1890, p. 287.
3. Smith 1829-42, Part 5, no. 65, p. 145.
4. With the dealer Dorus Hermsen, The Hague, 1923 and thereafter in the Gemeentemuseum, The Hague, but now sold. A photograph of the

painting is in the archive of the Gallery.
5. For example the picture formerly in the Cook Collection, Richmond (cat. 1932, no. 391); and the painting sold Lempertz, Cologne, 14 June 1941, lot 25a.

JACOB XAVERY The Hague 1736-after 1774?

He was the son of the sculptor, Jan Baptist Xavery and was born in The Hague in 1736. He was a pupil of Jacob de Wit and also of Jan van Huysum. He worked in Amsterdam where he was patronised by Gerrit Braamkamp (who owned a number of his pictures) and on the death of the latter in 1769, Xavery moved to Paris. He exhibited two landscapes at the Society of Artists in London in 1772 implying that he may also have lived in London. He painted portraits, landscapes and flower-pieces.

Ascribed to JACOB XAVERY

50 A garland of flowers hanging from a bough (Fig. 189).

Oil on canvas, 68.5 × 56.4 cms. (27 × 22¼ ins.).

CONDITION: paint surface in very good condition. The original edges of the canvas have been slightly trimmed. Cleaned in 1983.

PROVENANCE: Christie's, 1864, where purchased for 77 guineas.[1]

LITERATURE: Hofstede de Groot 1907-28, vol. 10, no. 147, p. 368; Hofstede de Groot 1925, p. 208; Grant 1954, no. 108, p. 25.

For the identification of the flowers[2] see Fig. 190. It will be noticed that it would be impossible, certainly in the eighteenth century, to assemble such a garland as the flowers shown do not all bloom at the same time of year. In this the artist follows the practice of other flower painters, notably Jan van Huysum, of painting such pictures over a prolonged period.

No. 50 was sold in 1864 as Jan van Huysum and has always been so catalogued at the Gallery. The attribution was accepted by Hofstede de Groot[3] and Grant.[4] In style, however, the painting is quite unlike the work of van Huysum. Segal,[5] on the basis of a photograph, has suggested an attribution to Jacob Xavery and offered as a comparison a signed and dated painting of 1759 by Xavery which was formerly in Cologne.[6] A

painting by him in the Wallraf-Richartz Museum, Cologne[7] of 1771 demonstrates, according to Segal, together with other later pictures, a broader brushstroke than is evident in no. 50. Segal has also pointed out that several Xavery signatures have been changed into van Huysum including the painting at Dulwich,[8] which in fact shows some similarities with no. 50.

Segal has suggested a date of about 1760 for no. 50, based on a comparison with the ex-Cologne painting referred to above.

1. No. 50 is first mentioned in the records of the Gallery when it was said in the Director's Annual Report for 1864 to have been purchased at Christie's for 77 guineas (as van Huysum), and that it was from the collection of W. Ellice *(sic)*. It was first catalogued in 1867 as van Huysum 'from the collection of Wynne *(sic)* Ellice'. It has always subsequently been said to have come from the Wynn Ellis collection but there is no obvious mention of the painting in any Wynn Ellis sale. There was an Edward Ellice sale at Christie's on 17-18 June 1864; but no. 50 is not identifiable in that sale.

2. For the identification of the flowers the compiler is indebted to Sam Segal.
3. Hofstede de Groot 1907-28, vol. 10, no. 147, p. 368 and Hofstede de Groot 1925, p. 208.
4. Grant 1954, no. 108, p. 25.
5. Sam Segal in a letter dated 19 November 1985 now in the archive of the Gallery.
6. Sold Kunsthaus am Museum, Cologne, sale no. 61, October 1974, lot 1647.
7. Inv. no. 2915.
8. Dulwich College Picture Gallery, inv. no. 139.

Numerical Index

Index of pictures by numerical order of catalogue number

1048	J. G. Cuyp	*Portrait of a lady*
1062	van den Tempel	*Portrait of a lady*
1087	After ter Borch	*Interior with a lady washing her hands*
1175	Foll. E. van de Velde	*St. John preaching in the wilderness*
1225	Style of van Brekelenkam	*The pancake maker*
1285	Claesz	*A breakfast-piece*
1315	de Wet the Elder	*Abraham and Melchizedek*
1379	van Honthorst	*A feasting scene (interior of a brothel)*
1386	After Wouwerman	*The collision*
1394	Ascr. J. B. Weenix	*The holy women at the tomb*
1529	Droochsloot	*A village festival*
1657	Style of Berchem	*A market scene*
1673	Bakhuizen	*A shipwreck*
1674	Style of de Meyer	*Shipping in inland waters*
1681	ten Compe	*Village with a windmill*
1699	After Wouwerman	*Horses watering: a landscape*
1702	Style of Wouwerman	*Horses and figures at a sutler's tent*
1706	de Meyer	*A seacoast with figures*
1712	Style of Wouwerman	*Huntsmen with horses*
1742	Studio of W. van de Velde the Younger	*The Royal visit to the Fleet in the Thames Estuary, 6 June 1672*
1755	Style of Wouwerman	*Halt with caravans*
1888	After A. van de Velde	*Scene on the ice*
1890	Style of van Everdingen	*Landscape with a mountain torrent*
1939	After Berchem	*A landscape with ford*
1944	Carree	*Portrait of a lady*
1949	Brakenburg	*Interior with figures*
1964	After W. van de Velde the Younger	*Calm: an English sixth-rate ship firing a salute*
1972	Style of D. Maes	*A coach party with a classical building*
1992	Style of A. van der Neer	*A town on fire*
1996	After Metsu	*A cavalier and lady*
4292CB	Both	*An Italianate landscape*
4307	Imit. of Rembrandt, 18th C.	*Portrait of a man*

CHANGES OF ATTRIBUTION

Since the National Gallery of Ireland, *Illustrated Summary Catalogue of Paintings* (1981)

(An asterisk indicates that a painting which was previously catalogued as Dutch, is not included in this catalogue)

PREVIOUS ATTRIBUTION	CAT. NO.	REVISED ATTRIBUTION
van Balen	1706	H. de Meyer
Berchem	1939	After Berchem
Berchem	1657	Style of Berchem
Bol	1394	Ascr. to Jan Baptist Weenix
ter Borch	270	Ascr. to Wallerand Vaillant
S. de Bray	180	Jan de Braij
van Brekelenkam	1225	Style of van Brekelenkam
*Brouwer	356	David Teniers the Younger

No. 356 is a version of a painting formerly ascribed to Brouwer in the Philadelphia Museum of Art (cat. no. 682) now called Teniers the Younger, repr. Valentiner 1913, vol. 2, p. 170.

Attrib. van Bylert	639	Ascr. to J. A. Rotius
A. Cuyp	49	Ascr. to A. Cuyp
J. G. Cuyp	151	Ascr. to J. G. Cuyp
J. G. Cuyp	346	Ascr. to P. Verelst
Jacob Delff	332	Ascr. to Jan Jansz. Westerbaen the Elder (c.1600-1686)

No. 332 is not catalogued in the main text as the compiler accepted the traditional attribution to Jacob Delff the Elder; but Ekkart (in a communication, June 1986) has suggested an attribution to Westerbaen and offered as a comparison the *Portrait of Arnoldus Geesteranus* by Westerbaen in the Mauritshuis (inv. no. 210. Repr. *The Hague, Mauritshuis, cat. 1977*, p. 257). Ekkart is of the view that no. 332 is certainly not sixteenth century (as the compiler believed) but possibly about 1630, although the clothing is old fashioned. No. 332 was presented to the Gallery by Antonio Brady of London in 1864 as the work of Cornelius Jonson and so catalogued until 1898 when Armstrong gave it to Delff and referred to the fact that it had once been given to Willem van Vliet. No. 332 is said in earlier catalogues to have come from the collection of the Bishop of Ely. There were two paintings in the Bishop of Ely sale, Christie's, 14 April 1864 which could reasonably have been no. 332: lot 202, Janssens, *Portrait of Frederick, King of Bohemia, in a black dress and ruff* and lot 262, Mierevelt, *Portrait of a gentleman, in a black dress and ruff.*

*Dutch School, 17 C.	291	After Cornelius Jonson

No. 291 is a version of a *Portrait of William III* shown three-quarter length in the National Portrait Gallery, London where it is catalogued as After C. Jonson, repr. *London, NPG, cat. 1981*, p. 613.

*Dutch School, 17 C.	877	After J. B. Monnoyer

No. 877 is a copy after a painting by J. B. Monnoyer formerly with Cailleux, Paris. Repr. Pavière 1966, cat. no. 91, pl. 57.

*Dutch School, 17 C.	1063	Not catalogued. Of very inferior quality and possibly English.
Dutch School, 17 C.	1087	After ter Borch
*Dutch School, 17 C.	1639	Not a Dutch picture, possibly German

*Dutch School, 17 C.	1694	After David Teniers the Younger
		No. 1694 is a copy after a painting by David Teniers the Younger in which the artist depicts himself playing a 'cello in a musical company. Repr. Boon 1947, p. 59.
*Dutch School, 17 C.	1698	After Daniel Mytens
		No. 1698 is a copy after a *Portrait of Lady Mary Fielding* by Daniel Mytens in a Scottish private collection.
Dutch School 18 C.	1972	Style of Dirck Maes
*Dutch School 18 C.	1971	Not catalogued. Of very inferior quality.
Duyster	333	Ascr. to Isack Elyas
van den Eeckhout	107	W. Drost
*Graat	1715	Not catalogued.
		Of very inferior quality and not necessarily Dutch.
*Haansbergen	341	No. 341 is a version of a painting in the Herzog Anton-Ulrich Museum, Braunschweig (cat. no. 513) in which similar figures are shown in a different landscape setting. The Braunschweig picture was ascribed to the Hovingham Master by Blunt, *Burlington Magazine*, vol. 103 (1961), p. 459.
van der Hagen	515	Jan Lagoor and Adriaen van de Velde
F. Hals	193	Ascr. to F. Hals
*Attrib. Hanneman	438	Probably English
I. van Hasselt	897	J. G. van Hasselt
van der Helst	55	Studio of van der Helst
de Hondecoeter	35	Jan Weenix
*Hondt	512	Follower of David Teniers the Younger
Attrib. van Honthorst	1379	van Honthorst
van Huysum	50	Ascr. to Jacob Xavery
After S. Koninck	329	Style of S. Koninck
*Lundens	1033	Not catalogued. Of inferior quality.
*Attrib. N. Maes	362	Not catalogued.
		Possibly English.
Molenaer	1529	Droochsloot
Attrib. Moreelse	640	After van Miereveld
de Moucheron	337	Style of de Moucheron
Moeyaert	1175	Follower of E. van de Velde
School of van der Neer	1992	Style of van der Neer
*Neranne	1678	Not catalogued.
		Of very inferior quality and not necessarily Dutch.
*van Os	716	Ascr. to Edward Ladell
van Os	1674	Style of H. de Meyer
Palamedesz.	36	Dutch School, 1641
Peeters	743	Ascr. to L. Verschuier
Potter	56	Imitator of Potter
Rembrandt	48	Imitator of Rembrandt, 19 C.
Rembrandt	319	Flinck
Rembrandt	808	Studio of Rembrandt
*Follower of Rembrandt	1677	Not catalogued.
		Of very inferior quality and not necessarily Dutch.
J. van Ruisdael	916	After J. van Ruisdael
*Slingeland	268	Not a Dutch picture; possibly German.
Steen	227	Follower of Steen
van Strij	344	After A. Cuyp
*Swanevelt	741	Peter Patel the Elder
		Information from Malcolm Waddingham in a letter dated 17 March 1984 now in the archive of the Gallery.

*van de Velde the Elder and Younger	**1741**	Isaac Sailmaker
Studio of van de Velde the Elder	**58**	After van de Velde the Younger
After van de Velde the Elder	**1742**	Studio of van de Velde the Younger
After W. van de Velde the Elder	**1888**	After A. van de Velde
Vliet	**530**	After Houckgeest
J. Weenix	**533**	Style of J. Weenix
J. B. Weenix	**488**	J. Weenix
de Witte	**450**	After de Witte
Wouwerman	**1699**	After Wouwerman
Wouwerman	**1702**	Style of Wouwerman
Wouwerman	**1712**	Style of Wouwerman
Wouwerman	**1755**	Style of Wouwerman
Style of Wouwerman	**1386**	After Wouwerman
*J. Wyck	**145**	To be catalogued with the British School
*J. Wyck	**748**	To be catalogued with the British School
*J. Wyck	**749**	To be catalogued with the British School
*J. Wyck	**988**	To be catalogued with the British School
T. Wyck	**894**	J. P. Wijck
*T. Wyck	**1652**	Not catalogued. Of very inferior quality although possibly Dutch in origin.

THE FORMATION OF THE COLLECTION

Chronological sequence of acquisitions

(Entries in italic were acquired through gift or bequest)

1854	*F. Bol, no. 47*
1855	*Style of van Everdingen, no. 1890*
	Style of S. Koninck, no. 329
1863	F. de Moucheron, no. 52
	C. Bega, no. 28
	J. D. de Heem, no. 11
	After G. Metsu, no. 1996
	Style of F. de Moucheron, no. 337
	After A. van de Velde, no. 1888
	After P. Wouwerman, no. 1386
1864	D. van Bergen, no. 59
	J. Griffier, no. 336
	Studio of van der Helst, no. 55
	W. Knijff, no. 53
	P. de Molijn, no. 8
	E. van der Poel, no. 22
	Ascr. J. Xavery, no. 50
1866	B. van der Helst, no. 65
1867	G. Flinck, no. 64
	J. Weenix, no. 35
1868	Imit. of P. Potter, no. 56
1871	Imit. of Rembrandt, no. 48
1872	Studio of A. Cuyp, no. 49
	Dutch School, 1641, no. 36
	M. van Miereveld, no. 39
1873	L. de Jongh, no. 44
	J. M. Molenaer, no. 45
	J. Mytens, no. 62
	A. van Ostade, no. 32
	J. M. Quinkhard, no. 238
	J. I. van Ruisdael, no. 37
	S. van Ruysdael, no. 27
1874	After W. van de Velde, no. 58
	D. Wijntrack, no. 29
1875	J. S. de Braij, no. 180
	J. van Goyen, no. 236
	D. Maes, no. 147
	Foll. J. Steen, no. 227
1878	*A. Storck, no. 228*
1879	After Berchem, no. 1939
	J. Steen, no. 226
	Studio of W. van de Velde, no. 1742
1880	J. Both, no. 179
1881	F. Hals, no. 193
1882	J. F. Soolmaker, no. 225
1883	L. Bakhuizen, no. 173
	Rembrandt, no. 215
1884	C. P. Berchem, no. 176

1885	C. P. Berchem, no. 510
	G. C. Bleker, no. 246
	J. C. Droochsloot, no. 252
	G. van den Eeckhout, no. 253
	Monogrammist I.S., no. 247
	P. Moreelse, no. 263
	J. Wijnants, no. 280
1886	C. P. Berchem, no. 245
	G. Flinck, no. 254
	A. van der Neer, no. 66
	E. van der Neer, no. 61
	P. van Slingeland, no. 267
	H. Sorgh, no. 269
	Ascr. W. Vaillant, no. 270
1887	D. van Bergen, no. 274
	J. van Ruisdael and T. de Keyser, no. 287
	Studio of W. van de Velde, no. 276
	P. Wouwerman, no. 170
1888	J. van de Cappelle, no. 74
	E. van der Poel, no. 9
1889	A. van Anthonissen, no. 152
	Ascr. J. G. Cuyp, no. 151
	D. van Delen and D. Hals, no. 119
	W. Drost, no. 107
	L. de Jongh, no. 148
	J. Mytens, no. 150
	A. de Pape, no. 149
	D. Stoop, no. 285
	A. Vermeulen, no. 432
1890	G. Flinck, no. 319
1891	J. Duck, no. 335
1892	P. Codde, no. 321
	A. J. van der Croos, no. 328
	C. Dusart, no. 324
	Ascr. I. Elyas, no. 333
	P. de Hooch, no. 322
1893	P. Claesz, no. 326
	B. Gael, no. 325
	N. de Gyselaer, no. 327
	W. de Poorter, no. 380
	P. S. Potter, no. 323
	W. Romeyn, no. 345
1894	P. J. van Asch, no. 343
	After A. Cuyp, no. 344
	J. Lingelbach, no. 348
	N. Maes, no. 347
	M. Stomer, no. 425

	P. Verelst, no. 346	1911	*D. Valkenburg, no. 625*
	T. Wijck, no. 349	1912	*After M. van Miereveld, no. 640*
1895	W. Duyster, no. 436		*J. Ochtervelt, no. 641*
	I. de Jouderville, no. 433		J. van Rossum, no. 623
	J. Ochtervelt, no. 435		*Ascr. J. A. Rotius, no. 639*
1896	H. G. Pot, no. 443	1913	*J. P. Horstok, no. 650*
	P. S. Potter, no. 445	1914	*J. A. Beerstraaten, no. 679*
	School of Rembrandt, no. 439		K. Molenaer, no. 682
	C. Saftleven, no. 449		*J. H. Prins, no. 681*
	F. Swagers, no. 448	1918	*F. Bol, no. 810*
	After E. de Witte, no. 450		*J. van Goyen, no. 807*
1897	T. de Keyser, no. 469		*G. Kamper, no. 806*
	J. Leyster, no. 468		*Studio of Rembrandt, no. 808*
1898	*N. Maes, no. 204*		*E. de Witte, no. 805*
	G. Schalcken, no. 476	1921	M. Hobbema, no. 832
1899	J. Weenix, no. 488	1921	S. Kick, no. 834
1900	*H. Avercamp, no. 496*	1923	G. ter Borch, no. 849
1901	*N. Berchem, no. 510*		G. Pompe, no. 850
	W. C. Heda, no. 514		F. Post, no. 847
	M. de Hondecoeter, no. 509	1926	J. Victors, no. 879
	After G. Houckgeest, no. 530	1927	J. G. van Hasselt, no. 897
	J. Lagoor, no. 515		P. Lastman, no. 890
	A. de Lorme, no. 516		J. P. van Wijck, no. 894
	A. Palamedesz., no. 531	1928	C. J. van der Heck, no. 904
	S. van Ruysdael, no. 507	1929	After J. I. van Ruisdael, no. 916
	J. B. Weenix, no. 511	1930	J. van Kessel, no. 933
	D. van Wijnen (called Ascanius), no. 527	1931	*J. Weenix, no. 947*
	J. Wijnants, no. 508	1933	*C. J. Dusart, no. 961*
1902	*L. Bakhuizen, no. 1673*	1934	*R. van Vries, no. 972*
	Style of N. Berchem, no. 1657	1939	*W. van Aelst, no. 1015*
	J. Both, no. 706	1940	*After ter Borch, no. 1087*
	B. Breenbergh, no. 700		J. G. Cuyp, no. 1047
	J. ten Compe, no. 1681		J. G. Cuyp, no. 1048
	H. de Meyer, no. no. 1706		*N. van Helt-Stockade, no. 1046*
	Style of H. de Meyer, no. 1674		*Style of D. Maes, no. 1972*
	Ascr. L. Verschuier, no. 743		*A. van den Tempel, no. 1062*
	Style of J. Weenix, no. 533		*After W. van de Velde, no. 1964*
	Style of P. Wouwerman, no. 1702	1948	*Foll. W. van de Velde, no. 1175*
	Style of P. Wouwerman, no. 1712	1951	Style of Q. van Brekelenkam, no. 1225
	Style of P. Wouwerman, no. 1755	1953	*P. Claesz, no. 1285*
	After P. Wouwerman, no. 1699	1954	*J. C. Droochsloot, no. 1529*
1903	K. Dujardin, no. 544	1955	J. de Wet the Elder, no. 1315
	W. Duyster, no. 556	1958	G. van Honthorst, no. 1379
	A. de Lorme, no. 558	1959	Ascr. J. B. Weenix, no. 1394
1905	*Ascr. A. van Ravesteyn, no. 571*	1969	*H. Carree, no. 1944*
1907	*P. Wouwerman, no. 582*	1978	*J. Both, no. 4292 CB*
1909	C. Troost, no. 497		*Imit. Rembrandt, no. 4307*
1910	*J. Lievens, no. 607*		

INDEX OF PREVIOUS OWNERS

(A name in capital letters indicates the donor of a gift or bequest)

Buttery, Ayerst H.
 Palamedesz., no. 531
 van Rossum, no. 623
 Victors, no. 879
Buttery, Horace
 van Kessel, no. 933
 de Keyser, no. 469
 School of Rembrandt, no. 439

de Cahen (or Cornelissen), Comte
 de Hondecoeter, no. 509
van Camp
 Soolmaker, no. 225
Campbell, Mr.
 After J. I. van Ruisdael, no. 916
Campbell, Harriet
 After J. I. van Ruisdael, no. 916
Campbell, Sir Hugh Hume
 Wijnants, no. 508
Carrée
 N. Maes, no. 347
Charles II
 Studio of W. van de Velde the Younger,
 no. 1742
CHESTER BEATTY, SIR ALFRED
 see Beatty, Sir Alfred Chester
Cholmondeley, G. J.
 Steen, no. 226
Cholmondeley, Reginald
 Lingelbach, no. 348
Cholmondeley, Rev. R. H.
 Lingelbach, no. 348
van Citters, J.
 Troost, no. 497
Clinton-Hope, Lord Francis Pelham-
 see Hope, Lord Francis Pelham-Clinton-
Clos
 Hobbema, no. 832
CLARKE, MISS A.
 Duyster, no. 556
Cliffe, A.J.
 de Hooch, no. 322
CLOUSTON, ROBERT
 Style of van Everdingen, no. 1890
Coclers, L. B.
 Dujardin, no. 544
van Coehoorn, Baron
 de Hooch, no. 322
Cogan, J. M.
 J. G. Cuyp, no. 1047
 J. G. Cuyp, no. 1048
Collings
 J. P. van Wijck, no. 894
Collins
 Moreelse, no. 263

Colnaghi, P. & D.
 Both, no. 4292 CB
 J. Leyster, no. 468
 Schalcken, no. 476
 Steen, no. 226
 de Wet the Elder, no. 1315
Constable Maxwell, The Hon. Marmaduke
 see Maxwell, The Hon. Marmaduke
 Constable
Cookes, Rev. Denham
 Ochtervelt, no. 435
Cookes, Thomas Henry
 Ochtervelt, no. 435
Coote, Sir Algernon
 Kamper, no. 806
Coote, Sir Charles
 Kamper, no. 806
Corbett-Winder, Major
 van Anthonissen, no. 152
de Cornelissen (or Cahen) Comte
 de Hondecoeter, no. 509
de la Court, Mrs. P. H.
 Troost, no. 497
de la Court-Ram
 Troost, no. 497
Cranfield, Miss
 After Berchem, no. 1939
Crowe, Miss M. O.
 Carree, no. 1944
Cruger Price, Henry
 see Price, Henry Cruger
Cunliffe, Sir Foster
 de Wet the Elder, no. 1315
Cunliffe, H. P.
 After G. Houckgeest, no. 530
Cunliffe, W. A. G.
 de Wet the Elder, no. 1315
Cussen, C. Parker
 van der Heck, no. 904
van Cuyck
 van Bergen, no. 59

DAMER, HENRY DAWSON, 3rd EARL OF PORTARLINGTON
 Storck, no. 228
Dansaert, Anthony
 Flinck, no. 319
Dawson-Damer, Henry, 3rd Earl of
 Portarlington
 see Damer, Henry Dawson, 3rd Earl of
 Portarlington
Deane, Sir Anthony
 Studio of W. van de Velde the Younger,
 no. 1742
Deane, Morgan
 Studio of W. van de Velde the Younger,
 no. 1742

Deane, William and Elizabeth (née Morgan)
 Studio of W. van de Velde the Younger,
 no. 1742
Delfos
 de Hooch, no. 322
Demidoff, Prince
 Studio of Rembrandt, no. 808
 S. van Ruysdael, no. 507
Denison, Christopher Beckett
 Berchem, no. 510
Dermer
 Steen, no. 226
Descamps, Luke
 de Heem, no. 11
Disney, Mrs. Edgar
 Berchem, no. 176
Doetsch, Henry
 Dujardin, no. 544
Donaldson, G.
 de Lorme, no. 558
DONALDSON, SIR GEORGE
 Stomer, no. 425
Double, Léopold
 van Delen, no. 119
Douglas, Robert Langton
 see Langton Douglas, Robert
Dowdeswell
 Troost, no. 497
Dumont, Alexandre
 van Hasselt, no. 897
de Dunstanville, Lord
 Imitator of Paulus Potter, no. 56
Durham, Archdeacon of
 de Moucheron, no. 52
Durlacher
 van Hasselt, no. 897
Dyer, Miss
 After W. van de Velde the Younger, no. 58
Dyer and Sons
 Pompe, no. 850

Eden
 J. P. van Wijck, no. 894
Elkins, W. L.
 Kick, no. 834
Elliotson, Miss E.
 Droochsloot, no. 252
Ellis, Wynn
 Lagoor, no. 515
Ellison
 Ascribed to Vaillant, no. 270
Ely, Bishop of
 Knijff, no. 53
Emmerson, Thomas
 van Rossum, no. 623
 J. I. van Ruisdael, no. 37

d'Eresby, Lord Willoughby
 Prins, no. 681
Essex, Earl of
 ter Borch, no. 849

Farrer
 Wijnants, no. 508
Farrer, Henry
 Aert van der Neer, no. 66
 Eglon van der Neer, no. 61
Fagel, Greffier
 Steen, no. 226
FERGUSON, LADY
 Ascribed to van Ravesteyn, no. 571
Finnegan, Mrs. E.
 Style of van Brekelenkam, no. 1225
FITZGERALD, JULIA, LADY
 P. S. Potter, no. 445
 Swagers, no. 448
Forbes and Patterson
 Dujardin, no. 544
Foucart
 van Hasselt, no. 897
Fouquet
 Both, no. 4292 CB
FRIENDS OF THE NATIONAL COLLECTIONS OF IRELAND
 van Vries, no. 972

Galton, Howard
 Drost, no. 107
 de Jongh, no. 148
 Mytens, no. 150
 de Pape, no. 149
 Ascribed to J. G. Cuyp, no. 151
Galton, Hubert
 Drost, no. 107
 de Jongh, no. 148
 Mytens, no. 150
 de Pape, no. 149
 Ascribed to J. G. Cuyp, no. 151
Gillot, Joseph
 Studio of Aelbert Cuyp, no. 49
de Gisignies, Viscomte du Bus
 see du Bus de Gisignies, Viscomte
Goldschmidt, Léopold
 After J. I. van Ruisdael, no. 916
Graves
 After J. I. van Ruisdael, no. 916
Greaves, Colonel Richard
 After W. van de Velde the Younger, no. 58
Greffier Fagel
 see Fagel, Greffier
Grenfell, Arthur
 Bol, no. 810
DE GROOT, MRS. J. I. MORGAN
 Follower of E. van de Velde, no. 1175

GUMBLETON, W. S.
 Valkenburg, no. 625
Haines Brothers
 de Hooch, no. 322
Hammersley
 Schalcken, no. 476
Hawkins, C. H. T.
 Pot, no. 443
HEUGH, JOHN
 Studio of Aelbert Cuyp, no. 49
de Heuval
 S. van Ruysdael, no. 27
HIGGINS, PIERCE
 van Helt-Stockade, no. 1046
Higginson, Edmund
 van Bergen, no. 59
Hoare collection
 van den Eeckhout, no. 253
Hoare, Henry
 Rembrandt, no. 215
Hofstede de Groot, C.
 ter Borch, no. 849
Holderness, Countess of
 Steen, no. 226
Hollond, John R.
 Bol, no. 810
Hooft, D.
 van Slingeland, no. 267
Hoogenbergh, Isaak
 Steen, no. 226
Hope, Adrian
 J. Weenix, no. 947
Hope, Lord Francis Pelham-Clinton-
 Both, no. 4292 CB
Hope, Henry Thomas
 Both, no. 4292 CB
Hope, Philip Henry
 Both, no. 4292 CB
Hope, William
 Bega, no. 28
Howard, Thomas
 Wijntrack, no. 29
Hume Campbell, Sir Hugh
 see Campbell, Sir Hugh Hume

Isaacs, R. C.
 J. B. Weenix, no. 947

Jeronz, J. de Bosch
 J. Weenix, no. 947
JOSEPH, S.S.
 C. Dusart, no. 324

KAY, ARTHUR
 van Wijnen, no. 527

King
 van Rossum, no. 623
Kinnaird, Lord
 Schalcken, no. 476
Knighton, Sir William
 Wijnants, no. 280

Labouchere, Mr. (iater Lord Taunton)
 Hobbema, no. 832
van der Land
 Both, no. 4292 CB
LANE, SIR HUGH
 Beerstraaten, no. 679
 Bol, no. 810
 van Goyen, no. 807
 Horstok, no. 650
 Kamper, no. 806
 Studio of Rembrandt, no. 808
 de Witte, no. 805
Langdale, Rev. W. J.
 Bleker, no. 246
LANGTON DOUGLAS, ROBERT
 Post, no. 847
Langton Douglas, Robert
 Hobbema, no. 832
 Kick, no. 834
Lapeyriere
 Dujardin, no. 544
Lawrie and Company
 de Jouderville, no. 433
Leatham, E. A.
 de Lorme, no. 558
LECKY, MRS.
 After van Miereveld, no. 640
 Rotius, no. 639
Leggatt Brothers
 Both, no. 4292 CB
Levy, Albert
 Schalcken, no. 476
Lewis, Charles Warner
 Imitator of Rembrandt, no. 48
van der Linden
 Imitator of Paulus Potter, no. 56
Lippmann
 van Hasselt, no. 897
Lormier, W.
 Steen, no. 226
Lovegrove, J. H.
 Prins, no. 681

McCoy, Bernard
 Lastman, no. 890
McKay, W.
 Elyas, no. 333

McLean
 Dujardin, no. 544
 Lievens, no. 607
Maitland Wilson, Arthur
 see Wilson, Arthur Maitland
Malherbe
 van Hasselt, no. 897
Martin
 van Goyen, no. 807
 Victors, no. 879
Martin, E. Bromley
 Victors, no. 879
Maud, Charles
 Studio of Rembrandt, no. 808
Maugham, Kevin
 van Honthorst, no. 1379
Maxwell, The Hon. Marmaduke Constable
 van Ostade, no. 32
Mayo, The Earl of
 Duyster, no. 436
Michaelis, Max
 Studio of Rembrandt, no. 808
Mildmay, H. Bingham
 Romeyn, no. 345
Miles, Sir Cecil
 Lievens, no. 607
MILLNER, R. S.
 P. S. Potter, no. 323
MILLTOWN, GERALDINE, COUNTESS OF
 see Milltown, Earls of
Milltown, Earls of
 Bakhuizen, no. 1673
 Style of N. Berchem, no. 1657
 Both, no. 706
 Breenbergh, no. 700
 ten Compe, no. 1681
 de Meyer, no. 1706
 Style of H. De Meyer, no. 1674
 Ascribed to Verschuier, no. 743
 After P. Wouwerman, no. 1699
 Style of P. Wouwerman, no. 1702
 Style of P. Wouwerman, no. 1712
 Style of P. Wouwerman, no. 1755
de Montcalm, Marquis
 Wijnants, no. 508
Morgan de Groot, Mrs. J. I.
 see de Groot, Mrs. J. I. Morgan
Morland
 Schalcken, no. 476
Morland, G. H.
 Imitator of Paulus Potter, no. 56
Morton, Mrs. S.
 van der Croos, no. 328
Muller
 van Hasselt, no. 897

Muller, F.
 Kick, no. 834
 After E. de Witte, no. 450
Munro, H. A. J., of Novar
 After J. I. van Ruisdael, no. 916

Nairn, Mr. J. C.
 Style of J. Weenix, no. 533
Naylor, Henry
 Ascribed to J. B. Weenix, no. 1394
Newall, W. J.
 Stoop, no. 285
Nieuhoff, Nicholas
 Both, no. 4292 CB
Nieuwenhuys, C. J.
 van Slingeland, no. 267
 Sorgh, no. 269
 Wijnants, no. 508
Nipp
 Imitator of Paulus Potter, no. 56
Norris, T.
 J. I. van Ruisdael, no. 37
North, Rt. Hon. Lord
 van Kessel, no. 933
Norton, P.
 N. Maes, no. 347
 After J. I. van Ruisdael, no. 916
Northwick, Lord
 de Lorme, no. 558
 N. Maes, no. 347
NUGENT, MRS. VINCENT
 K. Molenaer, no. 682

Orford, Earl of
 After J. I. van Ruisdael, no. 916
d'Orléans, Phillipe, Duc
 Schalcken, no. 476
Orme, Mrs. Malcolm
 van Bergen, no. 274

Patterson, W. B.
 de Lorme, no. 558
 J. P. van Wijck, no. 894
Pauw, Iman
 Lastman, no. 890
Peacock
 Imitator of Paulus Potter, no. 56
Peale Wellington, Miss Ivy
 see Wellington, Miss Ivy Peale
Pearson
 Schalcken, no. 476
Pelham-Clinton-Hope, Lord Francis
 see Hope, Lord Francis Pelham-Clinton-
Peñaranda, Conde de
 ter Borch, no. 849

Perière, Madame Isaac
 Studio of Rembrandt, no. 808
PFUNGST, H. J.
 Gael, no. 325
Pfungst, H. J.
 van Hasselt, no. 897
 Lievens, no. 607
Pickering, Charles William Harrison
 S. van Ruysdael, no. 507
POË, SIR W. HUTCHESON
 J. Weenix, no. 947
PORTARLINGTON, 3rd EARL OF
 Storck, no. 228
Pourtales, Count
 Studio of Rembrandt, no. 808
POWERSCOURT, VISCOUNT
 Quinckhard, no. 238
Price, Henry Cruger
 Saftleven, no. 449
Proileau Roupell, Robert
 see Roupell, Robert Proileau
PURSER, SARAH
 Prins, no. 681
Purvis, C.
 Studio of W. van de Velde the Younger, no.
 1742
Purvis, Thomas
 Studio of W. van de Velde the Younger, no.
 1742

Radstock, Admiral Lord
 van Rossum, no. 623
Rasponi, Comte Ferdinand
 Both, no. 179
Redcliffe
 Griffier, no. 336
REID, MISS H. M.
 van Aelst, no. 1015
Reynolds, F. W.
 Bakhuizen, no. 173
Richards, S.
 Troost, no. 497
Robinson, J. C.
 N. Maes, no. 347
Robinson, J. G.
 de Braij, no. 180
de Rochebrousseau, Marquis
 Mytens, no. 62
 S. van Ruysdael, no. 27
Roos
 Dujardin, no. 544
Ross, James
 After J. I. van Ruisdael, no. 916
Roupell, Robert Proileau
 Wouwerman, no. 170

Le Roy, Etienne
 J. B. Weenix, no. 511

van Sacegham
 Wouwerman, no. 582
Salmon, G. P.
 Vermeulen, no. 432
Sanders, Joseph
 Flinck, no. 254
Schamp d'Aveschoot
 de Heem, no. 11
Secretan
 van Delen, no. 119
Sedelmeyer
 Claesz, no. 326
 After J. I. van Ruisdael, no. 916
 J. Weenix, no. 488
Seymour, H. D.
 Imitator of Paulus Potter, no. 56
Sharp, S.
 van Wijnen, no. 527
SHERLOCK, PATRICK
 After ter Borch, no. 1087
 Style of D. Maes, no. 1972
 van den Tempel, no. 1062
 After W. van de Velde the Younger, no.
 1964
van Slingeland
 van Slingeland, no. 267
Sloane Stanley, Mrs.
 see Stanley, Mrs. Sloane
Smith
 Bega, no. 28
Smith, Augustus
 Ascribed to J. B. Weenix, no. 1394
Smith, G.
 Codde, no. 321
Smith, S. T.
 de Gyselaer, no. 327
SMITH, DR. TRAVERS
 C. J. Dusart, no. 961
Smits, W.
 N. Maes, no. 347
Stane, John Branston
 van der Poel, no. 9
Stanley, Capt. E. A. V.
 Hobbema, no. 832
Stanley, Mrs. Sloane
 van de Cappelle, no. 74
Stephenson
 Schalcken, no. 476
Stinstra, S. J.
 Follower of Steen, no. 227
Strutt, Joseph
 Drost, no. 107

de Jongh, no. 148
Mytens, no. 150
de Pape, no. 149
Ascribed to J. G. Cuyp, no. 151

Taunton, Lord
 Hobbema, no. 832
Thesiger
 de Wet the Elder, no. 1315
Thoré Burger
 N. Maes, no. 347
Thorp, the Ven. Charles
 de Moucheron, no. 52
Tonneman, Jeronimus
 Troost, no. 497
Terrot, Rev. C. P.
 Ascribed to Vaillant, no. 270
Turton, Thomas, Bishop of Ely
 Knijff, no 53
Twent, H.
 de Hooch, no. 322

Villiers
 Hobbema, no. 832
VINCENT, SIR EDGAR
 Lievens, no. 607
 Wouwerman, no. 582
Vinne
 Imitator of Paulus Potter, no. 56
de Vries, Jan
 Dujardin, no. 544

Walker
 van Rossum, no 632
Ward
 Troost, no. 497
WARD, T. HUMPHREY
 Avercamp, no. 496
Waters, C.
 Wijntrack, no. 29

Watkins, B., Esq.,
 Style of Koninck, no. 329
WELLINGTON, MISS IVY PEALE
 Imitator of Rembrandt, 18th century,
 no. 4307
White, Mrs
 J. G. Cuyp, no. 1047
 J. G. Cuyp, no. 1048
Whitehead, T. M.
 Imitator of Paulus Potter, no. 56
Wilson, Arthur Maitland
 van Goyen, no. 807
Wilson, John W.
 Ascribed to F. Hals, no. 193
Wine, Louis
 van Vries, no. 972
Winder, Major Corbett
 see Corbett-Winder, Major
Wise, James
 Studio of W. van de Velde the Younger,
 no. 276
Witsen, J.
 Wijnants, no. 508
Woodburn, Samuel
 Hobbema, no. 832
Woodin
 Studio of W. van de Velde the Younger,
 no. 1742
Wubbens
 Both 4292 CB
Wyatt, H. E.
 J. M. Molenaer, no. 45

Yver
 Wijnants, no. 508

Zachary, M.
 van Bergen, no. 59
de Zoete, S. Herman
 van den Eeckhout, no. 253

Related Works

Index of the location of related paintings in public collections

BRAUNSCHWEIG
Herzog Anton-Ulrich Museum
Brakenburg, no. 1949
Monogrammist I. S., no. 247
van der Neer, no. 61

BRUSSELS
Musée Royaux des Beaux-Arts de Belgique
Bega, no. 28
Mytens, no. 150
de Wet, no. 1315

BUDAPEST
Szépmüvészeti Múzeum
ascribed to Elyas, no. 333
Lagoor, no. 515
Maes, no. 347
van Ruisdael and de Keyser, no. 287
Victors, no. 879
van Vries, no. 972
Weenix, no. 35
de Wet, no. 1315

CAMBRIDGE
Fitzwilliam Museum
de Gyselaer, no. 327
van de Velde, no. 1742

CAPETOWN
National Gallery of South Africa
van de Velde, no. 58

CASSEL
Gemäldegalerie
Drost, no. 107

CHANTILLY
Musée Condé
after van Miereveld, no. 640

CINCINNATI
Art Museum
Maes, no. 347
Drost, no. 107

COLOGNE
Wallraf-Richartz Museum
ascr. to Xavery, no. 50

COPENHAGEN
Royal Museum of Fine Arts
Kick, no. 834
Stoop, no. 285

DELFT
Stadhuis
after van Miereveld, no. 640

DESSAU
Amalienstift
de Molijn, no. 8

DETROIT
Institute of Art
Post, no. 847

DORDRECHT
Dordrechts Museum
Cuyp, J. G., no. 1048

DRESDEN
Gemäldegalerie
after ter Borch, no. 1087
Drost, no. 107
van den Eeckhout, no. 253
Flinck, no. 63
van der Neer, no. 61
de Poorter, no. 380
after A. van de Velde, no. 1888
after Wouwerman, no. 1386

DULWICH
Dulwich College Picture Gallery
ascr. to Xavery, no. 50

DÜSSELDORF
Kunstmuseum
Kamper, no. 806

EDINBURGH
National Gallery of Scotland
Steen, no. 226

EMDEN
Verzameling Stiftung Henri Nannen
Bakhuizen, no. 1673

ENSCHEDE
Rijksmuseum Twenthe
after A. Cuyp, no. 344
van Ravesteyn, no. 571

FLORENCE
Uffizi
van Honthorst, no. 1379
van Kessel, no. 933
Stomer, no. 425

FRANKFURT-AM-MAIN
Städelsches Kunstinstitut
Bega, no. 28
Ochtervelt, no. 435
de Poorter, no. 380
Wouwerman, no. 170

GLASGOW
Art Gallery and Museum
van Asch, no. 343
Ochtervelt, no. 435

Hunterian Museum
Bol, no. 47

GRENOBLE
Musée des Beaux-Arts
van den Tempel, no. 1062
van de Velde, no. 1742

GRONINGEN
Museum voor Stad en Lande
Duck, no. 335

HAARLEM
Frans Halsmuseum
Bleker no. 246
style of van Brekelenkam, no. 1225
van Delen and D. Hals, no. 119

THE HAGUE
Gemeentemuseum
after van Miereveld, no. 640
Wijntrack, no. 29

Mauritshuis
Avercamp, no. 496
Berchem, no. 245
style of Berchem, no. 1657
van de Cappelle, no. 74
Droochsloot, no. 252
Dusart, C., no. 324
Duyster, no. 436
Duyster, no. 556
de Heem, no. 11
after Houckgeest, no. 530
Maes, no. 204
Molenaer, no. 45
de Molijn, no. 8
van der Neer, no. 61
Potter, no. 56
school of Rembrandt, no. 439
van den Tempel, no. 1062
ascr. to Verschuier, no. 743
Weenix, no. 511

Museum Bredius
ascr. to Elyas, no. 333
van Rossum, no. 623
ascr. to Rotius, no. 639
Steen, no. 226

Museum Meermanno Westreenianum
J. P. van Wijck, no. 894

Oranje-Nassau Museum
de Molijn, no. 8

HAMBURG
Kunsthalle
van Goyen, no. 807
style of de Meyer, no. 1674
de Witte, no. 805
after de Witte, no. 450

HANNOVER
Landesmuseum
Romeyn, no. 345

INNSBRUCK
Landesmuseum Ferdinandeum
Duck, no. 335

LEIDEN
De Lakenhal
Anthonissen, no. 152
style of van Brekelenkam, no. 1225

LEIDEN
University Library
after van Miereveld, no. 640

LEIPZIG
Museum der Bildenden Künste
Romeyn, no. 345
Valkenburg, no. 625

LENINGRAD
The Hermitage
Berchem, no. 510
Bol, no. 47
Both, no. 4292 CB
studio of A. Cuyp, no. 49
van der Poel, no. 9
van Rossum, no. 623
van den Tempel, no. 1062
Victors, no. 879

LILLE
Musée de la Ville
after de Witte, no. 450

LIVERPOOL
Walker Art Gallery
Bol, no. 47
de Hondecoeter, no. 509

LONDON
The National Gallery
ter Borch, no. 849
Drost, no. 107
van Honthorst, no. 1379
de Hooch, no. 322
Lingelbach, no. 348
Molenaer, no. 45
Ochtervelt, no. 435
de Pape, no. 149
van der Poel, no. 22
Rembrandt, no. 215
de Wet, no. 1315

The Tate Gallery
after van Ruisdael, no. 916

Wallace Collection
Steen, no. 226

LOUISVILLE
J. B. Speed Art Museum
de Hondecoeter, no. 509

LUGANO
Thyssen-Bornemiza Collection
van de Cappelle, no. 74

LUXEMBOURG
Museum Pescatore
after A. Cuyp, no. 344

MADRID
The Prado
van der Neer, no. 61

MAINZ
Mittelrheinisches Landesmuseum
T. Wijck, no. 349

MALIBU
The J. Paul Getty Museum
Victors, no. 879

MÄNTTÄ
Gösta Serlachuis Museum
de Wet, no. 1315

MILAN
Brera
van Honthorst, no. 1379

MOSCOW
Pushkin-Museum
Victors

MUNICH
Alte Pinakothek
Drost, no. 107
Duck, no. 335
van den Eeckhout, no. 253
Flinck, no. 254
van Honthorst, no. 1379
Rembrandt, no. 215
van Ostade, no. 32
Weenix, no. 511

Graphische Saamlung
Flinck, no. 64

Bayerische Staatsgemäldesammlungen
Stomer, no. 425

NAPLES
Palazzo Reale
van den Tempel, no. 1062

NEW YORK
Brooklyn Museum
ascr. to F. Hals, no. 193

Frick Collection
Mytens, no. 150

Metropolitan Museum of Arts
van Slingeland, no. 267
Stomer, no. 425

New York Historical Society
de Wet, no. 1315

OMAHA
Joslyn Art Museum
van der Neer, no. 61

ORLEANS
Musée des Beaux-Arts
Romeyn, no. 345

OTTAWA
National Gallery of Canada
Stomer, no. 425

PARIS
Institut Néerlandais
van de Cappelle, no. 74
studio of W. van de Velde the Younger,
no. 1742

The Louvre
after Berchem, no. 1939
van Bergen, no. 59

Duck, no. 335
van Goyen, no. 807
van Kessel, no. 933
Lingelbach, no. 348
after Metsu, no. 1996
van Rossum, no. 623
Rembrandt, no. 215
van den Tempel, no. 1062
Victors, no. 879

Musée Jacquemart-André
school of Rembrandt, no. 439

PASADENA
Norton Simon Museum
van Ruysdael, no. 507

PHILADELPHIA
Philadelphia Museum of Art
Valkenburg, no. 625

PLYMOUTH
The Saltram Collection National Trust
de Hooch, no. 322

POTSDAM
Sanssouci
de Poorter, no. 380

PRAGUE
The National Gallery
Maes, no. 347
van Vries, no. 972

RALEIGH
North Carolina Museum of Art
de Poorter, no. 380
Victors, no. 879

ROME
Borghese Gallery
van Honthorst, no. 1379

Galleria Spada
Stomer, no. 425

ROTTERDAM
Museum Boymans-van-Beuningen
Avercamp, no. 496
ter Borch, no. 849
style of van Brekelenkam, no. 1225
studio of A. Cuyp, no. 49
ascr. to Elyas, no. 333
de Lorme, no. 558
de Lorme, no. 516

Troost, no. 497
studio of W. van de Velde the Younger,
no. 1742
ascr. to Weenix, no. 1394

SALZBURG
Residenz Gallery
Both, no. 4292 CB
after de Witte, no. 450

SAN FRANCISCO
Palace of the Legion of Honor
van Delen and D. Hals, no. 119

SCHWERIN
Staatliches Museum
van Aelst, no. 1015
Bol, no. 47

SEVILLE
Museo Provincial
ter Borch, no. 849

STOCKHOLM
Nationalmuseum
Bega, no. 28
de Hondecoeter, no. 509

TOLEDO
Museum of Art
Stomer, no. 425

TORONTO
Art Gallery of Toronto
Stomer, no. 425

TOURS
Musée des Beaux-Arts
Rembrandt, no. 215

TURIN
Galleria Sabauda
Ochtervelt, no. 435

UTRECHT
Centraal Museum
van Honthorst, no. 1379
van Rossum, no. 623

VERSAILLES
Mytens, no. 62

VIENNA
Akademie der Bildenden Künste
van Delen and D. Hals, no. 119
Potter, no. 445

Albertina
Lastman, no. 890
studio of Cuyp, no. 49

Kunsthistorisches Museum
Steen, no. 226
follower of E. van de Velde, no. 1175

WARSAW
National Museum
Lastman, no. 890
Victors, no. 879
ascr. to Weenix, no. 1394

University Library; Potocki Collection
Flinck, no. 254

WIESBADEN
Wiesbaden Museum
after W. van de Velde the Younger,
no. 1964

ZIERIKZEE
Burgerweeshuis
van Anthonissen, no. 152

ZWOLLE
Overijssels Museum
ascr. to Vaillant, no. 270

BIBLIOGRAPHY

In the early years of the National Gallery of Ireland, 1864-1890, catalogues of the Collection were published on a regular basis, most of them reprints of previous catalogues updated by the addition of recent acquisitions. When Sir Walter Armstrong became Director in 1892 he set about a complete revision of the Catalogue and his first Catalogue, published in 1898, contained a great number of revised attributions, particularly with regard to the Dutch School, of which Armstrong was both a connoisseur and a scholar. This 1898 Catalogue is referred to frequently throughout this Catalogue, generally as 'Armstrong in 1898'. Armstrong published, in 1904, 1908 and 1914, further revised catalogues. Since his time, however, only three descriptive catalogues of the collection in the National Gallery of Ireland have been published, in 1920, 1928 and 1932; and all of these contained only a selection of the Gallery's pictures. A check-list of paintings was published in 1971, and in 1981 a complete concise catalogue was published in which the entire collection was illustrated. In the text of the present Catalogue references to previous Gallery catalogues are not cited specifically in the footnotes.

Ananoff 1976
A. Ananoff, *François Boucher*. 2 vols. (Lausanne and Paris 1976).

Andrews 1977
K. Andrews, *Adam Elsheimer, Paintings-Drawings-Prints*. (Oxford 1977).

Antwerp, cat. 1958
Musée Royal des Beaux-Arts, Antwerp, *Catalogue descriptif: maitres Anciens*. (1958).

Amsterdam 1976
Exh. cat., *tot Lering en Vermaak*. Rijksmuseum, Amsterdam. (1976). Cat. by J. B. Bedaux, P. Hecht, E. de Jongh, J. Stumpel, R. Vos.

Amsterdam 1985
Exh. cat., *Ludolf Bakhuizen 1631-1708: schryfmeester — teyckenaer — schilder*. Rijksmuseum 'Nederlands Scheepvaart Museum', Amsterdam. (1985). Cat. by B. Broos, R. Vorstman, W. van de Watering.

Amsterdam/Groningen 1983
Exh. cat., *The Impact of A Genius: Rembrandt, his Pupils and Followers in the Seventeenth Century*. Waterman Gallery, Amsterdam and Groninger Museum, Groningen. (1983). Cat. by A. Blankert, B. Broos, E. van de Wetering, G. Jansen, W. van de Watering.

Amsterdam, Rijksmuseum, cat. 1976
Rijksmuseum, Amsterdam, *All the paintings of the Rijksmuseum in Amsterdam: A completely illustrated catalogue*. (1976). Cat. by P. J. J. van Thiel, C. J. de Bruyn Kops, J. Cleveringa, W. Kloek, A. Vels Heijn.

Amsterdam/Toronto 1977
Exh. cat., *The Dutch Cityscape in the 17th Century and its Sources*. Amsterdams Historisch Museum, Amsterdam and Art Gallery of Ontario, Toronto. (1977).

Amsterdam/Washington 1981-82
Exh. cat., *Dutch Figure Drawings from the Seventeenth Century*. Rijksprentenkabinet, Rijksmuseum, Amsterdam and National Gallery of Art, Washington. (1981-82). Cat. by P. Schatborn.

Amsterdam/Zwolle 1982
Exh. cat., *Hendrick Avercamp 1584-1634, Barent Avercamp 1612-1679, Frozen Silence: Paintings from Museums and Private Collections*. Waterman Gallery, Amsterdam and Provinciehuis, Zwolle. (1982). Cat. by A. Blankert, D. Hensbroek-van der Poel, G. Keyes, R. Krudop, W. van de Watering.

Armstrong 1890
W. Armstrong, 'The National Gallery of Ireland — II.' *Magazine of Art*, (1890), pp. 281-88.

Armstrong 1891
W. Armstrong, 'The Dutch Kitchen.'
The Portfolio, vol. 22 (1891), pp. 111-12.

Armstrong 1893
W. Armstrong, 'The Breakfast.'
The Portfolio, vol. 24 (1893), pp. 18-19.

Armstrong 1912
W. Armstrong, 'A claim for Gerrit
Willemsz. Horst.' *Burlington Magazine*, vol.
20 (1912), pp. 258-63.

von Arps-Aubert 1932
R. von Arps-Aubert, *Die Entwicklung des
reinen Tierbildes in der Kunst des Paulus Potter.*
(Halle 1932).

von Arps-Aubert 1933
R. von Arps-Aubert, 'Paulus Potter' in
Thieme, Becker 1907-50, vol. 27, pp. 306-07.

Artaria 1841
H. Artaria, *A Descriptive catalogue of the
Gallery of Edmund Higginson, Esq., of
Saltmarsh Castle.* (London 1841).

Auckland 1982
Exh. cat., *Still-life in the age of Rembrandt.*
City Art Gallery, Auckland. (1982). Cat. by
E. de Jongh, T. van Leeuwen, A. Gasten,
H. Sayles.

Baetjer 1980
K. Baetjer, *European Paintings in the
Metropolitan Museum, New York.* 3 vols.
(New York 1980).

Balleger 1967
J. P. L. M. Balleger, 'Enkele Voorbeelden
van de invloed van Hans en Paulus
Vredeman de Vries op de
Architectuurschilders in de Nederlanden
gedurende de XVIᵉ en XVIIᵉ Eeuw.' *Gentse
Bijdragen*, vol. 20 (1967), pp. 55-70.

Bartsch
J. A. B. von Bartsch, *Le Peintre Graveur.*
21 vols. (Bienna 1803-21).

Bartsch 1979
W. L. Strauss (ed.), *The Illustrated Bartsch,
vol. 5 (formerly vol. 4), Netherlandish Artists.*
(New York 1979).

Bauch 1933
K. Bauch, *Die Kunst des jungen Rembrandts.*
(Heidelberg 1933).

Bauch 1960
K. Bauch, *Der frühe Rembrandt und seine Zeit.*
(Berlin 1960).

Bauch 1966
K. Bauch, *Rembrandt: Gemälde.* (Berlin 1966).

Beck 1972-73
H.-U. Beck, *Jan van Goyen 1596-1656.* 2 vols.
(Amsterdam 1972-73).

Belonje 1967
J. Belonje, 'Meer over Anthony Jansz. van
der Croos.' *Oud Holland*, vol. 82 (1967),
pp. 63-65 and p. 80.

Benesch 1935
O. Benesch, 'Rembrandt van Rijn' in
Thieme, Becker 1907-50, vol. 29, pp. 259-71.

Benesch 1940
O. Benesch, 'An early portrait drawing by
Rembrandt.' *The Art Quarterly*, vol. 3 (1940),
pp. 2-14.

Benesch 1954-57
O. Benesch, *The Drawings of Rembrandt: A
Critical and Chronological Catalogue.* 6 vols.
(London 1954-57).

van Beresteyn 1929
E. A. van Beresteyn, *Iconographie van Hugo
Grotius.* (The Hague 1929).

Bergström 1955
I. Bergström, 'Disguised symbolism in
Madonna pictures and still life.' *Burlington
Magazine*, vol. 97 (1955), pp. 303-08 and
342-47.

Bergström 1983
I. Bergström, *Dutch Still-life Painting in the
Seventeenth Century.* Reprint of the 1st
American edition, 1956. (New York 1983).

Berlin, Dahlem, cat. 1978
Picture Gallery, Berlin, *Catalogue of
Paintings, 13th-18th Century.* (1978).

Bernt 1948-62
W. Brent, *Die Niederländischen maler des
17. Jahrhunderts.* 3 vols. and Supplement.
(Munich 1948-62).

Bille 1961
C. Bille, *De tempel der kunst of het kabinet van
den Heer Braamcamp,* 2 vols. (Amsterdam
1961).

Blade 1976
T. T. Blade, *The Paintings of Dirck van Delen.*
Dissertation. (University of Minnesota,
1976).

Blanc 1858
C. Blanc, *Le trésor de la curiosité, tiré des
catalogues de vente.* 2 vols. (Paris 1858).

Blankert 1968
A. Blankert, 'Over Pieter van Laer als dieren land- schapschilder.' *Oud Holland*, vol. 83 (1968), pp. 117-34.

Blankert 1975-79
A. Blankert, *Amsterdams Historisch Museum, Schilderijen daterend van voor 1800: voorlopige catalogus.* (Amsterdam 1975-79).

Blankert 1978
A. Blankert, *Nederlandse 17ᵉ eeuwse Italianiserende landschapschilders.* (Soest 1978). Reprint of Utrecht 1965.

Blankert 1982
A. Blankert, *Ferdinand Bol (1616-1680): Rembrandt's Pupil.* (Doornspijk 1982).

Bock, Rosenberg 1930
E. Bock and J. Rosenberg, *Die Zeichnungen niederländischer Meister im Kupferstichkabinett zu Berlin.* 2 vols. (1930).

Bode 1883
W. Bode, *Studien zur Geschichte der holländischen Malerei.* (Braunschweig 1883).

Bode 1906
W. Bode, *Rembrandt und seine Zeitgenossen.* (Leipzig 1906).

Bode 1919
W. Bode, 'Ein neu aufgefundende Jugendwerk von Pieter de Hooch.' *Zeitschrift für bildende Kunst*, N. F. vol. 30 (1919), pp. 305-08.

Bode, Binder 1914
W. Bode and M. J. Binder, *Frans Hals: Sein Leben und seine Werke.* 2 vols. (Berlin 1914). English translation by M. W. Brockwell, (London 1914).

Bode, Hofstede de Groot 1897-1906
W. Bode and C. Hofstede de Groot, *The Complete Work of Rembrandt. History, Description and Heliographic Reproduction of all the Master's pictures with a study of his life and his art.* 8 vols. (Paris 1897-1906).

Bodkin 1924
T. Bodkin, 'Two recent acquisitions for the National Gallery of Ireland.' *Burlington Magazine*, vol. 45 (1924), p. 138 and pp. 142-43.

Bol 1973
L. J. Bol, *Die Holländische Marinemalerei des 17. Jahrhunderts.* (Braunschweig 1973).

Boon 1947
K. G. Boon, *Het Zelfportret in de Nederlandse en Vlaamse schilderkunst.* (Amsterdam 1947).

Borenius 1921
T. Borenius, 'Claes Hals — II.' *Burlington Magazine*, vol. 38 (1921), p. 143.

Borghero 1981
Thyssen-Bornemisza Pinakotheck, Castagnola di Lugano, *Catalogue of Exhibited Works.* (1981). Ed. by G. Borghero.

Boydell 1985
B. Boydell, *Music and Paintings in the National Gallery of Ireland.* (Dublin 1985).

Braun 1966
K. Braun, *Gerard und Willem van Honthorst.* Dissertation. (Göttingen 1966).

Braun 1980
K. Braun, *Alle tot nu toe bekende schilderijen van Jan Steen.* (Rotterdam 1980).

Braunschweig 1979
Exh. cat., *Jan Lievens, ein Maler im Schatten Rembrandts.* Herzog Anton Ulrich-Museum, Braunschweig. (1979).

Braunschweig, Anton Ulrich-Museum, cat. 1983
Herzog Anton Ulrich-Museum, Braunschweig, *Die holländischen Gemälde: Kritisches Verzeichnis.* (1983). Cat. by R. Klessmann.

Bredius 1911
A. Bredius, 'Een en ander over Jan Wijnants.' *Oud Holland*, vol. 29 (1911), pp. 179-84.

Bredius 1915-22
A. Bredius, *Künstler-Inventare: Urkunden zur Geschichte der holländischen Kunst des XVIten, XVIIten und XVIIIten Jahrhunderts.* 8 vols. (The Hague 1915-22).

Bredius 1927a
A. Bredius, *Jan Steen.* (Amsterdam 1927).

Bredius 1927b
A. Bredius, 'Rembrandt, Bol oder Backer ?' in *Festschrift für Max J. Friedländer zum 60. Geburtstage.* (Leipzig 1927), pp. 156-60.

Bredius 1933
A. Bredius, 'Jan Maurits Quinkhard' in Thieme, Becker 1907-50, vol. 27, p. 524.

Bredius 1935
A. Bredius, *Rembrandt Gemälde*.
(Vienna 1935).

Bredius, Moes 1892
A. Bredius and E. W. Moes, 'De
Schildersfamilie Ravesteyn.' *Oud Holland*,
vol. 10 (1892), pp. 41-52.

Brière-Misme 1927
C. Brière-Misme, 'Tableaux inédits ou peu
connus de Pieter de Hooch.' *Gazette des
Beaux-Arts*, vol. 15 (1927), pp. 361-80,
vol. 16 (1927), pp. 51-79 and vol. 17 (1927),
pp. 258-86.

Brochhagen 1957
E. Brochhagen, 'Karel Dujardins späte
Landschaften.' *Bulletin de Musées Royaux des
Beaux-Arts*, vol. 6 (1957), pp. 236-54.

Brochhagen 1958
E. Brochhagen, *Karel Dujardin: Ein Beitrag
zum Italianismus in Holland im 17.
Jahrhundert*. Dissertation. (Cologne 1958).

Broos 1975-76
B. P. J. Broos, 'Rembrandt and Lastman's
Coriolanus: the history piece in 17th century
theory and practice.' *Simiolus*, vol. 8
(1975-76), pp. 199-228.

Broulhiet 1938
G. Broulhiet, *Meindert Hobbema (1638-1709)*.
(Paris 1938).

Brown 1978
C. Brown, *The National Gallery Lends Dutch
Genre Painting*. (London 1978).

Brown 1984
C. Brown, *Scenes of everyday life: Dutch Genre
Painting of the Seventeenth Century*. (London
and Boston 1984).

Bruijn, Gaastra, Schöffer 1979
J. R. Bruijn, F. S. Gaastra and I. Schöffer,
(eds.), *Dutch-Asiatic Shipping in the 17th and
18th Centuries. Vol. 3. Homeward-bound
voyages from Asia and the Cape to the
Netherlands (1597-1795)*. (The Hague 1979).

Bruyn 1983
J. Bruyn, review of Blankert 1982, *Oud
Holland*, vol. 97 (1983), pp. 208-16.

Buchanan 1824
W. Buchanan, *Memoirs of Painting, with a
chronological history of the Importation of
Pictures by the Great Masters into England
since the French Revolution*. (London 1824).

Burger-Wegener 1976
C. Burger-Wegener, *Johannes Lingelbach,
1622-1674*. Dissertation, (Berlin 1976).

Burke 1976
J. D. Burke, *Jan Both: Paintings, Drawings
and Prints*. (New York and London 1976).

Burnett 1852
J. Burnett, *Turner and his works*.
(London 1852).

de Burtin 1808
F-X de Burtin, *Traité Theoretique et Pratique. .
. . 2 vols*. (Brussels 1808).

Butlin, Joll 1977
M. Butlin and E. Joll, *The Paintings of
J. M. W. Turner*. 2 vols. (New Haven and
London 1977).

Caldwell 1979
J. Caldwell, 'New acquisition, Portrait of the
Martini Family by Jan Mytens.' New
Orleans Museum of Art, *Arts Quarterly*,
(Oct.-Dec. 1979), p. 22.

Cambridge, Fitzwilliam, cat. 1960
Fitzwilliam Museum, Cambridge, *Catalogue
of Paintings. Volume 1. Dutch and Flemish,
French, German, Spanish*. (Cambridge 1960).
Cat. by H. Gerson, J. W. Goodison,
D. Sutton.

Cleveland 1971
Exh. cat., *Caravaggio and his followers*.
Cleveland Museum of Art, Cleveland.
(1971). Cat. by R. Spear.

Collins Baker 1920
C. H. Collins Baker, *Catalogue of the
Petworth Collection of Pictures in the possession
of Lord Leconfield*. (London 1920).

Collins Baker 1925
C. H. Collins Baker, *Masters of Painting.
Pieter de Hooch*. (London 1925).

Collins Baker 1926
C. J. Collins Baker, 'Rembrandt's *Painter in
his Studio*.' *Burlington Magazine*, vol. 48
(1926), p. 42.

Collins Baker 1930
C. H. Collins Baker, 'De Hooch or not De
Hooch.' *Burlington Magazine*, vol. 57 (1930),
pp. 189-99. Review of Valentiner 1930.

Copenhagen, Royal Museum, cat. 1951
Royal Museum of Fine Arts, Copenhagen,
Catalogue of Old Foreign Paintings. (1951).

Dansaert n.d.
G. Dansaert, *Courte Notice au sujet de deux portraits peints par Rembrandt.* (Brussels n.d.).

van Dantzig 1937
M. M. van Dantzig, *Frans Hals, echt of onecht.* (Amsterdam 1937).

Descamps 1753-64
J. P. Descamps, *La Vie des peintres flamands, allemands et hollandais.* 4 vols. (Paris 1753-64).

Dobrzycka 1966
A. Dobrzycka, *Jan van Goyen 1596-1656.* (Poznan 1966).

Dordrecht 1977-78
Exh. cat., *Aelbert Cuyp en zijn familie, schilders te Dordrecht. Gerrit Gerritsz. Cuyp, Jacob Gerritsz. Cuyp, Benjamin Gerritsz. Cuyp, Aelbert Cuyp.* Dordrechts Museum, Dordrecht. (1977-78).

Dresden, Gemäldegalerie, cat. 1979
Gemäldegalerie Alte Meister, Dresden, *Katalog der ausgestellten Werke.* (1979).

Dublin, National Gallery, cat. 1981
National Gallery of Ireland, Dublin, *Illustrated Summary Catalogue of Paintings.* (1981).

Dülberg 1930
F. Dülberg, *Frans Hals: Ein Leben und ein Werk.* (Stuttgart 1930).

Duncan 1906-07
E. Duncan, 'The National Gallery of Ireland.' *Burlington Magazine,* vol. 10 (1906-07), pp. 7-23.

Durantini 1983
M. F. Durantini, *The Child in Seventeenth-Century Dutch Painting.* (Ann Arbor 1983).

Duret 1882
T. Duret, 'Une visite aux Galeries Nationales d'Irlande et d'Ecosse.' *Gazette des Beaux-Arts,* vol. 25 (1882), pp. 180-85.

Dutuit 1883-85
E. Dutuit, *Tableaux et dessins de Rembrandt: catalogue historique et descriptif.* (Paris 1883-85).

Eckardt 1971
G. Eckardt, *Selbstbildnisse Niederländischer Maler des 17. Jahrhunderts.* (Berlin 1971).

Elkins 1887-1900
Anon. *Catalogue of Paintings in the Private Collection of W. L. Elkins.* Part 2 (Elkins 'Elstowe' Elkins, 1887-1900).

Enschede, Rijksmuseum Twenthe, cat. 1974-76
Rijksmuseum Twenthe, Enschede, *Catalogus van de Schilderijen.* (1974-76). Cat. by O. ter Kuile.

Enschede, Rijksmuseum Twenthe, cat. 1974-76
Rijksmuseum Twenthe, Enschede, *Catalogus van de Schilderijen.* (1974-76). Cat. by O. ter Kuile.

Fétis 1878
E. Fétis, *La Galerie du Vicomte du Bus de Gisignies.* (Brussels 1878).

Fishman 1982
J. S. Fishman, *Boerenverdriet: Violence between Peasants and Soldiers in Early Modern Netherlands Art.* (Ann Arbor 1982).

Fleischer 1976
R. E. Fleischer, 'An Altered Painting by Pieter de Hooch.' *Oud Holland,* vol. 90 (1976), pp. 108-14.

Fokker 1929
T. H. Fokker, 'Nederlandsche schilders in Zuid-Italië.' *Oud Holland,* vol. 46 (1929), pp. 1-24.

Fokker 1931
T. H. Fokker, 'Pieter de Molijn' in Thieme, Becker 1907-50, vol. 25, pp. 49-50.

Freise 1911
K. Freise, *Pieter Lastman: sein Leben und seine Kunst.* (Leipzig 1911).

Freise 1913
K. Freise, 'Rembrandt und Lastman.' *Der Cicerone,* vol. 5 (1913), pp. 610-11.

Fremantle 1959
K. Fremantle, *The Baroque Town Hall of Amsterdam.* Orbis artium, Utrechtse kunsthistoriche studiën, vol. 4. (Utrecht 1959).

von Frimmel 1904
T. von Frimmel, 'Von Monogrammisten (IS).' *Blätter für Gemäldekunde,* vol. 1 (1904), pp. 132-33.

von Frimmel 1913-14
T. von Frimmel. *Lexicon der Wiener Gemäldesammlungen.* 2 vols. (Munich 1913-14).

Frost n.d.
W. Frost, *Catalogue of the Paintings, Water-colour Drawings and Prints in the Collection of the late Hugh Andrew Johnstone Munro Esq., of Novar.* Revised by H. Reeve. (London, n.d.).

Gaskell 1982
I. Gaskell, 'Transformations of Cervantes's *La Gitanilla* in Dutch Art.' *Journal of the Warburg and Courtauld Institutes,* vol. 45 (1982), pp. 263-70.

de Gelder 1921
J. J. de Gelder, *Bartholomeus van der Helst: een studie van zijn werk, zijn levensgeschiedenis, een beschrijvende catalogus van zijn oeuvre.* (Rotterdam 1921).

van Gelder 1953
van Gelder, 'Rembrandt and his circle.' *Burlington Magazine,* vol. 95 (1953), pp. 34-39.

Gerson 1931
H. Gerson, 'Jacob Ochtervelt' in Thieme, Becker 1907-50, vol. 25, pp. 556-57.

Gerson 1938
H. Gerson, 'Abraham Storck' in Thieme, Becker 1907-50, vol. 32, pp. 119-20.

Gerson 1953
H. Gerson, 'Dutch Landscape.' *Burlington Magazine,* vol. 95 (1953), pp. 47-52.

Gerson 1968
H. Gerson, *Rembrandt Paintings.* (Amsterdam 1968).

Gerson 1969
H. Gerson, *Rembrandt: the complete edition of the paintings by A. Bredius.* Revised by H. Gerson. (London 1969).

Gerson 1976
H. Gerson, 'The Frans Hals Catalogue.' Review of Slive 1970-74, *Burlington Magazine,* vol. 118 (1976), pp. 422-24.

Ginnings 1970
R. J. Ginnings, *The art of Jan Baptist Weenix and Jan Weenix.* Dissertation. (University of Delaware, 1970).

Goldscheider 1960
L. Goldscheider, *Rembrandt, Paintings, Drawings and Etchings.* Introduction by H. Focillon. (London 1960).

Grant 1954
M. H. Grant, *Jan van Huysum, 1682-1749, including a catalogue raisonné of the artist's fruit and flower paintings.* (Leigh-on-Sea 1954).

Gregory 1973
Lady Gregory, *Sir Hugh Lane: his life and legacy.* Foreword by J. White. (Gerrards Cross 1973).

Grimm 1971
C. Grimm, 'Frans Hals und seine "Schule".' *Münchner Jahrbuch,* vol. 22 (1971), pp. 146-78.

Grimm 1972
C. Grimm, *Frans Hals.* (Berlin 1972).

Grimm, Montagni 1974
C. Grimm and E. C. Montagni, *L'opera completa di Frans Hals.* (Milan 1974).

Gudlaugsson 1959-60
S. J. Gudlaugsson, *Gerard ter Borch.* 2 vols. (The Hague 1959-60).

Guimarães 1957
A. Guimarães, 'Na Holanda com Frans Post.' *Revista do Instituto Histórico e Geográfico Brasileiro,* no. 235 (1957).

van der Haagen 1932
J. K. van der Haagen, *De schilders van der Haagen en hun werk.* (Voorburg 1932).

Haak 1969
B. Haak, *Rembrandt; his life, his work, his time.* (New York 1969).

Haex 1981-82
O. Haex, 'A Soldier's Piece by the 17th Century Genre Painter Simon Kick.' *Tableau,* vol. 4 (1981-82), pp. 294-98.

The Hague, Mauritshuis, cat. 1977
Mauritshuis, The Hague, *Mauritshuis, The Royal Cabinet of Paintings Illustrated General Catalogue.* (1977).

The Hague, Mauritshuis, cat. 1980
Mauritshuis, The Hague, *Hollandse Schilderkunst, Landschappen 17de eeuw.* (1980).

The Hague, Museum Bredius, cat. 1980
Museum Bredius, The Hague, *Catalogus van de schilderijen en tekeningen.* 2nd edition. (1980). Cat. by A. Blankert.

van Hall 1963
H. van Hall, *Portretten van Nederlandse Beeldende Kunstenaars.* (Amsterdam 1963).

Harms 1927
J. Harms, 'Judith Leyster: Ihr Leben und ihr Werk.' Parts 1-5. *Oud Holland,* vol. 44 (1927), pp. 88-96, 112-26, 145-54, 221-44, 275-79.

Haverkamp Begemann 1959
E. Haverkamp Begemann, *Willem Buytewech.* (Amsterdam 1959).

Held 1969
J. S. Held, *Rembrandt's Aristotle, and other Rembrandt studies.* (Princeton 1969).

Hellens 1911
F. Hellens, *Gérard Terborch.* (Brussels 1911).

Henkel 1929
M. D. Henkel, 'Dirck Maes' in Thieme, Becker 1907-50, vol. 23, pp. 544-45.

Henkel 1939
M. D. Henkel, 'Cornelis Troost' in Thieme, Becker 1907-50, vol. 33, pp. 426-27.

Henry 1937
F. Henry, 'La Galerie de peinture de Dublin enrichie de nouvelles oeuvres est l'objet d'un remaniement complet.' *Le Journal des Arts,* no. 223, 9 April 1937, p. 1.

Heppner 1935
A. Heppner, 'Cornelis Deckers Innenraum-Darstellungen,' in *Adolf Goldschmidt zu seinem Siebenzigsten Geburtstag.* (Berlin 1935), pp. 155-57.

Heppner 1946
A. Heppner, 'Rotterdam as the Center of a "Dutch Teniers Group."' *Art in America,* vol. 34 (1946), pp. 15-30.

Hoet 1752
G. Hoet, *Catalogus of Naamlyst van schilderyen.* 3 vols. in 2. (The Hague 1752).

Hofrichter 1973
F. F. Hofrichter, *Judith Leyster: A Preliminary Catalogue.* Dissertation. (City University of New York, 1973).

Hofstede de Groot 1899
C. Hofstede de Groot, 'Isaac de Jouderville: leerling van Rembrandt?' *Oud Holland,* vol. 17 (1899), pp. 228-35.

Hofstede de Groot 1907-28
C. Hostede de Groot, *Beschreibendes und kritisches Verzeichnis der Werke der her vorragendsten holländischen Maler des XVII. Jahrhunderts.* 10 vols. (Esslingen and Paris, 1907-28).

Hofstede de Groot 1908-27
C. Hofstede de Groot, *A Catalogue Raisonné of the Works of the Most Eminent Dutch Painters of the Seventeenth Century.* Translated by E. G. Hawke. 8 vols. (London 1908-27).

Hofstede de Groot 1916
C. Hofstede de Groot, 'Govert Flinck' in Thieme, Becker 1907-50, vol. 12, pp. 97-100.

Hofstede de Groot 1922
C. Hofstede de Groot, 'Frans Hals' in Thieme, Becker 1907-50, vol. 15, pp. 531-34.

Hofstede de Groot 1923-24
C. Hofstede de Groot, 'Rembrandts bijbelsche en historische voorstellingen.' *Oud Holland,* vol. 41 (1923-24), pp. 49-59 and 97-114.

Hofstede de Groot 1925
C. Hofstede de Groot, 'Jan van Huysum' in Thieme, Becker 1907-50, vol. 18, pp. 207-08.

Hofstede de Groot 1926a
C. Hofstede de Groot, 'Ludolf de Jongh' in Thieme, Becker 1907-50, vol. 19, pp. 132-34.

Hofstede de Groot 1926b
C. Hofstede de Groot, 'Isaac de Jouderville' in Thieme, Becker 1907-50, vol. 19, pp. 190-91.

Hofstede de Groot 1927a
C. Hofstede de Groot, 'Isaack Koedijk' in *Festschrift für Max J. Friedländer. Zum 60. Geburtstag,* (Leipzig 1927), pp. 181-90.

Hofstede de Groot 1927b
C. Hofstede de Groot, 'Wouter Knijff' in Thieme, Becker 1907-50, vol. 21, p. 46.

Hofstede de Groot 1935
C. Hofstede de Groot, 'Jan van Rossum' in Thieme, Becker 1907-50, vol. 29, p. 79.

Hollstein 1949-
F. W. H. Hollstein, *Dutch and Flemish Etchings, Engravings, and Woodcuts.* Vols. 1-. (Amsterdam 1949-).

Holmes 1915-16
C. J. Holmes, 'A picture by Ferdinand Bol.' *Burlington Magazine,* vol. 28 (1915-16), pp. 28-29.

Hoogewerff 1923
G. J. Hoogewerff, 'Bentvogels te Rome en Hun Feesten.' *Medeelingen van het Nederlandsch Historische Institut te Rome,* vol. 3 (1923), pp. 223-48.

Hoogewerff 1924
G. J. Hoogewerff, *Gerrit van Honthorst*
(The Hague 1924).

Hoogewerff 1952
G. J. Hoogewerff, *De Bentvueghels.*
(The Hague 1952).

van Hoogstraten 1678
S. van Hoogstraten, *Inleyding tot de hooge
schoole der schilderkonst: Anders de Zichtbaere
Werelt.* (Rotterdam 1678). Reprinted, Soest
1969, Ann Arbor 1980.

Houbraken
A. Houbraken, *De Groote Schouburgh der
Nederlantsche Konstschilders en Schilderessen.*
3 vols. (Amsterdam 1718-21).

Isarlo 1941
G. Isarlo, *Caravage et le caravagisme européen.*
(Aix-en-Provence 1941).

Isarlov 1936
G. Isarlov, 'Rembrandt et son entourage.'
La Renaissance, (July-September 1936),
pp. 1-50.

Jantzen 1909
H. Jantzen, 'Intérieurs d'Églises
Hollandaises.' *L'Art Flamand & Hollandais,*
vol. 11 (June 1909), pp. 186-93.

Jantzen 1910
H. Jantzen, *Das niederländische
Architekturbild.* (Leipzig 1910).

Jantzen 1913
H. Jantzen, 'Dirck van Delen' in Thieme,
Becker 1907-50, vol. 9, pp. 11-12.

Jantzen 1979
H. Jantzen, *Das niederländische
Architekturbild.* 2nd ed. (Braunschweig 1979).

de Jonge 1938
C. J. de Jonge, *Paulus Moreelse: Portret-en
genreschilder te Utrecht 1571-1638.*
(Assen 1938).

de Jongh 1967
E. de Jongh, *Zinne-en minnebeelden in de
schilderkunst van de zeventiende eeuw.*
(Amsterdam 1967).

de Jongh 1968-69
E. de Jongh, 'Erotica in vogelperspectief: De
dubbelzinnigheid van een reeks 17de
eeuwse genrevoorstellingen.' *Simiolus,* vol. 3
(1968-69), pp. 22-74.

de Jongh 1971
E. de Jongh, 'Realisme et schijnrealisme in
de Hollandse schilderkunst van de
zeventiende eeuw,' in exh. cat., *Rembrandt
en zijn tijd,* Palais des Beaux-Arts, Brussels.
(1971).

de Jongh 1972-73
E. de Jongh, Review of Niemeijer 1973,
Simiolus, vol. 6 (1972-73), pp. 76-80.

de Jongh 1974
E. de Jongh, 'Grape symbolism in Paintings
of the 16th and 17th centuries.' *Simiolus,*
vol. 7, (1974), pp. 166-91.

de Jongh 1986
E. de Jongh, *Portretten van echt en trouw:
Huwelijk en gezin in de Nederlandse kunst van
de zeventiende eeuw.* Exh. cat., Frans
Halsmuseum, Haarlem. (1986).

Judson 1959
J. P. Judson, *Gerrit van Honthorst:
A Discussion of His Position in Dutch Art.*
(The Hague 1959).

Juynboll 1933a
R. Juynboll, 'Pieter Potter' in Thieme,
Becker 1907-50, vol. 27, pp. 307-08.

Juynboll 1933b
R. Juynboll, 'Willem de Poorter' in Thieme,
Becker 1907-50, vol. 27, pp. 258-59.

Juynboll 1937
W. R. Juynboll, 'Hendrik Martensz Sorgh'
in Thieme, Becker 1907-50, vol. 31, p. 294.

Keyes 1979
G. S. Keyes, 'Jan Lagoor.' *Tableau,* vol. 1,
(1979), pp. 36-44.

Keyes 1984
G. Keyes, *Esaias van de Velde 1587-1630.*
(Doornspijk 1984).

Knoef 1947a
J. Knoef, *Cornelis Troost.* (Amsterdam 1947).

Knoef 1947b
J. Knoef, 'Een Portret van Tonneman?'
*Kunsthistoriche Mededelingen van het
Rijksbureau voor Kunsthistorische Documentatie
'S-Gravenhage,* vol. 2 (1947), pp. 14-15.

Koslow 1975
S. Koslow, 'Frans Hals's "Fisherboys":
Exemplars of Idleness.' *The Art Bulletin,*
vol. 57 (1975), pp. 418-32.

Kreplin 1942
B. C. Kreplin, 'Jan Baptist Weenix' in Thieme, Becker 1907-50, vol. 35, pp. 246-47.

Kruizinga, Banning 1966
J. H. Kruizinga and J. A. Banning, *Amsterdam van A tot Z.* (Amsterdam 1966).

Kuretsky 1979
S. D. Kuretsky, *The Paintings of Jacob Ochtervelt (1634-1682).* (London and Montclair, N. J. 1979).

Larsen 1962
E. Larsen, *Frans Post: interprète du Brésil.* (Amsterdam and Rio de Janeiro 1962).

Larsen 1983
E. Larsen, *Rembrandt, Peintre de Paysages: une vision nouvelle.* (Louvain-La-Neuve 1983).

Lawrence/New Haven/Austin 1983-84
Exh. cat., *Dutch Prints of Daily Life: Mirrors of Life or Masks of Moral?* Spencer Museum of Art, University of Kansas; Yale University Art Gallery, New Haven and Huntington Gallery, University of Texas at Austin. (1983-84). Cat. by L. A. Stone-Ferrier.

Le Brun 1792
J. B. P. Le Brun, *Galerie des Peintures Flamands, Hollandais et Allemands.* 2 vols. (Paris 1792).

Lecaldano 1973
P. Lecaldano, *The Complete Paintings of Rembrandt.* Introduction by G. Martin. (London 1973).

Leeuwarden/'S-Hertogenbosch/Assen 1980
Exh. cat., *In Het Zadel: Het Nederlands ruiterportret van 1550 tot 1900.* Fries Museum, Leeuwarden; Noordbrabants Museum, 'S-Hertogenbosch and Provincial Museum van Drenthe, Assen. (1980).

Leiden 1968
Exh. cat. *Rondom Rembrandt*, Stedelijk Museum 'De Lakenhal', Leiden. (1968).

Leiden, de Lakenhal, cat. 1983
Stedelijk Museum de Lakenhal, Leiden, *Catalogus van de schilderijen en tekeningen.* (1983).

Liedtke 1970
W. A. Liedtke 'From Vredeman de Vries to Dirck van Delen: sources of imaginary architectural painting.' *Bull. of Rhode Island School of Design, Museum Notes,* (1970), pp. 14-25.

Liedtke 1982
W. Liedtke, *Architectural Painting in Delft: Gerard Houckgeest, Hendrick van Vliet, Emanuel de Witte.* (Doornspijk 1982).

Lilienfeld 1924
K. Lilienfeld, 'Pieter de Hooch' in Thieme, Becker 1907-50, vol. 27, pp. 452-54.

Lilienfeld 1924-25
K. Lilienfeld, 'Wiedergefundene Gemälde des Pieter de Hooch.' *Zeitschrift für bildende Kunst,* vol. 58 (1924-25), pp. 183-88.

Liverpool, Walker, cat. 1977
Walker Art Gallery, Liverpool, *Foreign Catalogue.* 2 vols. (1977).

L.M. 1954
L.M., 'Un saggio critica su Mattia Stomer.' *Emporium.* (March 1954), p. 127.

London 1964
Exh. cat., *The Orange and the Rose: Holland and Britain in the Age of Observation.* Victoria and Albert Museum, London. (1964).

London 1985
Exh. cat., *Masterpieces from the National Gallery of Ireland.* National Gallery, London. (1985). Catalogue entries for Dutch pictures by H. Potterton.

London, National Gallery, cat. 1973
National Gallery, London, *The National Gallery Illustrated General Catalogue.* (1973).

London, NPG, cat. 1981
National Portrait Gallery, London, *Complete Illustrated Catalogue, 1856-1979.* Compiled by K. K. Yung. (1981).

London, Wallace, cat. 1979
Wallace Collection, London, *Summary Illustrated Catalogue of Pictures.* (1979).

Longhi 1943
P. Longhi, 'Ultimi Studi sul Caravaggio e la sua Cerchia.' *Proporzione,* vol. 1 (1943), pp. 5-63.

Lugt 1933
F. Lugt, *Musée du Louvre, Inventaire Général des dessins des Écoles du Nord: École Hollandaise: vol. 3, Rembrandt, ses élèves, ses imitateurs, ses copistes.* (1933).

van Luttervelt 1967
R. van Luttervelt, *The Rijksmuseum and other Dutch Museums.* (London 1967).

MacLaren 1960
N. MacLaren, *The National Gallery Catalogues: The Dutch School.* (London 1960).

Manchester 1974
Exh. cat., *Drawings by West European and Russian Masters from the Collections of the State Hermitage and the Russian Museums, Leningrad.* Whitworth Art Gallery, Manchester. (1974).

van Mander
C. van Mander, *Het Schilder-boeck.* (Haarlem 1603-04).

Manke 1963
I. Manke, *Emanuel de Witte, 1617-1692.* (Amsterdam 1963).

von Manteuffel 1937
Z. von Manteuffel, 'Jan Frans Soolmaker' in Thieme, Becker 1907-50, vol. 31, p. 284.

Martin 1913
W. Martin, *Gerard Dou.* Klassiker der Kunst. (Stuttgart 1913).

Martin 1935-36
W. Martin, *De Hollandsche schilderkunst in de zeventiende eeuw.* Vol. 1, *Frans Hals en zijn tijd.* Vol. 2, *Rembrandt en zijn tijd.* (Amsterdam 1935-36).

Michel 1893
E. Michel, *Rembrandt, sa vie, son oeuvre et son temps.* (Paris 1893).

Michel 1894
É. Michel, *Rembrandt: his Life, his Work, and his Time.* Translated by F. Simmonds, edited by F. Wedmore. 2 vols. (London 1894).

Millar 1963
O. Millar, *The Tudor, Stuart and Early Georgian Pictures in the Collection of Her Majesty the Queen.* 2 vols. (London 1963).

Milwaukee 1976
Exh. cat., *The Bible through Dutch eyes.* Milwaukee Art Center, Milwaukee. (1976).

de Mirimonde 1964
A. P. de Mirimonde, 'Les Concerts Parodiques chez les Maîtres du Nord.' *Gazette des Beaux-Arts,* vol. 64 (1964), pp. 253-84.

de Mirimonde 1970
A. P. de Mirimonde, 'Musique et symbolisme chez Jan-Davidszoon de Heem, Cornelis Janszoon et Jan II Janszoon de Heem.' *Jaarboek van het Koninklijk Museum voor Schone Kunsten Antwerpen,* (1970), pp. 241-96.

Moes 1897-1905
E. W. Moes, *Iconographia Batava: beredeneerde lijst van geschilderde en gebeeldhouwde portretten van Noord Nederlanders in vorige eeuwen.* 2 vols. (Amsterdam 1897-1905).

Moes 1909a
E. W. Moes, 'Cornelis Bega' in Thieme, Becker 1907-50, vol. 3, p. 174.

Moes 1909b
E. W. Moes, *Frans Hals: Sa Vie et son oeuvre.* Translated by J. de Bosschère. (Brussels 1909).

Moes 1912
E. W. Moes, 'Pieter Codde' in Thieme, Becker 1907-50, vol. 7, p. 156.

Moir 1967
A. Moir, *The Italian followers of Caravaggio.* 2 vols. (Cambridge, Mass. 1967).

von Moltke 1938-39
J. von Moltke, 'Salomon de Bray.' *Marburger Jahrbuch für Kunstwissenschaft,* vols. 11-12, (1938-39), pp. 309-420.

von Moltke 1965
J. W. von Moltke, *Govaert Flinck 1615-1660.* (Amsterdam 1965).

Müllenmeister 1981
K. J. Müllenmeister, *Meer und Land im Licht des 17. Jahrhunderts. Vol. 3. Tierdarstellungen in Werken niederländischer Künstler, N-Z.* (Bremen 1981).

Munich, Alte Pinakothek, cat. 1983
Alte Pinakothek, Munich, *Erläuterungen zu den ausgestellten Gemälden.* (1983).

Münster 1974
Exh. cat., *Gerard Ter Borch, Zwolle 1617, Deventer 1681.* Landesmuseum, Münster. (1974).

Münz 1953
L. Münz, 'Rembrandts Bild von Mutter und Vater.' *Jahrbuch der Kunsthistorischen Sammlungen in Wien,* vol. 15 (1953), pp. 141-90.

Naumann 1981
O. Naumann, *Frans van Mieris, the Elder (1635-1681).* 2 vols. (Doornspijk 1981).

Neale 1826
J. P. Neale, *Views of the Seats of Noblemen and Gentlemen in the United Kingdom.* Vol. 3. 2nd Series. (London 1826).

Neurdenburg 1930
E. Neurdenburg, *Hendrick de Keyser, beeldhouwer en bouwmeester van Amsterdam.* (Amsterdam 1930).

New York, Frick, cat. 1968
The Frick Collection, New York, *The Frick Collection: an Illustrated Catalogue. Vol. 1. Paintings, American, British, Dutch, Flemish and German.* (New York 1968).

Nicolson 1968
B. Nicolson, 'The National Gallery of Ireland.' *Burlington Magazine,* vol. 110. (1968), pp. 595-96.

Nicolson 1977
B. Nicolson, 'Stomer brought up to date.' *Burlington Magazine,* vol. 119 (1977), pp. 230-45.

Nicolson 1979
B. Nicolson, *The International Caravaggesque Movement: lists of Pictures by Caravaggio and his Followers throughout Europe from 1590-1650.* (Oxford 1979).

Niemeijer 1973
J. W. Niemeijer, *Cornelis Troost 1696-1750.* (Assen 1973).

Noack 1927
F. Noack, *Das Deutschtum in Rom seit dem Ausgang des Mittelalters.* 2 vols. (Stuttgart and Leipzig 1927).

Nystad 1975
S. Nystad, 'Joseph and Mary find their son among the doctors.' *Burlington Magazine,* vol. 107 (1975), pp. 140-47.

Oldenbourg 1911
R. Oldenbourg, *Thomas de Keysers Tätigkeit als Maler: ein Beitrag zur Geschichte des Holländischen Porträts.* (Leipzig 1911).

Paris 1970-71
Exh. cat., *Le Siècle de Rembrandt: Tableaux hollandais des collections publiques françaises.* Musée du Petit Palais, Paris, (1970-71).

Paris 1986
Exh. cat., *De Rembrandt à Vermeer: les peintres hollandais au Mauritshuis de La Haye.* Grand Palais, Paris. (1986). Cat. by B. Broos.

Paris, Institut Néerlandais, cat. 1983
Institut Néerlandais, Paris, *Reflets du Siècle d'Or: Tableaux Hollandais du dix-septième siècle.* (1983).

Paris, Louvre, cat. 1979
Musée du Louvre, Paris, *Catalogue sommaire illustré des peintures du Musée du Louvre, I, Ecoles flamande et hollandaise.* (1979). Cat. by A. Brejon de Lavergnée, J. Foucart, N. Reynaud.

Pauwels 1953
H. Pauwels, 'De Schilder Mattjias Stomer.' *Gentse Bijtragen tot de Kunst-geschiedenis,* vol. 14 (1953), pp. 139-92.

Pavière 1966
S. H. Pavière, *Jean Baptiste Monnoyer 1634-1699.* (Leigh-on-Sea 1966).

Philadelphia/Berlin/London 1984
Exh. cat., *Masters of Seventeenth-Century Dutch Genre Painting.* Philadelphia Museum of Art; Gemäldegalerie, Berlin (West) and Royal Academy, London. (1984). Cat. by C. Brown, J. Kelch, O. Naumann, W. Robinson, P. C. Sutton, C. von Bogendorf-Rupprath.

Pigler 1974
A. Pigler, *Barockthemen: eine Auswahl von Verzeichnissen zur Ikonographie des 17. und 18. Jahrhunderts.* 3 vols. (Budapest 1974).

Plietzsch 1944
E. Plietzsch, *Gerard Ter Borch,* (Vienna 1944).

Poensgen 1929
G. Poensgen, 'Judith Leyster' in Thieme, Becker 1907-50, vol. 23, pp. 176-77.

Porcella 1931
A. Porcella, *Le Pitture della Galleria Spada.* (Rome 1931).

Potterton 1982
H. Potterton, 'Recently-cleaned Dutch pictures in the National Gallery of Ireland.' *Apollo,* vol. 115 (1982), pp. 104-07.

Preston 1974
R. Preston, *Seventeenth Century Marine Painters of the Netherlands.* (Leigh-on-Sea 1974).

Raleigh 1956
Exh. cat., *Rembrandt and his pupils.* North Carolina Museum of Art, Raleigh. (1956). Cat. by W. R. Valentiner.

Redford 1888
G. Redford, *Art Sales, a History of Sales of Pictures and other Works of Art, etc.* 2 vols. (London 1888).

Reinold 1981
L. K. Reinold, *The Representation of the Beggar as Rogue in Dutch seventeenth-century art.* Dissertation. (University of California, Berkeley, 1981).

Reiss 1975
S. Reiss, *Aelbert Cuyp.* (London 1975).

Reznicek 1964
Exh. cat., *Mostra di disegni fiamminghi e olandesi.* Gabinetto Disegni e Stampe degli Uffizi, Florence. (1964). Cat. by J. Reznicek.

Richardson 1978
H. Richardson, 'Bol's *David's dying Charge to Solomon* in the National Gallery of Ireland.' *Studies*, vol. 67 (1978), pp. 212-33.

Robinson *forthcoming*
M. S. Robinson, *Willem van de Velde the Elder and the Younger: Catalogue of Paintings.*

Robinson 1974
F. W. Robinson, *Gabriel Metsu (1629-1667): A Study of His Place in Dutch Genre Painting of the Golden Age.* (New York 1974).

Roethlisberger 1981
M. Roethlisberger, *Bartholomeus Breenbergh, the Paintings.* (Berlin and New York, 1981).

Rosenberg 1904
A. Rosenberg, *Rembrandt, des meisters Gemälde.* Klassiker der Kunst. (Stuttgart and Leipzig 1904).

Rosenberg 1906
A. Rosenberg, *Rembrandt, des Meisters Gemälde*, vol. 2. Klassiker der Kunst. (Stuttgart and Leipzig 1906).

Rosenberg 1928
J. Rosenberg, *Jacob van Ruisdael.* (Berlin 1928).

Rosenberg, Slive, ter Kuile 1966
J. Rosenberg, S. Slive and E. H. ter Kuile, *Dutch art and architecture 1600-1800.* (Harmondsworth 1966).

Rotterdam, Boymans, cat. 1972
Museum Boymans-van Beuningen, Rotterdam, *Old Paintings 1400-1900: illustrations.* (1972).

Roy 1972
R. Roy, *Studien zu Gerbrand van den Eeckhout.* Dissertation. (Vienna 1970).

RRP 1982-
J. Bruyn, B. Haak, S. J. Levie, P. J. J. van Thiel, E. van de Wetering, *A Corpus of Rembrandt Paintings.* 10 vols. (The Hague, Boston and London 1982-). Vol. 1 (1982).

de Rudder 1914
A. de Rudder, *Pieter de Hooch et son oeuvre.* (Brussels and Paris 1914).

Russell 1975
M. Russell, *Jan van de Cappelle 1624/6-1679.* (Leigh-on-Sea 1975).

Russell 1977
M. Russell, 'The iconography of Rembrandt's *Rape of Ganymede.*' *Simiolus*, vol. 9 (1977), pp. 5-18.

de Saint Gelais 1727
Du Bois de Saint Gelais, *Description des Tableaux du Palais Royal.* (Paris 1727).

Schaar 1958
E. Schaar, *Studien zu Nicolaes Berchem.* Dissertation. (Cologne 1958).

Schatborn 1973
P. Schatborn, 'Olieverfschetsen van Dirck Hals.' *Bull. van het Rijksmuseum*, (1973), no. 3, pp. 107-16.

Schatborn 1975
P. Schatborn, 'Figuurstudies van Ludolf de Jongh.' *Oud Holland*, vol. 89 (1975), pp. 79-85.

Schloss 1983
C. Schloss, 'The early Italianate Genre Paintings of Jan Weenix, 1642-1719.' *Oud Holland*, vol. 97 (1983), pp. 69-97.

Schmidt 1981
W. Schmidt, *Studien zur Landschaftskunst Jacob van Ruisdaels.* (Hildesheim and New York 1981).

Schmidt-Degener 1906
F. Schmidt-Degener, 'Le Troisième Centenaire de Rembrandt en Hollande.' *Gazette des Beaux-Arts*, vol. 36 (1906), pp. 265-80.

Schnackenburg 1970
B. Schnackenburg, 'Die Anfänge des Bauerinteriurs bei Adriaen van Ostade.' *Oud Holland*, vol. 85 (1970), pp. 158-69.

Schnackenburg 1981
B. Schnackenburg, *Adriaen van Ostade, Isack van Ostade: Zeichnungen und Aquarelle.* 2 vols. (Hamburg 1981).

Schneeman 1982
L. T. Schneeman, *Hendrick Martensz. Sorgh: A Painter of Rotterdam.* Dissertation. (The Pennsylvania State University, 1982).

Schneider 1923
H. Schneider, 'Jan de Heem' in Thieme, Becker 1907-50, vol. 16, pp. 223-25.

Schneider 1929
H. Schneider, 'Jan Lievens' in Thieme, Becker 1907-50, vol. 23, pp. 214-15.

Schneider 1973
H. Schneider, *Jan Lievens, sein Leben und seine Werke,* with a Supplement by R. E. O. Ekkart. (Amsterdam 1973). Unchanged reprint of the Haarlem 1932 edition with corrected captions and a supplement.

Schneider, Hofstede de Groot 1932
H. Schneider and C. Hofstede de Groot, 'Anthonie Palamedesz.' in Thieme, Becker, vol. 26, p. 155.

Scholz 1978
W. Schulz, *Cornelis Saftleven, 1607-1681: Leben und Werke mit einem kritischen Katalog der Gemälde und Zeichnungen.* (Berlin and New York 1978).

Schwerin, Staatlisches Museum, cat. 1982
Staatlisches Museum, Schwerin, *Holländische und flämische Malerei des 17. Jahrhunderts.* (1982).

Sedelmeyer 1898
Sedelmeyer Gallery, Paris, *Illustrated Catalogue of 300 Paintings by Old Masters.* (Paris 1898).

von Sick 1930
I. von Sick, *Nicolaes Berchem, ein Vorläufer des Rokoko.* (Berlin 1930).

Simon 1930
K. E. Simon, *Jacob van Ruisdael, eine Darstellung seiner Entwicklung.* (Berlin 1930).

Simon 1935a
K. E. Simon, 'Salomon van Ruysdael' in Thieme, Becker 1907-50, vol. 29, pp. 189-90.

Simon 1935b
K. E. Simon, 'Jacob Isaackszoon van Ruisdael' in Thieme, Becker 1907-50, vol. 29, pp. 190-94.

Slive 1970-74
S. Slive, *Frans Hals.* 3 vols. (London and New York 1970-74).

Slive 1981-82
Exh. cat., *Jacob van Ruisdael.* Mauritshuis, The Hague and Fogg Art Museum, Cambridge, Mass. (1981-82). Catalogue by S. Slive.

Sluijter-Seijffert 1983-84
N. Sluijter-Seijffert, 'De Nassause cavalcade: een opmerkelijk doek in het Mauritshuis.' *Tableau,* vol. 6, no. 3, (1983-84), pp. 52-53.

Smith 1829-42
J. A. Smith, *A Catalogue Raisonné of the Works of the Most Eminent Dutch, Flemish, and French Painters.* 9 vols. and Supplement. (London 1829-42).

Smith 1982
D. R. Smith, *Masks of Wedlock, Seventeenth-Century Dutch Marriage Portraiture.* (Ann Arbor 1982).

de Sousa-Leão 1948
J. de Sousa-Leão, *Frans Post, 1612-80.* (Amsterdam 1973).

Staring 1924
A. Staring, 'Johannes Petrus van Horstok' in Thieme, Becker 1907-50, vol. 17, p. 537.

Staring 1956
A. Staring, *De Hollanders Thuis: Gezelschapstukken uit drie eeuwen.* (The Hague 1956).

Staring 1965
A. Staring, 'Een Raadselachtige Kamerbeschildering.' *Bull. van het Rijksmuseum,* vol. 13 (1965), pp. 3-13.

Stechow 1935
W. Stechow, 'Cornelis Saftleven' in Thieme, Becker 1907-50, vol. 29, pp. 309-10.

Stechow 1966
W. Stechow, *Dutch Landscape Painting of the Seventeenth Century.* (London and New York 1966).

Stechow 1969
W. Stechow, 'Some observations on

Rembrandt and Lastman.' *Oud Holland*, vol. 84 (1969), pp. 148-62.

Stechow 1973
W. Stechow, 'A Genre Painting by Brekelenkam.' *Allen Memorial Art Museum Bulletin*, vol. 30 (1973), pp. 74-84.

Stechow 1975
W. Stechow, *Salomon van Ruysdael.* (Berlin 1975).

Stechow, Ozinga 1931
W. Stechow and M. D. Ozinga, 'Paulus Moreelse' in Thieme, Becker 1907-50, vol. 25, pp. 131-32.

Steland-Stief 1971
A. C. Steland-Stief, *Jan Asselijn.* (Amsterdam 1971).

Stone Ferrier 1985
L. A. Stone-Ferrier, *Images of textiles: the Weave of Seventeenth Century Dutch Art and Society.* (Ann Arbor 1985).

Strutt 1827
Anon, *A Catalogue of Paintings, Drawings, etc., in the collection of Joseph Strutt, Derby.* (Derby 1827).

Sullivan 1980
S. A. Sullivan, 'Rembrandt's *Self-Portrait with a Dead Bittern.*' *The Art Bulletin*, vol. 62 (1980), pp. 236-43.

Sullivan 1984
S. A. Sullivan, *The Dutch Gamepiece.* (Totowa and Montclair 1984).

Sumowski 1968
W. Sumowski, 'Hitherto Unknown Draughtsmen of the Rembrandt School.' *Master Drawings*, vol. 6 (1968), pp. 271-76.

Sumowski 1979-
W. Sumowski, *Drawings of the Rembrandt School.* Multi vol. (New York 1979-).

Sumowski 1983-
W. Sumowski, *Gemälde der Rembrandt-Schüler.* 4 vols. (Landau 1983-).

Sutton 1980
P. C. Sutton, *Pieter de Hooch: Complete Edition with a Catalogue Raisonné.* (Oxford 1980).

Swillens 1946
P. T. A. Swillens, 'Jacob van Hasselt.' *Oud Holland*, vol. 61 (1946), pp. 133-41.

Tardieu 1873
C. Tardieu, 'Les Grandes Collections Étrangères, II, M. John W. Wilson.' *Gazette des Beaux-Arts*, vol. 8 (1873), pp. 215-22.

Thieme, Becker 1907-50
U. Thieme and F. Becker, eds., *Allgemeines Lexikon der bildenden Künstler von der Antike bis zur Gegenwart.* 37 vols. (Leipzig 1907-50).

Thirlestane 1846
Anon, *Hours in the Picture Gallery at Thirlestane House, Cheltenham.* (Cheltenham and London 1846).

Trautscholdt 1938
E. Trautscholdt, 'Dirck Stoop' in Thieme, Becker 1907-50, vol. 32, pp. 113-15.

Trautscholdt 1947
E. Trautscholdt, 'Emmanuel de Witte' in Thieme, Becker 1907-50, vol. 36, pp. 121-27.

Trivas 1941
N. S. Trivas, *The Paintings of Frans Hals.* (New York and London 1941).

Tümpel 1974
A. Tümpel, 'Claes Cornelisz. Moeyaert.' *Oud Holland*, vol. 88 (1974), pp. 1-163 and 245-90.

Utrecht 1965
Exh. cat., *Nederlandse 17e eeuwse Italianiserende landschapschilders.* Centraal Museum, Utrecht. (1965). Catalogue by A. Blankert.

Valentiner 1909
W. R. Valentiner, *Rembrandt, des meisters Gemälde.* Klassiker der Kunst. (Stuttgart and Berlin 1909).

Valentiner 1913
W. R. Valentiner, *Catalogue of a collection of paintings and some art objects (John G. Johnson Collection).* 2 vols. (Philadelphia 1913).

Valentiner 1921
W. R. Valentiner, *Frans Hals, des Meisters Gemälde.* Klassiker der Kunst. (Stuttgart and Berlin 1921).

Valentiner 1930
W. R. Valentiner, *Pieter de Hooch. Des Meisters Gemälde in 180 Abbildungen mit einem Anhang über die Genremaler um Pieter de Hooch und die Kunst Hendrick van der Burchs.*

Klassiker der Kunst. (Berlin and Leipzig 1929). English edition, translated by A. M. Sharkey and E. Schwandt (London 1930).

Valentiner 1933
W. R. Valentiner, 'Zum Werk Gerrit Willemsz. Horsts.' *Oud Holland*, vol. 50 (1933), pp. 241-49.

Valentiner 1934
W. R. Valentiner, *Rembrandt, des Meisters Handzeichnungen,* vol 2. Klassiker der Kunst. Vol. 2. (Stuttgart and Berlin 1934).

Voss 1909
H. Voss, 'Nochmals der Meister des Sterbenden Cato,' *Monatshefte für Kunstwissenschaft,* vol. 2 (1909), pp. 400-01.

de Vries 1977
L. de Vries, *Jan Steen, 'de kluchtschilder'.* Dissertation. (Groningen 1977).

Vroom 1980
N. R. A. Vroom, *A Modest Message as intimated by the painters of the 'Monochrome Banketje'.* 2 vols. (Schiedam 1980).

Waagen 1854
(G. F.) Waagen, *Treasures of Art in Great Britain.* 3 vols. (London 1854).

Waagen 1857
G. F. Waagen, *Galleries and Cabinets of Art in Great Britain . . . forming a Supplemental volume to the Treasures of Art in Great Britain.* (London 1857).

Waller 1938
F. G. Waller, *Biographisch Woordenboek van Noord-Nederlandse Graveurs.* (The Hague 1938).

Walpole 1762
H. Walpole, 'Journals of Visits to Country Seats &c.' ed. P. Toynbee, *Walpole Society,* vol. 16 (1928), pp. 9-80.

Warsaw, National Museum, cat. 1969-70
National Museum in Warsaw, *Catalogue of Paintings, Foreign Schools.* 2 vols. (1969-70).

Washington/Detroit/Amsterdam 1980-81
Exh. cat., *Gods, Saints and Heroes: Dutch Painting in the Age of Rembrandt.* National Gallery of Art, Washington D.C.; Detroit Institute of Arts, Detroit, and Rijksmuseum, Amsterdam. (1980-81). Cat. by A. Blankert, B. Breeninkmeyer-de Rooij, C. Brown, S. Donahue Kuretsky, E. J. Sluijter,

D. P. Snoep, P. van Thiel, A. Tümpel, C. Tümpel, A. K. Wheelock, Jr.

Welcker 1933
C. J. Welcker, *Hendrick Avercamp, 1585-1634, bijgenaamd 'de Stomme van Campen' en Barent Avercamp, 1612-1679, 'Schilders tot Campen,'* (Zwolle 1933).

Welcker 1979
C. J. Welcker, *Hendrick Avercamp, 1585-1634, bijgenaamd 'de Stomme van Campen' en Barent Avercamp, 1612-1679, 'Schilders tot Campen',* with a revised catalogue by D. J. Hensbroek-van der Poel. (Doornspijk 1979).

van Westrheene 1856
T. van Westrheene, *Jan Steen: Étude sur l'art en Hollande.* (The Hague 1856).

van Westrheene 1867
T. van Westrheene, *Paulus Potter. Sa vie et ses oeuvres.* (The Hague 1867).

van de Wetering 1983
E. van de Wetering, 'Isaac Jouderville, a pupil of Rembrandt.' in Amsterdam/Groningen 1983, pp. 59-69.

Wheelock 1975-76
A. K. Wheelock, Jr., 'Gerard Houckgeest and Emanuel de Witte: Architectural Painting in Delft around 1650.' *Simiolus,* vol. 8 (1975-76), pp. 167-85.

White 1982
C. White, *The Dutch Pictures in the Collection of Her Majesty the Queen.* (Cambridge 1982).

Wichmann 1929
H. Wichmann, 'Nicolaes Maes' in Thieme, Becker 1907-50, vol. 23, pp. 546-47.

Wolff 1947
H. Wolff, 'Jan Wynants' in Thieme, Becker 1907-50, vol. 36, pp. 329-31.

Wood 1913
T. M. Wood, exh. cat., *The Max Michaelis Gift to the Union of South Africa: Illustrated catalogue of Dutch and Flemish Paintings.* (London 1913).

von Wurzbach 1886
A. von Wurzbach, *Rembrandt Galerie: eine Auswahl von hundert Gemälde Rembrandts.* (Stuttgart 1886).

von Wurzbach 1906-11
A. von Wurzbach, *Niederländisches Künstler-*

Lexikon. 3 vols. (Vienna and Leipzig 1906-11).

Yale 1983
Exh. cat., *Rembrandt in eighteenth century England.* Yale Center for British Art, New Haven. (1983).

Zeri 1954
F. Zeri, *La Galleria Spada in Roma.* (Florence 1954).

Zülch 1929
W. K. Zülch, 'Johannes Lingelbach' in Thieme, Becker 1907-50, vol. 23, p. 252.

Zwolle 1957
Exh. cat., *Hendrick ten Oever een vergeten Overijssels meester uit de zeventiende eeuw.* Provinciaal Overijssels Geschiedkundig Museum te Zwolle. (1957). Cat. by J. Verbeek and J. W. Schotman.

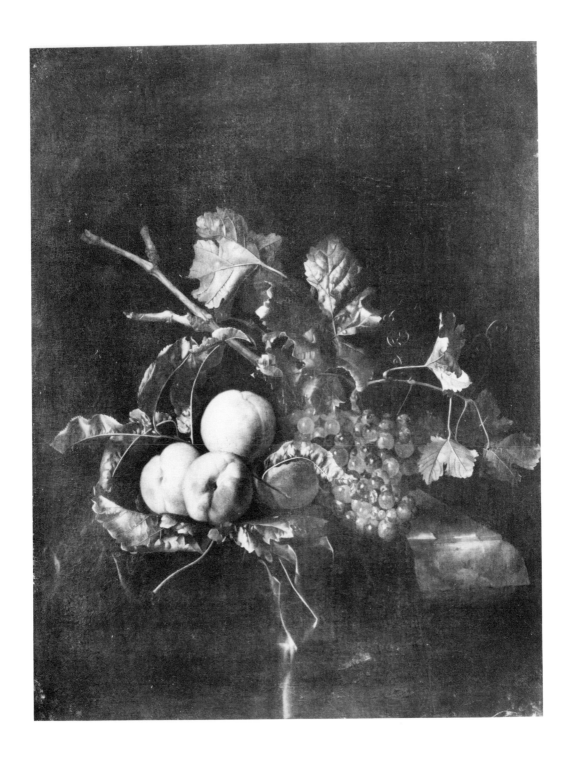

Fig. 1 Willem van Aelst, *A flower-piece* (cat. no. 1015).

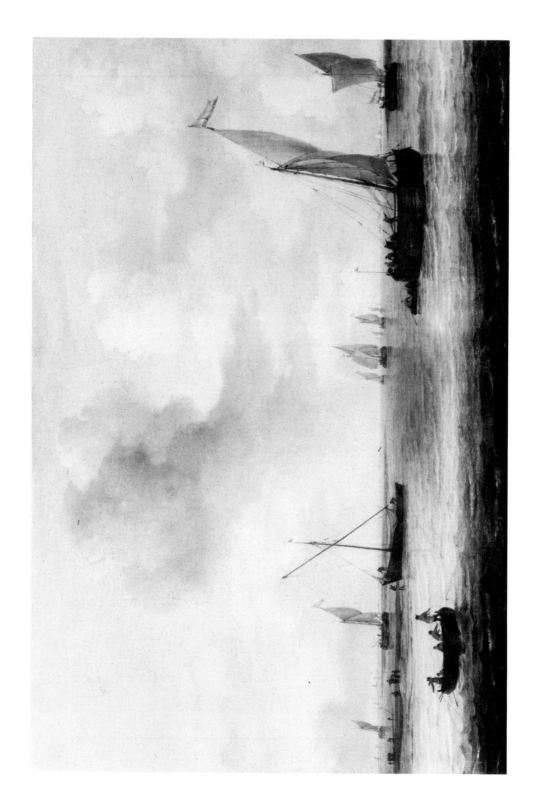

Fig. 2 Arnoldus van Anthonissen, *A river scene with shipping* (cat. no. 152).

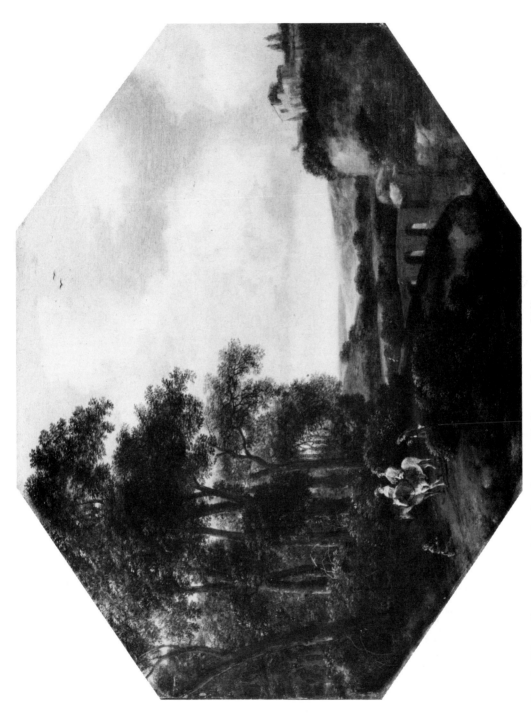

Fig. 3 Pieter Jansz. van Asch, *Landscape with figures* (cat. no. 343).

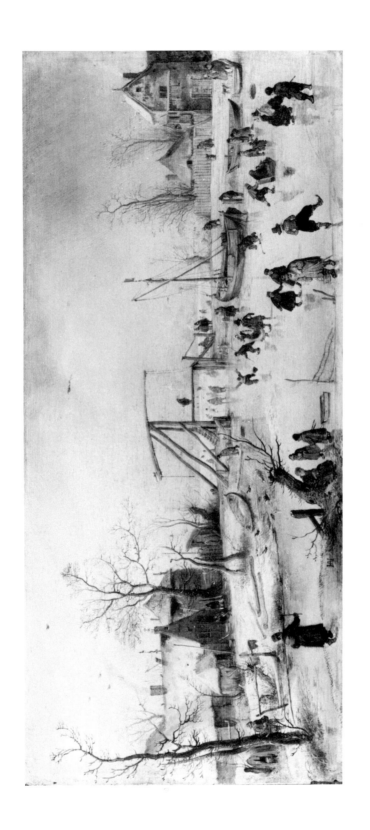

FIG. 4 Hendrick Avercamp, *Scene on the ice* (cat. no. 496).

Fig. 5 Hendrick Avercamp, *A winter landscape.* (Museum Boymans-van Beuningen, Rotterdam).

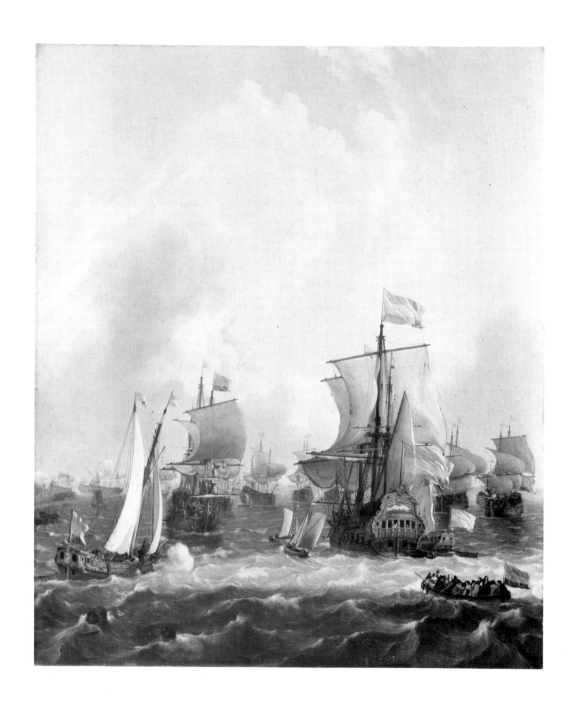

FIG. 6 Ludolf Bakhuizen, *The arrival of the 'Kattendijk' at The Texel, 22 July 1702* (cat. no. 173).

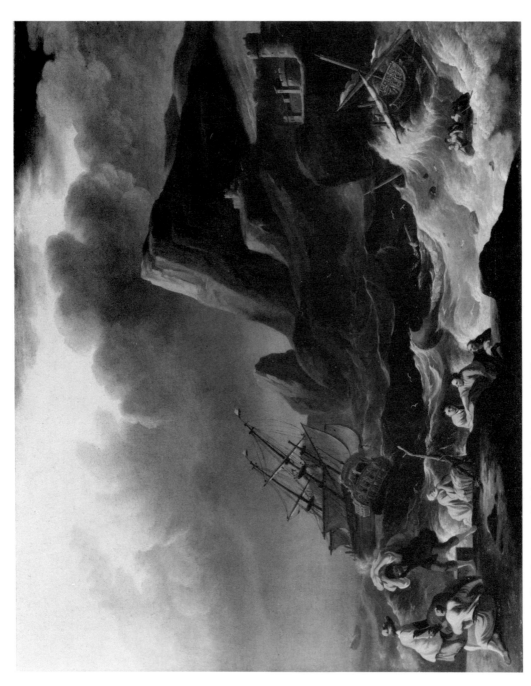

Fig. 7 Ludolf Bakuizen, *A shipwreck* (cat. no. 1673).

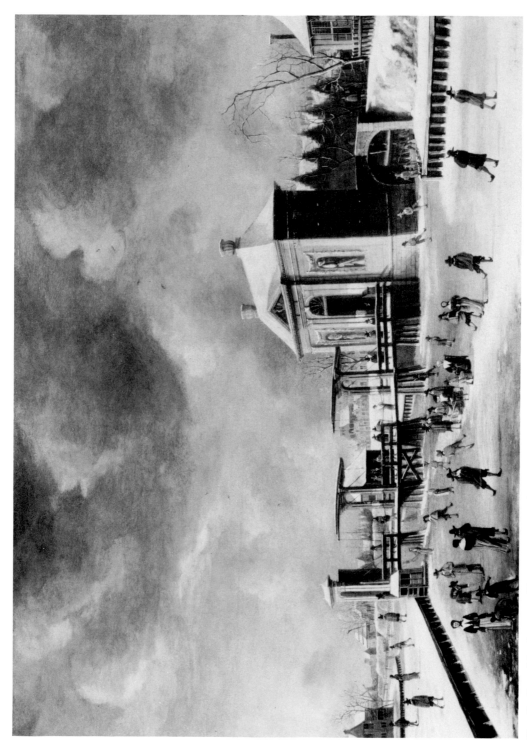

Fig. 8 Jan Abrahamsz. Beerstraaten, *The Heiligewegs Gate, Amsterdam* (cat. no. 679).

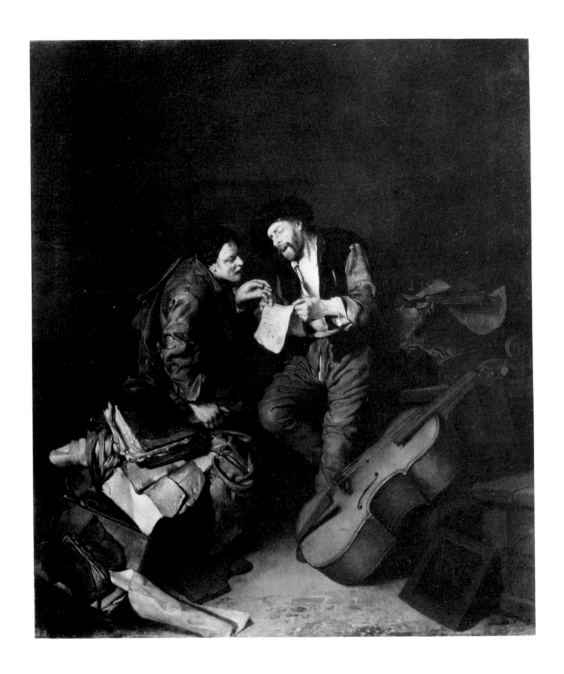

FIG. 9 Cornelis Bega, *Two men singing* (cat. no. 28).

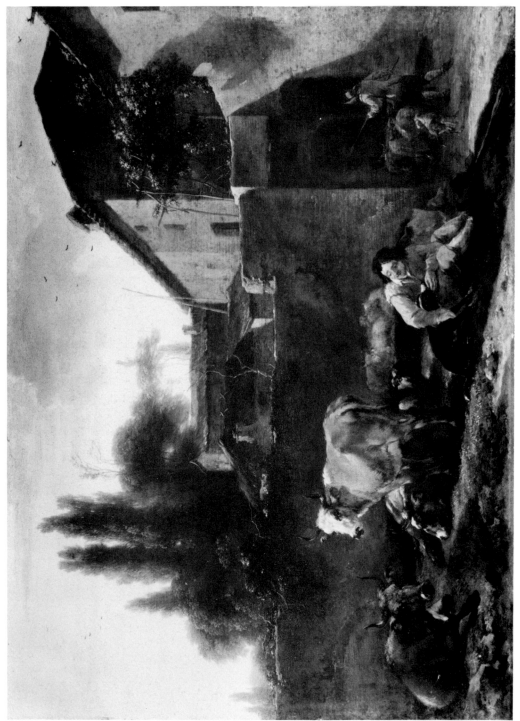

FIG. 10 Nicolaes Berchem, *An Italian farmhouse* (cat. no. 176).

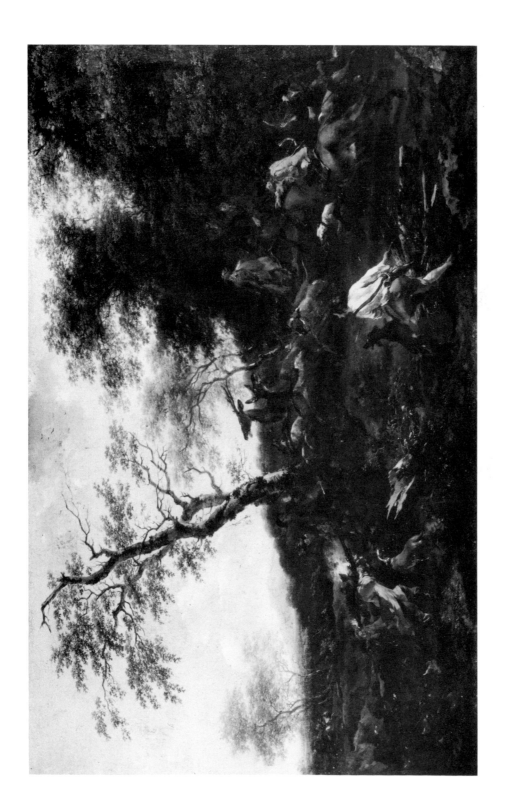

Fig. 11 Nicolaes Berchem, *A stag hunt* (cat. no. 245).

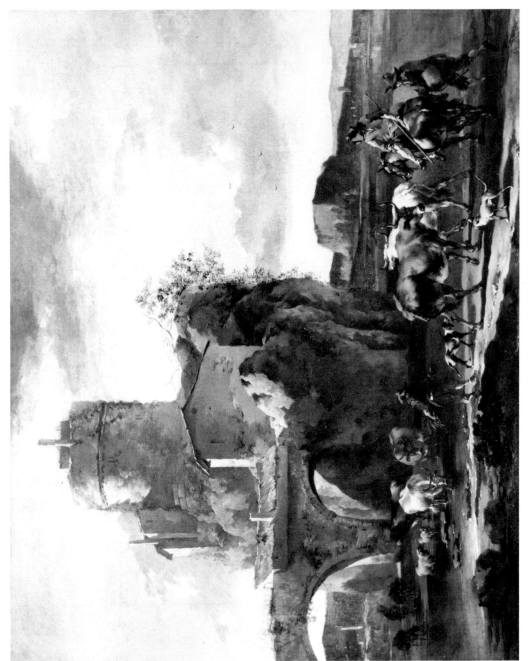

FIG. 12 Nicolaes Berchem, *An Italianate landscape* (cat. no. 510).

Fig. 13 Nicolaes Berchem, *A ruin with cattle in an Italianate landscape* (Hermitage, Leningrad).

F<small>IG</small>. 14 Dirck van Bergen, *The old white horse* (cat. no. 59).

Fig. 15 Dirck van Bergen, *Cattle in a rocky landscape* (cat. no. 274).

Fig. 16 Gerrit Claesz. Bleker, *A raid on a village* (cat. no. 246).

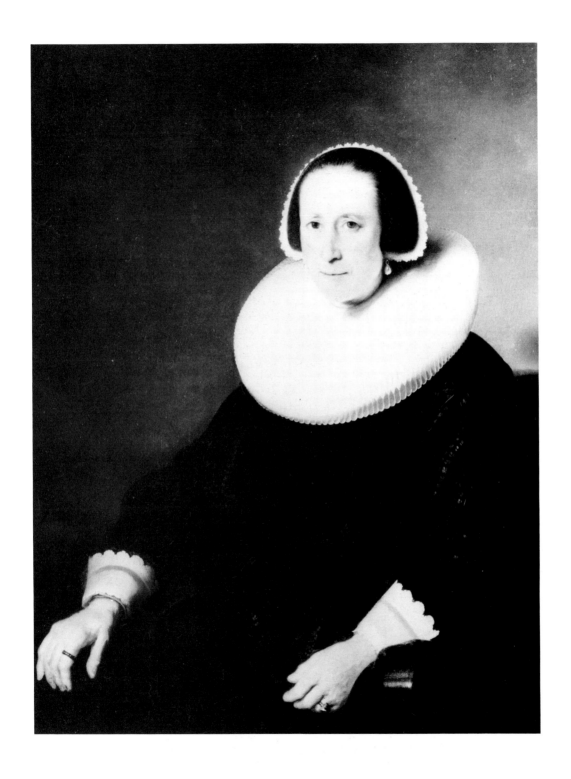

FIG. 17 Ferdinand Bol, *Portrait of a lady* (cat. no. 810).

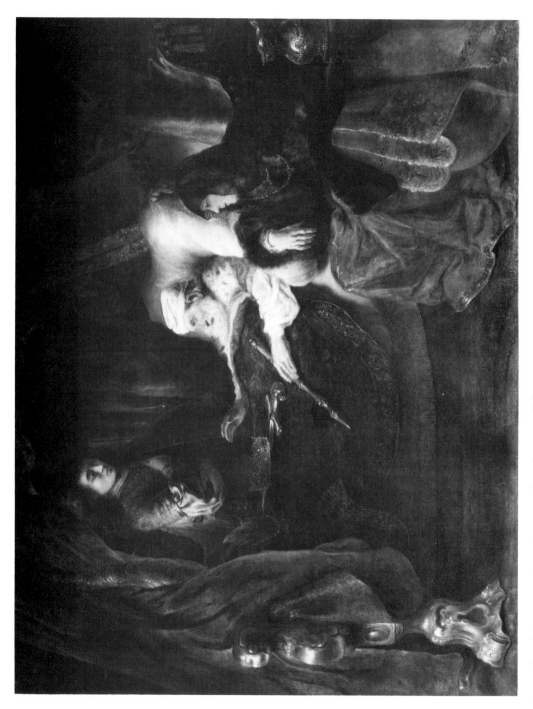

Fig. 18 Ferdinand Bol, *David's dying charge to Solomon* (cat. no. 47).

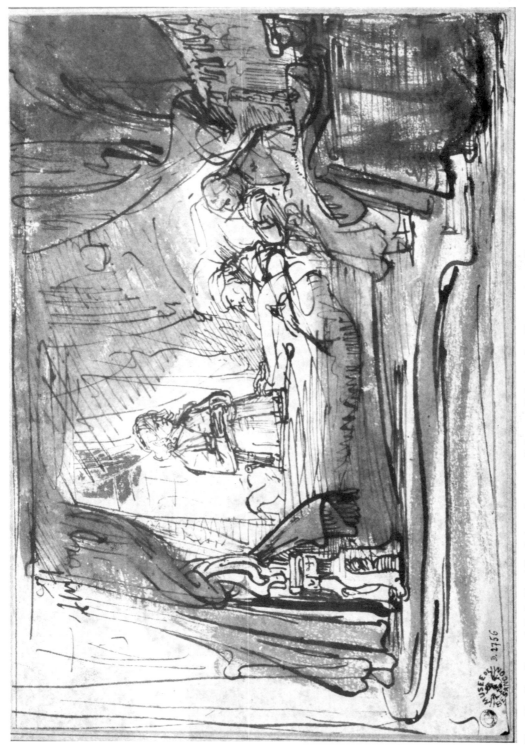

FIG. 19 Ferdinand Bol, *David's dying charge to Solomon* (Musée des Beaux-Arts, Besançon).

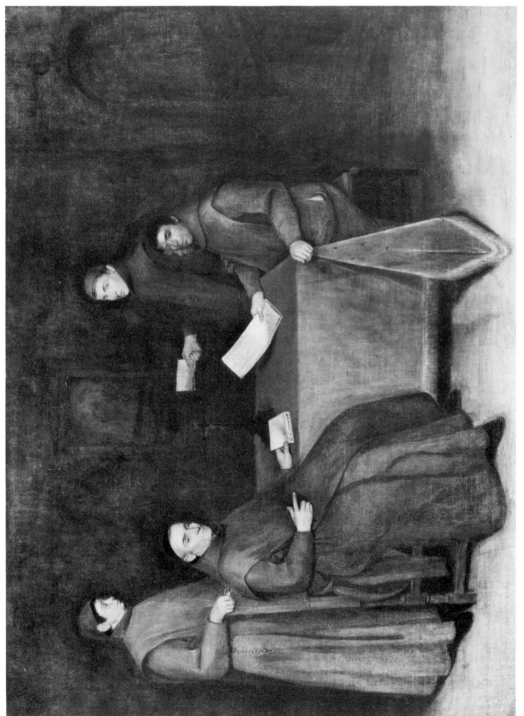

Fig. 20 Gerard ter Borch, *Four Franciscan monks* (cat. no. 849).

Fig. 21 Jan Both, *An Italianate landscape* (cat. no. 179).

FIG. 22 Jan Both, *A horse drinking* (cat. no. 706).

FIG. 23 Jan Both, *An Italianate landscape* (cat. no. 4292CB).

FIG. 24 Jan Salomonsz. de Braij, *The artist's brothers* (cat. no. 180).

FIG. 25 Radiograph of Jan Salomonsz. de Braij, *The artist's brothers* (cat. no. 180).

FIG. 26 Richard Brakenburgh, *Interior with figures* (cat. no. 1949).

FIG. 27 Bartholomeus Breenbergh, *A landscape with the ruins of the baths of Diocletian, Rome* (cat. no. 7194).

FIG. 28 Jan van de Cappelle, *A river scene in winter* (cat. no. 74).

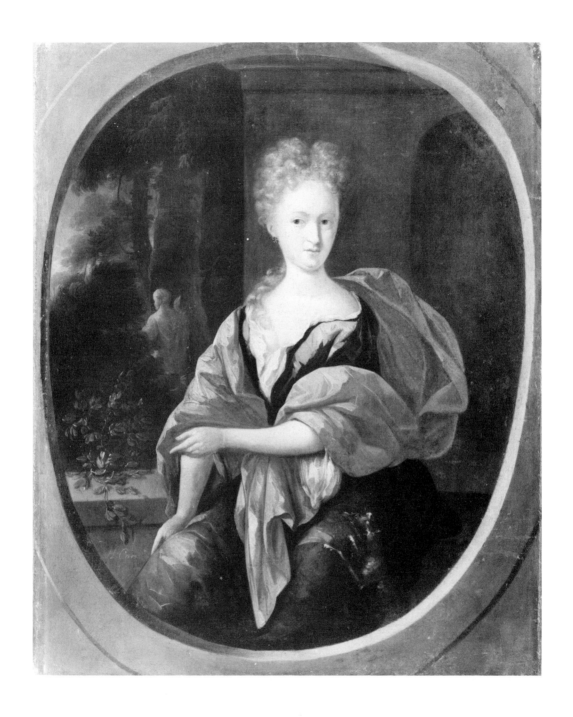

FIG. 29 Hendrik Carree, *Portrait of a lady* (cat. no. 1944).

Fig. 30 Pieter Claesz., *A breakfast-piece* (cat. no. 326).

FIG. 31 Pieter Claesz., *A breakfast-piece* (cat. no. 1285).

FIG. 32 Pieter Codde, *Interior with figures* (cat. no. 321).

FIG. 33 Jan ten Compe, *Village with a windmill* (cat. no. 1681).

FIG. 34 Anthony Jansz. van der Croos, *The castle of Montfoort near Utrecht* (cat. no. 328).

Fig. 35 After Aelbert Cuyp, *Landscape with three cows and a herdsman* (cat. no. 344).

FIG. 36 Studio of Aelbert Cuyp, *Milking cows* (cat. no. 49).

F<small>IG</small>. 37 Aelbert Cuyp, *Milking cows* (Present whereabouts unknown).

FIG. 38 Jacob Gerritsz. Cuyp, *Portrait of a man aged 40* (cat. no. 1047).

Fig. 39 Jacob Gerritsz. Cuyp, *Portrait of a lady aged 55* (cat. no. 1048).

FIG. 40 Ascribed to J. G. Cuyp, *A child with a dog* (cat. no. 151).

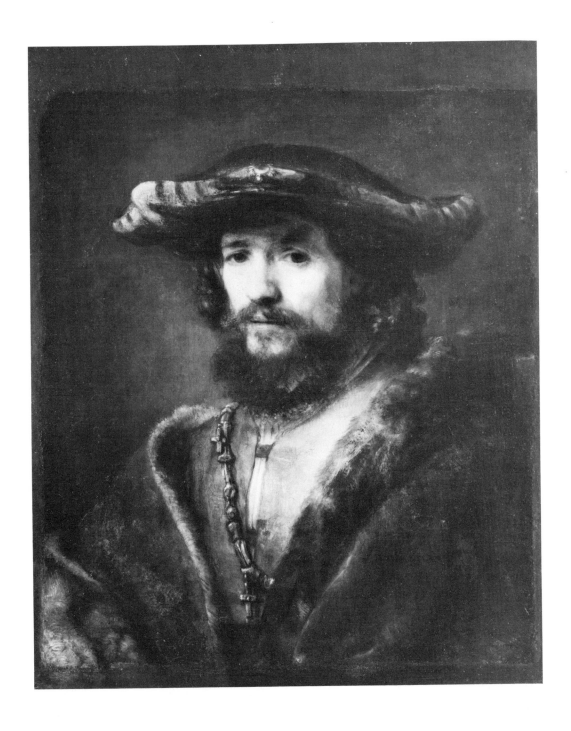

FIG. 41 Willem Drost, *Bust of a man wearing a large-brimmed hat* (cat. no. 107).

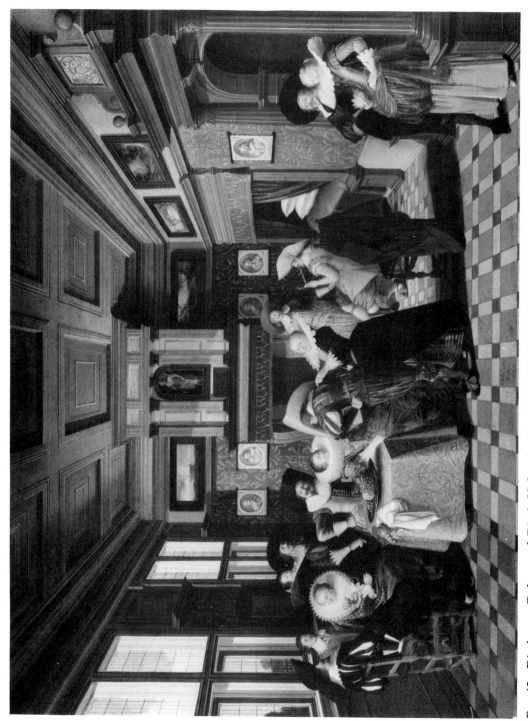

Fɪɢ. 42 Dirck van Delen and Dirck Hals, *An interior with ladies and cavaliers* (cat. no. 119).

FIG. 44 Dirck Hals, *A standing lady* (Stichting Victor de Stuers, Vorden).

FIG. 43 Dirck Hals, *A seated man smoking a pipe* (Rijksprentenkabinet, Amsterdam).

Fig. 45 Joost Cornelisz. Droochsloot, *The ferry* (cat. no. 252).

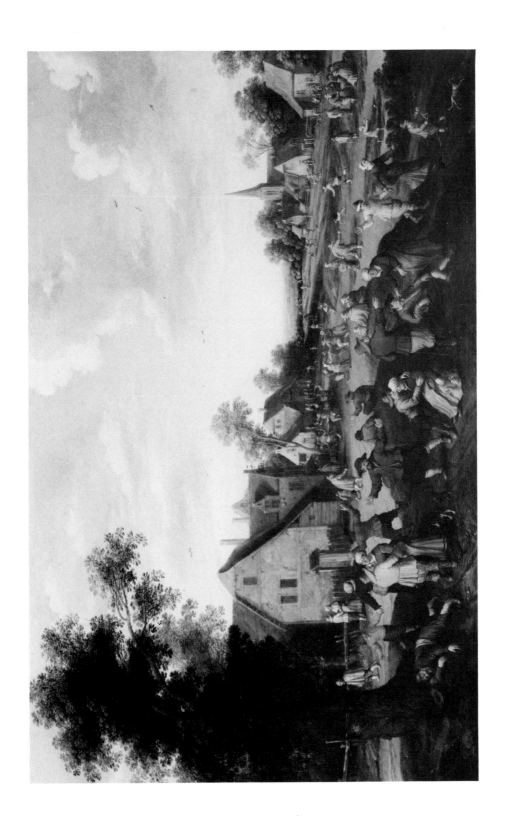

FIG. 46 Joost Cornelisz. Droochsloot, *A village festival* (cat. no. 1529).

Fig. 47 Jacob Duck, *Interior with a woman sleeping* (cat. no. 335).

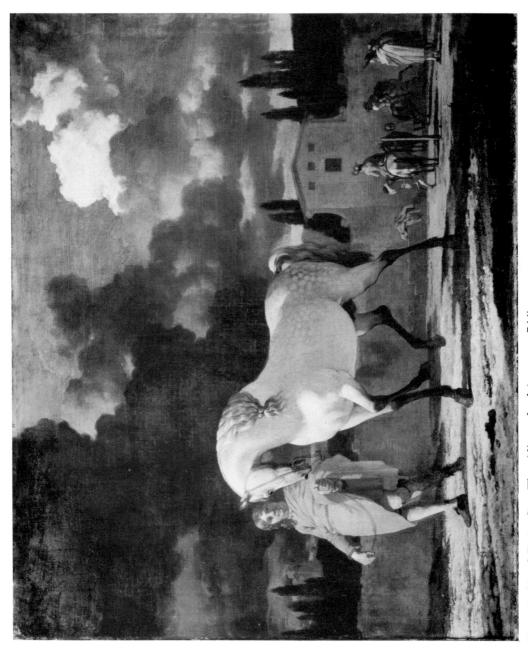

FIG. 48 Karel Dujardin, *The riding school* (cat. no. 544).

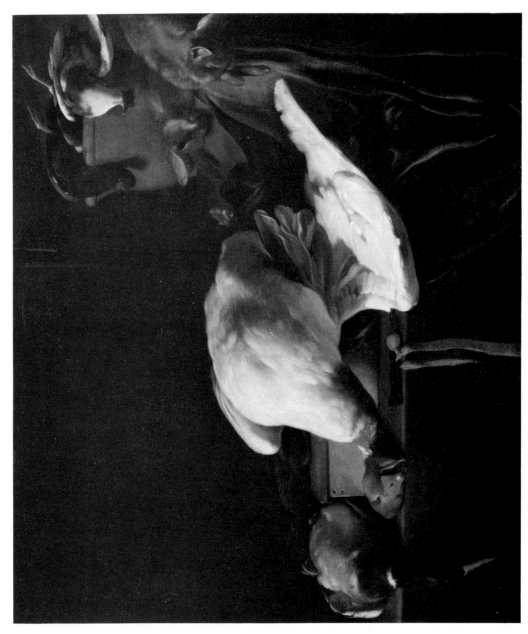

Fɪɢ. 49 Christiaen Jansz. Dusart, *Dead game* (cat. no. 961).

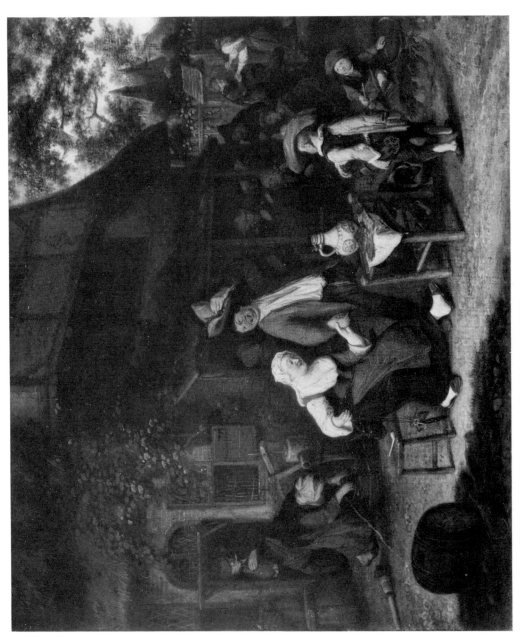

Fig. 50 Cornelis Dusart, *A merry-making* (cat. no. 324).

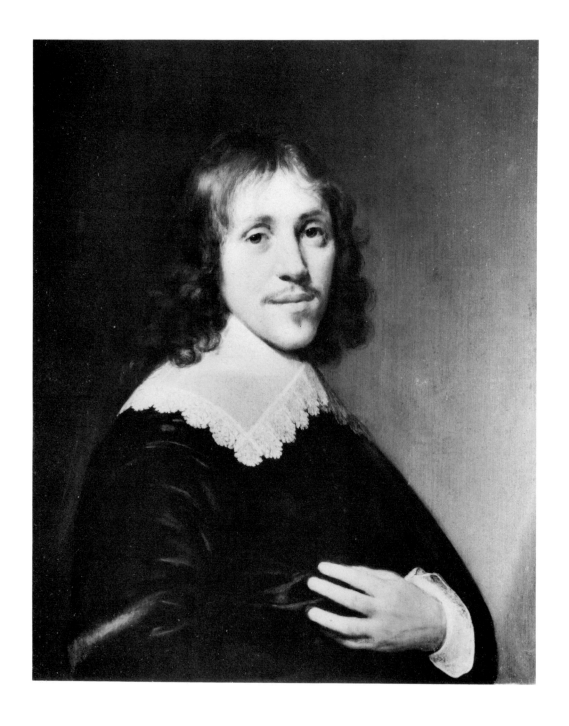

FIG. 51 Dutch School, 1641, *Portrait of a man aged 28* (cat. no. 36).

FIG. 52 Willem Duyster, *Portrait of a married couple* (cat. no. 556).

Fig. 53 Willem Duyster, *Interior with soldiers* (cat. no. 436).

FIG. 54 Gerbrandt van der Eeckhout, *Christ in the synagogue at Nazareth* (cat. no. 253).

FIG. 55 Ascribed to Isack Elyas, *The five senses* (cat. no. 333).

FIG. 56 Govert Flinck, *Bathsheba's appeal* (cat. no. 64).

FIG. 57 Govert Flinck, *Head of an old man* (cat. no. 254).

FIG. 58 Govert Flinck, *Portrait of a young man* (cat. no. 319).

FIG. 59 Barend Gael, *Landscape with figures* (cat. no. 325).

Fig. 60 Jan van Goyen, *A view of a town in Holland* (cat. no. 236).

Fig. 61 Jan van Goyen, *A view of Rhenen-on-the-Rhine* (cat. no. 807).

Fig. 62 Jan Griffier, *A river landscape* (cat. no. 336).

Fig. 63 Nicolaes de Gyselaer, *Interior with figures* (cat. no. 327).

Fig. 64 Ascribed to Frans Hals, *A fisherboy* (cat. no. 193).

Fig. 65 Jacob Gerritsz. van Hasselt, *View from the bishop's throne, west from the nave, towards the staircase tower in Utrecht Cathedral* (cat. no. 897).

Fig. 66 Claes (Nicolaas) Jacobsz. van der Heck, *A winter landscape* (cat. no. 904).

Fig. 67 Willem Claesz. Heda, *A banquet-piece* (cat. no. 514).

FIG. 68 Jan Davidsz. de Heem, *A vanitas fruit-piece* (cat. no. 11).

FIG. 69 Bartholomeus van der Helst, *Portrait of a lady aged 54* (cat. no. 65).

FIG. 70 Studio of Bartholomeus van der Helst, *Portrait of a man* (cat. no. 55).

FIG. 71 Nicolaes van Helt-Stockade, *Jupiter and Ganymede* (cat. no. 1046).

FIG. 72 Meindert Hobbema, *The ferry boat* (cat. no. 832).

Fig. 73 Melchior de Hondecoeter, *Poultry* (cat. no. 509).

Fig. 74 François Boucher, after de Hondecoeter, *A cock* (Nationalmuseum, Stockholm).

Fig. 75 François Boucher, after de Hondecoeter, *A hen* (Nationalmuseum, Stokholm).

Fig. 76 Gerrit van Honthorst, *A feasting scene (the interior of a brothel)* (cat. no. 1379).

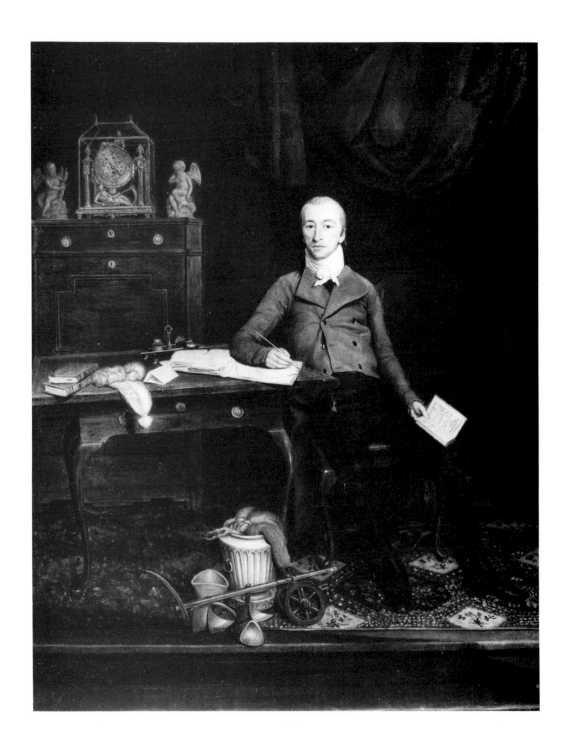

Fig. 77 Johannes Petrus Horstok, *Portrait of Jean-Jacques Dessont (1760-1809)*
(cat. no. 650).

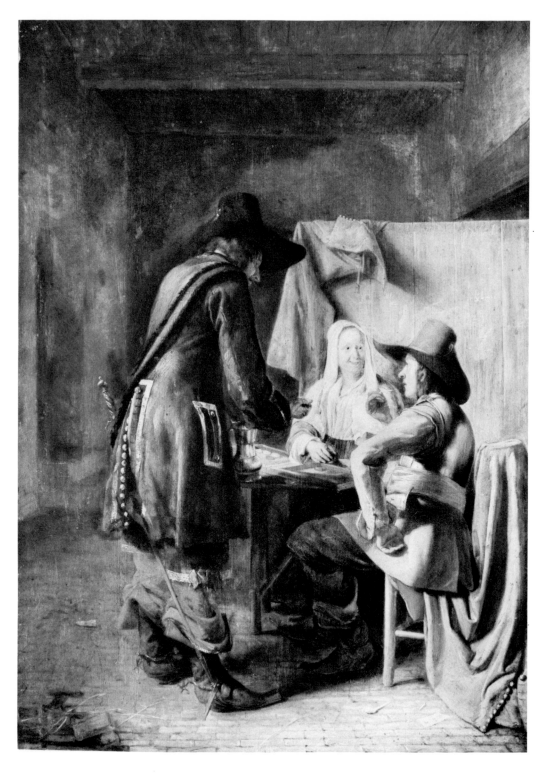

FIG. 78 Pieter de Hooch, *Players at tric-trac* (cat. no. 322).

Fig. 79 Radiograph of a detail of Pieter de Hooch, *Players at tric-trac* (cat. no. 322).

Fig. 80 After Gerard Houckgeest, *Interior of the New Church in Delft with the tomb of William the Silent* (cat. no. 530).

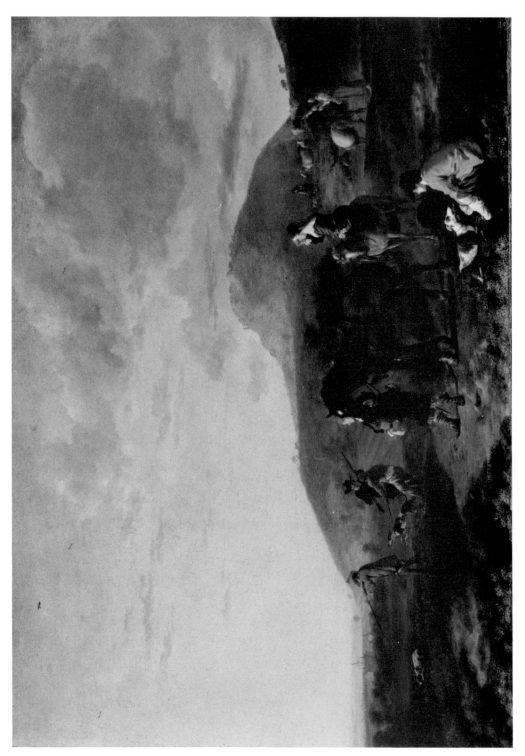

Fig. 81 Ludolf de Jongh, *Landscape with a shooting party* (cat. no. 44).

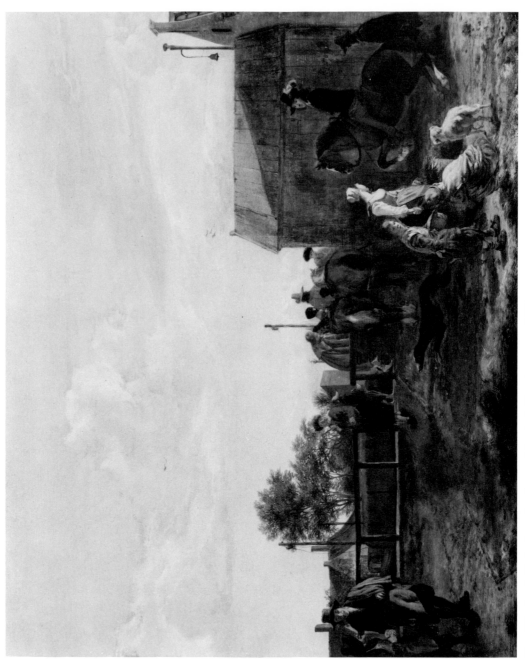

Fɪɢ. 82 Ludolf de Jongh, *A canal boat station* (cat. no. 148).

Fig. 83 Ludolf de Jongh, *Two standing figures*
(Kupferstichkabinett, Berlin-Dahlem).

FIG. 84 Isaac de Jouderville, *Bust of a young man* (cat. no. 433).

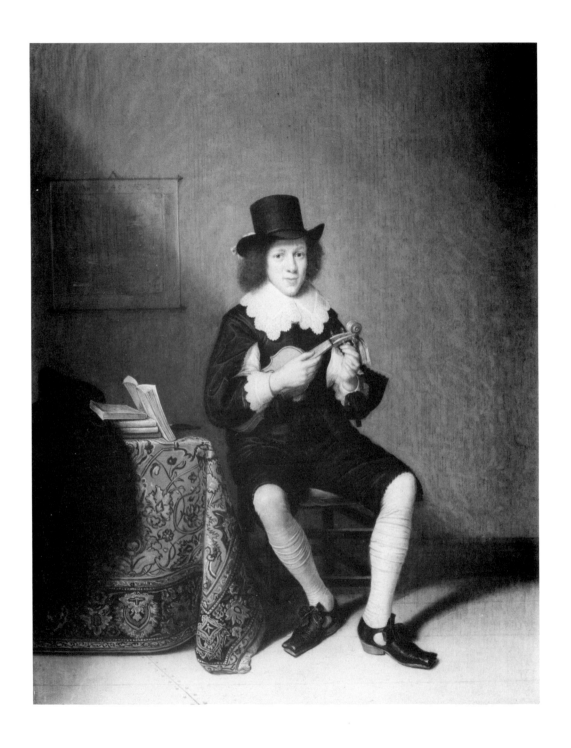

Fɪɢ. 85 Godaert Kamper, *A man aged 20 tuning a violin* (cat. no. 806).

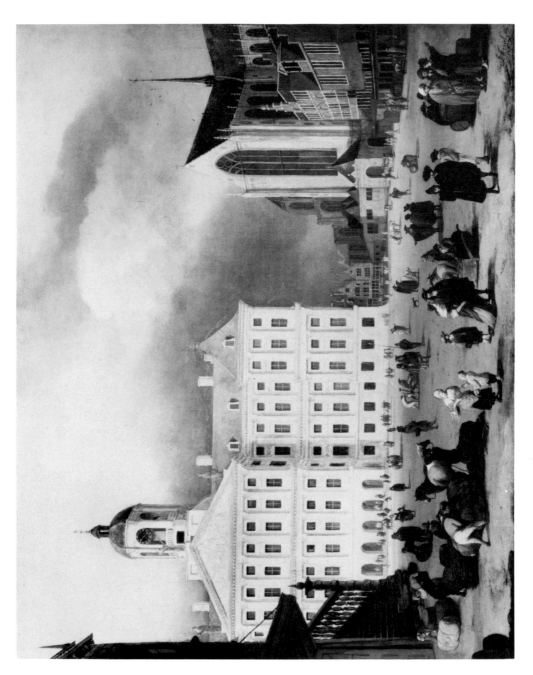

FIG. 86 Jan van Kessel, *The Dam at Amsterdam* (cat. no. 933).

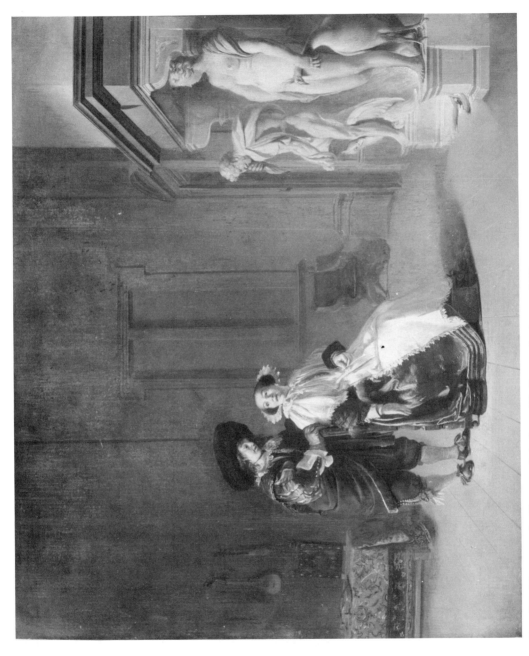

FIG. 87 Thomas de Keyser, *Interior with figures* (cat. no. 469).

Fɪɢ. 88 Simon Kick, *An artist painting a portrait* (cat. no. 834).

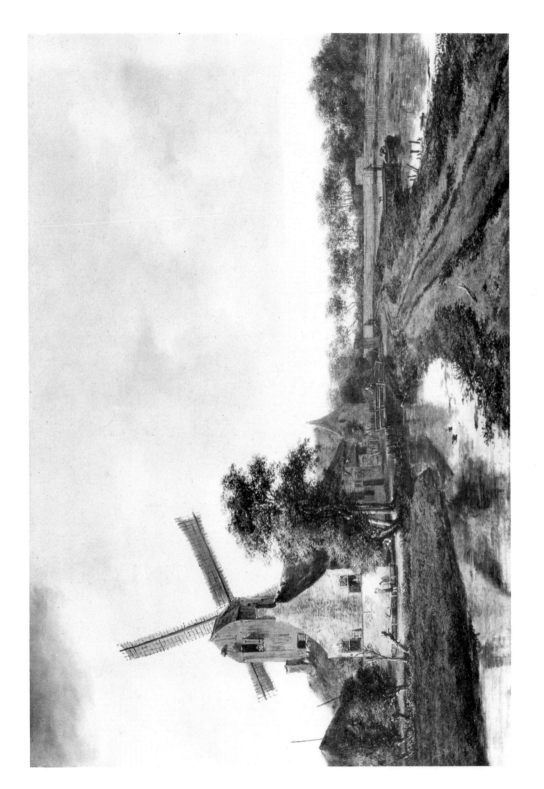

FIG. 89 Wouter Knijff, *The windmill* (cat. no. 53).

Fig. 90 Style of Salomon Koninck, *Portrait of a man* (cat. no. 329).

FIG. 91 Jan Lagoor and Adriaen van de Velde, *The ferry boat* (cat. no. 515).

FIG. 92 Pieter Lastman, *Joseph selling corn in Egypt* (cat. no. 890).

FIG. 94 van den Eeckhout,
after Pieter Lastman,
Joseph selling corn in Egypt
(Louvre, Paris).

FIG. 93 Rembrandt, after Pieter Lastman, *Joseph selling corn in Egypt*
(Albertina, Vienna).

Fig. 95 Judith Leyster, *A woman sewing by candlelight* (cat. no. 468).

FIG. 96 Jan Lievens, *Head of an old man* (cat. no. 607).

FIG. 97 Johannes Linglebach, *A hunting party* (cat. no. 348).

Fɪɢ. 98 Anthonie de Lorme, *Interior of the St. Laurenskerk, Rotterdam* (cat. no. 558).

FIG. 99 Anthonie de Lorme, *An interior of a Church* (cat. no. 516).

F<small>IG</small>. 100 Dirck Maes, *William III hunting at Het Loo* (cat. no. 147).

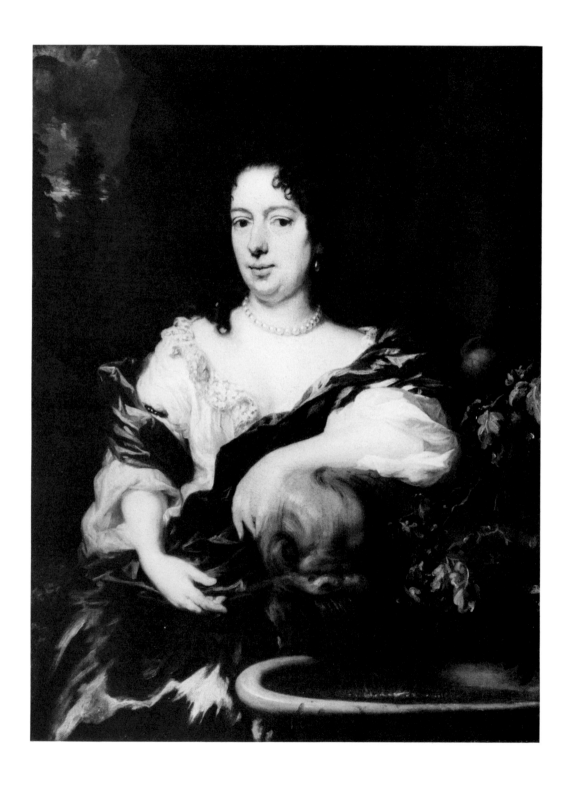

F<small>IG</small>. 101 Nicolaes Maes, *Portrait of a lady* (cat. no. 204).

FIG. 102 Nicolaes Maes, *Vertumnus and Pomona* (cat. no. 347).

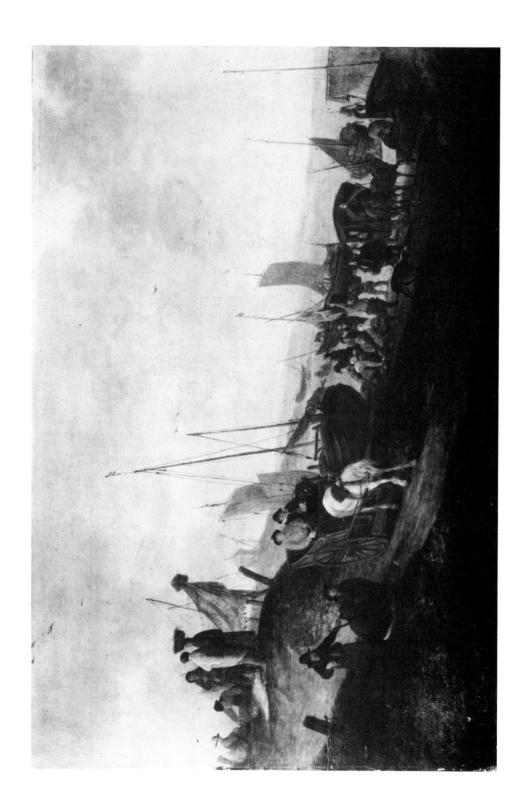

FIG. 103 Hendrik de Meyer, *A seacoast with figures* (cat. no. 1706).

FIG. 104 Ascribed to Michiel van Miereveld, *Portrait of a lady* (cat. no. 39).

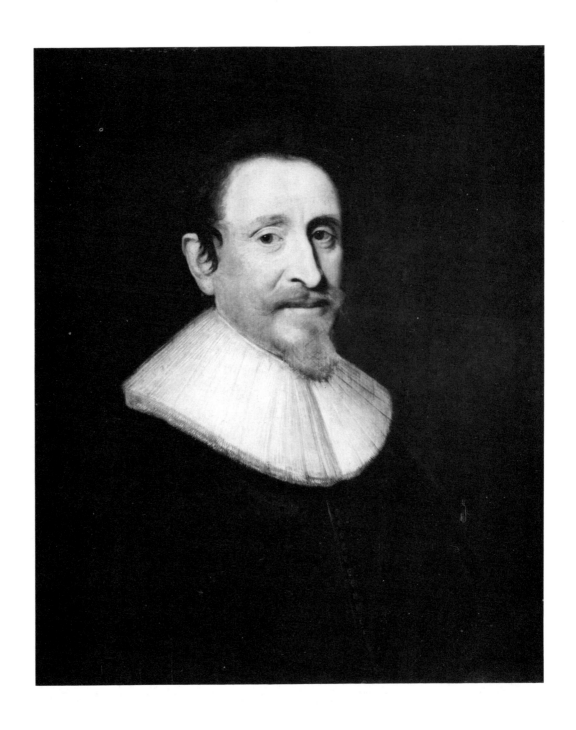

FIG. 105 After Michiel van Miereveld, *Portrait of Hugo Grotius (1583-1645)* (cat. no. 640).

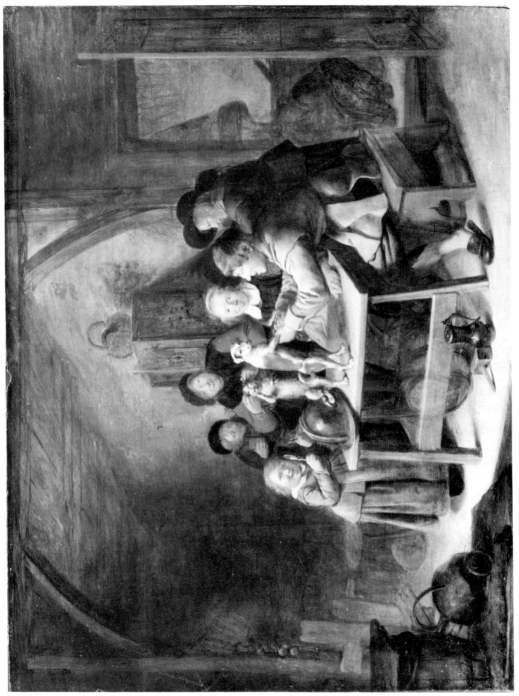

FIG. 106 Jan Miense Molenaer, *Peasants teaching a cat and a dog to dance* (cat. no. 45).

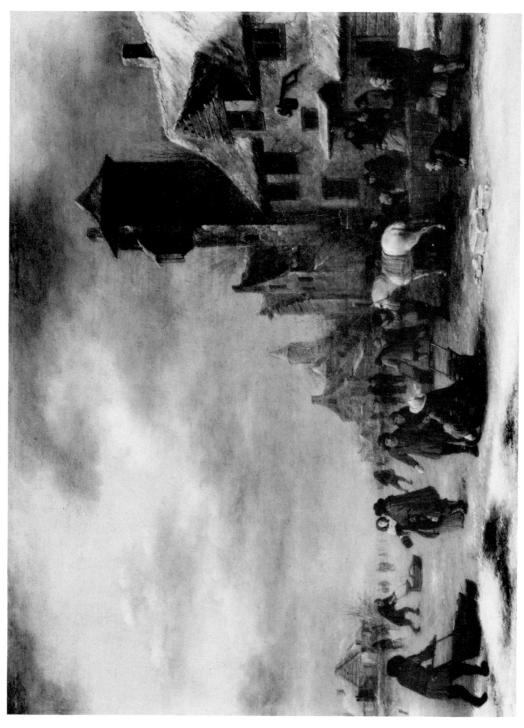

Fig. 107 Klaes Molenaer, *A winter scene* (cat. no. 682).

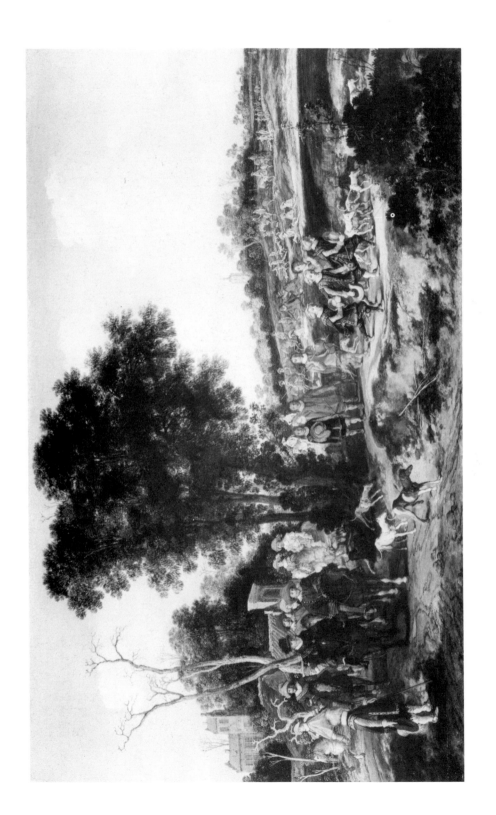

Fig. 108 Pieter de Molijn, *Prince Maurits and Prince Frederik Hendrik going to the chase* (cat. no. 8).

F<small>IG</small>. 109 Monogrammist IS, *A Dutch kitchen interior* (cat. no. 247).

FIG. 110 Paulus Moreelse, *Portrait of a child* (cat. no. 263).

FIG. 111 Frederik de Moucheron, *An Italianate landscape* (cat. no. 52).

Fig. 112 Jan Mytens, *A family group* (cat. no. 62).

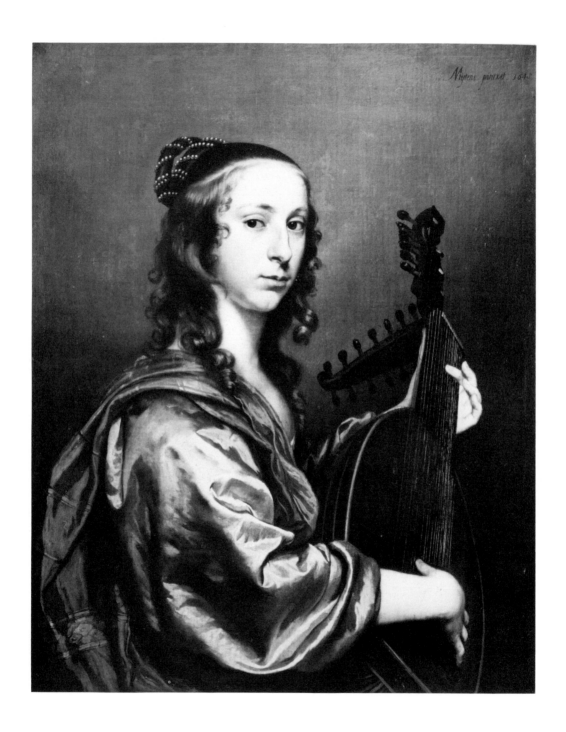

Fig. 113 Jan Mytens, *A lady playing a lute* (cat. no. 150).

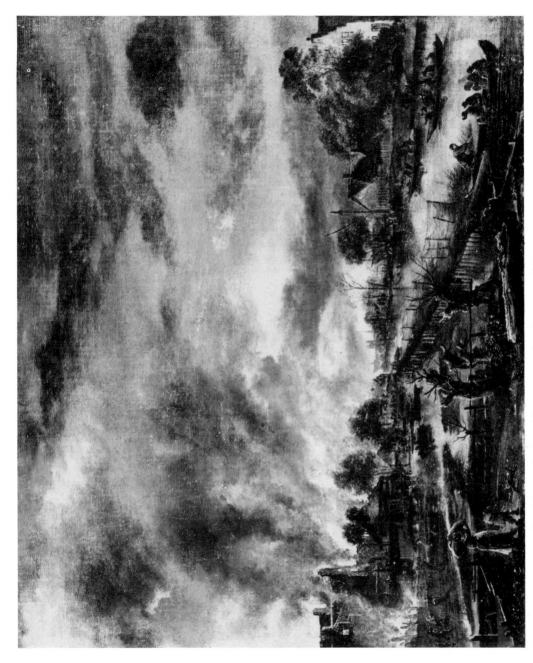

Fig. 114 Aert van der Neer, *A riverside town on fire* (cat. no. 66).

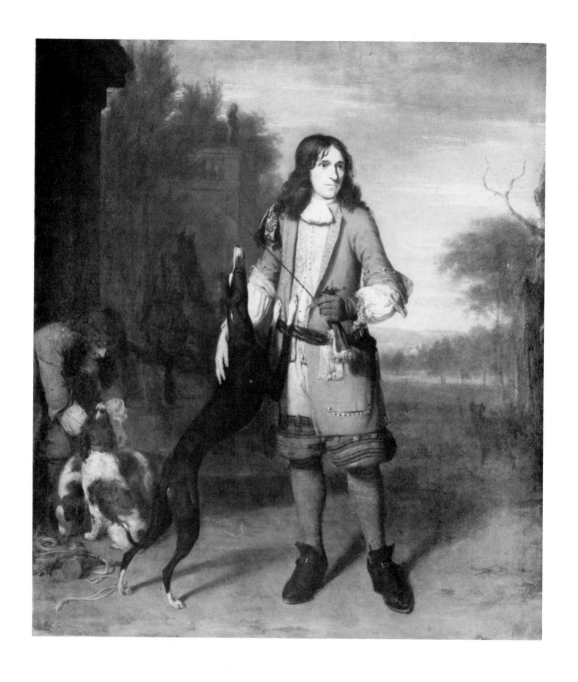

Fɪɢ. 115 Eglon van der Neer, *Portrait of a man as a hunter* (cat. no. 61).

Fig. 116 Jacob Ochtervelt, *A lady in a window holding a bunch of grapes* (cat. no. 435).

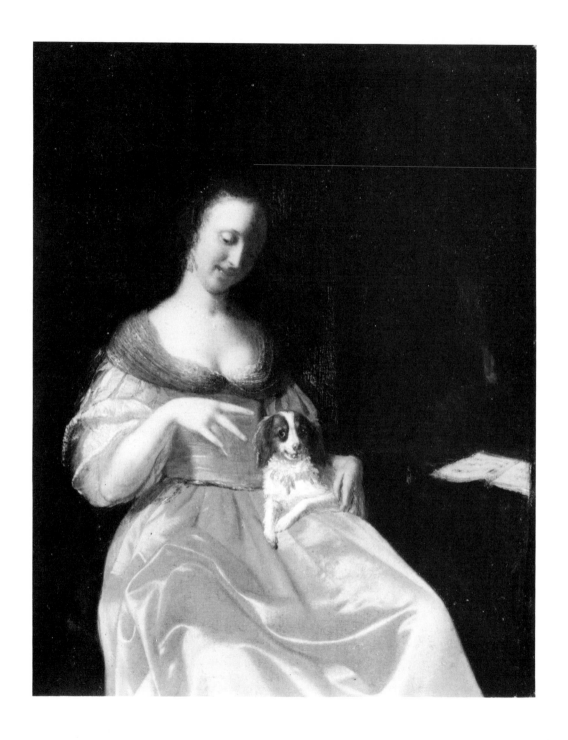

FIG. 117 Jacob Ochtervelt, *A lady with a dog* (cat. no. 641).

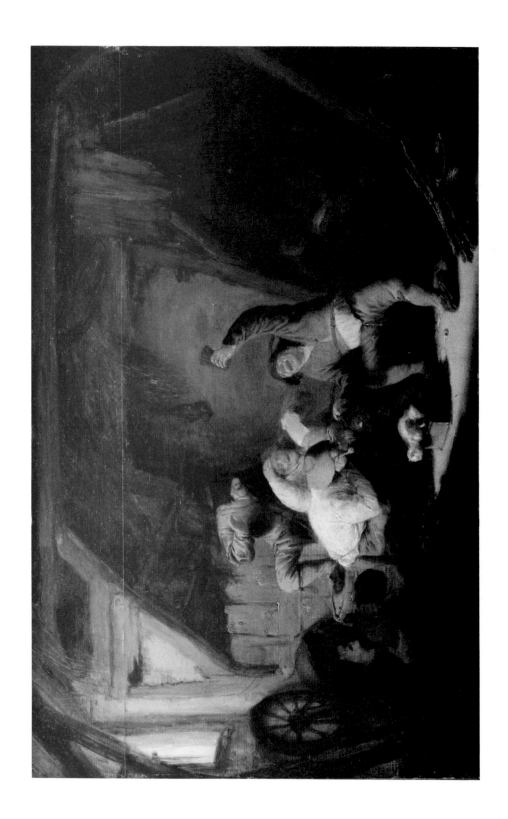

Fig. 118 Adriaen van Ostade, *Boors drinking and singing* (cat. no. 32).

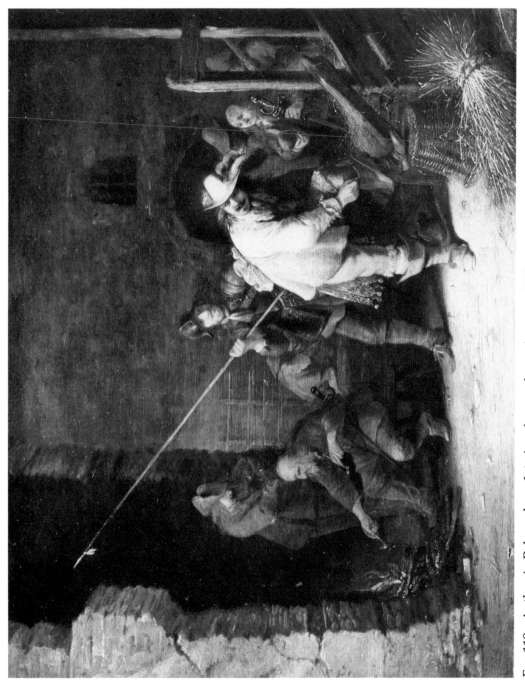

FIG. 119 Anthonie Palamedsz., *Interior of a guardroom* (cat. no. 531).

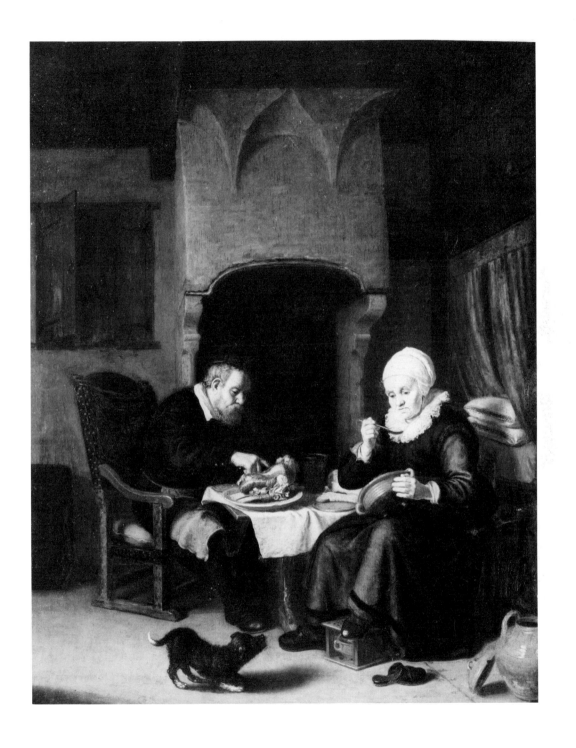

Fig. 120 Abraham de Pape, *The repast* (cat. no. 149).

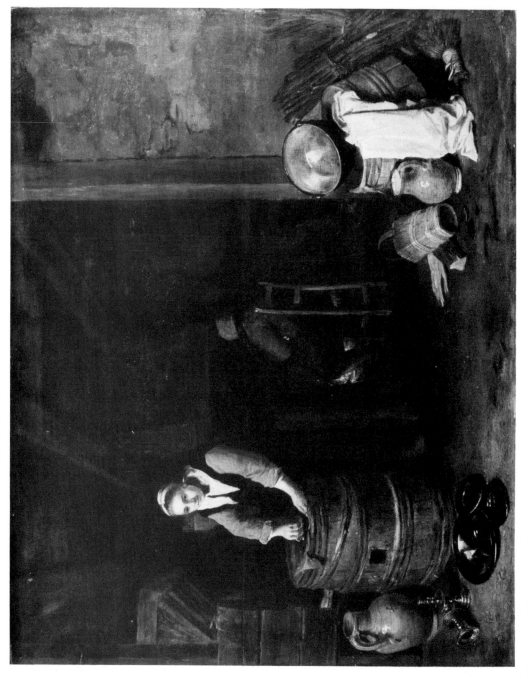

FIG. 121 Egbert van der Poel, *An interior with a woman ironing* (cat. no. 9).

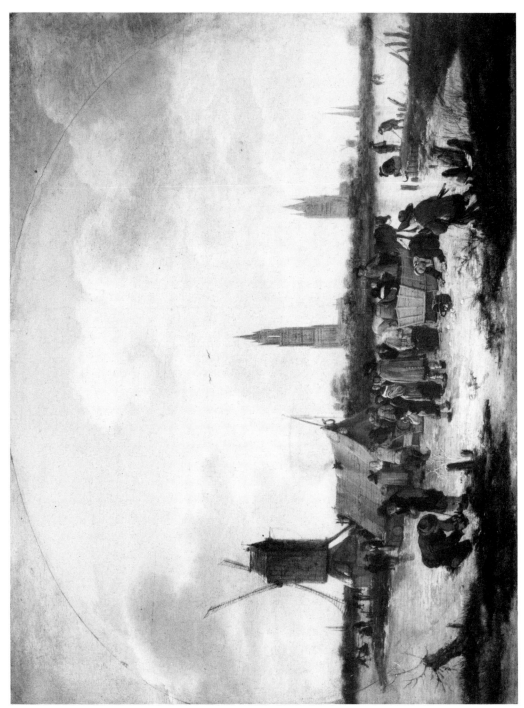

Fig. 122 Egbert van der Poel, *Scene on the ice* (cat. no. 22).

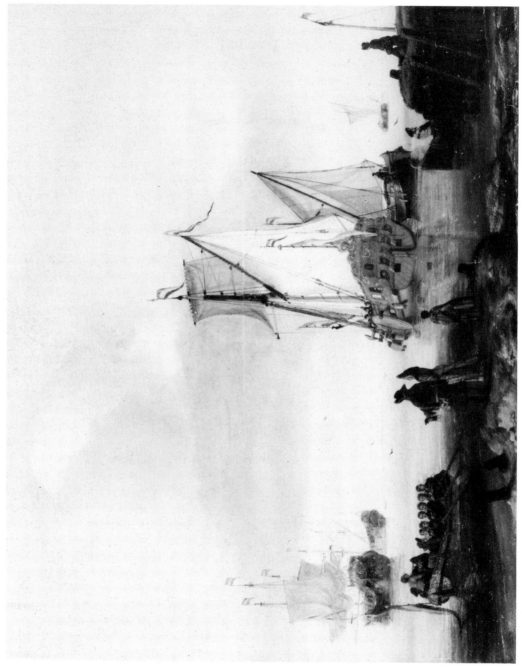

FIG. 123 Gerrit Pompe, *A Dutch yacht with fishing boats off a jetty* (cat. no. 850).

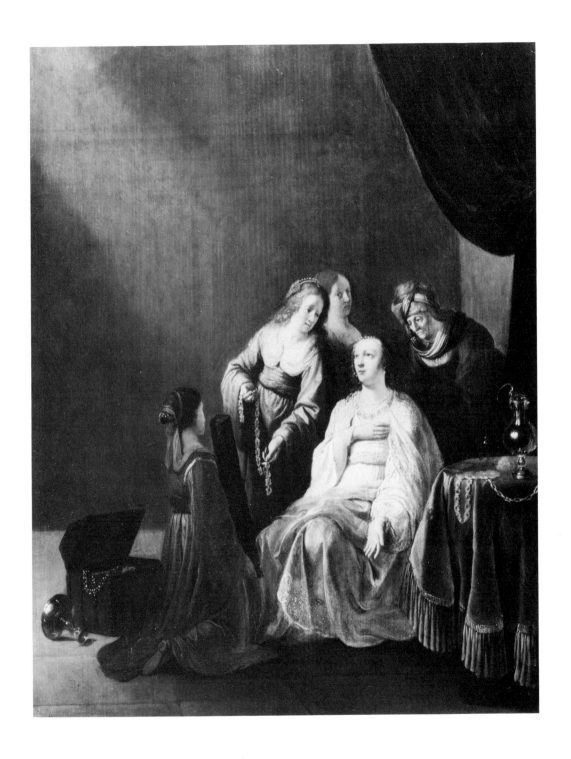

Fɪɢ. 124 Willem de Poorter, *The robing of Esther* (cat. no. 380).

FIG. 125 Frans Post, *A Brazilian landscape* (cat. no. 847).

FIG. 126 Hendrick Gerritsz. Pot, *Portrait of a man* (cat. no. 443).

Fɪɢ. 127 Imitator of Paulus Potter, *Head of a white bull* (cat. no. 56).

Fig. 128 Pieter Symonsz. Potter, *Soldiers in a guardroom* (cat. no. 323).

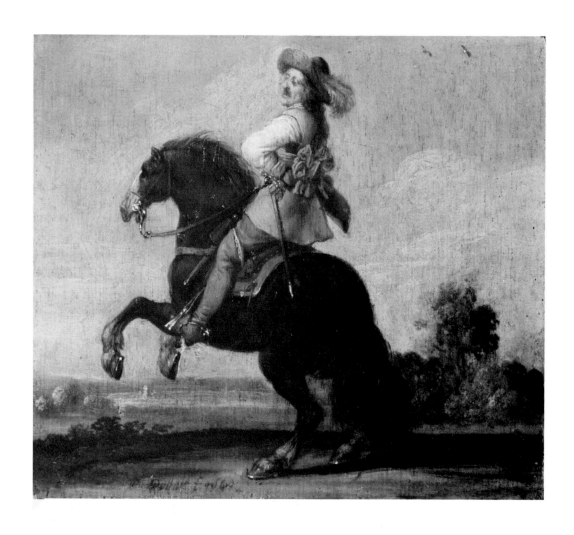

FIG. 129 Pieter Symonsz. Potter, *A mounted cavalier* (cat. no. 445).

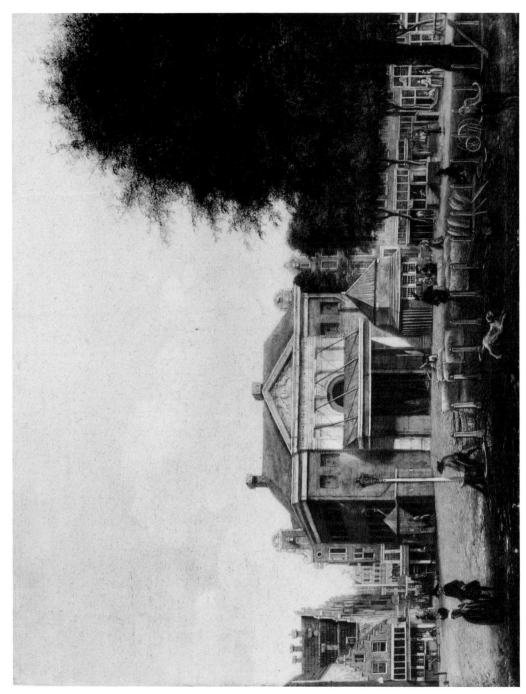

Fig. 130 Johannes Hubert Prins, *The weigh-house on the Buttermarket, Amsterdam* (cat. no. 681).

FIG. 131 Jan Maurits Quinkhard, *Portrait of an old lady* (cat. no. 238).

FIG. 132 Ascribed to Arnoldus van Ravesteyn, *Portrait of a girl* (cat. no. 571).

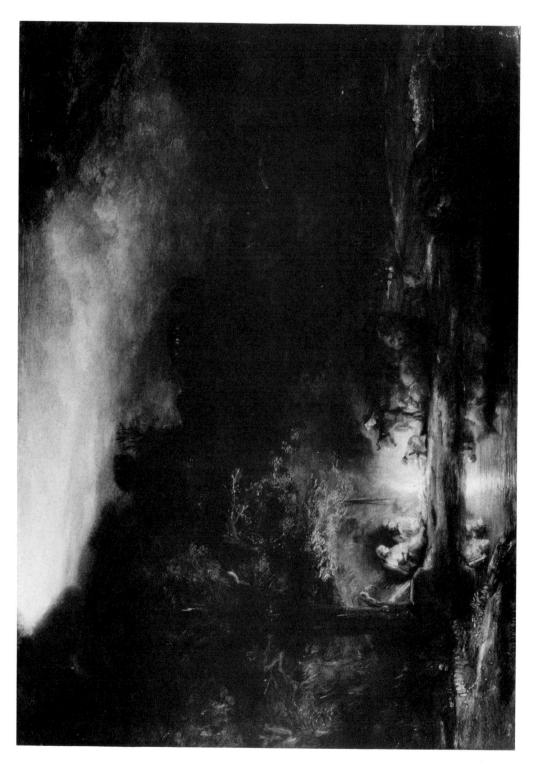

FIG. 133 Rembrandt, *Landscape with the rest on the flight into Egypt* (cat. no. 215).

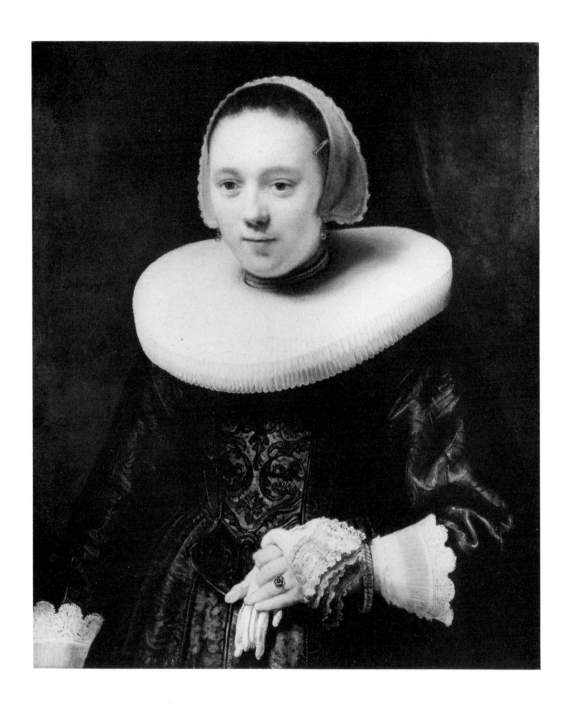

Fig. 134 Studio of Rembrandt, *Portrait of a lady holding a glove* (cat. no. 808).

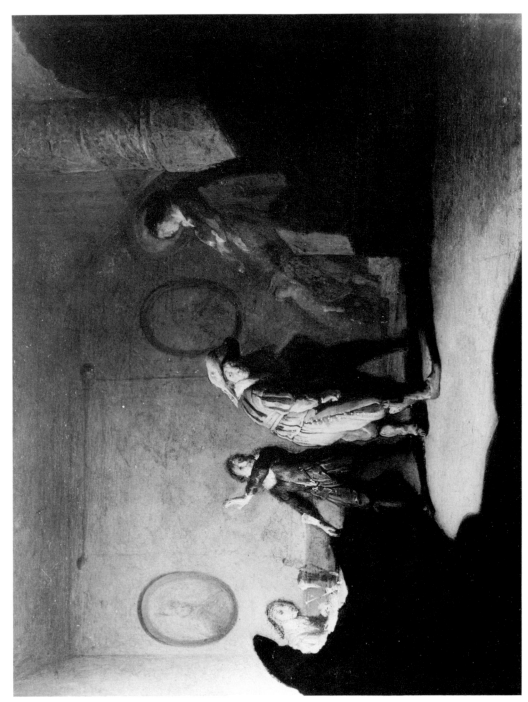

FIG. 135 School of Rembrandt, c.1628-30, *Interior with figures* (cat. no. 439).

FIG. 136 Radiograph of School of Rembrandt, c.1628-30, *Interior with figures* (cat. no. 439). The *Portrait of a man* underneath the composition may be seen by turning the page to the right.

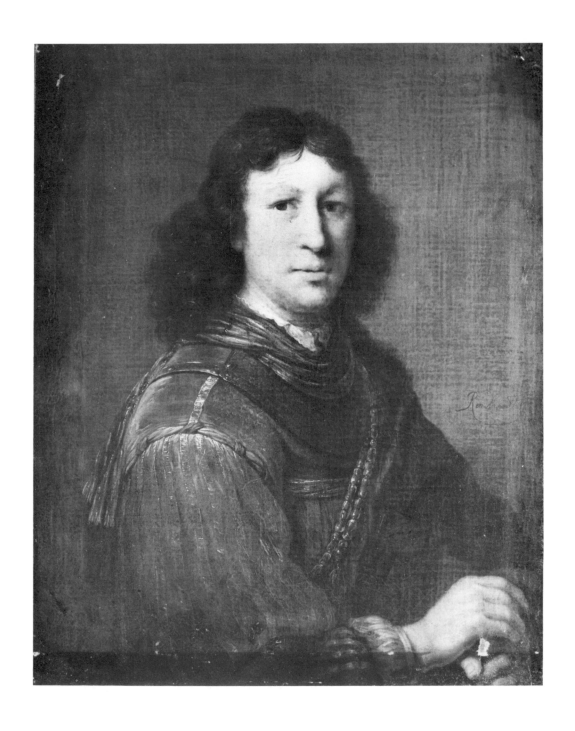

Fig. 137 Imitator of Rembrandt, 18th Century, *Portrait of a man* (cat. no. 4307).

Fig. 138 Radiograph of Imitator of Rembrandt, 18th Century, *Portrait of a man* (cat. no. 4307).

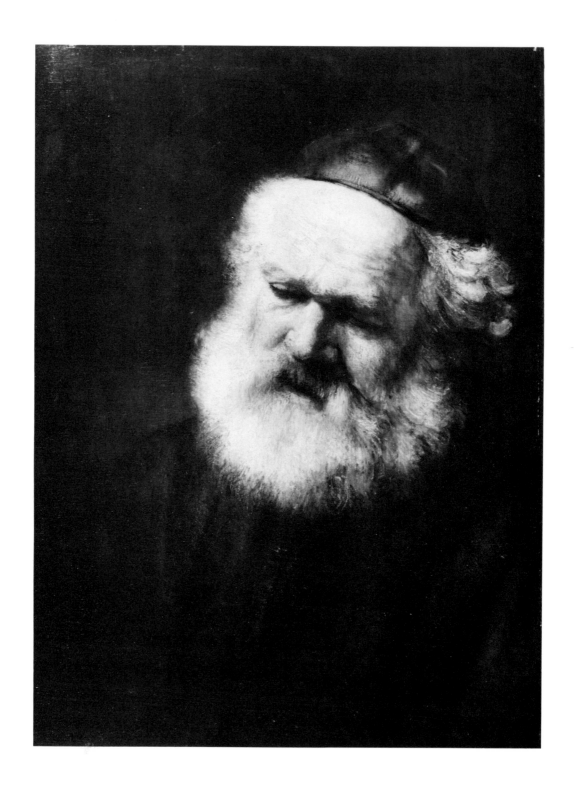

FIG. 139 Imitator of Rembrandt, 19th Century, *Head of an old man* (cat. no. 48).

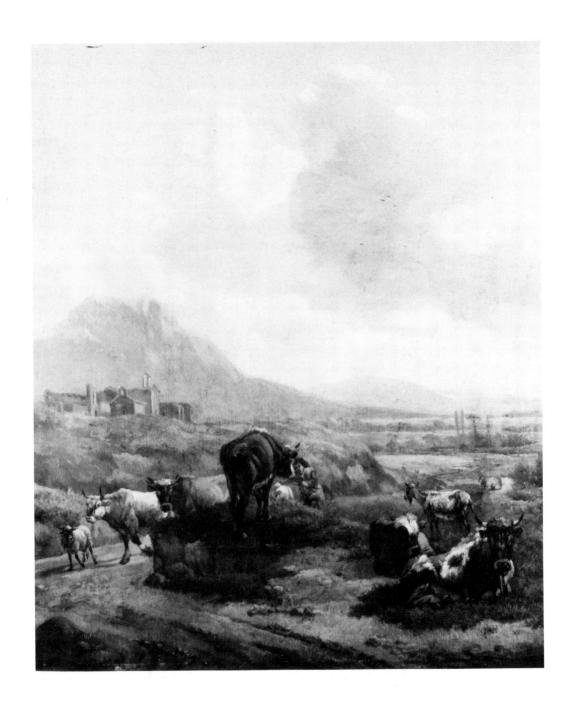

FIG. 140 Willem Romeyn, *Landscape with cattle* (cat. no. 345).

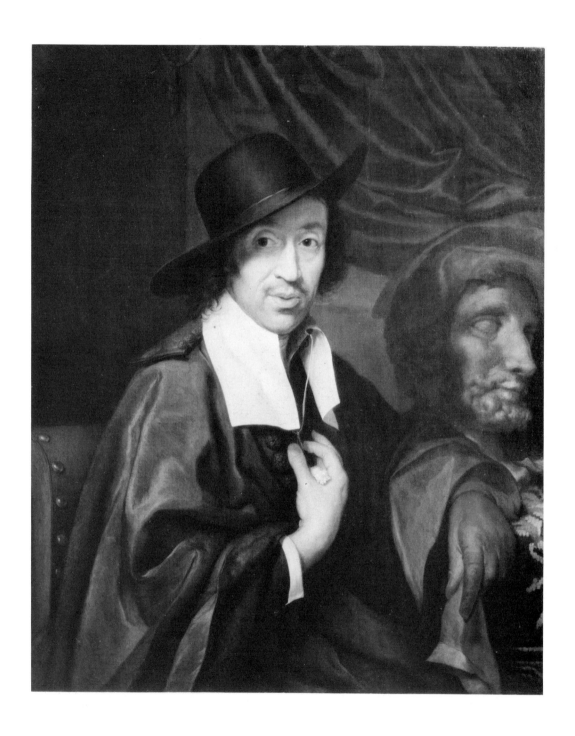

Fig. 141 Jan van Rossum, *Portrait of a man* (cat. no. 623).

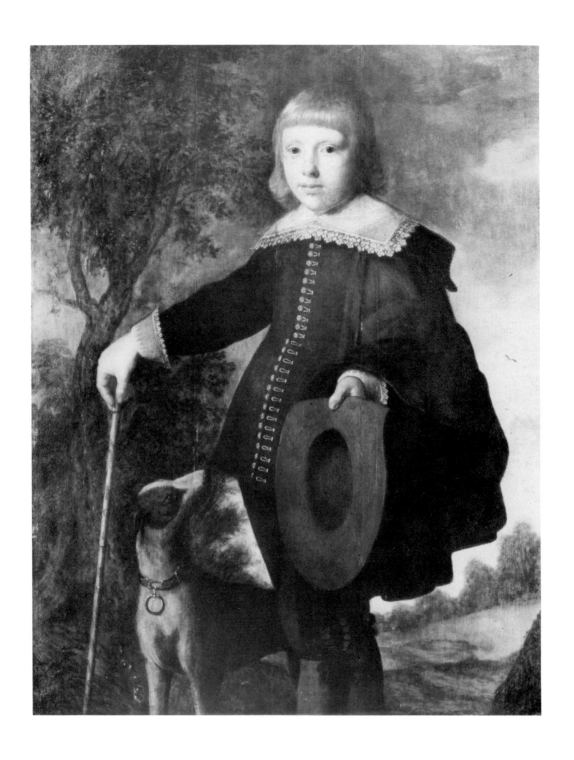

FIG. 142 Ascribed to Jan Albertsz. Rotius, *Portrait of a boy* (cat. no. cat. no. 639).

FIG. 143 Jacob Isaacksz. van Ruisdael, *A wooded landscape* (cat. no. 37).

FIG. 144 Jacob Isaacksz. van Ruisdael and Thomas de Keyser, *Cornelis de Graeff with his wife and sons arriving at Soestdijk* (cat. no. 287).

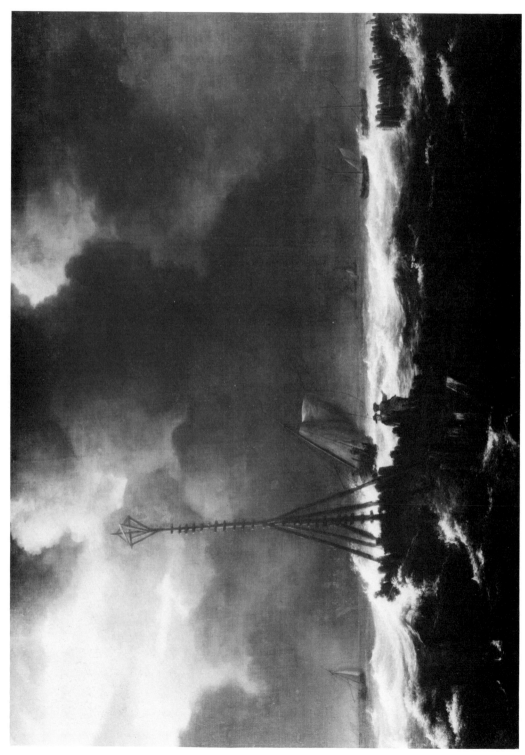

FIG. 145 After Jacob Isaacksz. van Ruisdael, *A stormy sea* (cat. no. 916).

Fig. 146 Salomon van Ruysdael, *The halt* (cat. no. 507).

Fig. 147 Salomon van Ruysdael, *Alkmaar with the Grote Kerk, winter* (cat. no. 27).

FIG. 148 Cornelis Saftleven, *The return of Tobias with the angel* (cat. no. 449).

FIG. 149 Godfried Schalcken, *Pretiose recognised* (cat. no. 476).

F<small>IG</small>. 150 Pieter van Slingeland, *Portrait of a lady* (cat. no. 267).

Fig. 151 Jan Frans Soolmaker, *Cattle in a hilly landscape* (cat. no. 225).

Fig. 152 Hendrik Sorgh, *The breakfast* (cat. no. 269).

FIG. 153 Jan Steen, *The village school* (cat. no. 226).

Fig. 154 Follower of Jan Steen, *A woman mending a stocking* (cat. no. 227).

Fig. 155 Matthias Stomer, *The arrest of Christ* (cat. no. 425).

Fig. 156 Matthias Stomer, *The arrest of Christ*
(Gabinetto disegni e stampe degli Uffizi, Florence).

Fig. 157 Dirck Stoop, *A hunting party in a landscape* (cat. no. 285).

Fɪɢ. 158 Abraham Storck, *Shipping* (cat. no. 228).

FIG. 159 Frans Swagers, *Landscape* (cat. no. 448).

FIG. 160 Abraham van den Tempel, *Portrait of a lady* (cat. no. 1062).

FIG. 161 Cornelis Troost, *Portrait of Jeronimus Tonneman and his son Jeronimus: 'The Dillettanti'* (cat. no. 497).

Fig. 162 Ascribed to Wallerand Vaillant, *Portrait of a man* (cat. no. 270).

Fig. 163 Dirck Valkenburg, *Birds with an urn in a landscape* (cat. no. 625).

Fig. 164 Studio of Willem van de Velde the Younger, *Calm: the English ship Britannia at anchor* (cat. no. 276).

Fig. 165 Studio of Willem van de Velde the Younger, *The Royal Visit to the Fleet in the Thames Estuary, 6 June 1672* (cat. no. 1742).

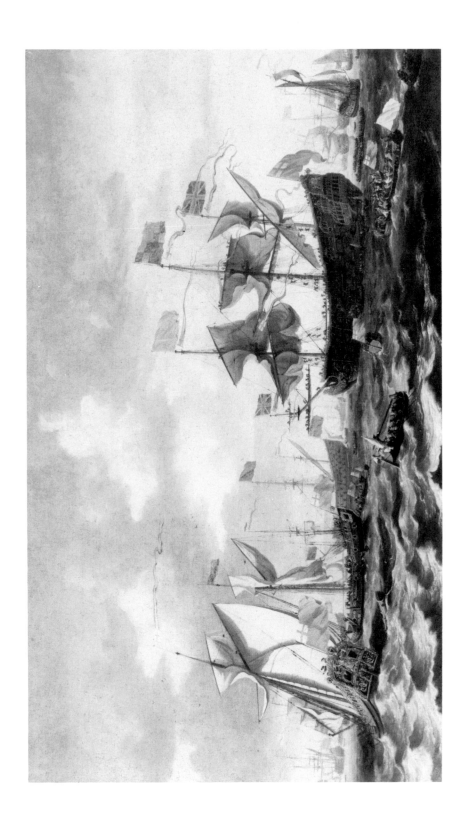

FIG. 166 After Willem van de Velde the Younger, *The Royal Visit to the Fleet in the Thames Estuary, 6 June 1672* (cat. no. 58).

FIG. 167 After Willem van de Velde the Younger, *Calm: an English sixth-rate ship firing a salute* (cat. no. 964).

Fig. 168 Ascribed to Pieter Verelst, *Portrait of an old lady* (cat. no. 346).

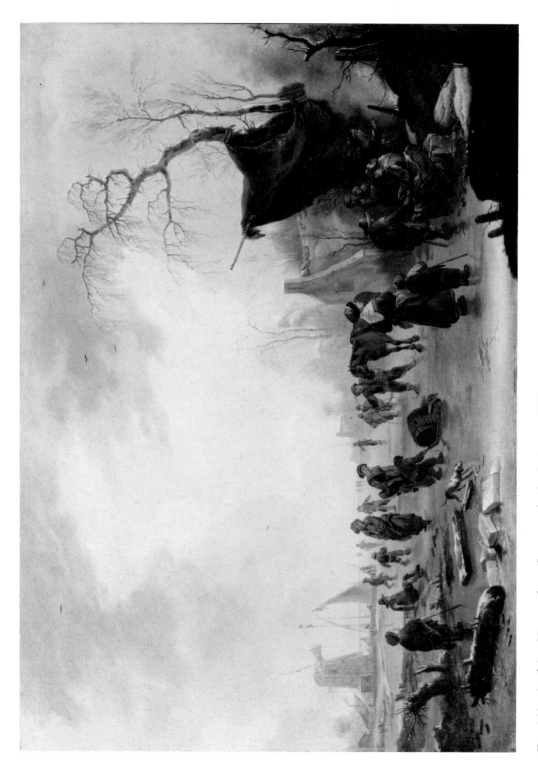

FIG. 169 Andries Vermeulen, *Scene on the ice* (cat. no. 432).

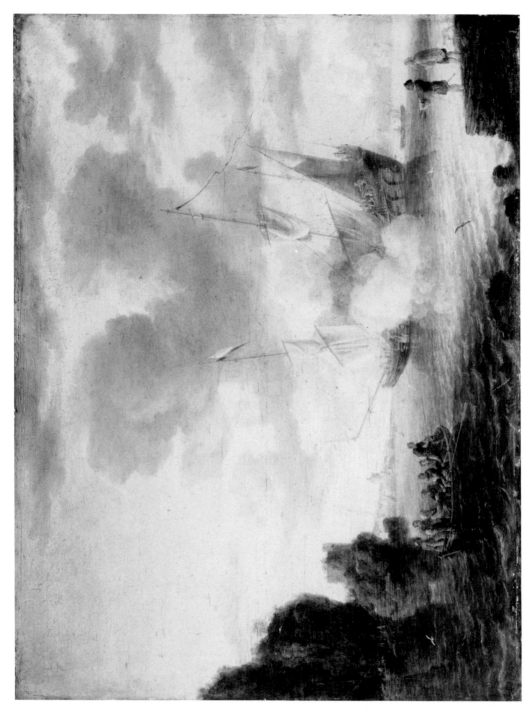

Fig. 170 Ascribed to Lieve Verschuier, *A seaport with a vessel firing a salute* (cat. no. 743).

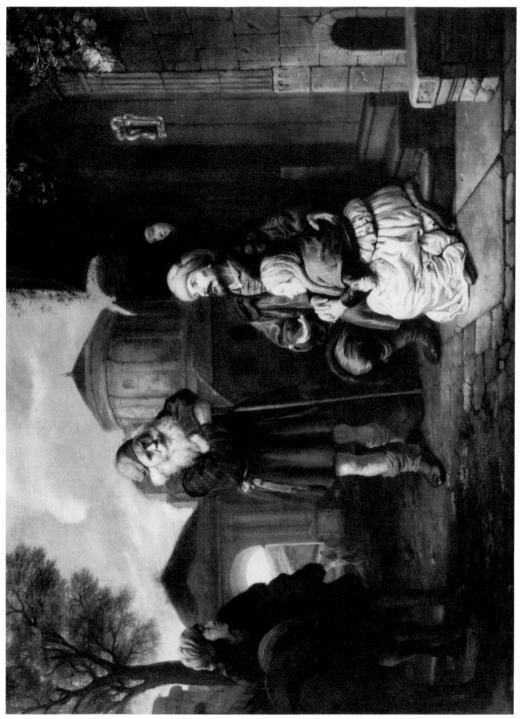

Fig. 171 Jan Victors, *The Levite and his concubine at Gibeah* (cat. no. 879).

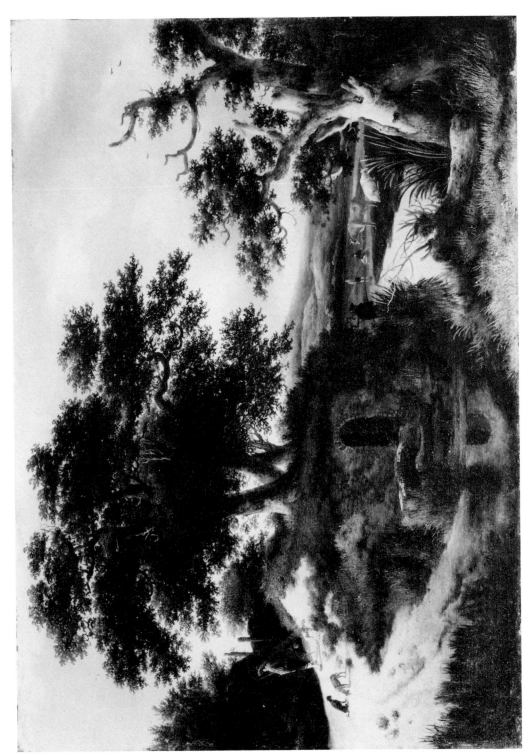

Fig. 172 Roelof van Vries, *A landscape with figures* (cat. no. 972).

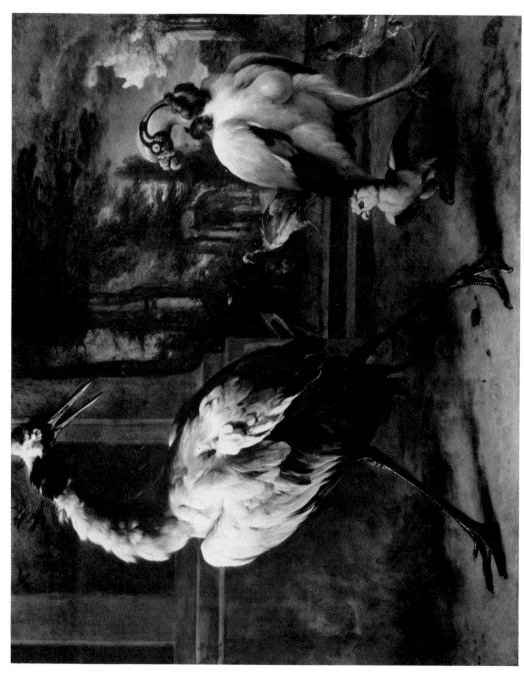

FIG. 173 Jan Weenix, *A Japanese crane and king vulture* (cat. no. 35).

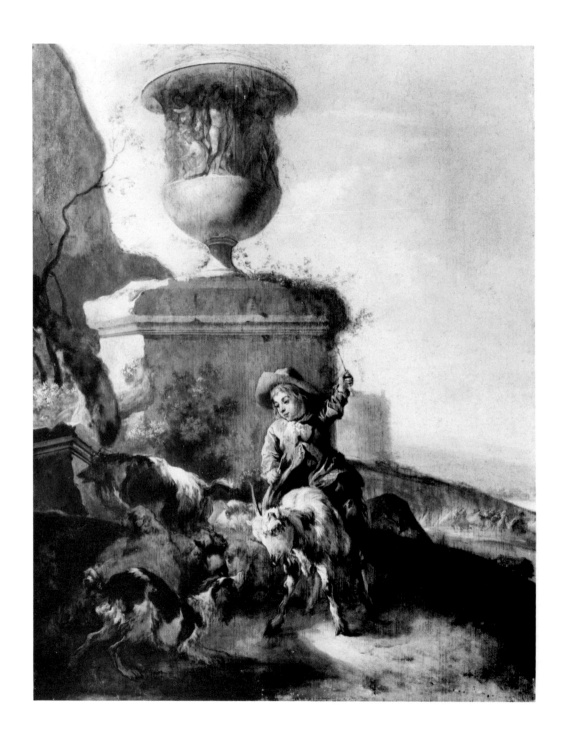

Fig. 174 Jan Weenix, *In the Campagna* (cat. no. 488).

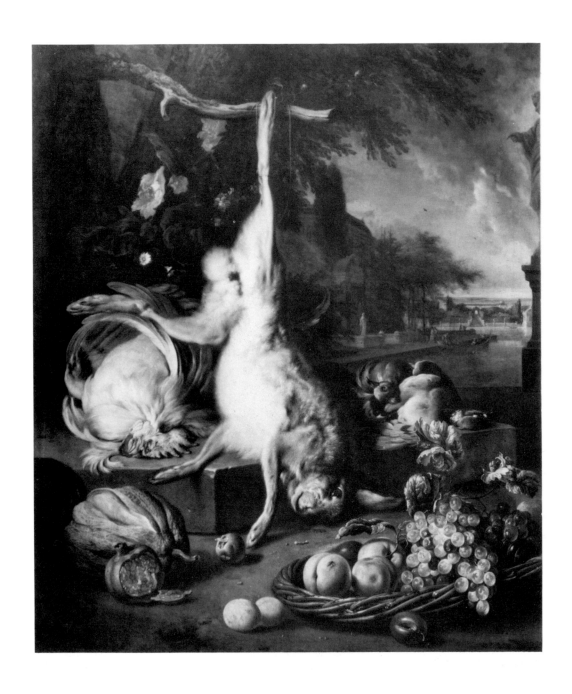

Fig. 175 Jan Weenix, *Game-piece: the garden of a château* (cat. no. 947).

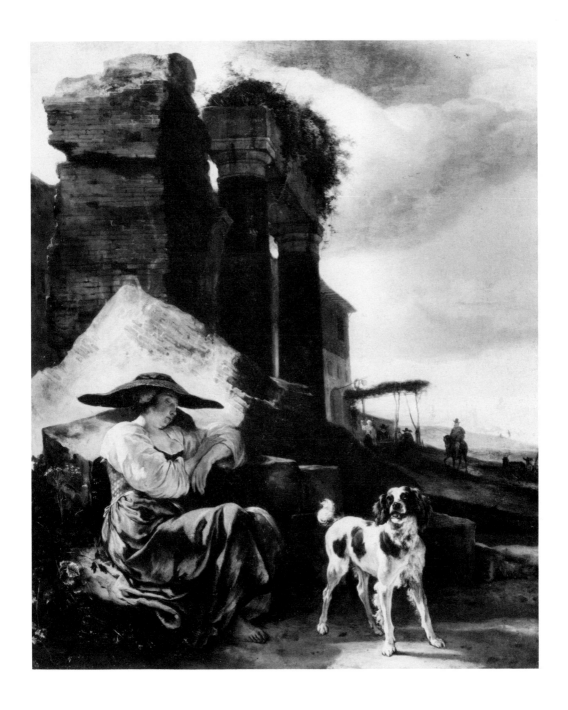

FIG. 176 Jan Baptist Weenix, *The sleeping shepherdess* (cat. no. 511).

Fig. 177 Ascribed to Jan Baptist Weenix, *The Holy Women at the tomb* (cat. no. 1394).

FIG. 178 Jacob de Wet the Elder, *Abraham and Melchisedek* (cat. no. 1315).

FIG. 179 Emanuel de Witte, *Interior of a Protestant classical church* (cat. no. 805).

FIG. 180 After Emanuel de Witte, *The interior of the New Church at Delft with the tomb of William the Silent* (cat. no. 450).

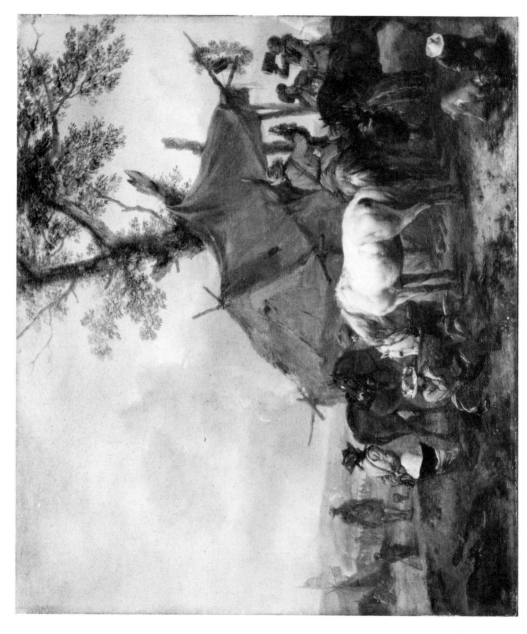

Fig. 181 Philips Wouwerman, *Cavalry halted at a sutler's tent* (cat. no. 170).

FIG. 182 Philips Wouwerman, *The Annunciation to the shepherds* (cat. no. 582).

FIG. 183 J. P. van Wijck, *Portrait of a lady* (cat. no. 894).

Fig. 184 Thomas Wijck, *Interior of a weaver's cottage* (cat. no. 349).

FIG. 185 Jan Wijnants, *The dunes near Haarlem* (cat. no. 280).

Fig. 186 Jan Wijnants, *A wooded landscape with a river* (cat. no. 508).

FIG. 187 Domenicus van Wijnen, called Ascanius, *The temptation of St. Anthony* (cat. no. 527).

FIG. 188 Dirck Wijntrack, *Rabbits at the mouth of a burrow* (cat. no. 29).

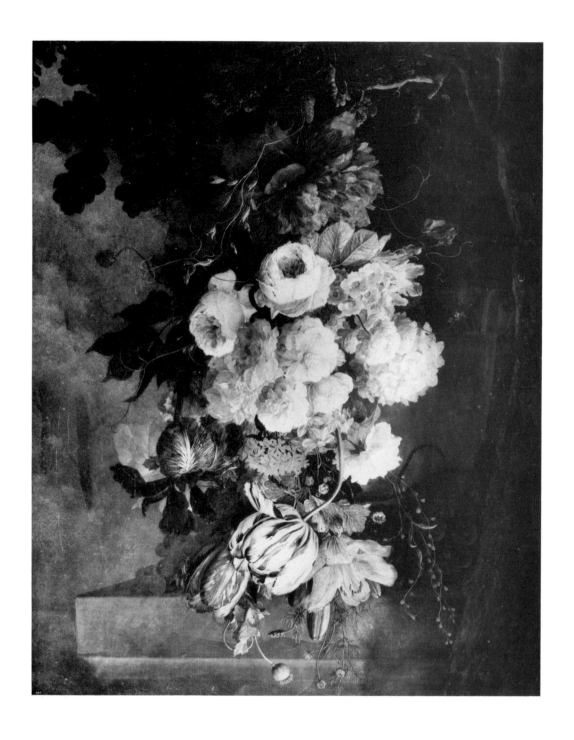

F<small>IG</small>. 189 Ascribed to Jacob Xavery, *A garland of flowers hanging from a bough* (cat. no. 50).

1	Opium Poppy	*Papaver somniferum* L.			
2	Pheasant's Eye	*Adonis flammea* Jacq.			
3	White Grapes	*Vitis vinifera* L.			
4	Tulip	*Tulipa clusiana* Vent. *x T. schrenkii* Reg.			
5	Tulip	*Tulipa clusiana* Vent. *x T. praecox* Ten.	15	White Rose (with Yellow Meadow Ants)	*Rosa alba* L. *plena* *Lasius flavus* F.
6	Orange Lily	*Lilium bulbiferum* L. var. *croceum* (Chaix) Pers.	16	Snowball	*Viburnum opulus* L. cv. *Roseum* (cv. = culture variety)
7	Flax (?)	*Linum usitatissimum* L.			
8	Black Grapes	*Vitis vinifera* L.			
9	Salt Marsh Iris	*Iris spuria* L.	17	Cabbage Rose	*Rosa centifolia* L.
10	Maltese Cross	*Lychnis chalcedonica* L.	18	Pot Marigold	*Calendula officinalis* L.
11	Bachelor's Button	*Ranunculus acris* L. var. *multiplex* G. Don	19	Ranunculus	*Ranunculus asiaticus* L.
			20	Forget-me-not	*Myosotis scorpioides* L.
12	Polyanthus Narcissus	*Narcissus tazetta* L. hybrid	21	Oat	*Avena fatua* L.
13	Hollyhock (?)	*Alcea rosea* L.	22	Auricula	*Primula x pubescens* Jacq.
14	Narcissus "Van Zion"	*Narcissus pseudonarcissus* L. *plenus* (if a yellow rose: *Rosa haemispherica* Herrm.)	23	Sweet Pea	*Lathyrus odoratus* L.
			24	Peony	*Paeonia officinalis* L. *plena*
			25	Oak	*Quercus robur* L.

FIG. 190 Diagram of Ascribed to Jacob Xavery, *A garland of flowers hanging from a bough* (cat. no. 50) showing the identification of the flowers.

FIG. 191 After Nicolaes Berchem, *A landscape with ford* (cat. no. 1939).

FIG. 192 Style of Nicolaes Berchem, *A market scene* (cat. no. 1657).

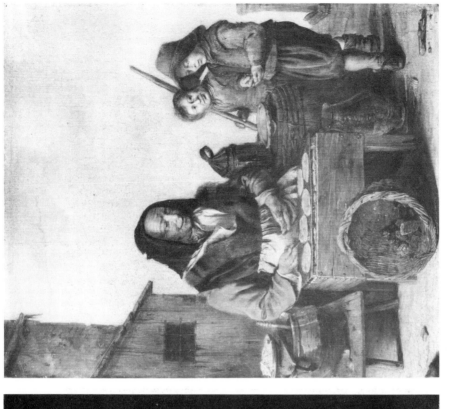

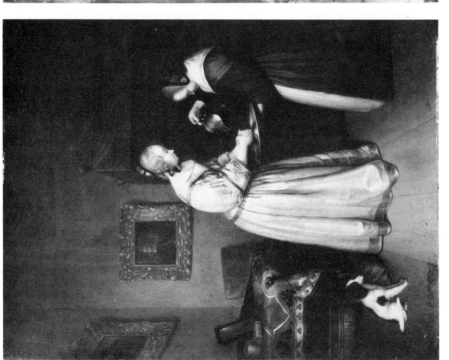

Fig. 193 After ter Borch, *Interior with a lady washing her hands* (cat. no. 1087).

Fig. 194 Style of Quirijn van Brekelenkam, *The pancake maker* (cat. no. 1225).

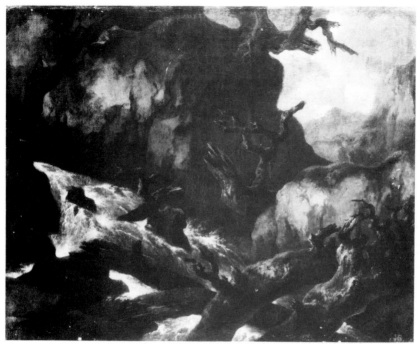

FIG. 195 Style of Allaert van Everdingen, *Landscape with a mountain torrent* (cat. no. 1890).

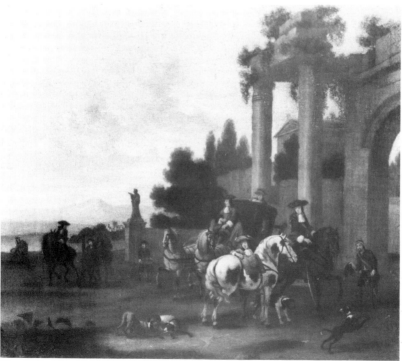

FIG. 196 Style of Dirck Maes, *A coach party with a classical building* (cat. no. 1972).

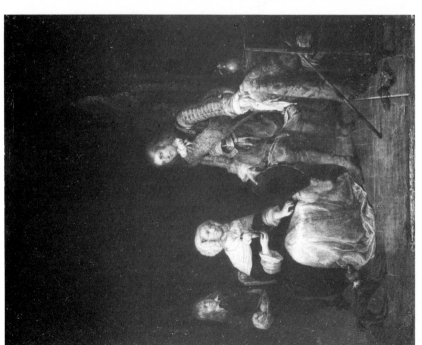

Fig. 197 After Gabriel Metsu, *A cavalier and lady.*
(cat. no. 1996).

Fig. 198 Style of Frederik de Moucheron, *An Italianate
Landscape with muleteers* (cat. no. 337).

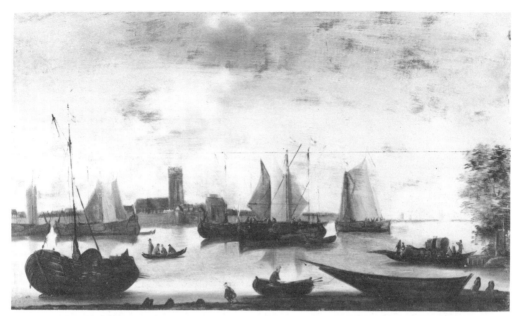

FIG. 199 Style of Hendrik de Meyer, *Shipping in inland waters* (cat. no. 1674).

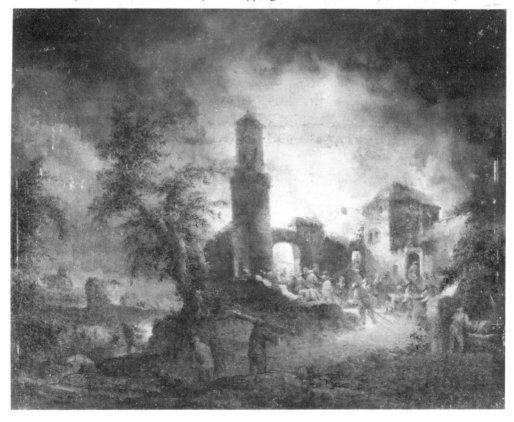

FIG. 200 Style of Aert van der Neer, *A town on fire* (cat. no. 1992).

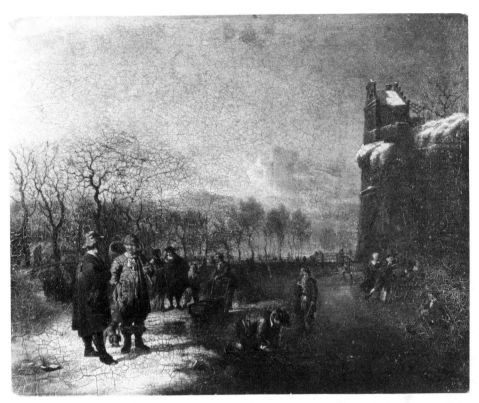

Fig. 201 After Adriaen van de Velde, *Scene on the ice* (cat. no. 1888).

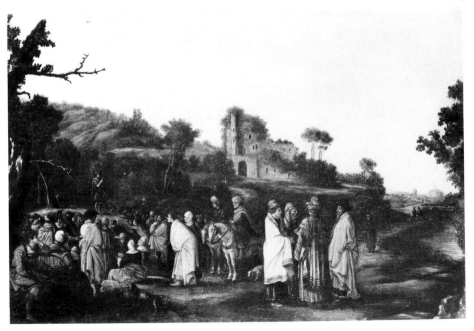

Fig. 202 Follower of Esaias van de Velde, *St. John preaching in the wilderness* (cat. no. 1175).

Fig. 204 Style of Philips Wouwerman, *Horses and figures at a sutler's tent* (cat. no. 1702).

Fig. 203 Style of Jan Weenix, *Game-piece* (cat. no. 533).

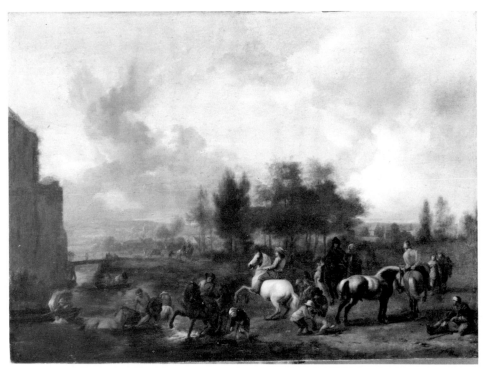

FIG. 205 After Philips Wouwerman, *Horses watering: a landscape* (cat. no. 1699).

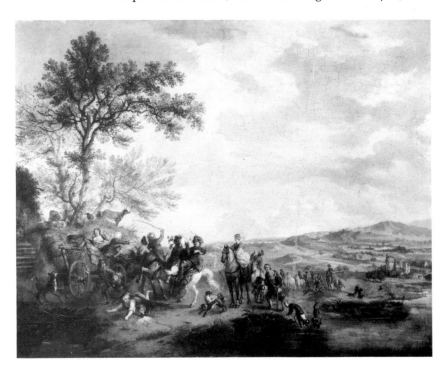

FIG. 206 After Philips Wouwerman, *The collision* (cat. no. 1386).

FIG. 207 Style of Philips Wouwerman, *Halt with caravans* (cat. no. 1755).

FIG. 208 Style of Philips Wouwerman, *Huntsmen with horses* (cat. no. 1712).

COMPARATIVE ILLUSTRATIONS

Fig. 209 Jacob Duck, *A woman sleeping* (Landesmuseum Ferdinandeum, Innsbruck).
Refer to Fig. 47.

FIG. 210 Claes Jacobsz. van der Heck, *A winter landscape* (Present whereabouts unknown). Refer to FIG. 66.

Fig. 211 Simon Kick, *Portrait of a young man standing by an open stove* (Present whereabouts unknown). Refer to Fig. 88.

Fig. 212 Simon Kick, *A group portrait* (Royal Museum of Fine Arts, Copenhagen). Refer to Fig. 88.

Fɪɢ. 213 Jan Asselijn, *A mounted cavalier* (Akademie der Bildenden Kunst, Vienna).
Refer to Fɪɢ. 129.

FIG. 214 Thomas de Keyser, *Portrait of Jacob de Graeff with his servant*
(Szépmüvészeti Muzéum, Budapest). Refer to FIG. 144.

Fig. 215 Pieter van Slingeland, *Portrait of a man* (Metropolitan Museum, New York).
Refer to Fig. 150.

FIG. 216 Jan Steen, *The village school* (Collection the Marquess of Northampton).
Refer to FIG. 153.

FIG. 217 Dirck Stoop. *A hunting party in a landscape* (Royal Museum of Fine Arts, Copenhagen). Refer to FIG. 157

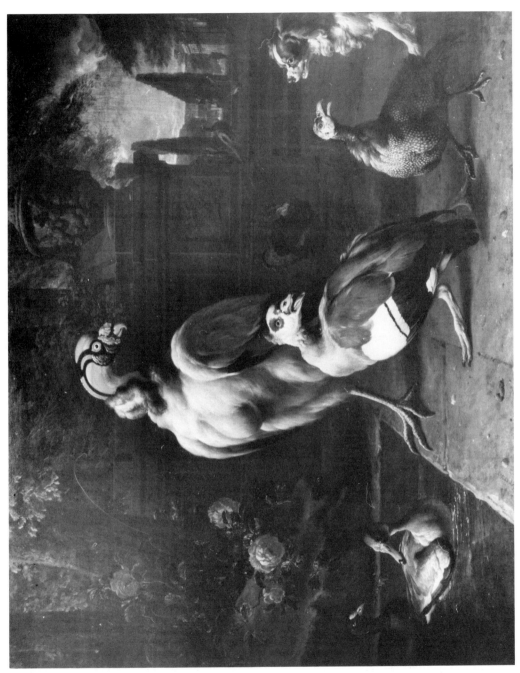

FIG. 218 Jan Weenix, *A king vulture and other birds* (Szépművészeti Muzéum, Budapest). Refer to FIG. 173.

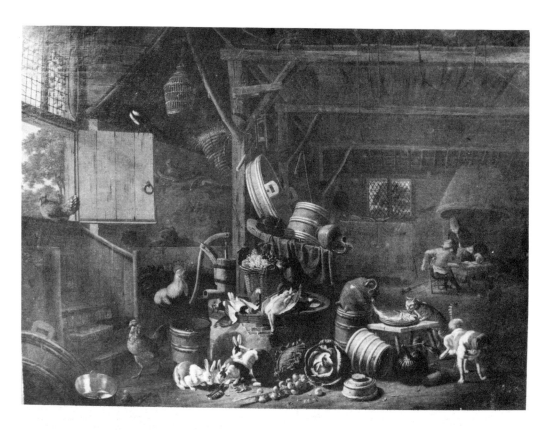

Fig. 219 Dirck Wijntrack, *The interior of a barn* (Present whereabouts unknown). Refer to Fig. 188.

Fig. 220 Dirck Wijntrack, detail of *The interior of a barn*, fig. 219. Refer to Fig. 188.

Artists' Signatures on Paintings in the Catalogue

FIG. 221 J. A. Beerstraaten, cat. no. 679

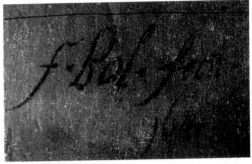

FIG. 226 F. Bol, cat. no. 810

FIG. 222 C. Bega, cat. no. 28

FIG. 227 J. Both, cat. no. 179

FIG. 223 N. Berchem, cat. no. 176

FIG. 224 G. C. Bleker, cat. no. 246

FIG. 228 J. Both, cat. no. 4292CB

FIG. 225 F. Bol, cat. no. 47

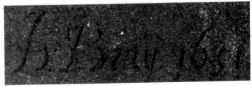

FIG. 229 J. de Braij, cat. no. 180

FIG. 230 P. Claesz, cat. no. 326

FIG. 231 P. Claesz, cat. no. 1285

FIG. 232 J. ten Compe, cat. no. 1681

FIG. 233 A. J. van der Croos, cat. no. 328

FIG. 234 Studio of A. Cuyp, cat. no. 49

FIG. 235 J. G. Cuyp, cat. no. 1047

FIG. 236 J. G. Cuyp, cat. no. 1048

FIG. 237 D. van Delen and D. Hals, cat. no. 119

FIG. 238 J. C. Droochsloot, cat. no. 252

FIG. 239 W. Drost, cat. no. 107

FIG. 240 van den Eeckhout, cat. no. 253

FIG. 241 C. J. Dusart, cat. no. 961

FIG. 242 G. Flinck, cat. no. 64

FIG. 243 J. Griffier, cat. no. 336

FIG. 244 N. de Gyselaer, cat. no. 327

FIG. 245 J. G. van Hasselt, cat. no. 897

FIG. 246 J. D. de Heem, cat. no. 11

FIG. 247 B. van der Helst, cat. no. 65

FIG. 248 M. Hobbema, cat. no. 832

FIG. 249 P. de Hooch, cat. no. 322

FIG. 250 J. P. Horstok, cat. no. 650

FIG. 251 L. de Jongh, cat. no. 148

FIG. 252 J. van Kessel, cat. no. 933

FIG. 253 T. de Keyser, cat. no. 469

FIG. 254 J. Lagoor and A. van de Velde, cat. no. 515

FIG. 255 P. Lastman, cat. no. 890

FIG. 256 J. Lingelbach, cat. no. 348

FIG. 257 H. de Meyer, cat. no. 1706

FIG. 258 J. M. Molenaer, cat. no. 45

FIG. 259 K. Molenaer, cat. no. 682

FIG. 260 P. de Molijn, cat. no. 8

FIG. 261 P. Moreelse, cat. no. 263

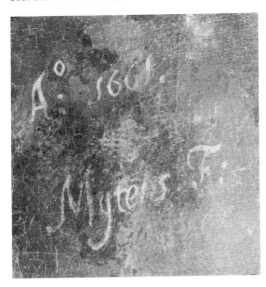

FIG. 262 J. Mytens, cat. no. 62

FIG. 263 J. Mytens, cat. no. 150

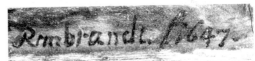

FIG. 264 G. Pompe, cat. no. 850

FIG. 265 F. Post, cat. no. 847

FIG. 266 P. S. Potter, cat. no. 323

FIG. 267 Rembrandt, cat. no. 215

FIG. 268 J. van Ruisdael, cat. no. 37

FIG. 269 S. van Ruysdael, cat. no. 507

FIG. 270 G. Schalcken, cat. no. 476

FIG. 271 P. van Slingeland, cat. no. 267

FIG. 272 J. F. Soolmaker, cat. no. 225

FIG. 273 H. M. Sorgh, cat. no. 269

FIG. 274 A. Storck, cat. no. 228

FIG. 275 C. Troost, cat. no. 497

FIG. 276 D. Valkenburg, cat. no. 625

FIG. 277 J. B. Weenix, cat. no. 511

FIG. 278 J. P. Wijck, cat. no. 894

FIG. 279 J. Wijnants, cat. no. 280

FIG. 280 J. Wijnants, cat. no. 508

FIG. 281 D. van Wijnen (Ascanius), cat. no. 527

COLLECTORS' SEALS AFFIXED TO PAINTINGS IN THE CATALOGUE

FIG. 282 de Braij, cat. no. 180

FIG. 285 Duyster, cat. no. 436

FIG. 283 Style of Brekelenkam, cat. no. 1225

FIG. 286 Flinck, cat. no. 254

FIG. 284 J. G. Cuyp, cat. no. 1047

FIG. 287 Griffier, cat. no. 336

FIG. 288 Molenaer, cat. no. 45

FIG. 289 Molenaer, cat. no. 682

FIG. 290 Monogrammist IS, cat. no. 247

FIG. 291 Ochtervelt, cat. no. 641

FIG. 292 Palamedesz., cat. no. 531

FIG. 293 de Poorter, cat. no. 380

FIG. 294 School of Rembrandt, cat. no. 439
de Poorter, cat. no. 380

FIG. 297 Weenix, cat. no. 511

FIG. 295 Potter, cat. no. 323

FIG. 298 Wouwerman, cat. no. 582

FIG. 296 Weenix, cat. no. 488